"A feat of investigative inquiry woven together by Morris's delicate but cunning threads of cultural criticism, *Believing Is Seeing* is an absolute masterpiece of rigorous nonfiction that pulls you in like the best of mystery fiction." —Brainpickings.org

"Delightfully conversational . . . Morris . . . transmut[es] the slippery, intellectually curious, playful tone of his films into his written work." —*The Boston Globe*

"[A] meticulous and passionate statement." —*San Francisco Chronicle*

"Morris can be a first-rate philosopher on the page as well as onscreen."

—*A.V. Club*

"A valuable contribution to the literature on culture and photography, and, most important, it is a text that will make its readers think—a crucial response, given that we live in an era where the photographic image is often still too habitually and too trustingly taken as fact." —*Los Angeles Review of Books*

"A great book. Like a police procedural in a murder mystery . . . Morris eliminates possibility and finds the truth." —*The Moderate Voice*

"Morris has become one of America's most idiosyncratic, prolific, and provocative public intellectuals." —Ron Rosenbaum, *Smithsonian*

"If more prosecutors and police investigators were this rigorous, we would have far fewer innocent people on Death Row, and if more reporters and editors were this thorough, our news would be less tainted with factual errors and outright lies."

—*The Millions*

"[The] much-needed book that codifies our relationship to photography in the post-digital world . . . [*Believing Is Seeing*] is simultaneously an homage to and a warning against the power of images over the human brain." —*Columbia Journalism Review*

PENGUIN BOOKS

BELIEVING IS SEEING

Errol Morris is a world-renowned filmmaker and a recipient of a MacArthur "genius" award. He won the Academy Award for *The Fog of War*. His other films include *Tabloid, Standard Operating Procedure, Mr. Death, Fast Cheap & Out of Control, A Brief History of Time, The Thin Blue Line,* and most recently, *The Unknown Known.* He is the author of *A Wilderness of Error: The Trials of Jeffrey MacDonald.*

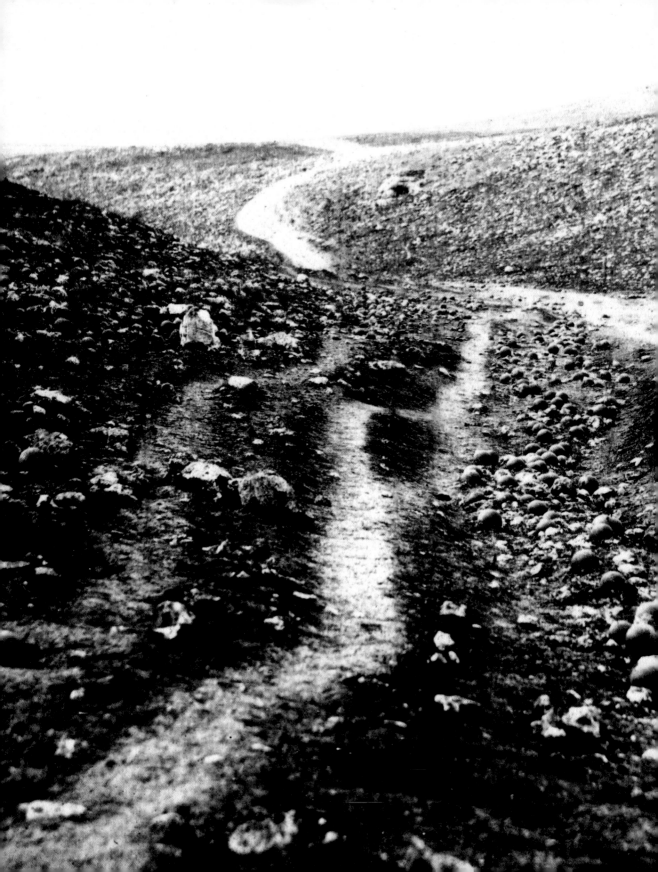

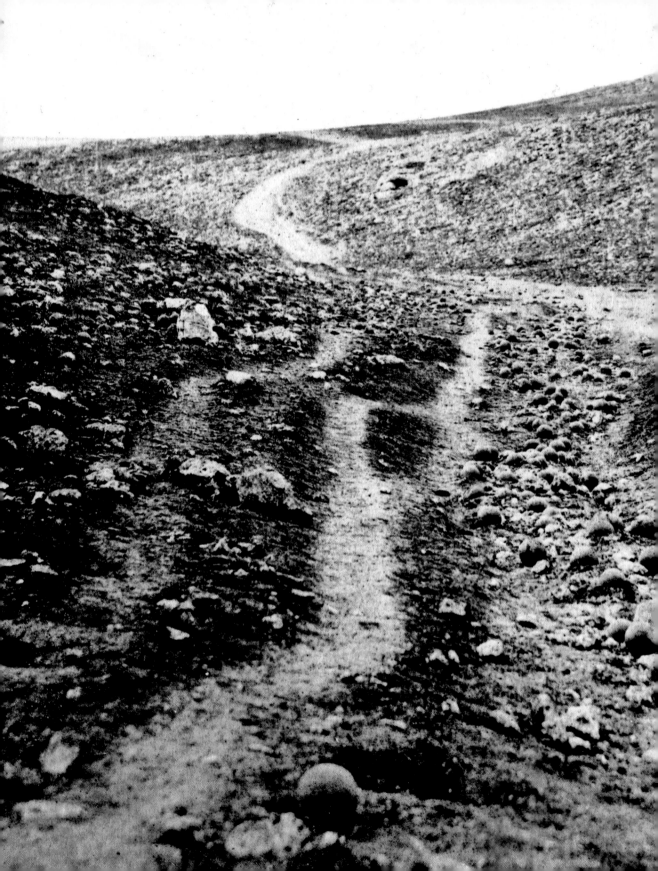

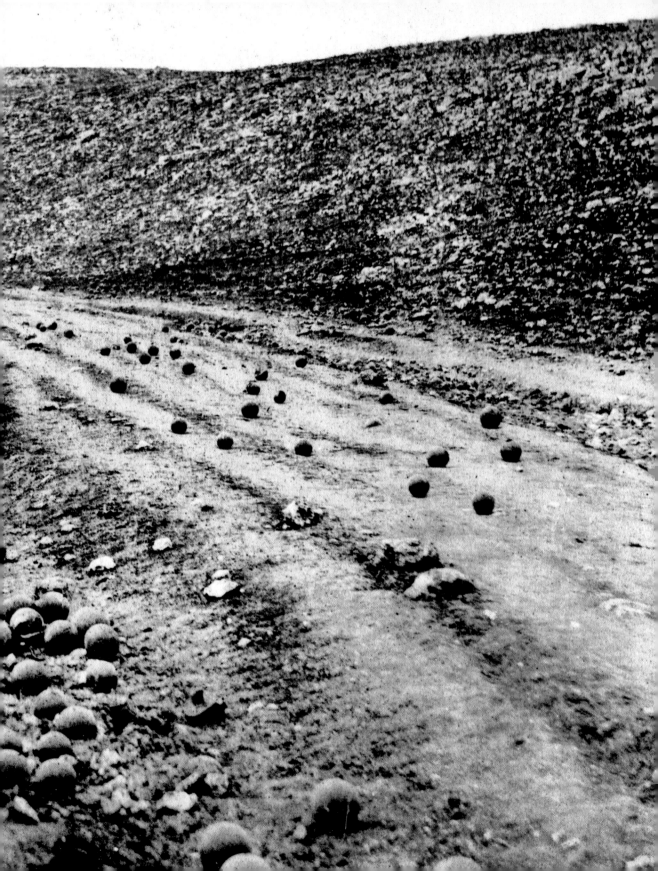

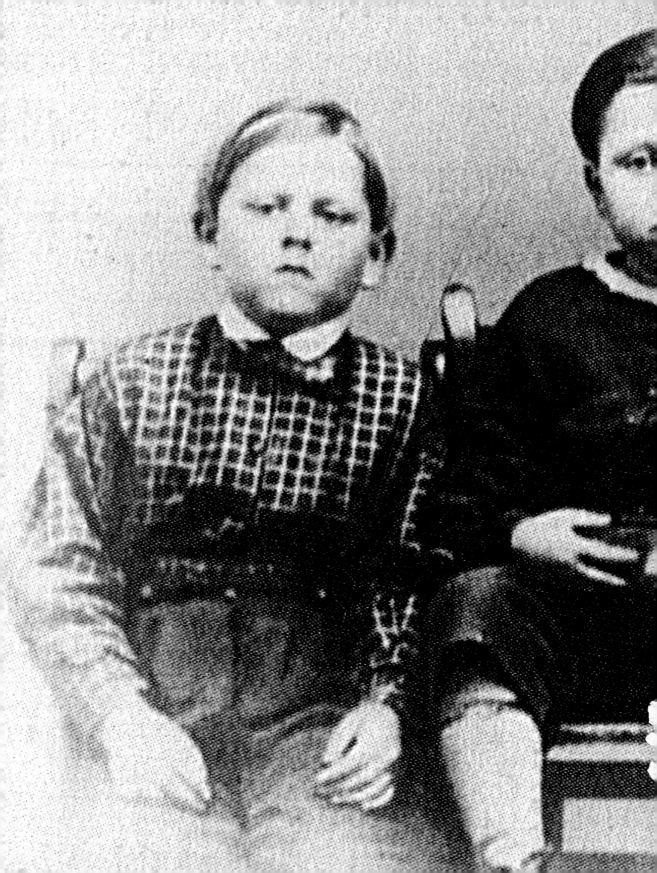

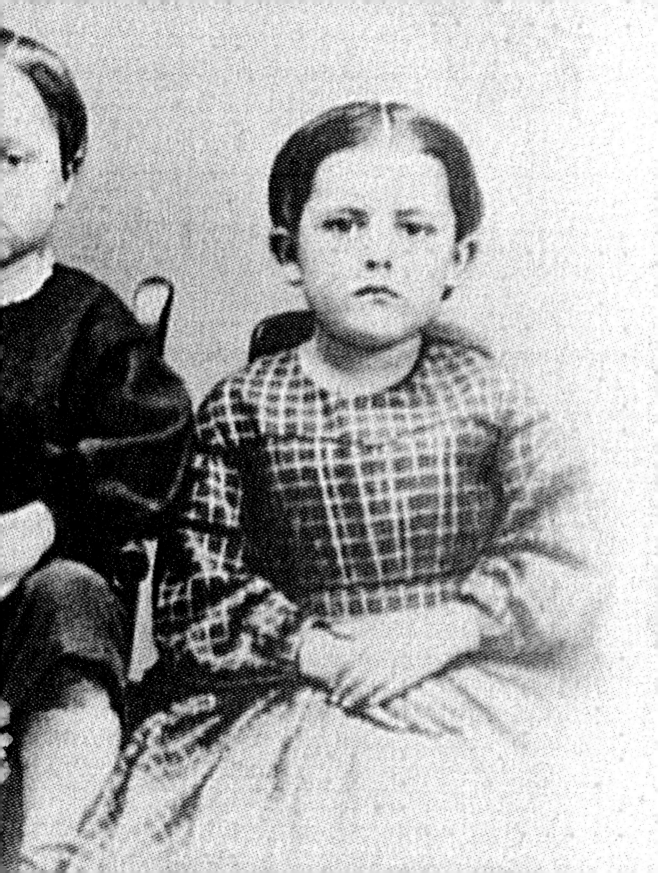

ERROL
BELIEVING
(OBSERVA
THE MY
OF PHOT

MORRIS IS SEEING

TIONS ON

STERIES

OGRAPHY)

PENGUIN BOOKS

To Julia, as always

PENGUIN BOOKS
Published by the Penguin Group
Penguin Group (USA) LLC
375 Hudson Street
New York, New York 10014

USA | Canada | UK | Ireland | Australia
New Zealand | India | South Africa | China
penguin.com
A Penguin Random House Company

First published in the United States of America
by The Penguin Press, a member of
Penguin Group (USA) Inc., 2011
Published in Penguin Books 2014

These essays appeared in different form as the author's
blog on the Web site of *The New York Times.*

Illustration credits appear on pages 276–279.

THE LIBRARY OF CONGRESS HAS CATALOGED THE HARDCOVER
EDITION AS FOLLOWS:

Morris, Errol.
 Believing is seeing : observations on the mysteries of
photography / Errol Morris.
 p. cm.
 Includes bibliographical references and index.
 ISBN 978-1-59420-301-5 (hc.)
 ISBN 978-0-14-312425-2 (pbk.)
 1. Documentary photography. I. Title.
 TR820.5.M676 2011
 770.9—dc23
 2011013101

Printed in the United States of America
10 9 8 7 6 5 4 3 2 1

Set in Chronicle Text and Helvetica Neue
Designed by Michael Bierut and Yve Ludwig,
Pentagram Design

CONTENTS

PREFACE

The essays in this book should be seen as a collection of mystery stories. Imagine finding a trunk in an attic filled with photographs. With each photograph we are thrown into an investigation. Who are these people? Why was their photograph taken? What were they thinking? What can they tell us about ourselves? What can we learn about the photographer and his motivations? Each of these questions can lead us on a winding, circuitous path. An excursion into the labyrinth of the past and into the fabric of reality.

ILLUSTRATION #1
MORRIS FAMILY PHOTO

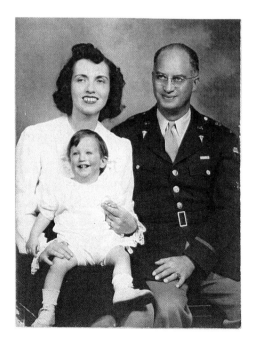

My own endless questions about the relationship between images and reality, and in particular, photographic images and reality, began with photographs of my father. My father died on December 10, 1950. I was almost three years old. He was at a party with my mother, complained of chest pains, and collapsed. He died within minutes of a massive heart attack, leaving my mother a widow at the age of thirty-two with two children (myself and my brother, Noel, who was almost six years older than me) and an adored housekeeper, Mary Jane Hardman, whom we called "Hardy." This picture of my mother, my father, and my older brother was probably taken in 1943, while my father, who was a doctor, was stationed at Fort Sill, Oklahoma. He was a captain in the army.

I have absolutely no memory of my father. Other than a few photographs, all I have is an elaborate lithograph of a skull drawn with the words of the Declaration of Independence: "We hold these truths to be self-evident." It was a prize for excellence from his anatomy professor at the University of Edinburgh. (In the 1930s it was extremely difficult for a Jew to gain admission to one of the top American medical schools since there were quotas in place. Hence, my father ended up in Edinburgh.)

ILLUSTRATION #2
SKULL DRAWING

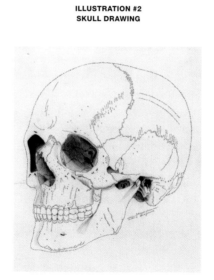

There were also the limited recollections of my father from my mother, my brother, and other family members. My brother, who I believe was horribly traumatized by my father's death, never spoke about him.[1] No stories, no anecdotes. Nothing. (Maybe I was reluctant to ask him, but he never volunteered information.) My mother also said very little. It was as though there was a secret about my father and I had to figure out what it was. Although my mother often suggested that I should become a physician—"like your father," she would say—I told her that I wanted to become an artist like her. After all, I knew my mother; I didn't know him.

ILLUSTRATION #3
DETAIL OF SKULL DRAWING

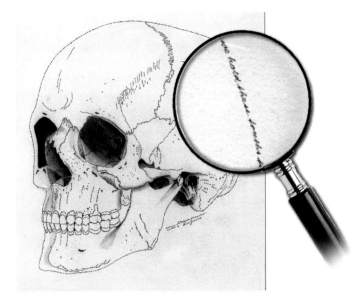

For years after my father died, his doctor's office was still part of the house—downstairs, in what later became the living room. There were hundreds of medical books with grotesque pictures of various diseases and deformities. There was his chair, his pipe, his tobacco jar. But he himself was absent. My mother, on the other hand, was very much present. She was an exceptional musician, a graduate of Juilliard, and an extraordinary sight-reader. I was in my twenties before I realized that not every mother plays Schumann's *Carnaval* or Schubert's *Wanderer Fantasy*.[2]

Hardy would often use my father as a warning when I misbehaved. "Your father would never have tolerated this behavior," she would tell me. But my father was dead, so the issue of whether he would or would not have tolerated my behavior seemed remote, at best academic. At some point, I learned from Hardy that my father often fought with my brother and that my father called me "the little professor."

And then there were the *photographs* of my father. Who was this man in the photographs? On one hand, the photographs were familiar to me. I grew up with them around the house. They showed my father and mother together while he was in the service; my father and mother with Hardy; my brother and my father. I'm not exactly sure what I thought about them growing up, but I was surprised when, years later, someone observed that my father had a rather severe, forbidding expression.

In a sense, the photographs both gave me my father and took him away. Photographs put his image in front of me, but they also acutely reminded me of his absence. He existed for me primarily in photographs accompanied by sketchy family stories. There was ample evidence that he had once been in the house with us, but

nevertheless, he was inherently unknowable to me. Who was he? I have no idea. I have the photographs, but I can only imagine who he actually was.

There is a further complication. Just after my father's death, my eyes were operated on. I had strabismus, a condition in which one of the eyes is misaligned. I was wall-eyed, like Jean-Paul Sartre. With strabismus there is nothing functionally wrong with the eye, just with its alignment. Once the eye has been put back into the correct position, the brain can then integrate the output of the two eyes into a single stereoscopic image; that is, it can produce normal vision. In order to promote the development of the "lazy eye," a patch is placed over the good eye. This treatment doesn't always work, and I reduced whatever chances I had for normal vision by repeatedly tearing the patch off. My mother bought me a Philco television as a reward for wearing the eye patch. I dutifully watched *Winky-Dink and You, The Howdy Doody Show*, and *Captain Video*, but I still refused to wear the patch. It was my fault, and it left me without normal stereoscopic vision (stereopsis) and limited vision in my left eye.

ILLUSTRATION #4
WINKY-DINK AND YOU

Ironically, the eye surgeon was Ben Esterman, the family ophthalmologist, who became my stepfather twenty years later. When I was older, my mother told me how she had come to visit me in the hospital shortly after my operation. Both my eyes were wrapped in gauze like something out of a film noir story, except I was a small child. My future stepfather said to my mother, "Don't say anything. Don't let him know you're here, because if he can't see you it will be too upsetting." My wife, Julia, calls it a new version of the Oedipus story: my future stepfather blinds me and then marries my mother. But it all ended happily. My mother married Ben when I was in my early twenties. They were married close to thirty years, and without both of them, I could never have become a writer and filmmaker.

If I share anything with Oedipus, it is asking one too many questions. Why do I see things the way I do? I suppose it must have something to do with my skepticism about vision. Did this influence the way I look at still photographs or my skeptical approach to documentary filmmaking? I wish I could pin it down more precisely. Maybe that's what I'm trying to do here.

CRIMEAN
(INTENT
THE PHOT

WAR ESSAY
IONS OF
OGRAPHER)

Which Came First, the Chicken or the Egg?

Part 1

———

Between the idea
And the reality
Between the motion
And the act
Falls the Shadow . . .

—T. S. Eliot, "The Hollow Men"

"You mean to tell me that you went all the way to the Crimea because of one sentence written by Susan Sontag?" My friend Ron Rosenbaum seemed incredulous. I told him, "No, it was actually two sentences."

The sentences in question are from Sontag's *Regarding the Pain of Others,* her last published book.

Here are the two sentences:

Not surprisingly, many of the canonical images of early war photography turn out to have been staged, or to have had their subjects tampered with. After reaching the much-shelled valley approaching Sebastopol in his horse-drawn darkroom, [Roger] Fenton made two exposures from the same tripod position: in the first version of the celebrated photo he was to call "The Valley of the Shadow of Death" (despite the title, it was *not* across this landscape that the Light Brigade made its doomed charge),

ILLUSTRATION #5
VALLEY OF THE SHADOW OF DEATH "OFF"

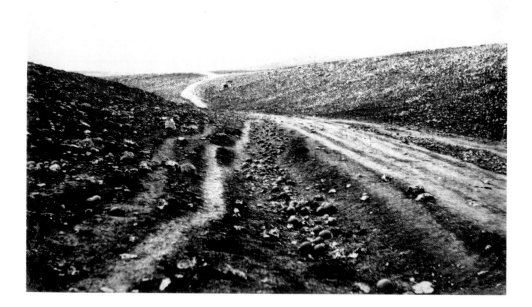

"OFF"

the cannonballs are thick on the ground to the left of the road, but before taking the second picture—the one that is always reproduced—he oversaw the scattering of the cannonballs on the road itself.

To give a little background, in 1855 Roger Fenton, a well-regarded British photographer, was sent by the publisher Thomas Agnew & Sons to photograph the ongoing war in the Crimea between British, French, and Turkish forces on one side and Russian forces on the other. For four months, from March 8 to June 26, 1855, Fenton and his assistant, John Sparling, worked from a horse-drawn darkroom behind the British front lines. They produced 360 photographs, of which the pair entitled "Valley of the Shadow of Death" are the best known.

Despite the iconic status of the photographs, they are not illustrated in Sontag's book. Sontag provided *no* photographs in her book, only references to photographs.[1] I will make this a little easier for the reader. Here are the two Fenton photographs taken, according to Sontag, "from the same tripod position." I have given them the names: OFF and ON. OFF for the photograph with cannonballs off the road and ON for the photograph with cannonballs on the road.

ILLUSTRATION #6
VALLEY OF THE SHADOW OF DEATH "ON"

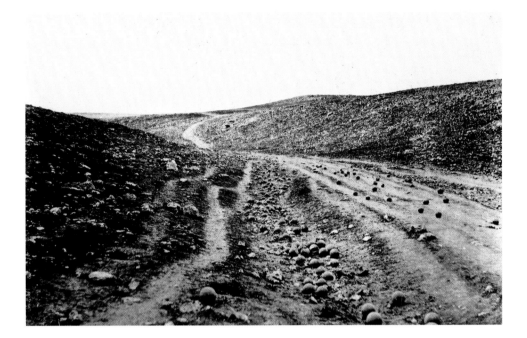

"ON"

I have spent a considerable amount of time looking at the two photographs and thinking about Sontag's two sentences. Sontag, of course, does not claim that Fenton altered either photograph after taking them—only that he altered, or "staged," the second photograph by altering the landscape that was photographed. But how did Sontag know that Fenton altered the landscape or, for that matter, "oversaw the scattering of the cannonballs on the road itself"?

Surely, any evidence of this would have to be found independent of the photographs. We don't see Fenton (or anyone else for that matter) in either of the photographs bending down as if to pick up or put down a cannonball. How does Sontag know what Fenton was doing or why he was doing it? To up the ante, Sontag's sentence also suggests a certain laziness on Fenton's part, as if he himself couldn't be bothered picking up or putting down a cannonball but instead supervised or oversaw their placement. One can imagine the imperious Fenton: "Hey, you over there. Pick up that cannonball and move it onto the road. No, not there. A little more to the left." Or maybe it wasn't laziness. Maybe he had a bad back. The incapacitated Fenton: "Boy, my back is killing me. Would you mind picking up a few cannonballs and carrying them onto the road?"

While I was wrestling with these questions, it occurred to me that there was an even deeper question. How did Sontag know the sequence of the photographs? How

did she know which photograph came first, OFF or ON? Presumably, there had to be some additional information that allowed the photographs to be ordered: before and after. If this is the basis for her claim that the second photograph was staged, shouldn't she offer some evidence?

There are no footnotes in Sontag's book, but fortunately there is an acknowledgment section at the end:

> I owe the information that there were two versions of Fenton's "The Valley of the Shadow of Death" to Mark Haworth-Booth of the Victoria and Albert Museum; both are reproduced in *The Ultimate Spectacle: A Visual History of the Crimean War,* by Ulrich Keller (Routledge, 2001).

I bought a copy of Ulrich Keller's book and turned immediately to the section in Chapter 4 on the two photographs. I found the following passage where Keller lays claim to a number of historical discoveries—namely that there are two photographs, that the photographs are slightly different, and that the cannonballs in the second photograph were placed there either by Fenton or under Fenton's direction.

Here is the text (the italics are mine):

> A slight but significant difference between Fenton's two pictures of the site seems to have escaped the attention of photographic historians. The first variant *obviously* represents the road to the trenches in the state in which the photographer found it, with the cannonballs lining the side of the road. In a second version we discover a new feature. Some round-shot is now demonstratively distributed all over the road surface—as if the balls had just been hurled there, exposing the photographer to a hail of fire. Not content with the peaceful state of things recorded in the first picture, Fenton *obviously* rearranged the evidence in order to create a sense of drama and danger that had originally been absent from the scene.

In turn, this passage references a footnote where Keller further expands on his claims about Fenton's personality:

> That Fenton tended to exaggerate the dangers of his photographic campaign, too, can be gathered from "The Daily News" of September 20, 1855, which lists a series of his close calls, such as his operating van . . . being frequently an object of suspicion with the Russians; himself being wounded by a shell; his assistant shot in the hand by a ball from a Minié rifle.

But where is the exaggeration here? There is nothing in the *Daily News* article to support Keller's claim. If anything, the article contradicts what Keller is saying. Is Keller arguing that Fenton made false claims to the journalist from the *Daily News* (with the possibility, of course, that it was the journalist, and not Fenton, who exaggerated what Fenton said)? Does Keller know that the van was not "an object of suspicion with the Russians" or that Fenton's assistant, Sparling, was not "shot in the hand by a ball from a Minié rifle"? Where does Keller show that these claims are false? Fenton himself had written:

> The picture was due to the precaution of the driver [Sparling] on that day, who suggested as there was a possibility of a stop being put in that valley to the further travels of both vehicle and driver, it would be showing a proper consideration for both to take a likeness of them before starting.

Again, a possible exaggeration or misstatement, but supposedly Sparling was concerned that he might be making a one-way trip to the front.

ILLUSTRATION #7
SPARLING, FENTON'S ASSISTANT

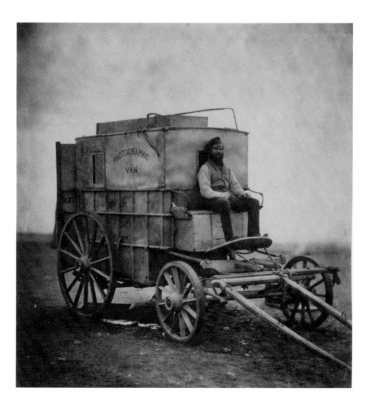

Keller says that the first photograph *obviously* "represents the road . . . in which the photographer found it" (OFF) and Fenton *obviously* "rearranged the evidence," that is the cannonballs, in the second photograph (ON).

As I've said elsewhere: *nothing* is so obvious that it's obvious. When someone says that something is *obvious*, it seems almost certain that it is anything but obvious—even to them. The use of the word "obvious" indicates the absence of a logical argument—an attempt to convince the reader by asserting the truth of a statement just by saying it a little louder.

Soon after I read his book, I called Keller to discuss his claims about Fenton, which were repeated by Sontag.

ERROL MORRIS: I became aware of your book on Fenton [*The Ultimate Spectacle*] from reading Susan Sontag. She talks about your analysis of the two photographs captioned "The Valley of the Shadow of Death." And suggests that Fenton posed one of the photographs.

ULRICH KELLER: Yes.

ERROL MORRIS: She seems to have taken most of that material wholesale from you.

ULRICH KELLER: Yes, I guess one could say that. Yes.

ERROL MORRIS: What interests me is this idea that one of the photographs was posed. That one of the photographs is a fake.

ULRICH KELLER: It has been sort of retouched or interfered with to get some drama into it that wasn't originally in it. I wouldn't go so far as to say it's a fake, but it's deceptive. Certainly.

ERROL MORRIS: Deceptive in what way?

ULRICH KELLER: Well, deceptive in that it creates the impression that the picture was taken under great danger when that was not the case.

ERROL MORRIS: Both pictures?

ULRICH KELLER: The second one. It's clear that the one with cannonballs on the surface of the road must be later, obviously.

ERROL MORRIS: Why?

ULRICH KELLER: Well, because of two pictures, one has the cannonballs resting in the ditch there to the side [OFF] and the other one has them on the surface of the road [ON]. It's much, much more likely to assume that Fenton would have taken these balls out of the ditch and onto the road rather than the other way round. What motivation would he have had to take cannonballs that were on the road and remove them? Why would he do that? So I think it's pretty obvious. But you have doubts about that?

ERROL MORRIS: Yes. I have wondered how you came to the conclusion that the one with the cannonballs on the road [ON] has to be the second photograph. You suggest that Fenton was not in danger but wanted to ratchet up the drama of the scene by making it look as though he were under attack.

That Fenton wanted to convey a false impression of derring-do to the prospective viewer of the photograph. But why do you believe that? I may not be phrasing this very well. If not, my apology.

ULRICH KELLER: Well, I can see a motivation for him to take the balls out of the ditch and put them in the middle of the road. That makes sense to me. It's something that I think is plausible for someone to do. The other way around, I don't know why anyone would do that. I don't think it's likely.

ERROL MORRIS: Is it the absence of an explanation that makes "the other way around" unlikely or implausible?

ULRICH KELLER: Yes.

But is it so implausible for Fenton to have removed the balls from the road? As Ann Petrone, my researcher, told me, "Of course the balls were taken off the road. Didn't they need to use the road?" She calls it the commonsense solution.

There also could be artistic reasons. Fenton could have liked the aesthetic quality that the barren road would have given him. He could have left the balls on the road for the first picture (ON) and then taken them off the road for the second (OFF), because he preferred the simplicity of the latter. Maybe he saw the balls on the road and felt they looked fake, and removed them in the interest of creating a more honest picture.

In Keller's book, there is a letter from Fenton to his wife dated April 24, 1855.[2] This is an excerpt:

Yesterday after finishing the last picture of the Panorama I got Sir John to lend me a couple of mules to take my caravan down to a ravine known by the name of the valley of the shadow of Death from the quantity of Russian balls which have fallen in it. . . . We were detained in setting off & so got down just about 3PM yesterday. I took the van down nearly as far as I intended it to go & then went forward to find out the chosen spot. I had scarcely started when a dash up of dust behind the battery before us showed something was on the road to us, we could not see it but another flirt of earth nearer showed that it was coming straight & in a moment we saw it bounding up towards us. It turned off when near & where it went I did not see as a shell came over about the same spot, knocked it [*sic*] fuse out & joined the mass of its brethren without bursting. It was plain that the line of fire was upon the very spot I had chosen, so very reluctantly I put up with another reach of the valley about 100 yds short of the best point. I brought the van down & fixed the camera & while leveling it another ball came in a more slanting direction touching the rear of the battery as the others but instead of coming up the road bounded on to the hill on our left about 50 yards from us & came down right to us stopping at our feet. I picked it up put it into the van & hope to make you a present of it. After this no more

came near though plenty passed up on each side. We were there an hour &
a half an [*sic*] got 2 good pictures returning back in triumph with our trophies
finishing the days work but taking the van to the mortar battery on the top of
the hill in front of the light division.

Here are the facts that emerge from the letter:

1. The photographs were taken on April 23, 1855—the day before the letter
was written.
2. Fenton took the photographs in the Valley of the Shadow of Death, so named
because of "the quantity of Russian cannonballs that had fallen there."
3. The two photographs were taken between 3:00 p.m. and 5:00 p.m. They arrived
"about 3PM" and stayed "about an hour & a half."
4. Fenton and his assistant set up in a hazardous location and then retreated one
hundred yards up the road. Even though the location was no longer directly in the
line of fire, they were still at considerable risk.
5. Fenton took one of the cannonballs as a trophy to present to his wife.

The letter is a godsend. It provides an extraordinary amount of useful information.
Without it, we would probably not be able to determine when and where the photo-
graphs were taken. But the letter makes no reference to the order of the photographs
nor to the question of whether the cannonballs were put on or taken off the road.

I continued reading Keller's book but found no reference to Fenton overseeing
the scattering of the cannonballs. I began to wonder: If it's not in Fenton's letters,
where did this idea come from? Which came first? Did Keller first make a conjecture
about the order of the photographs based on Fenton's (real or imagined) intentions,
or did Keller first have a specific piece of historical information—such as something
Fenton had written—that he based the order on? If Fenton had written to his wife,
for example, that he had overseen the scattering of the balls, then the question
would be laid to rest. At least we would know that Fenton had *claimed* to have done
that, regardless of whether he actually did it.

My next interview was with Mark Haworth-Booth, the former curator of photog-
raphy at the Victoria and Albert Museum in London. Haworth-Booth, of course, was
Sontag's primary source. He was the one who referred her to Ulrich Keller's mono-
graph on Fenton, and I was of course interested in the details of how this all happened.

MARK HAWORTH-BOOTH: Mark Holborn, Sontag's editor in London, called me
and told me that Sontag was looking for some material about Fenton, and I
sent him some photocopies of a thing I'd written a long time ago. He passed
them on to her, and she was very grateful. She didn't really quote them
very accurately. She overstated what I said, which is very characteristic of

her writing. It became much more black and white and strident than it was when I said it. I was raising doubts, but she assumed that my doubts were a matter of fact rather than speculation. Anyway, I was very grateful for the nice acknowledgment.

ERROL MORRIS: And the nature of the speculation?

MARK HAWORTH-BOOTH: Well, I noticed that there are two versions of the "Valley of the Shadow of Death" about twenty-five years ago, and it made me think: one of the pictures is clearly much more interesting and expressive than the other. So I began to wonder if Fenton and his assistant helped the composition by moving the cannonballs themselves. That's what I raised as a speculation.

ERROL MORRIS: Hold on just one second. My aging dog wants to get up on a chair. Well, the issue of the two Fenton photographs, were you the first to notice that?

MARK HAWORTH-BOOTH: As far as I'm aware. Other people have claimed it, but they claimed it many years after me. The main person I'm aware of who thinks he was the first, the man who did the book on all the different representations of the Crimean War. I think his name is Ulrich Keller.

ERROL MORRIS: Yes. I've spoken to him. I'm familiar with the book.

MARK HAWORTH-BOOTH: Good. His book is terrific. Anyway, he thought he had invented the idea. But I had published it in 1981, so I'm kind of a long way in the lead of him. I mean, it's certainly pretty obvious, but no one that I'm aware of had noticed it before. I just happened to have two books open on my desk at the same time when I was having lunch, and I noticed this difference between the two photographs.

Over the years, I myself had seen the ON photograph many, many times in books, and invariably it came with a caption that told you what to think about the photograph. It was often described as the first real photograph of war. You were told that from the cannonballs strewn across the landscape, you should infer unseen carnage. The photograph was mysterious, but the mystery is compounded when you learn that there are actually two photographs. And the mystery is further compounded when those two photographs are ordered for you and you are told what that order represents.

———

Even though Haworth-Booth and Keller disagree about who first discovered the twin photographs, they do agree that OFF was first and ON second. They also agree that Fenton, in all likelihood, posed the second photograph. However, as Haworth-Booth suggested in my interview with him, this is not a view shared by all museum curators of photography. Gordon Baldwin, recently retired as a curator from the

J. Paul Getty Museum in Los Angeles, has his own views on the order of the two photographs. After my conversation with Haworth-Booth, I called him up.

ERROL MORRIS: I'm interested in two photographs—the two versions of Fenton's "Valley of the Shadow of Death."

GORDON BALDWIN: Okay, excellent. As you perhaps have heard, I have strong opinions on the subject.

ERROL MORRIS: Ah. I am more than interested.

GORDON BALDWIN: Well, I've written an essay—not a very long one—the Folio Society is publishing a book in a few months called *The Hundred Greatest Photographs*. I wrote three essays for the book and that's one of them. I think there's a clear explanation for what happened—why there are two photographs and why they're different. And I think earlier readings in which people have thought that Fenton was moving cannonballs around are erroneous. I don't think he moved cannonballs around. The cannonballs were harvested, so to speak, by soldiers who were there. The place that Fenton went to make the photograph—there are accounts in the *Illustrated London News* about that place, and in that account that appeared they talk about the fact that the soldiers harvested the cannonballs in order to fire them back.

ERROL MORRIS: Recycled them?

GORDON BALDWIN: Yeah, recycling. Heavy-duty recycling. I think that's what happened. I don't know if you've had the chance to look at Fenton's correspondence on the subject of "Valley of the Shadow of Death," but there are two different letters that he wrote which deal with that place and what happened there. In the first one he talked about going to reconnoiter the site—and this is without a camera—and talks about cannonballs so thick on the ground it was difficult to walk without treading on them. Which indicates to me a lot of cannonballs. And then in the second letter where he describes making the photographs, he talks about being under fire. At the time, cannonballs are bouncing around. I don't think that someone who was under fire would have had the time or inclination to be moving cannonballs around, but soldiers might well have done so. There's a correspondent for the *London Times* who describes horses swaybacked from the weight of the cannonballs that they were carrying. Russell, the *Times* correspondent, describes it, and this is part of that recycling process. I think that's what happened. So what people commonly have thought is the first photograph with few cannonballs [OFF] is the second photograph, after some of them have been removed.

ERROL MORRIS: What attracted my attention to all of this is a couple of paragraphs in Susan Sontag's last book.

GORDON BALDWIN: Oh, dear. Yes, okay. I don't think she's very good on Fenton, frankly, but go ahead.

ERROL MORRIS: She mentions how one of the Fenton photographs was posed or staged. That we're always disappointed when we learn that a photograph has been posed. Then she goes on to talk about the difference between fake paintings and fake photographs. Namely, a fake painting is a painting with faulty provenance—say, a painting that is purportedly by Vermeer but turns out to be painted by somebody else. But according to Sontag, a fake photograph is a photograph that's been posed. Her example is the purportedly posed photograph by Fenton, what she takes to be the second photograph [ON] in the Valley of the Shadow of Death.

GORDON BALDWIN: There are photographs of which this is quite true, particularly photographs made by Alexander Gardner during the American Civil War, but I don't think that is what Fenton did. Fenton's own work tells us that isn't what happened. I don't think it was like him to have manipulated—to have falsified an image in that way. And one reason I'd say that is: he was simply photographing the place as he found it. I don't think he had an idea about the symbolic—what later people would say was the symbolic value of the photograph. In other words, most of his photographs from the Crimea are documentation of places where battles have occurred. I don't think he meant to make a highly charged photograph. The place was quite well known. He didn't name it the Valley of the Shadow of Death; the soldiers had, and it was named that simply because it was a dangerous place. The ravine was a place where the Russians feared a surreptitious attack would be launched on a position of theirs and to forestall that, they shelled it periodically regardless of whether there were people there. And so it got this nickname. When Fenton went there, he was going to a place he knew about, but I don't think he intended to so weight the image as subsequent critics have. As a metaphor for devastation, it's a wonderful photograph, but I'm not sure that was really his intention in making it. That makes some sense I hope?

ERROL MORRIS: Yes, of course it does. But it is still unusual that he took two photographs. I don't know of any other example—correct me if I'm wrong—where he took a pair of photographs from the same camera position.

GORDON BALDWIN: No, I don't think there is one. I think you're quite right. Certainly when he makes panoramas in the Crimea, the camera is in one place and it's rotated to a degree.

Baldwin is referring to the overlapping photographs that Fenton took from the British encampments. Just as Fenton had made an experiment with time by taking two still pictures from the same camera position, he experimented with space by creating some of the first panoramas.

ERROL MORRIS: Yeah, he's panning.

GORDON BALDWIN: Yeah, although he's not terribly skillful at it, to tell the truth. The edges don't quite line up the way they might. But those are quite different from the photographs in the Valley of the Shadow of Death. He's there for an hour and a half and comes back with two photographs. His van is drawn by army mules, not by horses in this instant, and with the army mules came a soldier or two. Sparling, his assistant, was there. He was always there. I've pulled out the page from the Folio Society book. What Fenton wrote to his wife in this first one, this is a couple of weeks before he made the photographs. "Farther on the balls lay thicker but in coming to a ravine called the valley of death the site passed all imagination. Ground shot and shell lay like a stream at the bottom of the hollow all the way down. You could not walk without treading upon them." That was written on the fourth of April. On the twenty-fourth of April, when he's writing again, he writes saying—because he's been forced to retreat from the camera position he wanted to use, because of being fired at. He writes, "very reluctantly I put up with another reach of the valley about 100 yards short of the best point. I brought the van down and fixed the camera. . . . We were there an hour and a half and got two good pictures, returning in triumph with our trophy." He doesn't say anything about moving cannonballs around. I really don't think he's managing the image in that way. Much as I find Ms. Sontag interesting about photography, I don't think she's right about Fenton.

ERROL MORRIS: In the book there's a citation to a monograph by Ulrich Keller. Which I dutifully bought and read.

GORDON BALDWIN: I don't think he likes Fenton very much. He certainly thinks he's a creature of the establishment. But how could he not be, in a sense?

ERROL MORRIS: Keller's argument, which was essentially picked up by Sontag, is that Fenton was a coward. Or, if not a coward, that he was a person who was very, very reluctant to expose himself to any real danger. That the cannonballs were rearranged by Fenton—this would be Keller's argument—to make it look as though he was in greater danger than he was, that the place where he had taken the photograph was something of a tourist attraction for visitors whom you wanted to show a piece of the Crimean War. I hope I'm characterizing it correctly. I believe I am.

GORDON BALDWIN: It was a place that wasn't very safe to be. It wouldn't have acquired that name had it not been. The fact that the *Illustrated London News* sketch artist made a picture at exactly, or very close to, the same point that Fenton's photograph was made indicates it certainly had a certain renown, and I don't suppose every nook or fold of the landscape had a name given to it by soldiers.

ILLUSTRATION #8
ILLUSTRATED LONDON NEWS

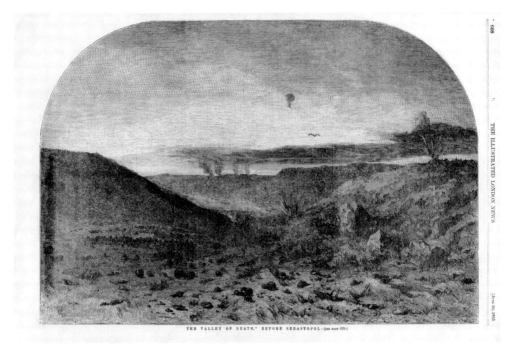

THE VALLEY OF DEATH," BEFORE SEBASTOPOL—(see page 670.)

But I wouldn't have said that Fenton was at all cowardly. I think he was quite an adventurous character. He simply documented what was available to him during the time he was there. He happened to be in the Crimea at a point when there wasn't much fighting going on. The great assault on Sebastopol occurred after he'd left.

ERROL MORRIS: I read that the photograph of Sparling and the van was taken the same day Fenton took the "Valley of the Shadow of Death" picture and that Fenton had taken Sparling's photograph at Sparling's request because Sparling thought that this would be his last day on Earth.

GORDON BALDWIN: Yes, I think that's how the story runs, but I'm not sure where it comes from. I don't have any reason to think that it may not be true, but Sparling is a fairly funny character. He isn't simply Fenton's assistant, although he functioned that way for a long time and advertised himself as being assistant to Mr. Fenton. He was a very smart guy. He wrote a manual on photography that is extraordinarily clear and beautifully phrased, but he didn't have Fenton's class advantages. Sparling asked that the photograph be made because he knew they were going back to this place which was dangerous, which Fenton had been to before—although it doesn't say that Sparling was with him the first time and since he didn't have a camera

with him when he went out to reconnoiter three weeks before, it's possible Sparling wasn't there. If Sparling thought it was that dangerous, isn't that testimony to the contrary of Keller's contention that Fenton was cowardly?

ERROL MORRIS: Yes, it is. Although it could just be that Sparling was also cowardly.

GORDON BALDWIN: Perhaps. *(Laughter.)* How far can one extrapolate that? Who else was cowardly? My general view is that Fenton is a more admirable kind of character than Keller thinks. He and I have had some conversation— quite a number of years ago—about Fenton. I simply disagreed with everything he had to say on the subject. I just didn't think the way he was analyzing his character was useful, and I thought that the evidence we have runs to the contrary. The letters, of course—Fenton could not have foreseen that they would be published. And they were published way after his death. The family realized that they were important enough to copy them. The letters that have been published are the result of somebody in the family copying the letters into a book. The letters themselves don't exist. There were two books which descended in different parts of the family. One of them is at Austin and the other one's at Bradford.[3] They vary slightly. They're not exactly the same content, but they preserved the letters and clearly the family felt they were important enough to want to preserve them. He is not writing for the public, and of course he doesn't want to make himself seem unattractive or cowardly to his family or his publisher, since the letters are variously written to his wife, to his brother, and to his publisher. He's just trying to tell about what happened. It's too bad there aren't letters from other periods of his life, but there aren't, except for his official correspondence for the Photographic Society. Clearly, the letters give a picture of a different kind of man than Keller thinks.

Baldwin's view is contrary to Keller's and Sontag's, but his conclusion is still based on psychology—how he interprets Fenton's character and his intentions. Baldwin would order the photographs ON, then OFF, a view also held (more or less) by Malcolm Daniel, the curator of photography at the Metropolitan Museum of Art and the author of an article in the recent exhibition catalog, *All the Mighty World: The Photographs of Roger Fenton, 1852–1860.* When I put the question of the order of the photographs to Mr. Daniel, he told me that he too leans toward the recycling theory.

MALCOLM DANIEL: The long and short of it—or the short of it—is: we don't know which of the two pictures came first. For a long time it was thought that the first one would be without the cannonballs on the road [OFF] and that Fenton pulled them out of the ditches and littered the road with them

[ON] to make the picture more dramatic. We now think that the opposite is true. There are references in Fenton's own letters—a reference to British soldiers collecting the cannonballs to fire them back in the other direction. We just can't know. People have sort of assumed that he put more cannonballs there [ON] to make the photograph more dramatic, but it's just speculation. The danger was real, also—as you can tell from the fact that there are cannonballs there at all. It is an area that was certainly within range, and he had this big van that he was carrying along with him, and you remember that Marcus Sparling, his assistant, made him take the picture of Sparling sitting on the photographic van before they went into the Valley of the Shadow of Death because he was worried that they might not come out. So, I don't know. There's no inscription, no documentation, to say which one is first, and so we can speculate that he's making a more dramatic picture or one can say: "Well, we have this reference to soldiers collecting the cannonballs to fire back in the opposite direction, and so it's probably more likely they were removed than that he went out there and lugged them around." I mean, those things are heavy. It's just highly unlikely that he would go traipse around and scatter them over the road.

In other words, Baldwin eventually comes down on the side of ON, then OFF, but isn't entirely convinced.

Two sets of esteemed curators. Two sets of diametrically opposite conclusions. I decided to look for a tiebreaker—a fifth arbiter, Richard Pare. Pare, the author of a monograph on Fenton, has written eloquently on why these photographs are important:

One of the undisputed masterpieces of photography is the Valley of the Shadow of Death, so potent was it already as a symbol of the war that the location is indicated on the printed key. Here he increases still further the divorcement of the subject from any specific identification with place. He had wanted to make an altogether different picture facing towards Sebastopol and full of specific and identifiable markers. Instead he was compelled by immediate danger to retreat a little way back up the track and in so doing was presented with the picture that he chose to record. It is devoid of any topographical detail that defines a particular place; it becomes instead an image about the horror of all war and the mundane business of destruction. It suggests only the potential for sudden and indiscriminate death. Fenton made two versions of the image and by imposing the one on the other it is possible to see that the second and published version is in all likelihood an arranged image. It makes the message of the image more emphatic and is a photographic solution that was unique. It

has no precedent and no successors; it is a stark description of a dreadful subject. The first iconic photograph of war.

Despite his published opinion, Pare describes himself as a flip-flopper on this very question. Some days he looks at the photographs and thinks it's OFF followed by ON; on others, ON followed by OFF. Far from breaking the tie between the OFF-then-ONers (Keller and Haworth-Booth) and the ON-then-OFFers (Daniel and Baldwin), he further underlines the problem of using "logic" or "psychology" to adjudicate the issue.

RICHARD PARE: I go back and forth. Probably Fenton went out there or Sparling, his assistant, went out there and arranged the cannonballs, but then I look at it again and there just doesn't seem to be a logic for that conclusion. If you compare, by flipping back and forth between the two frames on the computer, you can see where the cannonballs go missing from, and it doesn't necessarily seem to follow what you would do if you were going to embark upon an enterprise of that kind. So there's another possibility. There was a salvaging party, down there at the same time, gathering them up, but he doesn't say in the letters that he wrote to his wife that there was anything like that going on. In other accounts of the war there are the most explicit descriptions of the ground being literally littered with cannonballs to the point where the horses had trouble picking their way between them. So it's not in any way an extreme situation that he's laying out, even if he is arranging them.

ERROL MORRIS: The oddity, of course, is that there're two photographs.

RICHARD PARE: Right. You know, of course, that they are not the pictures he was intending to make, right? It's not even the picture that he intended to make originally. He'd been out scouting, some days before, and had intended to make a picture further down the valley or the gully—it's not so much a valley—towards Sebastopol and was driven back because there was too much fire coming in. Probably the pictures he was intending to make would have been far more site-specific. There would have been identifiable topographical features that people would recognize.

As Gordon Baldwin points out, Fenton had gone to the Valley of the Shadow of Death at least once before. Fenton mentions this in a letter dated April 4–5, 1855:

We walked along a kind of common for half a mile coming towards the end upon Russian cannon balls scattered about. Further on the balls lay

thicker, but in coming to a ravine called the valley of death the sight passed all imagination . . . round shot & shell lay in a stream at the bottom of the hollow all the way down you could not walk without treading upon them . . . following the curve of the ravine towards the town we came to a cavern in which some soldiers were stationed as a picket. They had made a garden in front forming the borders of the beds with cannon balls. We had gone a little further down & were admiring the rugged outline of the rock & pondering out where the face had been smashed by the Russians fire when we were startled by a great crack in the rock in front of us & a cloud of dust followed by a second knock upon the opposite face of the ravine as the ball bounded across it & then a heap of stones & the ball rolled away together down the ravine. . . .

But what does this tell us?

"The sight passed all imagination . . . you could not walk without treading on them." There were cannonballs everywhere. Could it be—having seen the road on April 4 when the Russian cannonballs were "scattered about"—that Fenton sought to re-create on April 23 what he had seen earlier? Is ON merely a reenactment of a previously seen event? Did he arrive at the Valley of the Shadow of Death on April 23 only to be disappointed to see fewer cannonballs on the road than he had seen earlier, then scatter the balls to evoke what he had seen previously?

Again, these questions are not answered by Fenton's letters.

The recycling issue is also of interest, but it cannot resolve the question of which came first—ON or OFF. British soldiers could have collected the balls on the hillsides and left them to be picked up on the road. In this scenario, Fenton takes the first picture (OFF) before the British soldiers pick up the balls, and then takes the second picture after the balls have been piled on the road (ON). In this scenario, OFF comes first, then ON. On the other hand, Fenton could have come on the cannonballs collected on the road, taken the first picture (ON), watched as British soldiers piled them on horse-drawn carts, waited for the carts to leave, and then taken the second picture (OFF). In this other scenario, ON comes first, then OFF. But in both scenarios Fenton has not intervened, and by Sontag's criteria, neither image would be posed.

And so the possibility of recycling does not help. It can support either conclusion—ON before OFF or OFF before ON. Recycling may be a good thing—even when it involves cannonballs—but it can't help us determine the order of the photographs.

So why are these respected curators proposing such a theory? One simple reason is that it preserves Fenton's reputation: he is still a brilliant photographer who has not posed anything. Recycling *does* speak to the question of Fenton's intentions. If someone *else* scattered the balls or picked them up, it's not Fenton's doing. It is not *his* attempt to make a better picture or to convey to some prospective viewer that he is in a very dangerous situation. But why this obsession with Fenton's character? Both Baldwin and Daniel imagine ON comes before OFF, and they invent an

underlying set of circumstances that adopts the recycling theory to preserve their favorable view of Fenton's character, just as Keller invents an underlying set of circumstances that preserves his *unfavorable* view of Fenton's character.[4]

Much of the problem comes from our collective need to endow photographs with intentions. The minute we start to conjecture about Fenton's reasons, his intent—his psychological state—we are walking on unhallowed ground. Can we read Fenton's intentions from a photographic plate? Is there anything in the letters that tells us what he was really thinking and what really happened? We may project on to these photographs (or any photograph) the photographer's *imagined* intentions, but why is this anything other than a speculative exercise?

This led me to a more general question: would it be possible to order these photographs based on evidence in the photographs themselves? This idea appealed to me because it did not require me to imagine something about Fenton's intentions, that is, about his internal mental state. After all, how can I know what the guy sitting next to me in Starbucks is thinking, let alone a man who lived 150 years ago? I wanted to leave Fenton out of it. Was there a way to order the photographs based on the photographs alone?

I suspected that lighting and shadows might provide clues as to the time of day, and thus the order, if we could determine where the sun was in the sky. Following this line of inquiry, my first question was: which direction was Fenton facing—north, south, east, or west? Was he looking in the direction of where the cannonballs were coming from or in the opposite direction? The photograph looks as though the camera is pointed up into the hills rather than down into the valley; in other words, south rather than north.

Keller makes this point in *The Ultimate Spectacle*:

> Fenton made two decisions reflecting his reluctance to expose himself to risks. First of all, of the two similarly shaped valleys, he chose the less dangerous one in the back of Chapman's Batteries. Secondly, he stopped in the upper, shallow part of the ravine, not in the deeper, more advanced part shown in the "best general views." Here, he decided to turn the camera back up towards the camps, rather than downward in the direction of Sebastopol, as Simpson and Robertson had done.

Fenton "decided to turn the camera back up towards the camps," that is, the pictures were taken looking south. Pare came to the same conclusion. He is also convinced that Fenton "turned around and, literally facing in the opposite direction, looking uphill back towards the Allies encampment . . . was confronted by the picture." But where is the evidence?

Keller has never gone to the Crimea. Pare has gone but was unable to find the Valley of the Shadow of Death.

Both Keller and Pare believe that Fenton was facing south—back toward the British encampments. Could they be mistaken? How did they determine this? Neither of them had stood where Fenton stood, looked through a camera lens and tried to match the contemporary landscape with the images that Fenton had taken 150 years before.

It was at this point that I resolved to go to the Crimea to find the Valley of the Shadow of Death.

Part 2

It was a historic occasion when I arrived in the Crimea with my cameraman, Bob Chappell, and his first assistant, Eric Zimmerman—it was within a few days of the 150th anniversary of the fall of Sebastopol on September 8, 1855, a date that marks the end of the Crimean War.

The airport at Simferopol—the Crimea's capital—was clotted with dozens of elderly British tourists who arrived on the afternoon flight from Istanbul. For a brief moment I had a fantasy that I would make a movie about people at the end of their lives reaching back into some unknowable past, trying to recover something perhaps unknowable about their own past. I would follow them about, record their attempts to reconnect with history.

Because of the anniversary, it was difficult to locate an available guide, but eventually we found Olga Makarova—the guide of guides—often disgruntled but extremely knowledgeable. When I told her about the Valley of the Shadow of Death, she assumed that I wanted to go to the Valley of Death, as named by Tennyson in his poem "The Charge of the Light Brigade."[5] Susan Sontag herself points out the difference—to disabuse us, her readers, of the possibility of such confusion. She even suggests that Fenton might have deliberately fostered such a confusion. She writes: "... in the first version of the celebrated photo he was to call 'The Valley of the Shadow of Death' (despite the title, it was not across this landscape that the Light Brigade made its doomed charge)."[6] Tennyson, in his poem "The Charge of the Light Brigade," writes about "the valley of death," not "the valley of the shadow of death":

> Half a league, half a league,
> Half a league onward,
> All in the valley of Death
> Rode the six hundred:
> "Forward, the Light Brigade!
> Charge for the guns!" he said:
> Into the valley of Death
> Rode the six hundred.

Even before going to the Crimea, I had assembled an impressive collection of maps of the area. You can see that the Valley of the Shadow of Death is clearly marked on the period maps. And you can see why the valley was given that name. It is at the confluence of cannonball trajectories from three major Russian artillery batteries: the Flagstaff, Barracks, and Garden batteries.

ILLUSTRATION #9
SIEGE OF SEBASTOPOL 1854–55

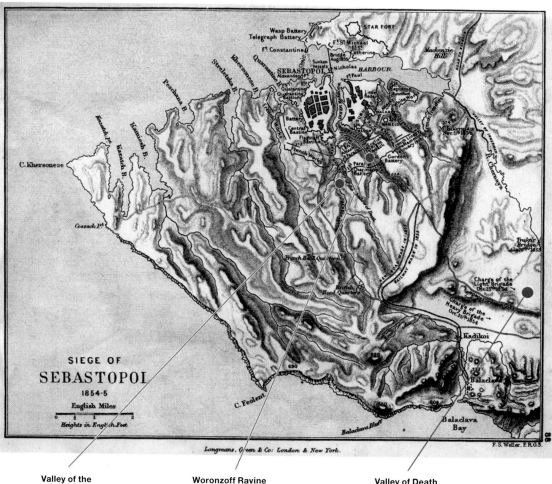

**Valley of the
Shadow of Death**　　　　　**Woronzoff Ravine**　　　　　**Valley of Death
(Charge of the Light Brigade)**

ILLUSTRATION #10
DETAIL OF SIEGE OF SEBASTOPOL

Valley of the Shadow of Death

Olga led us first to the Woronzoff Ravine, but I was adamant. "No, no! This is the Woronzoff Ravine," I told her. "This is not the Valley of the Shadow of Death." This was an error that I myself made when I first started looking at maps of the area. Present-day maps do not include the Valley of the Shadow of Death, but it is clearly marked on many period maps, and it is mentioned in many written accounts.[7] (Of course, the *name* does not appear on French or Russian maps. It was a name given to a specific valley by British forces that occupied that area of the conflict.)

ILLUSTRATION #11
DETAIL SHOWING VALLEY OF THE SHADOW OF DEATH

Which Came First, the Chicken or the Egg?

There is always difficulty when you try to tell local guides their business, but we retraced our steps back to Sebastopol and took a different road, which took us up to a ridge to the west of the Woronzoff Ravine. At last we were able to look down into the Valley of the Shadow of Death.

Miraculously, the area is still undeveloped.[8] You can still see the remnants of trenches on the hill facing the Great Redan, and the old Chapman batteries. The cannonballs are gone, but the ground is littered with very tiny snail shells on what is called Shell Hill in many accounts from the Crimean War. The snails, oddly enough, made me feel connected to history.

We parked off to the side and then descended into the valley, down to a road at the bottom—the same road that can be seen in the Fenton photographs. Olga had shoes with high heels. Not stilettos, but heels high enough to make walking difficult.

ILLUSTRATION #12
OLGA'S SHOES

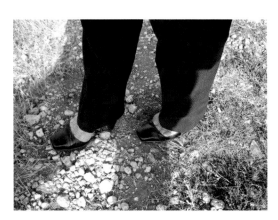

The apex of her career had been shepherding the Duke of Edinburgh around Sebastopol for the commemoration of the fiftieth anniversary of the World War II liberation of the Crimea by the Russian forces from German occupation. We were a few rungs down from her most illustrious customers, and we were, according to her, "breaking the rules." The usual tour includes the site of the charge of the Light Brigade, the monuments to the British and Russian war dead, a visit to Balaclava Harbor and the Panorama, an extraordinary 360-degree tableau of the siege of Sebastopol. We were definitely off the beaten track and wandering around in the middle of nowhere.

We continued south along the road, checking the overgrown views against copies of the Fenton photographs. Soon we came to a fork—possibly the same fork seen on the horizon in the 1855 photographs. After a certain amount of rummaging around, walking back and forth over a smaller and smaller patch of terrain, a couple of false alarms and a faulty calculation, we found the actual place where Fenton's two photographs were taken.

ILLUSTRATION #13
THE SAME FRAME 1

ILLUSTRATION #14
THE SAME FRAME 2

Here are two pictures taken with the same frame, from the same camera position—not unlike Fenton's pair of photographs. In the first photograph, the lens is partially covered by Fenton's 1855 photograph (OFF). In the second photograph, OFF has been taken away, revealing the "identical" landscape behind it—though it is not quite identical because the photographs were taken 150 years apart. The frame enlargements are from motion picture film shot by Bob Chappell.

There is no other point on the road where the landscape looks so similar to the landscape in the Fenton photographs. In this one spot, there was a match. Looking

south, away from Sebastopol, the landscape flattens out toward the high plains of the British encampments. Looking north, we see the hills just before Sebastopol.

There is no way of telling for sure from Fenton's photographs which direction he was facing. Both Ulrich Keller and Richard Pare believed that Fenton was looking south, and I can easily understand their mistake. Looking at the photographs, it looks as though we are looking back into the hills, but appearances are often deceiving and so are photographs. When one is standing in the landscape, it is evident Fenton was looking north. Or, more specifically, north-northwest.[9]

Fenton's April 24 letter tells us that the photographs were taken in the afternoon but gives us little information about the direction his camera was pointing. At least the trip to the Crimea had provided this empirical data. Now we knew both camera direction and time of day. This is more than idle information. Think about it for a moment. Depending on time or direction, the lighting gets reversed.

When I first saw the Fenton photographs the cannonballs looked back-lit. But they can't be—not if we are really looking north. In the Northern Hemisphere the light comes from the south. The balls are, in fact, front-lit. Had I assumed that the cannonballs were back-lit because they *looked* back-lit? Had I allowed my beliefs to determine what I saw? Had I, too, fallen victim to the principle, believing is seeing?

My hunch was that the lighting and shadows on the cannonballs might be the key to ordering them. I wanted to experiment with lighting the cannonballs from various directions, replicating the direction of the sun and time of day. But first I needed an 1850s cannonball.

I am pretty certain the Duke of Edinburgh never asked Olga to go to the Panorama Museum to borrow a Crimean War cannonball. But to her credit, she took us there anyway.

An old Soviet-style guard ushered us into what looked like the parlor of a mental institution. The museum is an extraordinary place with a rotunda that houses

a 360-degree painted panorama. It was not long after the war that panoramas of the siege were constructed—first in Paris, later in Sebastopol. Panoramas were in vogue in those days. Installed in a special rotunda in 1905, marking the fiftieth anniversary of the siege, it shows the Russians temporarily victorious before their ultimate defeat by the allied forces (the French, the English, the Turks, and, believe it or not, the Sardinians). The Panorama—a panorama of the destruction of war—was destroyed by German bombing during World War II and then reconstructed in a new rotunda building after the war.

ILLUSTRATION #16
INTERIOR OF THE PANORAMA MUSEUM

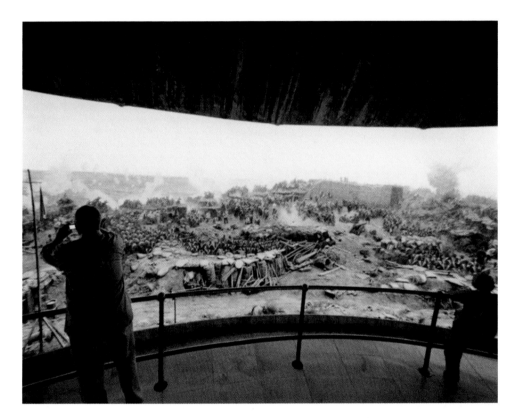

After some confusion, we were brought upstairs to meet the curator and some of the staff. (I told them I'd won an Oscar.) After a desultory conversation—as desultory as a conversation can be when none of the parties understand one another or have a clear idea of what is going on—I asked for a cannonball. There were additional translation difficulties. I remember Olga gesticulating wildly. But remarkably, they agreed to our request. Successful, we returned to the Valley of the Shadow of Death with a cannonball and took various pictures.

ILLUSTRATION #17
CANNONBALL AND HAND

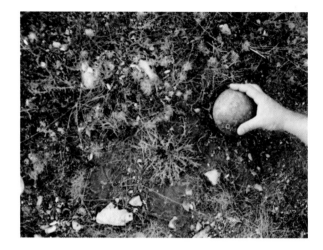

ILLUSTRATION #18
CANNONBALL

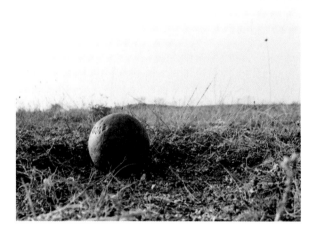

As the sun descended in the west, the sky became hazy and the shadow line on the cannonball less and less well defined, perhaps the first indication that an examination of the pattern of light and shadow on the cannonballs might be more difficult than I had imagined.

The day after our second excursion to the Valley of the Shadow of Death, we took a trip to the harbor at Balaclava and then to Yalta. Balaclava was a central supply point for the war effort in the Crimea. Eventually, a railroad was built from the harbor to the heights overlooking Sebastopol. Over a hundred years later, the Soviets had

hollowed out the entire mountain overlooking the entrance to the harbor and built a submarine base worthy of Dr. No. It was complete with concrete blast walls a hundred feet thick, an assembly room for thermonuclear weapons, dormitories where soldiers could live for months at a time, and a disguised entrance portal through which the submarines could secretly access the subterranean chambers. How was it possible that we could be walking in such a place? Only fifteen years earlier we would certainly have been killed as Western spies.

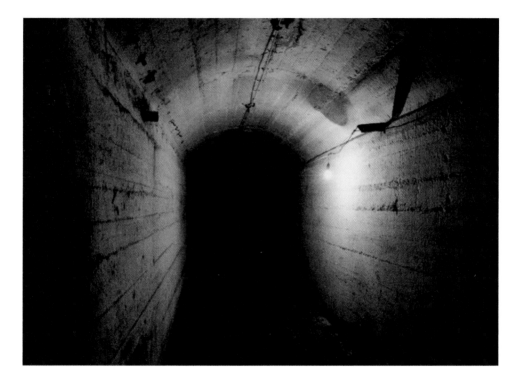

Yalta is a three-hour drive from Sebastopol along the southern coast of the Crimea. On our way there, Olga asked us to pull off the road. There was no turnout. No signs. Just a guardrail, shrub brush, and a steep hill looking down to the Black Sea. Olga pointed to something in the distance. You could just make out the orange roofs of a large building complex. It was Gorbachev's summer home. It kind of looked like a metastatic International House of Pancakes. As Olga told us, "He came to this home as premier of the Soviet Union and left as nobody."

Not far from Gorbachev's complex is Khrushchev's dacha, although it can't be seen from the road. Olga, who considers herself a Russian, had a bone to pick with Khrushchev. Khrushchev, a Ukrainian, had given the Crimea to the Ukraine as a

birthday present to himself. When the Soviet Union broke up, the Crimea stayed with the Ukraine even though it had traditionally been part of Russia. Olga was not prepared to forgive him for this largesse—to himself and to the Ukraine—at the expense of the Russian Federation.

Khrushchev's dacha was built at the closest point across the Black Sea from Turkey. I remember reading that Khrushchev would sit on the deck of his dacha and look out across the water. I imagine his pawlike hand holding an exquisite crystal glass of vodka. At times, he thinks that he can see Turkey—a physical impossibility because of the curvature of the Earth. Not just Turkey, but Kennedy's damn Jupiter missiles in Turkey aimed at the Soviet Union and at his dacha. That was when he decided on a tit-for-tat policy: if Kennedy could put his missiles in Turkey a couple of hundred miles from the Soviet Union—a couple of hundred miles from Khrushchev's dacha—then Khrushchev could (with impunity) put his missiles in Cuba. The die was cast.

I also remember reading an account of October 28, 1962—the last night of the Cuban missile crisis, when many knowledgeable people thought the world would end. Khrushchev had not yet capitulated and Kennedy was poised for nuclear war. Khrushchev was in Moscow, Kennedy in Washington. We know what Khrushchev was doing from the accounts written by his son, Sergei. Khrushchev was so worried about the possibility of nuclear war that he spent a sleepless night and then announced his decision to remove the missiles from Cuba over Radio Moscow the following morning so that it could be broadcast to the entire world without delay. On the same night, Kennedy was down by the White House pool with his aide, Dave Powers, and two girlfriends watching Audrey Hepburn in *Roman Holiday*. What a story. Hepburn, heir to some unspecified throne, dreams of being free of the obligations of state, but in the end knows that she must return to the requirements of the monarchy. That die, too, was cast. It was a fantasy within a fantasy within the reality of the White House.

War is such a peculiar thing—inaugurated by the whims of few, affecting the fate of many. It is a difficult, if not impossible, thing to understand, yet we feel compelled to describe it as though it has meaning—even virtue. It starts for reasons often hopelessly obscure, meanders on, then stops.

———

On my return from the Crimea, I spoke to Richard Pare in more detail about the Crimean War and Fenton's images.

RICHARD PARE: Fenton always had a taste for the abstract and the geometrically formal in image making. There's this strange collapsing of perspective that he gets because of the footpath that's trodden into the left-hand side

of the road that connects up in the further distance to the main track as it disappears over the horizon. They have a parallel width that causes the thing to flip-flop in a way, visually condenses it into a kind of uneasy restlessness. He was very satisfied with the two pictures he made—in getting two negatives—and left it at that. The way it fits into the whole of his output is interesting. I don't know how familiar you are with the whole body of work. It's largely given over to portraits of the major senior officers, camp activities, and landscapes. Portraits of Lord Raglan, the commander in chief, and Omar Pasha, in charge of the Turkish troops, Pélissier, in charge of the French, and senior generals. Do you know about the history of the Crimean War?

In my obsessive discussion of these two pictures, had I forgotten that Roger Fenton was one of the first photographers to chronicle war—and a truly terrible war at that? Had I forgotten about the war while drifting into the war photograph? I hope not. Photographs provide an alternative way of looking into history. Not into general history—but into a specific moment, a specific place. It is as if we have reached into the past and created a tiny peephole.

RICHARD PARE: It's 1854 and Napoleon III wheels out an old treaty from 1740 to insist upon the right of the French to defend foreigners and people visiting from other nations into the Holy Land—which was then part of the Ottoman Empire. The original pretext was monks quarreling—Catholic and Russian Orthodox monks fighting it out in the Church of the Nativity in Bethlehem. They got in a fight and some of them were killed over who should have the right to put a star up over the manger.[10]

Napoleon III has just got onto the throne after a coup d'état in 1852. But he has been effectively snubbed by the tsar, who looked down at him as a kind of arriviste upstart and used the squabble as an excuse to march down towards the Holy Land. Immediately the French established an alliance with the British, quite an extraordinary thing in itself. It's only thirty years after Waterloo.

The British and French were both working at the extreme limits of their supply lines. The winter of 1854–1855 was absolutely ghastly. When they arrived in September, they had perfect fall weather, wildflowers blooming in all directions. It was like heaven on Earth. By January they were in the most desperate situation, in complete misery. There was a freak windstorm, a hurricane that blew all the tents away, so nobody had any shelter at all. Officers, men, it didn't make any difference. Cholera was rampant. Dysentery. Casualties grew. Two-thirds were killed by disease and sickness rather than actual battle wounds.

Fenton arrives when things are beginning to improve a bit after a huge uproar in England. The government has fallen over the miscarriage of what was going on, having started out with almost complete support from pretty much everybody. A brilliant and controversial contrarian called John Bright—who was one of the great civil libertarians of the age—stood up in Parliament and gave impassioned speeches about the angel of death being brought to the land. Fenton arrives after all this, looking at these men who've seen hell very close up, and it shows in their faces. So he was trying to, somehow or other, with the very difficult mechanics of working at the time, to encapsulate some of that, and gets it, finally, in that one photograph.

There is also an extraordinary photographic panorama in eleven parts that he did of the whole plateau of Sebastopol. It starts off with the camp on the left, troops marshaling, armaments stacked in pyramidal forms, ditches being dug, tents, clothes being aired, all kinds of activity going on. You can see stretcher parties ready to go and people gazing out toward Sebastopol with bombardment going on as a daily occurrence, then it goes to the wasteland in the middle, which is, literally, the killing field where people died by the thousands, and finishes up with the graves of the senior officers on the far right hand side. So it operates as a kind of background to the other single image—the Valley of the Shadow of Death—which is without question the greater picture. But that single image gains in resonance by comparison with the panorama.

<div align="center">

ILLUSTRATION #20
PANORAMA
(following spread)

</div>

It is of course impossible to capture the horror of war in a single image or single letter.

The British artillery had assembled on the hills overlooking Sebastopol, the lines split into two parts, bisected by the Woronzoff Road, the Chapman batteries on the left (facing Sebastopol) and the Gordon batteries on the right. A railway had been built from the port at Balaclava to the British encampments on the heights above Sebastopol. The French and British had positioned approximately five hundred large guns close to the Russian fortifications. Artillery shells of every size and description had been stockpiled. And then the barrage began. Fenton's letter of April 4–5, which refers to the "valley of death," was written on a Wednesday or Thursday. The second bombardment started several days later.

There has been very heavy firing today, but the promised opening of all the batteries did not take place. It is now said to be adjourned until the question of peace or war is finally settled . . . up to the present time the Russians

have decidedly the best of it . . . that is the siege though . . . whenever they attack they loose [*sic*] heaps of men but they keep advancing their works & getting fresh batteries made & new rifle pits. . . . The rumour today is that the firing is to begin on Monday & continue 5 days when the troops are all to go in.

The "firing" actually began (as Fenton had predicted) on Easter Monday, April 9, 1855, and continued for ten days. I have read estimates that 6,000 Russians were killed, and 1,600 allies. The following letter is from a young captain to his wife. It attracted my attention because it was written on April 20, a couple of days after the bombardment ended and three days before Fenton took his two photographs. It captures the desperation that many British soldiers felt after the second bombardment. The shelling, designed to put an end to the war, ushered in just another period of indecision, confusion, and violence.

Our siege must be numbered among the things that have been. It is over & has been a more ridiculous & disgusting farce than the first. The Russian batteries & works are as good & strong as ever & further than the mischief that such a fire must have caused in the town [Sebastopol], we are no nearer our end than we were months ago. There is one universal feeling of disgust and humiliation among us at this second ridiculous exhibition. . . . We are now, as we have been for months, ourselves the besieged in our corner of the Crimea. We have a most splendid army thrown away on our chiefs, either by their dissensions or their incompetency. . . . An absurd "Reconnaissance" took place the day before yesterday in which the Turks and our Cavalry took part. They solemnly went out & killed one Cossack & took another and our loss consisted in the capture by the enemy of two Navvies who went out to see the fun! Our only other attempt at offensive operation consisted of an attack on some ambuscades that annoy our Batteries on the right. It was conducted as all our operations seem to be. A body of the 77th went out last night, drove the Russians out of their holes & were left totally unsupported to hold their places against whole columns of the Russes. They were of course cut to pieces but fought splendidly & held their ground in one of the ambuscades. They lost their Colonel, Egerton, a very fine fellow, and a Captain, a little boy named Lempriere, who had just got his company, about 20!, killed, & two officers wounded. All of this is very sad & has caused great feelings of disgust among us; men's lives, if one may use the term, being frittered away, in wretched little mismanaged attacks of this sort that do nobody any good & that are only redeemed from being ridiculous by the gallantry our poor soldiers always show.[11]

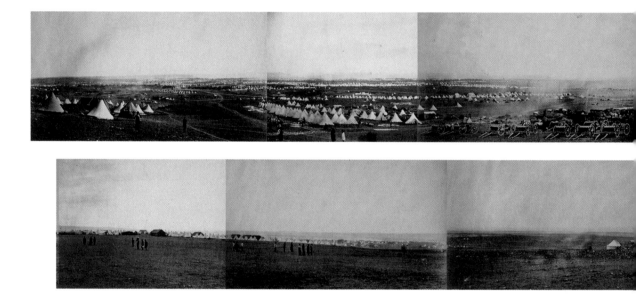

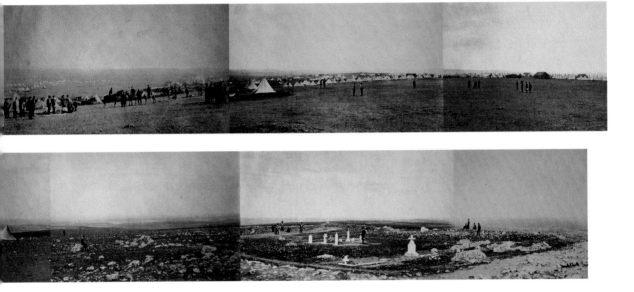

For me, the Crimean War is the "perfect war." It was started for obscure reasons, was hopelessly murderous, and accomplished nothing. Even the charge of the Light Brigade was a senseless exercise. (If you believe Cecil Woodham-Smith's account in *The Reason Why*—one of the truly great books about war—the charge may have occurred because of a missing comma in Lord Raglan's orders to Lord Lucan.)[12]

The Crimean War is often described as a harbinger of the American Civil War, but it is more akin to World War I—a stationary front informed by endless and futile exchanges of lethal artillery fire. Trench warfare par excellence. Lord Raglan, the commander of the British forces, previously the Duke of Wellington's aide-de-camp, lost his arm to a French cannonball at Waterloo. His specially designed sleeve—the Raglan sleeve, along with the cardigan and the balaclava—is now mainly how we remember the Crimean War. A war defined by innovations in wardrobe—a sleeve, a sweater, and a hat. Raglan, who died in the Crimea just before the fall of Sebastopol, often seemed confused about what was going on. He would exhort his soldiers to go out and fight the French and had to be reminded that, in this particular war, the Russians were the enemy. The French were his allies.

There is an extraordinary passage in A. W. Kinglake's eight-volume history of the Crimean War, *The Invasion of the Crimea: Its Origins and an Account of Its Progress down to the Death of Lord Raglan*. The passage concerns the April 1855 bombardment and makes liberal use of what is known as the "pathetic fallacy." The term, coined by John Ruskin in 1856, refers to our propensity to endow inanimate nature with humanlike characteristics. Ruskin clearly disapproved of this tendency—he called it a fallacy, after all. But to navigate in the world—to read the world, so to speak—we need to see the world as having some sort of purpose, some sort of motivation. (It is too frightening otherwise.) Hence, we see intentionality everywhere. The hurricane wants to thwart our plans; the earthquake intends to teach us a lesson.

Here is the passage from Kinglake in its entirety. It is possibly the masterpiece of the pathetic fallacy.

The Ways of a Cannonball When Obstructed Without Being Stopped

Whether taking its flight through the air, or encountering more solid obstacles; a round-shot of course must be always obeying strict, natural laws, and must work out the intricate reckoning enjoined by conflict of power with absolute, servile exactness; but between the "composition" of "forces" maintained in our physical world and the fixed resolve of a mind made up under warring motives there is always analogy, with even sometimes strange resemblance; and to untutored hearers a formula set down in algebra would convey less idea of the path of a hindered, though not vanquished cannonball than would the simple speech of a savage who, after tracing its course (as only savages can), has called it a demon let loose. For not only does it seem to be armed with a mighty will, but somehow to govern its action with

ever-ready intelligence, and even to have a "policy." The demon is cruel and firm; not blindly, not stupidly obstinate. He is not a straightforward enemy. Against things that are hard and directly confronting him he indeed frankly tries his strength, and does his utmost to shatter them, and send them in splinters and fragments to widen the havoc he brings; but with obstacles that are smooth and face him obliquely he always compounds, being ready on even slight challenge to come, as men say, to "fair terms" by varying his line of advance, and even if need be, resorting to crooked, to sinuous paths. By dint of simple friction with metal, with earth, with even the soft, yielding air, he adds varied rotatory movements to those fell skill as he goes; he acquires a strange nimbleness, can do more than simply strike, can wrench, can lift, can toss, can almost grasp; can gather from each conquered hindrance a new and baneful power; can be rushing for instance straight on in a horizontal direction, and then—because of some contact—spring up all at once like a tiger intent on the throat of a camel.

Wow.

"The demon is cruel and firm," "he acquires a strange nimbleness . . . a new and baneful power," "a tiger intent on the throat of a camel." The soulless, inanimate world of the iron cannonball comes alive, literally with a vengeance. Not only does the cannonball have intent—it plans, it connives, it is hopelessly devious, maybe even deviant.

Photographs work the same way. They are nothing more than silver crystals arranged on paper or, in the case of digital photography, nothing more than a concatenation of 1s and 0s resident on a hard drive. Yet, when it's a portrait, a person looking back out at us from a photograph, we could believe that the photograph has captured something of the sitter's essence—something of the stuff that is in his head.

I, too, look at the two Fenton photographs and try to imagine what Fenton's intentions might have been. It's unavoidable. People have been programmed to do so by natural selection—to project ourselves into the world—and to imagine Fenton's world as we imagine ours. We want to know where we end and the world begins. We want to know where that line is. It's the deepest problem of epistemology.

All of the central issues of photography that I address in this book of essays—questions of posing, photo fakery, reading the intention of the photographer from the image itself, questions about what a photograph means and how it relates to the world it photographs—are contained in these twin Fenton photographs. The *good* Fenton photograph, honest and unadorned by a desire for contrivance or misdirection, and the *bad* Fenton photograph—the photograph decried by Sontag—corrupted by the sleight of hand, the trick, the calculated deception.[13]

But the question remains—which is which?

One last thought: I have often imagined a counterpart to Fenton—someone on the Russian lines who also experienced the terrible shelling during April 1855. And

then I found him—a young artillery officer who despaired of ever having a military career. He said, "I may never be a general of the army, but perhaps I can become a general of literature." In his *Sebastopol Sketches*, written June 26, 1855, sixty days or so after Fenton's letter to his wife, he says:

> Now I have said all I wish to say on this occasion. I am, however, beset by a painful thought. Perhaps I ought not to have said it. Perhaps what I have said belongs to the category of those harmful truths each of us carries around in his subconscious, truths we must not utter aloud lest they cause active damage. . . . Where in this narrative is there any illustration of evil that is to be avoided? Where is there any illustration of good that is to be emulated? Who is the villain of the piece? And who its hero? All the characters are equally blameless and equally wicked. . . . No, the hero of my story, whom I love with all my heart and soul, whom I have attempted to portray in all his beauty and who has always been, is now and will always be supremely magnificent, is truth.

There is no evidence to support this, but I imagine one of the flaming hot cannonballs careening from wall to rocky wall in the Valley of the Shadow of Death—perhaps landing at Fenton's feet—bearing the invisible fingerprints of Leo Tolstoy.

Part 3

"Too bad, it was a cloudy day," I lamented to my friend, the inventor Dennis Purcell. "You really can't see any shadows."

Dennis corrected me: "I don't think it was cloudy. It was a bright, sunny day. Or perhaps cloudy-bright." We were looking at the two Fenton photographs on our respective computers.

Dennis explained that most nineteenth-century photographic emulsions are blue-sensitive and hence cannot record the sky—overcast, partially cloudy, and sunny skies are all overexposed. The sky is a featureless white, but the "whiteness" of the sky is unrelated to the question of whether there are clouds or whether you can see shadows. It was only much later that panchromatic film—film that was less blue-sensitive—was developed.

Dennis was right. In both ON and OFF the sky looks overcast but you can see shadows. You have to look at the shadows: from them it may be possible to calculate the height of the sun in the sky. In "Valley of the Shadow of Death" the shadows are produced by cannonballs. In other photographs shadows may be produced by trees, various man-made objects, or people standing in the frame.

ILLUSTRATION #21
CLOSE-UP OF SHADOW

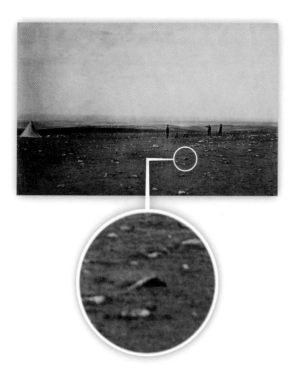

Long before I journeyed to the Crimea, I had been shown an extraordinary book written by Billy Klüver, *A Day with Picasso*.[14] A Berkeley-trained engineer, Klüver had collaborated with a number of artists, including John Cage, Robert Rauschenberg, and Andy Warhol. He had also, over a period of some twenty years, assembled a collection of early-twentieth-century photographs of Picasso, Modigliani, and Moise Kisling, but it was not until fairly late in the game that Klüver surmised that the photographs were taken with one camera on four rolls of film—twenty-four pictures, six pictures on a roll—and that they were taken over a very short period, possibly a single day.

As Klüver writes,

> When I came across the tenth photograph (No. 24 in the sequence in which they were taken) reproduced in the catalogue of the Modigliani exhibition at the Musée d'Art Moderne de la Ville de Paris in spring of 1981, with its very distinct shadows on the buildings in the background, it occurred to me that if the buildings could be identified, it might be possible to use the shadows to determine the exact day and time the photographs were taken.

Which Came First, the Chicken or the Egg?

ILLUSTRATION #22
NO. 24 A DAY WITH PICASSO

No. 24 Position J. Around 4:30. Modigliani, now wearing his hat, smokes a cigarette as Jacob sits beside Ortiz on a bench outside the P.T.T. administration building reading the book he was holding in his hand in photograph No. 21. Salmon looks over his shoulder. A mysterious shadow of someone standing outside the picture is cut off by Ortiz's knee. The shadows of the ledges behind Salmon's left shoulder and Modigliani's right shoulder, as well as the shadows in the doorways, were used to establish the time. The tables set up for dinner at Restaurant Napolitain can be seen in the background.

Printed from Cocteau Archive negative.

The first step for Klüver was to determine the angle of the sun. He employed various "markers": the awning of the Café de la Rotonde, the foliage on trees, Kisling's dog, Kouski; the dress worn by Picasso's mistress, Pâquerette. Using these, he was able to order the twenty-four photographs, to determine that the photographs were taken on August 12, 1916, and to identify the photographer: Jean Cocteau.

ILLUSTRATION #23
NO. 8 PICASSO AND MISTRESS

No. 8 Position D. Around 2:20 p.m. Sitting at the Rotonde, Pâquerette, who appears for the first time in the photographs, Wassilieff, and Picasso. He is still clutching his envelope.

Kisling has now joined the party and his arm can be seen on the far left. Far right is the left side of a waiter holding an ice bucket. Picasso's right knee seems to be solidly lodged against that of Pâquerette. No satisfactory explanation has been offered for the curled-up piece of paper; but inside of it, the handle of a cup is visible. The bar in the background is lit up by the sun, indicating that the sun is still nearly perpendicular to the buildings along Boulevard du Montparnasse and the time is shortly after that of photograph No. 7. All four photographs at the café table are taken within a few minutes of each other.

Printed from Cocteau Archive contact print.

ILLUSTRATION #24
THE INTERSECTION OF RASPAIL AND MONTPARNASSE

The intersection of Boulevard Raspail and Boulevard du Montparnasse, where most of the photographing took place. The cross marks with identifying capital letters indicate where Cocteau was standing to take a photograph, and the arrows indicate the direction he was pointing the camera. The circles with the dots represent gas lights. Boulevard du Montparnasse is oriented 26.7 degrees from west to north.

ILLUSTRATION #25
NO. 7 POSITION C

No. 7 Position C. 2:15. The rays of the sun have just passed being perpendicular to the building along Boulevard du Montparnasse, which on this date occurred at 2 o'clock. The five-degree shadow seen on the building above Max Jacob's hat sets the time at around 2:15. Max Jacob is standing on the traffic island between the tramway tracks going along Boulevard Raspail and those going along Boulevard du Montparnasse. To the right of his shoulder is the entrance to Hazard.

Ortiz and Picasso, with his uneven pants legs, look as if they are waiting for the Gare Montparnasse-Bastille tram to pass. Right in front of them on the other side of the boulevard is the flower stand. This is the first photograph on Cocteau's second roll of film.

Printed from Cocteau Archive negative.

Which Came First, the Chicken or the Egg?

ILLUSTRATION #26
THE ADMINISTRATION BUILDING

The administrative building of the P.T.T. is located 150 meters from the Rotonde toward Gare Mont-parnasse. Restaurant Napolitan was another well-known Montparnasse restaurant before the war.

Unfortunately, the Fenton photographs offer few opportunities for this sort of forensic examination. The lack of features that makes these photographs a powerful metaphor for the desolation of war also makes them a difficult source of information about shadows and sun angle. Where Klüver had buildings, light posts, and various people to cast different sorts of shadows at different times of day, as well as the correspondence of many of the people in the photographs, I had a couple of letters and an almost featureless landscape. It was a kind of existentialist's dream. Something like a surrealist painting without the driftwood.

The cannonballs become the first and only place to look for shadows. Nothing else in the picture casts one. There are no trees, no landmarks of any kind, save for the dirt road and footpath that bisect the frame and disappear into the distance. There is also nothing to tell us about the sky—it is washed out, featureless, and dirty white. Did a cloud pass across the sun, changing well-defined shadows to diffuse, murky lines? Was there bright sunlight? The sky—or lack of sky—is compatible with both.

I thought the sun position and shadows could be used to calculate the time of each of the photographs and lead to a solution of the ON-OFF problem. I constructed a sun map for Sebastopol, April 1855, based on software routinely used by gaffers (lighting technicians) in the motion picture business. I set the latitude (44°37′ N)

and longitude (33°31′ E) for Sebastopol and the date, April 23, 1855. (The software only goes back a hundred years or so, but mercifully, April 23, 1855, is much the same as April 23, 1955—at least as far as sun angle in Sebastopol is concerned.)

ILLUSTRATION #27
SEBASTOPOL SUN MAP

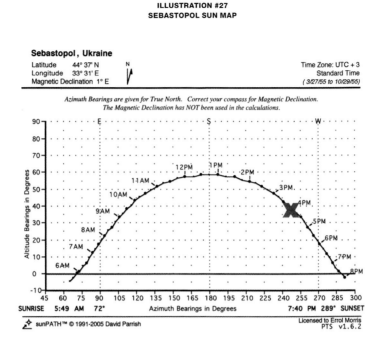

On April 23, 1855, the sun rose around 6:00 a.m. and set a little before 8:00 p.m. The chart also tells us that the sun reached its zenith around 1:00 p.m. and was 60 degrees above the horizon from the south. The sun at around 4:00 p.m. was about 40 degrees above the horizon.

The sun map, of course, can take us just so far. We have to know several additional things. Were the photographs taken in the morning or the afternoon? Which direction was the camera facing—east, west, north, or south? Happily, my trip to the Crimea had resolved any disagreements about the direction Fenton was facing when he took the picture. I had discovered that Fenton was facing north, toward the shelling— toward Sebastopol. Isn't this the first law of artillery, after all? Face the direction the fire is coming from—that way you don't get hit in the back with a cannonball.

And from the April 24, 1855, letter that he wrote his wife we know that Fenton took the photographs between 3:00 p.m. and 5:00 p.m. Using the time of day and camera direction with the sun diagram, I would expect the cannonballs to be lit from the south; that is, they would be front-lit. And as the afternoon wore on, they would become side-lit. The cannonballs would be side-lit from right to left in the photos as the sun moved from east to west.

But there was an additional worry. Were the shadows distinct enough to see a clear difference between the two photos? The sun map showed that if the photographs were taken about an hour apart, then the sun moved not much more than a 10-degree arc—up and down or left to right. Ten degrees is not that much. Could it be accurately measured in the photographs—that subtle shifting of shadows from right to left or up and down? And how long did it take Fenton to take the two photographs? An hour? More than an hour? Or perhaps much less time elapsed. Furthermore, as I learned on my trip, as it became more and more hazy toward sundown, the shadows on my 24-pound cannonball became less and less distinct.

I have always prided myself that my work is, as I like to put it, a combination of the prurient and the pedantic. I was thoroughly convinced that the current endeavor was pedantic, but had I lost the prurient element?

I had entered the shadowland of the shadows. Before I had determined the direction of Fenton's camera, I had thought that the cannonballs in ON looked more top-lit than the cannonballs in OFF. But then when I determined that we were looking north or north-northwest, not south or south-southeast, the cannonballs looked different. I mean, they actually looked different. What was I measuring? The shift in the shadows could be very small, too small for accurate measurement. Furthermore, what did I know about interpreting shadows?

Type in "shadow master" or "shadow expert" on Google, and a number of bizarre references pop up. One of the first search results is Connie Zweig, author of *Romancing the Shadow: A Guide to Soul Work for a Vital, Authentic Life* (with Steve Wolf), "an in-depth look at our hidden, wounded selves and how they form in early childhood . . . often wrecking [*sic*] havoc on our lives." Ms. Zweig was followed by how-to books on eye shadow application, video games, and comic book heroes. Eventually, Ralph Bouwmeester, an engineer and sun and shadow specialist, popped up.

I got excited. The very idea of "a shadow expert" conjures something out of film noir. Armed with a set of sine and cosine tables, isn't it possible to undermine the world?

R. Bouwmeester & Associates
Sun & Shadow Position Specialists
with Modeling Applications in
Accident and Crime Scene Reconstruction,
Urban Development, Site Planning and Building Design

I sent Mr. Bouwmeester copies of ON and OFF, and not long afterward we got on the phone.

RALPH BOUWMEESTER: The bottom line is that the checks and balances seem to point in the same direction, and I am coming up with a couple of

RALPH BOUWMEESTER: Balls that appear in [OFF] all of a sudden are gone in [ON], as if they have been picked up from the hill and moved over to the road. But the nature of the cannonballs on the road—just the way they look—appears to be different from the cannonballs on the hill in the foreground.

ERROL MORRIS: I'm not sure I understand.

RALPH BOUWMEESTER: I don't know how you would ever doctor these. But if these were digital photos, I'd be inclined to say that it was a poor job of cutting and pasting. The perspective doesn't seem to be 100 percent right from what I can see.

ERROL MORRIS: How so?

RALPH BOUWMEESTER: What I'm trying to say is there are cannonballs that seem to be exactly the same size, some are in the foreground and some are set back further down the road. When you measure them, they're exactly the same size, which would happen if you were to clone them without resizing them. There are many little inconsistencies like this that make me uncomfortable.

Bouwmeester was not proposing uncertainty; he was suggesting some kind of chicanery. The cannonballs are all the same size? Because they have been cloned? Fenton with a cloning tool!? He seems to be confusing the technical possibilities of twenty-first-century digital photography with the process of manufacturing nineteenth-century wet-plate glass negatives and albumen prints. First of all, the cannonballs are *not* the same size. There are clumps of cannonballs in one foreground position that appear different in size. Second of all, don't we have to know the focal length of the lens and the distance from the foreground to the background? That aside, how would cannonball size affect the measurement of sun angle, anyway? A spherical cannonball is a spherical cannonball is a spherical cannonball. Would it make any difference—for calculating sun angle—to know that one cannonball is a 24-pounder, another a 32-pounder?[15]

This raises a question that greatly interests me: why people accept claims of posing, fakery, and alteration rather than looking at the data. The data may be complex and hard to understand, but instead of trying to determine its meaning, people leap to a simplistic conclusion: The data is not real data. It has been doctored.

Isn't Sontag's theory something like that? She resolves a mystery simply by declaring it a trick, a plan to deceive. The claim that a photograph is posed is a claim that the photographer intended to deceive the viewer. It's not that photographers never set out to fool or trick us, it's just that trickery is often a too simple and convenient explanation.

Today, possibly because of Photoshop and other photography-doctoring software, people have become suspicious of photographs. This is a good thing. It's better

to be on the tip of our toes about the possibility of error rather than oblivious to it. But not every photograph has been tampered with. Bouwmeester wasn't analyzing shadows; he was looking for things hidden *in* the shadows.

We returned briefly to Bouwmeester's original hunch: that the cannonballs had been removed from the hillside and placed on the road.

> **ERROL MORRIS:** Have you done a count, by any chance?
>
> **RALPH BOUWMEESTER:** I was thinking about it, but I thought the heck with that; I'm not going to count them.

My indefatigable researcher, Ann Petrone, pointed out that if the number of cannonballs was the same, then the recycling theory could be eliminated. If soldiers had come to collect cannonballs from the road after the first photograph had been taken, then there would be fewer total cannonballs in the second picture. But if Fenton had just moved the cannonballs around as props, then the total number of cannonballs would be the same in both photographs.

Dennis Purcell suggested that I talk to John and Chris Russ, the father-and-son creators of Fovea Pro—a forensic photography program for processing and measuring images.

John Russ was busy, but Chris had time to look at the photographs and do a forensic analysis.

> **CHRIS RUSS:** And you know that Fenton was looking northward?
>
> **ERROL MORRIS:** Yeah. North by northwest, like the movie.
>
> **CHRIS RUSS:** Okay, knowing that you're pointing north-northwest in the afternoon, shadows will be longer on the right side later.
>
> **ERROL MORRIS:** Yes.
>
> **CHRIS RUSS:** Well, I'm going to try to match the overall contrast between the two pictures if I can. The top layer of OFF is considerably brighter in places. So it's got a much higher contrast. So I could try to flatten that and see what I can do. I'm going to have to balance these pictures to match each other. Let me play for a few minutes. I'll be right back with you.

A couple of hours later . . .

> **CHRIS RUSS:** I have balanced the two images out and I've got some observations. Now that I've balanced the contrast and dealt with a few interesting printing artifacts, the shadows of the balls are very, very hard to measure.

There are specular highlights in OFF, making me think there are no clouds at that point.

ERROL MORRIS: Specular highlights? What do you mean?

CHRIS RUSS: Okay, the difference between a bright metal surface and a polished plastic surface is the plastic seems flat and the metal has a bright spot on it relative to where the light source is. That bright light source is a specular highlight. That happens with material if you've got something that's polished versus something that isn't. It also happens with the same subject if you change the light from being a single point source, which you have on a sunny day, to a diffuse light source, which you have on a cloudy day. So one of the things that's causing problems for us is that one of these pictures was taken—and you can tell that by the contrast of the picture—one was taken with clouds and the other was taken with no clouds. So that's one of the things that's going on.

ERROL MORRIS: Uh-huh.

CHRIS RUSS: Considering that, I felt that because the balls were metal, they might not be as good a measure as the countryside itself. Therefore, it's important to know the angle of the hills on the sides of the road and the road itself. That's the part I started looking at. Because first I felt, "Oh well, let me compare the relative shadow from left to right on the two different sides of the road." When I first did that, I got the impression that ON happened earlier in the day than OFF, with the sun going farther over because the embankment on the right side got brighter. Now, this is all completely backwards if Fenton's pointing southward instead of northward. I'm looking at the valley as a sort of a bowl shape that is lit in different places depending on the time of day. You with me so far?

ERROL MORRIS: I think so.

ILLUSTRATION #28
DETAIL OF SHADOWS AND SUN

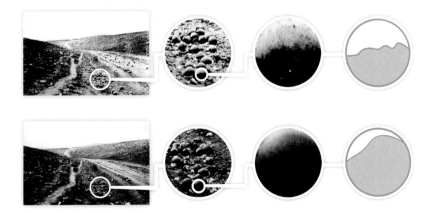

CHRIS RUSS: And that's consistent with the other way of measuring where the sun is—looking at the balls (because they're spheres) and determining where the light is on them. In OFF the light is farther down toward the right. In ON the balls seems to be lit over pretty much the top half of the ball. Closer to the middle of the day. Assuming afternoon for both, and assuming a camera direction of north-northwest, then ON was taken first. I'll try to balance thegray scale between the images using the road itself. There is one other thing different between these two images that makes it so hard to tell anything from the lighting. In ON, there's a hill off in the distance—just straight ahead—that is roughly the same intensity of the embankment on the right. In OFF, the hill's considerably brighter. And I'm trying to figure out what that means. Because we could be chasing our tails in a circular argument just because of what the clouds do.

ERROL MORRIS: Yes.

CHRIS RUSS: Now, the other observation I have is that the number of balls that seem to be missing from the left side and present on the road are not consistent. A lot more show up in the road than disappear from the side. And most of the ones in the major gully, which are where the vast majority of the balls are, don't change, although a couple have moved slightly.

ERROL MORRIS: Another odd thing, of course, is if you look, there's that dirt path that you see coming down on the left, and you'll notice again just to camera left of that path, there's a rock which is present in ON, but absent in OFF. I've named the rock "Esmeralda."

Enter Esmeralda.

CHRIS RUSS: Esmeralda? Why add a rock?

ERROL MORRIS: Or *subtract* a rock?

CHRIS RUSS: Yes, I saw that rock. I was using the rock that's farther up that path. It's present in both, a fairly large rock, given the distance, as my primary method of balancing brightness. Because I felt that the side to the camera of that rock was least likely to be affected by the lighting. But why would someone add the rock? You might argue that someone walked through there.

ILLUSTRATION #29
DETAIL OF "OFF"

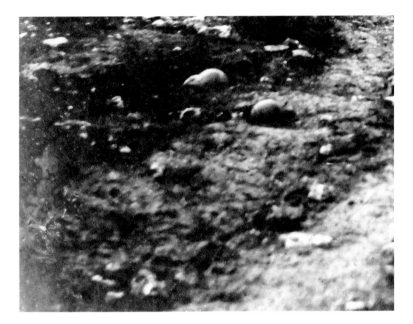

ILLUSTRATION #30
DETAIL OF "ON"

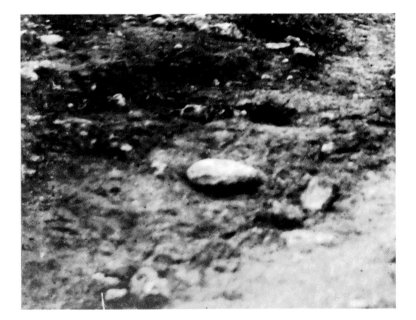

Which Came First, the Chicken or the Egg?

ILLUSTRATION #31
TWO CANNONBALLS

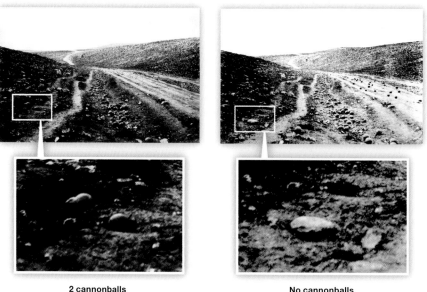

**2 cannonballs
No oval rocks**

**No cannonballs
Oval rocks**

ERROL MORRIS: Someone had to have walked through there. Something happened between the two photographs. The cannonballs didn't just roll off or on to the road. Someone moved them.

All of a sudden there was an exclamation from Chris Russ. It was a eureka moment for him, but I was no longer sure what he was talking about. Had we both retreated into a pixel-based fantasyland?

CHRIS RUSS: Bingo! Bingo! You know that hill in the distance? Let's say we're close to sunset in the second shot. It would be lit up. Earlier in the day, it wouldn't be. Okay, there's this other hill, interestingly enough, over toward the left. Do you mind if I take the phone and beat it against my head for a couple of minutes?

ERROL MORRIS: Please don't injure yourself on my account over this.

CHRIS RUSS: Oh, don't worry. This is a very intriguing puzzle. One trick that's going to help you: after you scan the images at high resolution, change your Photoshop mode to 16 bits. That won't do anything right away, but then change the image size. And what that's going to do is: every new pixel is

going to be made up of original pixels from before and will produce much better averages and give you tonality. And then as you start stretching and compressing contrast, you might start to see something. I reduced my image size down to about 2,000 pixels wide from the 5,000 we attempted before, and it let me do some things. Got rid of some—some but not *all*—of the speckle. But it also let me see some definition, some tone on the back of rocks. A useful trick. I am hoping to find a footprint.

Find a footprint! Whose footprint? Fenton's footprint? Or his assistant, Sparling's? Or some nameless British soldier—the unknown soldier who unwittingly left his imprint on one of the iconic pictures of the Crimean War? A phantom? A clue? And just what was Chris's eureka moment? Later, he told me what was going through his head. He went from (1) looking at the cannonballs as reflective spheres that should show the direction of the light; to (2) looking for some kind of addition to the scene that might indicate the passage of time, for example, a footprint; and then, finally, to (3) looking at the valley as a bowl in which he could study an overall change in the lighting. The eureka moment was, presumably, the moment he abandoned looking at lighting on the cannonballs and started looking at the overall pattern of the light on the landscape.

CHRIS RUSS: I've got a proposal for you. Let's say the person on the hill was chucking balls down toward the gully from the left. Later, they walked down and picked some up and put them in the road. That would account for why a number of rocks have been moved toward the right.

ERROL MORRIS: The cannonballs could have been coming from camera right to left. Now, they could have overshot the road and then rolled down that hill—

CHRIS RUSS: But where did the balls come from? There are some that are in OFF that are not in ON, and vice versa.

ERROL MORRIS: This could lead to madness, no?

CHRIS RUSS: The cloud cover makes all the arguments about shadows ineffective. And then I'm finding a small number of objects, it's not very many, that are present in OFF that are not present in ON. Some are balls, some are rocks. As opposed to a few cases where I found things that clearly had been moved. Same object, but its position has changed. It is completely consistent with the theory that this is staged. But there is no proof here that it is one or the other.

ERROL MORRIS: Staged in the sense that he put the cannonballs on the road?

CHRIS RUSS: That the balls were not present in the first photo, were added in the second.

ERROL MORRIS: So now you think that ON is the second photograph?

CHRIS RUSS: Yes. I think the balls are local and the balls were moved onto the road for contrast because there is a plethora of balls in OFF. The number

of new balls is not a very significant number compared to the number that are already there. So it's probably for purposes of making the picture—for aesthetic purposes. Not to say, hey, look how dangerous my life is. Because in both pictures, if you look at the number of balls in the gully, it outnumbers the ones on the road by a factor of five easily. So the number of balls that's different is a relatively small percentage, and I bet they came from the hill on the left. So I think this is more for the purposes of creating a pretty picture than for being boastful.

ERROL MORRIS: Clearly, you could make the argument that it makes the picture more graphic because you can see the cannonballs more clearly. The black balls are contrasted against the relatively light surface of the road.

CHRIS RUSS: Sure. He may have even waited for a cloud to block out the sun to get a better tonality, a better picture. If he's a photographer, he's going to do the best he can to control lighting. It's what I would do. He found his spot, and it was a matter of getting the light right and moving some of the balls so that the picture would be better. He was composing. The characterization of this as being a function of [lack of] bravado is probably overstated. He did make a very nice picture to present the story better, given the medium he had at the time—black-and-white, limited dynamic range of brightness and darkness. This gives it the kind of contrast that tells the story better, but I don't think it's not true. So I do think that he modified the scene, but I don't think he did it in a manner that's illegitimate.

Illegitimate? Are there really legitimate and illegitimate reasons for altering a scene? According to Russ, if Fenton changed the scene to improve it aesthetically, he did it with just cause. Have we been thrown back to the original question of Fenton's intentions? I feel the shadows growing longer.

ERROL MORRIS: So, ON is the second photograph?

CHRIS RUSS: The logic for removing them from the road—that would leave the others that are in the gully next to the road. If they were in that order, wouldn't it involve putting these ones that are on the road into the gully? I couldn't find a motive for that direction. If the balls in the road were removed, there are other things I would have expected to have moved, too. If someone was taking the balls to shoot them back, there are five times as many balls in the gully, why not take them from there, too? Conversely, if you're removing them from the road to be able to travel down the road, they'd probably end up in the gully or in the gully on the other side. That does not appear to have happened. Furthermore, if you were doing that, why wouldn't you put them over on the hill on the left side in a convenient declivity? It doesn't make sense.

ERROL MORRIS: Okay. But then your main reason for believing OFF comes before ON is based on the psychology of people, about why they do the things they do, about how they would act, do act, have acted—independent of the question of what we can learn from the photograph itself?

CHRIS RUSS: There are the things I can learn from the photograph itself. That there's a difference between the pictures and their lighting that is consistent with the hour and a half that he's talking about . . . if someone very kindly put in a true vertical pole and pointed the camera in a known direction. But if we're sloping slightly downhill north by northwest, then the western sun is going to light up the ground. But then please explain to me why the ground is considerably darker in OFF than ON? The only thing that comes to mind is: because the light is more diffuse. So let's look at OFF, which has relatively darker ground compared to the ruts in the road. How can we be pointing north-northwest and have dark ground? Could it be that we are in the shadow of the hill to the left?

ERROL MORRIS: So you're saying that—

CHRIS RUSS: If we really were in the shadows, then we wouldn't have highlights on the cannonballs. So the thought was to use a different surface that isn't going to be in shadow, and there are two. There's the hill in the far distance at the 1:00 position, and then there's the nearer embankment on the right side of the road. Well, it's brighter in OFF than in ON—which I suppose could mean the sun has dropped farther. The hill in the distance does the same thing, but the hill is not a plane, it is a curved surface, and if they were an hour and a half apart and one was at 3:00 and one was at 4:30, the sun would have had to have been a lot farther down. It's diffuse in ON, and therefore we can't tell what the time is in that picture.

ERROL MORRIS: I'm not sure I understand.

CHRIS RUSS: I bet he waited until a cloud got in front of the sun, and then he took the picture. He first got a picture of the spot, and then he got the picture he wanted to print. The first picture was because he had a feeling that it was going to be a good picture, and he didn't know if that was the only one he was going to get. And the second one is the one he wanted to publish.

He had a feeling? So much for forensic photography.

What started me on my pilgrimage to the Crimea were my suspicions about Sontag's ability to order the photographs in a hierarchy of authenticity based on what she imagined were Fenton's intentions. Now Chris Russ, a specialist in forensic photography, had also based his ordering of the photographs by imputing Fenton's feelings. Russ differs from Sontag and Keller, however, in his interpretation of Fenton's motives. The reason Russ believes ON came second is that ON is the aesthetically more pleasing image (to Russ) and thus must have been Fenton's second effort at photographing the scene.

The conversation turned from the question of sequence to the issue of posing.

CHRIS RUSS: If a picture's taken in a studio, I think it's pretty much safe to say that it is posed. And photography that is done where the subject is not aware of your presence, an argument could be made that that is not. That's certainly true for people. Once you change the scene, you cease to simply be an observer. That's what a purist could say. Then the follow-up question would be: did he substantively change the scene?

ERROL MORRIS: But if you *only* had the photograph in front of you, how would you ever be able to even answer such a question?

CHRIS RUSS: Well, the whole point is, we can't. But if it were posed, I would say it's compositional. It's an aesthetic choice. The balls are readily available because they're there, and the contrast in the picture shows them very nicely on the road because the road appears quite bright. It looks like he was looking for the contrast, and that would also be consistent with picking a time of day for the photograph when the lighting is diffuse. If someone is arguing that he is going to great lengths to puff up his reputation, I would say: no, you're wrong. If someone is trying to be the purist and say that he modified the scene, I would probably agree but say: it was just for aesthetics; it certainly wasn't for any other purpose. Because putting cannonballs on the road *does* add to the aesthetics of the image. That seems to be the primary reason. He's a photographer—that's the way photographers think. Look at Fenton, look at Mathew Brady, fast-forward to Ansel Adams. They're developing a whole new art form, and we're learning about both what they themselves saw and how to present it. Ansel Adams was renowned for doing an immense amount of work in the darkroom to show the kinds of things that he wanted because the process itself, particularly paper, was very limited in what kind of contrast it would show. So he did an awful lot to emphasize contrast in ink and to show detail. This I believe was Fenton's primary concern. Do I think that a number of things could be determined by just looking at a picture? Yes. But we need to know things about it to add information to the scene.

ERROL MORRIS: Are you saying: to interpret a picture we need more than the picture itself? We need context.

CHRIS RUSS: One of the things we do in image analysis is that we control the situation under which the image was taken so we can make these inferences. Even Ansel Adams did things in the darkroom. I don't know what the equivalents were in 1854. It would be very interesting to know what Fenton did. Clearly, changing the stage a little bit is well within the realm of possibility, and waiting for the right kind of lighting is in the realm. I've done shoots that are at sunrise or sunset [purposely] because of the color and the angle of the sun. I'm sure he was aware of it. If you go back to the 1700s, they were aware of it in their paintings. The problem with the scientific side of it is that the photographer was not a neutral observer. He picked the best picture he could find. That's the problem when you look at a picture in a scientific journal and underneath it there's a little caption that says,

"Representative image." It's not a representative image. It's the only one the guy ever got. Or the prettiest one he ever got.

ERROL MORRIS: Are you asked to do much criminal forensic work?

CHRIS RUSS: I do some, and a number of my tools go to people who do that. We're constantly battling the *CSI* effect. I'm sure you know what that is.

ERROL MORRIS: Tell me.

CHRIS RUSS: It's where people watch *CSI* on television and assume that we can do all sorts of things that we can't. So they'll keep zooming in on a picture and zooming in and ultimately they turn a pixel into a face. That's science fiction; that's not real. But there are some things that we can do. For instance, when the Hubble telescope went up, it was nearsighted for three years. We had to use it anyway, so we were able to compute just how nearsighted it was and do a mathematical transform called "deconvolution" on it, and with the 15 percent of the light that it did manage to capture, we'd make good pictures out of. Once they fixed the optics, then we were capturing all the light, and the pictures were that much better. There are some things that are doable and there are some things that aren't. I could do amazing things if I could get my hands on this guy's camera and retrace his optics. I could do even better if I could get my hands on his plates, but all we have are these prints.

The problem begins to look intractable. If the contrast levels in the two photographs are different, what does that mean? The hill on the left is darker in ON, lighter in OFF. Was this due to a cloud? Haze? A different time of day? Or something more elusive? Or was it an artifact of how the emulsion was put on the glass plate, or how it was exposed, developed, or printed? With so many variables, how can one ever determine whether the shadows reflect real shadows or some artifact of the photographic process? It was an epistemic shadow.

I was trying to figure out the next step. One possibility: collecting copies of every extant Fenton photograph (from around the world because the Fenton prints had been widely dispersed), comparing them, trying to match the various versions of ON and the various versions of OFF. It seemed painstaking and absurd, but would this be any more absurd than what I had already done?

There is something deeply unsettling about the thought that all the evidence might depend on a print. Which print? Why one print over another? If all the prints are different, where is reality? How can the real world be recovered from the simulacrum? Antonioni's *Blow-Up* is often taken as an essay on whether reality can be uncovered from a photograph. And it is often assumed that Antonioni argues that it can't be recovered—that the film is a thinly disguised essay on the subjectivity of truth.

I disagree. I believe it is closer to the opposite. David Hemmings, as the photographer in the movie, thinks he sees a gun in the shadows and a corpse in the park. The photographs he takes suggest a gun in the shadows and a corpse in the park. But Antonioni makes it clear they are real—the corpse and the gun are real. We watch as

David Hemmings returns to the park and touches the corpse. We the audience, as well as Hemmings the photographer, know that there is a corpse—there is evidence. There is a fact-of-the-matter. But where is the fact-of-the-matter here?

And then there is the separate issue of posing. Posing is not necessarily deception. Deception is deception. The existence of *two* versions of "The Valley of the Shadow of Death" is a powerful piece of evidence that points away from the claim that Fenton tried to deceive his audience. On Fenton's return from the Crimea, his publisher, Thomas Agnew & Sons, organized a show in London of his photographs. If Fenton had *intended* to deceive, why would he make prints from *both* glass-plate negatives, and why would he exhibit (and presumably sell) *both* prints? Curators and photo historians have argued about the *meaning* of the two photographs, but that's because they had the *two* photographs to compare. Fenton never attempted to suppress or hide one of them—quite the contrary, he exhibited *both*.

ILLUSTRATION #32
FENTON DEDICATION PAGE

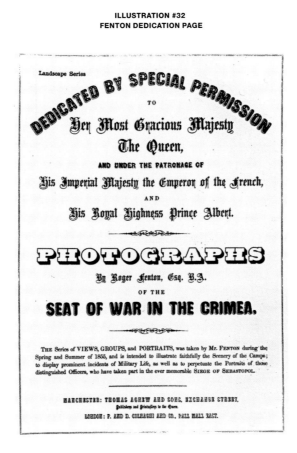

In the first major monograph on Fenton, Helmut and Alison Gernsheim's *Roger Fenton: Photographer of the Crimean War: His Photographs and His Letters from the*

Crimea (published in 1954), OFF appears as plate 51. ON does not appear at all. Did the Gernsheims consider OFF the superior photograph? Hadn't Keller and Sontag (and now Russ) argued that ON was more powerful and aesthetically pleasing?

———

I contacted Roy Flukinger at the Harry Ransom Humanities Research Center, University of Texas at Austin, to get his thoughts on this very question. Flukinger is the curator of the Gernsheim collection, which included many of Fenton's own photographs.

ERROL MORRIS: One thing that has puzzled me—in the Gernsheim book, they reproduce OFF. But more recently and far more often, you see the other photograph reproduced—ON. I'm curious, after Fenton's return from the Crimea: Which photograph did he show? Or did he show both?

ROY FLUKINGER: I'm not certain I could tell you. I do know that probably both were sold in the portfolio sets. But which one he exhibited in his exhibition at the Photographic Society, I don't know.

ERROL MORRIS: But when Helmut Gernsheim turned over the collection to the University of Texas, did he have both photographs? Or did he have only one photograph, namely OFF.

ILLUSTRATION #33
HELMUT GERNSHEIM, 1946

Neither camera, nor lens, nor film determine the quality of pictures; it is the visual perception of the man behind the mechanism which brings them to life. Art contains the allied ideas of making and begetting, of being master of one's craft and able to create. Without these properties no art exists and no photographic art can come into being. —Helmut Gernsheim, 1942

ROY FLUKINGER: I'm sure Gernsheim had both in the set, because Gernsheim's collection came from Fenton's own set of Crimean photographs. Now, why Gernsheim chose [OFF] over [ON], I have never been able to find out. I'm right now in the middle of researching and writing a big book on how Gernsheim put his collections together. He very unkindly didn't leave one essay that said how the collection was formed. It's all over Gernsheim's manuscripts, and I'm going through all that right now. I don't think there's anything but the actual mounted prints that date the Fenton photographs in any way, shape, or form. I don't think there's any reference to when one image was made, as opposed to another. I've never seen anything like that anyway. Now one can argue that because of the slowness of the speed and exposures of everything, most of Fenton's images were posed, in terms of people and figures and groups—things like that. So that is, to that extent, a manipulation of quote-unquote "the truth." But I just can't imagine him gathering together a bunch of people and rolling cannonballs out there in that valley to make the picture.

There are two separate issues here—the issue of posing and the question of which came first. And yet, for most people the two issues are inexplicably intertwined. Fenton took the first picture and then posed the second. But it doesn't matter in theory whether OFF came before ON or vice versa, either or both could still be posed. Namely, Fenton could have intentionally posed either or both photographs independent of the order in which they were taken.

One way to look at it: ON could be first and could be posed or unposed, and OFF could be first and could be posed or unposed. Is OFF true and ON false, or vice versa? Or are both equally true? Is one more truthful than the other, because one is more *natural* than the other? Or *authentic*? And what is "natural"? Or "authentic"?

Furthermore, is it unnatural to have people move cannonballs? Or inauthentic? Aren't these photographs of human events—even if there are *no* people in the frame? They are photographs about war. The effects of war. Is war itself natural or authentic? The concepts of naturalness, authenticity, and posing are all slippery slopes that when carefully examined become hopelessly vague.

━━━

Meanwhile, my friend Dennis Purcell started scrutinizing the photographs, counting cannonballs, and examining sun angles. And it was he who ultimately put the issue to rest by isolating the essential detail from the many false trails that led nowhere. Dennis looked at the hard facts of the photographs themselves and arrived at a beautiful, absolutely convincing solution, which, once read, seemed simple. But isn't that the essential quality of a great solution? The series of events are as follows:

first no one can figure out the problem, they trot out numerous equivocal solutions, then they hear the solution, which seems so utterly simple, and say: "Now why didn't I think of that?"

Dennis started by examining individual rocks—their size, shape, and placement. By overlaying the two photographs and looking at them carefully, he found a group of rocks that had moved positions. He named them Fred, George, Oswald, Lionel, and Marmaduke. Perhaps he too had felt the pull of the pathetic fallacy. Were the rocks in the photographs alive, like the cannonballs in Kinglake's description?

DENNIS PURCELL: The direction is downhill. So here's Lionel in OFF (blue) and here's Lionel in ON (yellow). Somebody kicked this rock, and it ended up here. Here's George. All it did was just go a short distance, but it's a little lower down in ON than it is in OFF. These are small movements. When you just pull out a small section [of the entire photograph], you just get this feeling of something that happened there.

ILLUSTRATION #34
DIAGRAM OF ROCK MOVEMENT

ILLUSTRATION #35
FRED, OSWALD, GEORGE, MARMADUKE, AND LIONEL BLUE "OFF"

ILLUSTRATION #36
FRED, OSWALD, GEORGE, MARMADUKE, AND LIONEL ORANGE "ON"

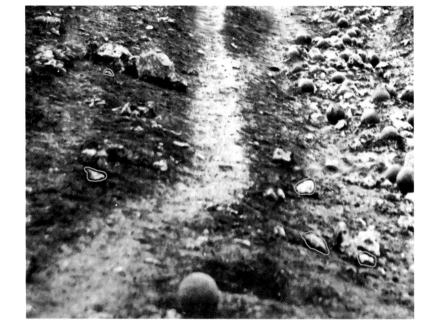

ERROL MORRIS: Wow.

DENNIS PURCELL: These are small movements. This is Lionel here and that's it over there.

ERROL MORRIS: And there is no way to balance the contrast between these two photographs?

DENNIS PURCELL: No. You can for small patches, but not for the image as a whole. Despite all the warping and stuff I did—I couldn't quite make the two whole pictures match. They're very close but shrinkage of the gelatin—or whatever this thing was on—makes it impossible. But you can make a small area match almost precisely, and then as you flip between one and the other, you just say, "What changed here?" If you're looking at a small area—a lot is going on because some balls move and some don't. How big are these cannonballs?

ERROL MORRIS: They're not that big. About the size of a grapefruit. A 24-pounder is smaller than you would think.

DENNIS PURCELL: And here's a small rock. You can sort of see it's got a point and two bumps on it. It's the same one as that. And again, it's moved downhill as though someone carrying something kicked it and it slid. Now it's down here. When you just pull out a smaller section, you just get this feeling of something that happened there. But looking overall you can't do that because the pictures really aren't the same in graininess or contrast, and there's a tremendous amount of garbage in these photos.

ERROL MORRIS: Hold on a second. Here's a picture of Olga Makarova, our Russian guide. I'll try to get the other pictures for you.

ILLUSTRATION #37
OLGA

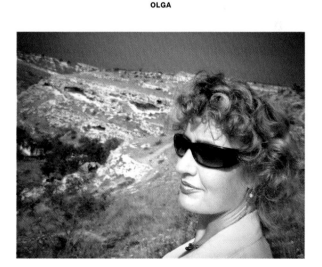

DENNIS PURCELL: She looks like she could be a good guide.

ERROL MORRIS: Have I showed you my self-portrait in the Valley of the Shadow of Death?

DENNIS PURCELL: No.

ERROL MORRIS: Let's see if I can find it.

ILLUSTRATION #38
ERROL'S SHADOW

DENNIS PURCELL: That's nice. That's a real Lee Friedlander.

ERROL MORRIS: Thank you. And this is the picture that Bob Chappell took in the Valley of the Shadow of Death.

DENNIS PURCELL: It's the same road. Look at this! There it is. Oh my god. There it is! That's Marmaduke. The picture is pretty darn good. It's quite similar—for one hundred and fifty years. Subtract a few bushes, and you're back to where you were. How many things in the world have changed so little in one hundred and fifty years? How in the world, where there's so much information, can there be such a high level of ignorance? Certainly the more information we get, the higher the level of ignorance seems to be.

What is Dennis saying? I believe he is pointing out the difference between information and knowledge.

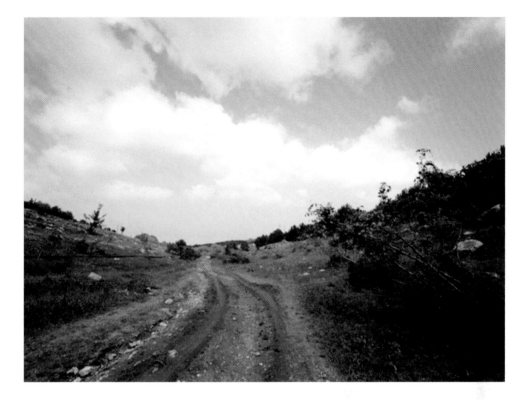

ERROL MORRIS: So it's based on those two guys, George and Lionel.

DENNIS PURCELL: Those two guys plus Marmaduke—or whatever we want to call him. Those two went down. These two went this way. There's one over here and there are others up in here.

ERROL MORRIS: So the whole shadow thing turns out to be a red herring. A dead end.

DENNIS PURCELL: It doesn't give us the answers we're looking for. If you matched the contrast in the two photographs perfectly, there hardly seems to be any difference.

ERROL MORRIS: Yet from the motion of rocks, you can determine which photograph was taken first.

DENNIS PURCELL: Absolutely. First look at the motion of the rocks, then look at the photographs. The rocks move from up to down if OFF precedes ON.

I feel the gravity argument is very strong. If you stepped up to pick up something, you'd just kick a stone or two. The smaller is the more significant because no one would have noticed that and no one would have kicked it uphill by accident. I find that pretty strongly. And I find the sun angle business ambiguous and paradoxical. The shadows are not that different. If you add and subtract contrast, the shadow position is almost the same. You do it and you say, "Which one of these is different in which way?" You can't tell because the slightest amount of adding or subtracting contrast, darkening this and lightening this, moves the shadow. So there really isn't much difference between the shadows in ON and OFF. You can move that shadow around the ball just by lightening and darkening it. I don't get much out of the shadows, but I get a lot out of the little guys who were kicked aside. Some of those rocks, those main boulders, they're still there. The cannonballs are gone, but the rocks are still there. It would be nice to find that funny one with the two bumps and the nose. The rocks have very distinct characters, whereas the cannonballs have none.

———

One is tempted to say, following Chris Russ and Archimedes, "Eureka!" Dennis has found the solution. When the rocks are uphill—before they have been dislodged—the cannonballs are off the road [OFF]. Then, you look at the rocks after they have been dislodged—rocks that were kicked and then tumbled downhill—the cannonballs are on the road [ON]. In short, the first shot had to be taken when the balls were uphill. We can see: rocks up, cannonballs off the road. And, the second shot, when the balls tumble down a bit, rocks down, cannonballs on the road. It is the law of gravity that allows us to order the photographs.

And yet, a second, central question remains: were either [OFF] or [ON] posed? Or both? We may know the order of the photographs, but that doesn't mean we know whether they were "authentic" or deliberately posed. I asked Dennis Purcell about this question, and he turned to the question of authenticity in a more general sense.

DENNIS PURCELL: Take the question of the moon landing. There are people who believe that it was fabricated in a studio. The question is, how do you really know they're on the moon? It's pretty simple. Because the dust that they kicked up fell straight to the ground.
ERROL MORRIS: It did?
DENNIS PURCELL: It didn't float. It dropped. It was very strange-looking. The dust that they kicked up instantly plunged straight down in a way that no dust on Earth would.

ERROL MORRIS: Dust on Earth is suspended by the Brownian motion of molecules in the atmosphere, but there is no atmosphere on the moon.

DENNIS PURCELL: Yes. There were people saying that they faked it. They never were on the moon. They just did it in their training camp in the Black Hills or wherever it was they trained. But you can't fake dust plunging straight down. There's no way to do that.

The dust-plunging-straight-down test. I had a strange intuition. What about a different kind of test—about the notion of "posing"? A thought experiment. Say, for the sake of argument, Susan Sontag is right. Fenton posed one of the photographs, but she's wrong about the order. They are in the reverse order (ON before OFF) to the one claimed by Sontag, Keller, and Haworth-Booth and established by Dennis Purcell.

Consider this hypothetical story. Fenton came across the balls on the road and scattered them on the hillside, thereby posing the picture that he took of the road without the balls on it (OFF). It doesn't matter why he did it—just that he intended to do it. It wasn't inadvertent. But then OFF is posed, *and* it's posed because of the absence of something. The cannonballs should have, could have been there, but Fenton altered the landscape by removing them from the road.

Couldn't you argue that every photograph is posed because every photograph excludes something? Even in framing and cropping? Someone has made a decision about what time-slice to expose on the emulsion, what space-slice (i.e., the frame) to expose on the emulsion. Fenton could have had an elephant in the Valley of the Shadow of Death, plus all the workers you might imagine heaving cannonballs about. The elephant could have been walking through the frame of Fenton's camera, and Fenton waited until the elephant had just cleared the frame. Click. (Or removed the lens cap, the method in mid-nineteenth-century photography.) Or told Sparling, his assistant: "Get rid of the elephant." But in that event, he posed the photograph by *excluding* something. He posed the photograph, but how would you know? The photograph is posed not by the presence of the elephant but by its *absence*. Isn't something always excluded, an elephant or something else? Isn't there always a *possible* elephant lurking just at the edge of the frame?

ILLUSTRATION #40
EXCLUDED ELEPHANT

For those who object to this experiment (and there have been a couple) because there were no elephants in the Crimea, I urge them to substitute a dromedary—like the one photographed by Fenton in the Crimea in 1856.

ILLUSTRATION #41
FENTON CAMEL PHOTO

As preposterous as it may seem, I would like to make the claim that the meaning of photography is contained in these two images. By thinking about the Fenton photographs we are essentially thinking about some of the most vexing issues in photography—about posing, about the intentions of the photographer, about the nature of photographic evidence—about the relationship between photographs and reality. We also have the first motion picture because we have two images in sequence. We just don't know (at first) what the sequence is because they are not conjoined in celluloid.

Isn't much of science the attempt to fill in what happened between two moments of time, t_0 and t_1? To explain how and why something changed?

Shortly after our discussion, Dennis sent me a note. It indicated he had not only matched my level of obsession, but also contained a solution to the puzzle.

Dear Errol:

I've worked some more on the images, and with warping and equalization have brought them a bit more into sync, so that quickly flipping between the two pictures reveals more of the detail and less of the distracting large-scale brightness differences. When you do flip them, making a two-image movie, you see of course a lot of change in cannonball location. But you also

see movement of non-cannonball features. And my case rests (quite firmly, I think) on the two close-up views. These show movement of inconspicuous rocks that have been kicked, jostled or vibrated. Each one has ended up lower down the hill. I haven't found any that went the other way.

It is really difficult to imagine a scenario in which all these objects, at some distance from each other, would spontaneously move uphill. So I just can't see any way in which the cannonballs-on-the-road view comes first.

ILLUSTRATION #42
BLUE CANNONBALLS

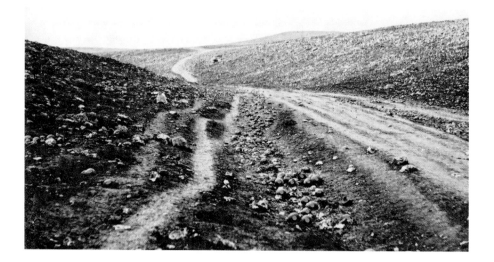

ILLUSTRATION #43
RED CANNONBALLS

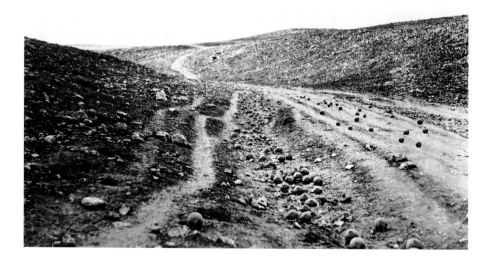

Some less conclusive but corroborating evidence: a very careful count shows that there are the same number of balls in both pictures (about 250, if I remember correctly). So no one has gone around policing the balls for reuse or any other reason. They have been removed from the surrounding area and placed on the road. Another point, and this is only an impression, is that the placement of balls on the road is too nicely and evenly "random." It's sort of like the error that people make when they try to invent a "random" sequence of numbers: much too well distributed and avoiding runs and oddities. Here, the dynamic physical forces and rough terrain form a kinetic system in which there will not likely be a nice pattern spread out in open space (and nicely in camera-range) but rather a strong tropism for local minima—which we see in the first picture where most of the balls are "in the gutter" or in depressions on the hillside.

Dennis

Dennis has solved the problem. It is gravity and the movement on the rocks. The rocks in OFF move downhill to the position they are found in ON. We may not know *exactly* how the cannonballs got on the road, but we do *know* OFF came before ON. The cannonballs set up the problem but are irrelevant to its solution. There is no way—at least as far as I can see—to wiggle out of his argument. And so, it turns out that Keller, Haworth-Booth, and Sontag are all right. It is OFF before ON. I tried hard to prove that Keller and Sontag were wrong—to prove that ON came before OFF. I failed. I can't deny it. But I did prove that they were right for the wrong reasons. It is not their assessment of Fenton's character or lack of character that establishes the order of the pictures. Nor is it sun angle and shadow. Rather it is the motion of ancillary rocks—rocks that had been kicked, nudged, displaced between the taking of one picture and the other. Rocks that no one cared about. "Those little guys that got kicked aside," as Dennis called them. Their displacement was recorded on those wet collodion plates not because someone wanted to record it. It happened inadvertently. Ancillary rocks, ancillary evidence—essential information.

The one thing that we know about the rocks—Marmaduke, George, Lionel, Oswald, and Fred—is that they were not posed. No one noticed them, let alone posed them. But together they helped unlock the secret of how to order the Fenton photographs.

Photographs preserve information. They record data. They present evidence. Not because of our intentions but often in spite of them. Sontag, Keller, and Haworth-Booth could be right about the order of the photographs, but nothing that they have said shows that one photograph—either ON or OFF—or both photographs were posed. The change in the photographs suggests that Fenton may have moved the cannonballs for aesthetic or other reasons. But we can never know for sure. And even if Sontag is right, namely, that Fenton moved the cannonballs to telegraph the horrors of war, what's so bad about that? Why does moralizing about

"posing" take precedence—moral precedence—over moralizing about the carnage of war? Is purism of the photography police blinding them to the human tragedy the cannonballs represent?

———

At the very end of my discussion with Roy Flukinger, he turned to the mystery of photographs—the mystery of recording light and shadow without telling us what they mean.

ROY FLUKINGER: It's one of the fascinating things about photo history. It always gives us more questions than answers. Historical photographs may give you the possibility of new facts, and may give you the chance to ask new questions. The thing I like about old photographs is that they offer me a different sort of visual, and hopefully, therefore, emotional experience of what I'm looking at, that words can't do, or that words can only do part of.

ERROL MORRIS: Something beyond language?

ROY FLUKINGER: Definitely. There's a whole other level that reaches a person through the eyes. And I just find that fascinating.

ERROL MORRIS: How would you describe that "other level"?

ROY FLUKINGER: Photography has a certain immediacy—not only in the taking, but also at the end of the equation, the presenting of the image to a viewer. There's a strong chance for distortion of fact or for inadequate—no, not inadequate, shall we say, limited amount of experience. But there's always something that's possible to be revealed and shared in the process. If you sit down and really lay out these portfolios of prints on a table, and look at them for an afternoon—we've got a big wall easel here so we can lay out a bunch of them—and you move them around and look at them, you really get a sense of what it must have been like to be there—even a level of goosebump experience. That's the sort of power that photography can have. If you're looking at the original prints the way the photographer printed them, and wanted to make them known, that possibility is enhanced, even beyond just what's reproduced in a book.

ERROL MORRIS: The feeling of being there?

ROY FLUKINGER: At least a better sense of being there, a better sense of the emotional experience that went into the creation of the image. Fenton was there—freezing his butt off and getting in the mud and everything else. That's something you experience when you look at the roughness of the prints and the detail of the imagery—that is, when you stop and look at what's there in the photographs.

Will the Real Hooded Man
Please Stand Up?

ILLUSTRATION #45
HOODED MAN
(opposite)

It was arguably one of the least newsworthy pictures in the world, if only because it had already been seen by everybody. And yet, on March 11, 2006, the *New York Times* published on the front page of the first section, in the upper left-hand corner, a photograph of a man holding the photograph that had been seen around the world.

ILLUSTRATION #46
NEW YORK TIMES FRONT PAGE

Ali Shalal Qaissi, the man shown holding the photograph, had come forward as "The Hooded Man."

The Hooded Man, no longer anonymous, became a national news story—not because he was a victim of torture and abuse at Abu Ghraib but because he was in an infamous photograph. The accompanying story in the *Times* made this clear. The article was written by Hassan M. Fattah.

> Amman, Jordan, March 8—Almost two years later, Ali Shalal Qaissi's wounds are still raw. There is the mangled hand, an old injury that became infected by the shackles chafing his skin. There's the slight limp, made worse by days tied in uncomfortable positions. And most of all, there are the nightmares of his nearly six-month ordeal at Abu Ghraib prison in 2003 and 2004.
>
> Mr. Qaissi, 43, was prisoner 151716 of Cellblock 1A. The picture of him standing hooded atop a cardboard box, attached to electrical wires with his arms stretched wide in an eerily prophetic pose, became the indelible symbol of the torture at Abu Ghraib, west of Baghdad.

Put simply: without the iconic photograph, it's likely there would have been little or no interest in Qaissi or his story. Qaissi was not the first ex-prisoner at Abu Ghraib to be interviewed by human rights workers, but he was the first to be profiled on page one of the *Times*. (Although the *Times* did not use the expression "iconic photograph," it did call the photo "the indelible symbol of torture." It might amount to the same thing.)

The picture was captioned "Ali Shalal Qaissi in Amman, Jordan, recently with the picture of himself standing atop a box and attached to electrical wires in Abu Ghraib."

The story continues with a quote from Qaissi:

> "I never wanted to be famous, especially not in this way," he said, as he sat in a squalid office rented by his friends here in Amman. That said, he is now a prisoner advocate who clearly understands the power of the image: it appears on his business card.
>
> At first glance, there is little to connect Mr. Qaissi with the infamous picture of a hooded man except his left hand, which he says was disfigured when an antique rifle exploded in his hands at a wedding several years ago. A disfigured hand also seems visible in the infamous picture, and features prominently in Mr. Qaissi's outlook on life. In Abu Ghraib, the hand, with two swollen fingers, one of them partly blown off, and a deep gash in the palm, earned him the nickname "Clawman," he said.

ILLUSTRATION #47
ALI SHALAL QAISSI *NEW YORK TIMES* DETAIL

VOL. CLV .. No. 53,515 Copyright © 2006 The New York Times NEW YORK, SATURDAY, MARCH 11, 2006

Shawn Baldwin for The New York Times

Ali Shalal Qaissi in Amman, Jordan, recently with the picture of himself standing atop a box and attached to electrical wires in Abu Ghraib.

Symbol of Abu Ghraib Seeks to Spare Others His Nightmare

The *Times* hedged its bets and wrote, "A disfigured hand also seems visible..." It left open the possibility that what appeared to be a disfigured hand might be something else. The *International Herald Tribune,* however, was more definite. It said simply, "A disfigured hand shows up in the photograph."

But it isn't a disfigured hand, and Qaissi isn't The Hooded Man.

The first questions arose two days later on *Salon,* when Michael Scherer presented army documents, photographs, and files "suggesting that the paper had identified the wrong man."

In response to this and other criticism, the *Times* formally admitted the error in a March 18 article and in an editors' note that tried to explain how the mistake had been made:

> The *Times* did not adequately research Mr. Qaissi's insistence that he was
> the man in the photograph. Mr. Qaissi's account had already been broadcast

and printed by other outlets, including PBS and *Vanity Fair,* without challenge. Lawyers for former prisoners at Abu Ghraib vouched for him. Human rights workers seemed to support his account. The Pentagon, asked for verification, declined to confirm or deny it.

The *Times*'s public editor, Byron Calame, commented upon the error one week later, focusing on the reporters' use of sources. The human rights workers cited in the story had never said they believed Qaissi was the man in the photograph, only that it was possible. Moreover, the article did not mention its reliance on the earlier stories, quietly taking their identification of Qaissi for the truth.

But there was one aspect of the controversy—the most crucial aspect—that was overlooked. No one acknowledged the central role that photography itself played in the mistaken identification, the way that photography lends itself to those errors and may even engender them.

I spoke to Hassan Fattah, author of the *Times* article that identified The Hooded Man. A graduate of the Columbia School of Journalism and correspondent for the *Times* in the Middle East, he was unusually honest and forthcoming in our discussion. I was impressed by the way he spoke about his attempts to verify Qaissi's account. It was certainly not something he shrugged off. He called the week that the story was discredited the worst week in his career. It was a journalist's worst nightmare.

HASSAN FATTAH: I basically was assigned the story. I was told to go see this guy who had been on Italian TV and had been interviewed several times elsewhere. I spent a few days trying to find him, actually. And he actually pulled out one or two times, and then finally was willing to meet me. I'm Iraqi myself, Iraqi-American. I worked in Iraq for a long time.

And I sat with him for a very, very long time and we talked. He's a very compelling figure. You spoke to him, didn't you?

ERROL MORRIS: Yes, but with difficulty. You would, of course, have had a much easier time.

HASSAN FATTAH: You spoke to him in English, obviously?

ERROL MORRIS: There was a translator. But we had trouble understanding each other. The poor phone connection, the constant stopping and starting for translation made conversation difficult. But he remembered Sabrina Harman [one of the MPs who guarded him at Abu Ghraib]. He told me that he liked her and asked if I could relay a message to her. He wanted her to speak on behalf of his organization. I wish I could have met him in person.

ILLUSTRATION #48
HOODED MAN BUSINESS CARD

جمعية ضحايا سجون الإحتلال الأمريكي
Association of Victims of American Occupation Prisons

علي القيسي
مؤسس ومنسق عام الجمعية

Address / Iraq - Baghdad - Mobile: 962 79 6419270
Email: iraqisourheart@yahoo.com / ali_shalal1@yahoo.com / prisoners11@yahoo.com

HASSAN FATTAH: I sat with him for a while because I just felt there was something too good about this story. But I kept in mind several things. First of all, he was able to describe the whole environment and everything that happened very, very accurately, in terms of how other people were describing it. He described the details of it and other aspects. It was very interesting that he knew the place so very well. He had a prisoner number, and he spoke about other prisoners that were there. He clearly had been in the prison, and we just needed to confirm that. And then I asked him, "Can you point yourself out in the picture?" And he got on his computer and he printed out the picture. And then we took his picture holding up that picture. And he said, "Here it is. Here's my hand. Can you see it?" And then we looked at the picture, and the picture of the hand, and it looks very much like his hand. It turned out later that actually there is a high-resolution picture that came out that shows that it's not his hand. I wish I had gotten that earlier. But that was the series of data points that our decision was based on.

ERROL MORRIS: So part of the problem was that the photograph was low-res and you couldn't clearly see his deformed hand? That in some odd way, the photo was presented as definitive identification, but that Qaissi's most distinguishing feature wasn't visible?

HASSAN FATTAH: Yes. But he was able to describe the prison, the dynamics of the prison, and everything that was happening quite accurately. He had a very vivid memory of where the light fixtures were. The question was how do we really confirm his identity. I did talk first to Human Rights Watch, and then to Amnesty International. Human Rights Watch felt that yeah, this is the guy, we've known of him before, but they were a little tentative about it. So I talked to Amnesty and the guy—I forget his name, a German man who had spoken to him several times, in fact. He had referred to him on different issues about other prisoners and conditions in Abu Ghraib. So the Amnesty representative knew him well. He helped me go through the list of

prisoners, and there he was on the list. That step proved he definitely was in Abu Ghraib, and we had the data for that. We have some of the pictures. And then he was quite convinced that he was the man. At least that's how he said it. Of course, afterwards, he changed his story.

But it was ultimately Susan Burke [legal counsel acting on behalf of the Abu Ghraib torture victims] who sealed it for me. She went through the whole thing. They had the blanket, they had a lot of circumstantial evidence that linked Qaissi to the image. And she was very, very confident he was the one. The fact that they had the blanket was important to me. So we moved ahead with the story—

ERROL MORRIS: I'm sorry to interrupt, but when you said, "She had the blanket," what does that mean? That she had the physical blanket?

HASSAN FATTAH: Yes, she had the physical blanket that he was wearing. They gave them blankets, and she walked me through this. Most of the time they were naked. And we know this; this is now on the record. And they gave them blankets at some point. And so they cut holes in the blankets and used them like ponchos. It ended up being a piece of clothing, and that's what they slept with. Now, they had this poncho. And she felt that it was exactly the same poncho as the one in the picture.[1] She had a bunch of other evidence that seemed to suggest this was true. And from there we went to the military and asked them to help us confirm his identity. At first they said, "Oh, yes, we've heard of him before, and we'll get back to you." And then the day afterwards—this is not to me, but to somebody who knows the military well, who did that reporting—they said, "We are not able to discuss this issue because it will violate his Geneva Convention rights." So we ended up with all these different data points. And by the end I was convinced: this was the guy. His story was very accurate. It was also a very compelling story, but he wasn't bitter about it. He was going to use this experience to help out some of the former prisoners. Obviously, the lawsuit that they [Human Rights Watch] have going is a big piece of the puzzle. This was going to be his way of getting some proper restitution. What is clear is that he was a man who was at Abu Ghraib, there's no doubt about that. There was no reason for him to jeopardize this lawsuit. Why would he ruin it for himself by lying to the press? So we ran with the story. At some point we decided, okay, everything seems to stick.

ERROL MORRIS: And there had already been other news stories about him.

HASSAN FATTAH: Yes. There have been several profiles of him before in mainstream places. There was nothing that would suggest, after two years of this guy being out there, that this guy was not the man. There was nobody else who came up and said, "This was me." There were court records. But because I didn't cover the courts-martial I had not actually seen them. That proved to be the fatal flaw in my reporting. If I had to do it over again, if I'd seen the whole series of the latest photographs that had come out and

had seen the courts-martial records first, and had ignored the fuzzy picture itself, I would have probably remained skeptical and would have held off for a lot longer. Probably I wouldn't have done the story at all. More importantly, the more interesting story was the fact that these guys were around and were starting to talk to people. That there was the whole group of Abu Ghraib prisoners that had organized, and they were meeting with the lawyers the week that I was reporting the story.

ERROL MORRIS: Yes.

HASSAN FATTAH: And then we went to press, and the doubts about his identity came out. I called Qaissi and was talking to him, and it turned out that the lawyers were there with him, Susan Burke and her associates. Anyway, the lawyers were there with him, and they sought to convince me that he was telling the truth. Then it became apparent that they had nothing that could properly refute the allegations. And then he [Qaissi] finally admitted that the picture he printed out was not actually a picture of him. That's when it was all over—

ERROL MORRIS: And who did he admit that to?

HASSAN FATTAH: He finally admitted it to me. He knew he was lying.

ERROL MORRIS: But wait. Is it clear that he knew he was lying?

HASSAN FATTAH: Maybe not. He still insists he's the real thing—and I've run into him several times since—and he continues to come to me and apologize, and continues to insist, "Please understand, I am in one of those pictures." I personally believe there are many pictures, and he is probably the next guy in line. We do have some photographs in the same space, around the same time. We also have him with the blanket. We have seen him in other poses as well as the orange jumpsuit that he was wearing that said "Claw Man" on the back of it. There's enough to suggest that he was in the space, he had been part of this, he had been involved and he had witnessed everything. But once he admitted that—"I am not the man in the photograph"—that was it. What more could I say? I realized I had been had. And then we had to do the retraction. What to me makes this especially a tragedy is that in many ways it detracted from his real story.

———

Susan Burke, the attorney who represents many of the torture victims, also suggested that it made no difference whether Qaissi, The Claw, was also really The Hooded Man—that his testimony is no less valid. This opinion was echoed by Donovan Webster, a *Vanity Fair* reporter, who argued that Ali Shalal Qaissi was doubtlessly subject to similar abuse:

As the reporter who first interviewed Qaissi—or as I called him, Haj Ali—for *Vanity Fair,* I was scrupulous to qualify that while he says the abuse happened to him (and his lawyer now has medical records to prove he was electrified), there might have been more than one person subjected to the same treatment, and we will likely never know unless someone else associated with the incident steps forward. During my months of reporting that story, I pushed to learn if there was more than one "hooded man on the box," but, predictably, got nowhere with U.S. Army spokespeople, the Abu Ghraib soldiers present who were still available for comment, or several senators and congressmen working on a variety of Abu Ghraib investigations and commissions. Nonetheless, the army's own records place Haj Ali on Tier 1A at the time of the Abu Ghraib abuses, and Haj Ali maintains that these abuses happened to him with the kinds of consistent, telling details that lead many to believe he is telling the truth. To discount the horrors visited upon this man because the famous photo shows a different detainee on the box—and to disbelieve what happened because no photo currently confirms it—well, it shows just how much of an abstraction torture has become inside American culture. Long to short: the issue is not about "individual interpretations of reality" or photographic imagery inspiring unearned lunges for international fame. It is about the idea at least two people might have been abused in a similar manner, but only one can produce a digital image to prove it.

I believe we are talking about two different things. The Claw was a prisoner at Abu Ghraib. He was most likely subjected to abuse, but whatever happened to him, whatever his account might be, it's not the same as being the man in the picture.

And there is also the question of what Qaissi really believed, and what was going on inside his head. Had he also been hooded and put on a box with wires attached to him? In other words, was he a hooded man, but not The Hooded Man? If that was the case, he could have easily come to believe that he was The Hooded Man. If he truly believed that he was The Hooded Man, then he was innocent of conscious manipulation or misrepresentation.

But if The Claw was not The Hooded Man, and he knew it, why would he have made this false claim? Why would he have printed business cards with a drawing of The Hooded Man displayed next to his name? Did he see it as a business opportunity, as well as an opportunity to speak out against American policies in Iraq?

Human rights workers and prisoners needed a spokesperson to dramatize the growing evidence for abuses at Abu Ghraib and at other U.S. military prisons around the world. The Hooded Man was an ideal candidate—a living symbol of abuse. An icon. Susan Burke and the Center for Constitutional Rights had filed a class-action suit on behalf of Qaissi and several other named prisoners from Abu Ghraib. Qaissi had suffered at Abu Ghraib, and he had an interest in being heard. This is not to say that he or

anyone else was involved in conscious fraud. But it is to say that there were pressures on everyone to believe that Qaissi was the man under the hood. For the lawyers, he was the centerpiece of litigation against torture at Abu Ghraib. For journalists, he presented the opportunity, on a date approaching the two-year anniversary of the release of the photographs, to tell the real story behind the most infamous among them. For the public, his story offered the allure of a solved mystery linked to a major scandal in American history.

————

Years ago I became enamored with the writings of Norwood Russell Hanson, a philosopher and ex–fighter pilot who died at the age of forty-three while flying his own plane to a lecture engagement at Cornell. Long before Thomas Kuhn's paradigms and Michael Polanyi's tacit knowledge, Hanson pioneered the idea that observations in science are not independent of theory but are, on the contrary, quite dependent on it. In his book, *Patterns of Discovery,* published in 1958, Hanson coined the term "theory-laden" and wrote: "There is more to seeing than meets the eyeball." Hanson had taken these ideas in part from Wittgenstein. In *Philosophical Investigations,* Wittgenstein uses a gestalt figure called the duck-rabbit, which can be seen either as a duck or a rabbit. The rabbit is facing right and the duck is facing left.[2]

ILLUSTRATION #49
RABBIT/DUCK PROFILE

To use the familiar gestalt image of the duck-rabbit: if we believe we see a rabbit, we see a rabbit. If we believe we see a duck, we see a duck. But the situation is even worse than the Gestalt psychologists imagined. Our beliefs can completely defeat

sensory evidence. If we believe that we see The Claw in the photograph, then we see The Claw in the photograph, even though all we are looking at is a hooded man draped in a blanket, standing on a box, with only his legs and hands visible. The left hand might look disfigured, but the photograph has been taken with a low-resolution digital camera that provides limited evidence one way or the other. That we believe The Claw to be the man in the photograph does not mean he is the man in the photograph. Our beliefs do not determine what is true or false. They do not determine objective reality. But they can determine what we "see."

There is yet another wrinkle to this. From this complex story about a photograph, its interpretation and reinterpretation, emerges another photograph and another story. The photograph of Qaissi holding the photograph of The Hooded Man. A photo of a photo. This photograph was the final piece of evidence in Qaissi's claim to be The Hooded Man, even though it had no evidentiary value. Sadly, the new photograph for the *Times* also retained the same ambiguity, the same problematic lack of information, as the original photograph.

Take another look at the photograph that appeared in the *Times*. The Claw is seen standing holding the iconic photograph, but only his right hand is visible. His left hand is framed out of the photograph. His deformed hand is hidden. Intentionally? Unintentionally?

ILLUSTRATION #50
ALI SHALAL QAISSI PHOTO

The *Times* photographer who took the shot could have helped me sort through these possibilities, but he declined to be interviewed, insisting when I reached him by phone in Cairo that the photograph was a "false" photograph and that he didn't want to discuss it. I tried to reassure him. There was nothing false about the photograph. The photograph is simply a photograph of Qaissi holding a photograph of The Hooded Man, which is neither true nor false. "Yes," I told him, "there was something false about Qaissi's claim that he was the man under the hood, but the photograph itself is not making that claim. The photograph is just a photograph."

I asked Hassan what he remembered about the photo shoot.

> **HASSAN FATTAH:** Although we took frames of his hand, Qaissi had sought to keep his hand out of the frame in this photo, as I remember it. It was as if he had the image and the shot already orchestrated in his mind.

Was there a conscious decision made to crop the photograph, or to frame the image in such a way as to leave out the left hand? Or was it something subtler, possibly intangible? Presumably, many photographs were taken, and this photograph was chosen because the image is more powerful, more mysterious, without the hand. Quite often photographs gain power from what is omitted from the frame rather than from what is included. This one leaves the question of what Qaissi's "claw" might look like open to the imagination.

But framing out the left hand from the photo merely aids and abets the mystery. As such, the photograph should be a constant reminder—not of how photographs can be true or false—but of how we can make false inferences from a photograph. Photography presents things and at the same time hides things from our view, and the coupling of photography and language provides an express train to error.

The nickname is part of the problem. Like many of the names given to prisoners at Abu Ghraib by the MPs who guarded them, "The Claw" recalls characters from American popular culture—comic books, television, movies. The name conjures up an image of a seriously deformed hand—a pincer or worse. And because we have no picture of the claw itself, we are free to imagine anything from a broken finger that didn't heal properly to a horribly disfigured, well, claw. These imaginings are based on seeing nothing and imagining everything.

ILLUSTRATION #51
"THE CLAW" BACK OF JUMPSUIT

When my friend Charles Silver finally saw the photograph below of Qaissi's actual hand, he was disappointed. He felt it wasn't really a claw, and that he had been misled. He suggested that The Claw's hand was not shown in the original article because readers might have concluded that he was an impostor, based on the comparative normalcy of the hand.

ILLUSTRATION #52
"THE CLAW" LEFT HAND

Qaissi was given the nickname by Hydrue Joyner, the staff sergeant who supervised the day shift that guarded prisoners on Tier 1A at Abu Ghraib.

I spoke with Sgt. Joyner about The Claw:

> **ERROL MORRIS:** And The Claw? How did he get his name?
>
> **HYDRUE JOYNER:** The Claw? Dr. Claw. Oh, yeah, Dr. Claw. I don't know if you ever saw that movie, *Scary Movie: Part 2,* where the guy had the hand and everything? He had a hand just like that. I couldn't think of anything else but Dr. Claw. That wasn't my fault. I work with the material that I have, and he just provided material for me, so that's how he ended up with the name "Dr. Claw."
>
> **ERROL MORRIS:** Are you the one responsible for naming all these people?
>
> **HYDRUE JOYNER:** Yes, it's my fault. I named all of them. And it came to a point where because of the nicknames I gave them, we were able to identify them a lot easier than Detainee #67328. It got to a point where I would call them by their nickname and they would answer, "Yes, here." So it became a popular thing. The detainees liked it. I tried to make it somewhat entertaining. It was still jail but you can still laugh in jail. It's not a crime, I hope.

Sergeant Joyner also had a nickname for Detainee #18470, whose real name was Abdou Hussain Saad Faleh. He called him "Gilligan" because he was so skinny. (I continue to use the nicknames—The Claw and Gilligan—not out of disrespect for the prisoners involved but because the nickname is an essential part of the story of misidentification.) Gilligan is the real Hooded Man.

While working on *Standard Operating Procedure,* a film about the infamous photographs of Abu Ghraib, I interviewed many of the MPs who were involved. Principal among them was Sabrina Harman, who had taken some of the Hooded Man photographs. Sabrina offered considerable evidence that Gilligan was the real Hooded Man.

Sabrina remembers both The Claw and Gilligan vividly. She photographed both of them on the same night. Gilligan, as his name implies, was slight of build. The Claw was heavyset. There was no doubt in Sabrina's mind. "Gilligan was on the box," she told me, "not The Claw." The Claw was her prisoner, and he was not put on a box, nor attached to wires. According to Sabrina, "The Claw weighed over three hundred pounds. If The Claw had been put on an MRE [Meals Ready to Eat] box, he would have crushed it." For me this is one of those telling little details that give her account the ring of truth.

But both The Claw and Gilligan were interrogated in the same area of Abu Ghraib, Tier 1A, on the night that the Hooded Man photographs were taken. *Salon* reported

on an e-mail from Qaissi: "I have seen at least two pictures showing this dreadful experience. . . . One is me. The other I believe could be Saad because he went before me to the area I had to go, where I was to be interrogated."

There are multiple photographs taken on November 3, 2003, on Tier 1A, Abu Ghraib—the night of the Hooded Man photograph. Both *Salon* and I had copies of these photographs, which were collected by the Criminal Investigation Division (CID) of the U.S. Army for use in the varied courts-martial related to the Abu Ghraib abuse photographs. I don't believe the *Times* had a copy prior to the publication of its story.

In the photograph below, you can clearly see that The Claw is fully clothed in an orange jumpsuit, which has been labeled on the back in black Magic Marker "The Claw" above a crude caricature of a deformed hand. He is shown to be stocky and made to kneel on the floor, not stand on a box. The detail photograph of his hand was taken the same night as he was apparently made to proffer it.

ILLUSTRATION #53
"THE CLAW" BACK OF JUMPSUIT, FULL BODY

Gilligan, by contrast, is hooded and wearing only a black blanket or poncho. He's photographed from different angles and by different cameras. There are two (virtually identical) "iconic" photographs of The Hooded Man taken within one second of each other by Sergeant Ivan Frederick with a Deluxe Classic Cam.[3] Both of these photographs are comparatively low-resolution: 640 × 480 (0.3 megapixels) and were taken without a flash. (Since they are virtually identical—the second one seems to be only slightly panned to the right—I will write about them as essentially one photograph.)

ILLUSTRATION #54
EXIF FILE PHOTO D-20

Photo D-20
Camera Make: Mercury Peripherals Inc.
Camera Model: Deluxe Classic Cam
Camera Date/Time: 2003.11.05 00:01:18
Baghdad Date/Time: 2003.11.04 23:01:18

ILLUSTRATION #55
PHOTO D-20

Will the Real Hooded Man Please Stand Up?

ILLUSTRATION #56
EXIF FILE PHOTO D-21

Photo D-21
Camera Make: Mercury Peripherals Inc.
Camera Model: Deluxe Classic Cam
Camera Date/Time: 2003.11.05 00:01:19
Baghdad Date/Time: 2003.11.04 23:01:19

ILLUSTRATION #57
PHOTO D-21

And then there is a wide-angle shot of Gilligan on the box taken by Sabrina Harman. Sergeant Ivan Frederick, who took the two previous pictures, is standing on the right side of the frame. This photograph was taken approximately three minutes later with the FD Mavica, which has a much higher resolution: 1280 × 1600 (2.0 megapixels, more than six times the resolution of the iconic photographs), and was taken with a flash.

ILLUSTRATION #58
WIDE-ANGLE BY HARMAN

For me, it is by far the more interesting photograph. It shows Frederick looking at the picture he has just taken—a picture that was destined to become a photograph seen around the world. What is he thinking? It is unlikely that he imagined this image printed in newspapers and displayed on computer screens everywhere. We are looking at the photograph of Frederick looking at his photograph of The Hooded Man with The Hooded Man in the background.

Such a photograph would have been impossible during World War II, when professional photographers like Joe Rosenthal were covering the war. Rosenthal never even saw his photo of the flag raising at Iwo Jima until it made the papers. The Hooded Man is a radically modern image, insofar as it shows someone looking at an image instantaneously displayed on a digital camera screen while the "reality" behind that image is seen clearly next to him.

I have often wondered why it was Frederick's photograph, and not Sabrina Harman's photograph, that became iconic. (It is even possible to create a facsimile of Frederick's photograph by cropping Harman's, save that Frederick's is in portrait mode and Harman's in landscape mode, and there is more "room" under the box in Frederick's photograph. Also, there is a soft shadow behind The Hooded Man in Frederick's photo, a hard shadow behind Frederick in Harman's photo.) My belief is that Harman's photograph is more complicated and requires context. Who is that man standing on the right of the frame? He seems disengaged. What is he doing? When I interviewed Lieutenant Colonel Steve Jordan,[4] who was the director of the Joint Interrogation and Debriefing Center (JIDC) at Abu Ghraib, he described the picture to me as a picture of Sergeant Frederick clipping his nails. It was only after I explained to him that Frederick was looking at the photograph he had just taken that Jordan realized he had misinterpreted what he was looking at. It makes a big difference. In

one version Frederick is indifferent to the scene next to him; in the other, he is contemplating his image of it—an image that he saw the need to record and preserve.

Frederick's picture—the one that became iconic—has no one else in the frame. It is stripped of context, like the gestalt duck-rabbit, ambiguous and open to interpretation.

Photographs attract false beliefs the way flypaper attracts flies. Why my skepticism? Because vision is privileged in our society and our sensorium. We trust it; we place our confidence in it. Photography allows us to uncritically think. We *imagine* that photographs provide a magic path to the truth.

What's more, photographs allow us to think we know more than we really do. We can imagine a context that isn't really there. In the pre-photographic era, images came directly from our eyes to our brains and were part of our experience of reality. With the advent of photography, images were torn free from the world, snatched from the fabric of reality, and enshrined as separate entities. They became more like dreams. It is no wonder that we really don't know how to deal with them.

ILLUSTRATION #59
HOODED MAN THROUGH DOORWAY

The *New York Times*'s public editor, in his March 26, 2006, article about the misidentification, suggested that lack of research was the problem.

He focused on the evidence in the archives of his own paper:

> Embarrassingly, evidence to prevent the whole mess was in The *Times*'s archives. In an article on May 22, 2004, the paper had correctly identified the man in the photograph as Abdou Hussain Saad Faleh. Ethan Bronner, deputy foreign editor, wrote to me in an e-mail that editors had done several searches of the paper's archives using various keywords. He said editors now realize that one search—using the terms "Abu Ghraib," "box" and "hood"—missed the crucial May 2004 article because it didn't contain the word "hood."
>
> My test of the same three search words last week, however, turned up two *Times* articles from last year reporting that the man in the famous photograph had been called "Gilligan" by guards at Abu Ghraib. Mr. Qaissi, according to the March 11 story, had been nicknamed "Clawman." The contradictory nicknames, it seems to me, should have spurred more intensive search efforts and raised an overall caution flag.
>
> Mr. Bronner disputes the value of the two stories with "Gilligan" references. He said editors had come across at least one of them in their searches, but hadn't considered it significant. Among other things, he said, it wasn't clear then that Mr. Qaissi had only one nickname.

The detail about the extra search term "hood" obscuring "the crucial May 2004 article" is telling. It wasn't that the article was overlooked. Bronner says they saw the "Gilligan" reference but "hadn't considered it significant." I would suggest it was because Bronner already believed that the photo of Qaissi was The Hooded Man. And so he turned to a clunky, speculation-laden theory—that The Hooded Man was called both "Clawman" (or "The Claw") and "Gilligan"—rather than questioning his belief in Qaissi's story.[5]

But the failure to look at certain kinds of evidence may be explained by the belief that a proof had already been offered, that there was already enough evidence to make the case. Yes, there was archival material that could have cast suspicion on the claim that The Claw was also The Hooded Man. But the mistaken identification was driven by The Claw's own desire to be the iconic victim, to be The Hooded Man, and our own need to believe him. It is an error engendered by photography and perpetuated by us. And it comes from a desire for "the ocular proof," a proof that turns out to be no proof at all. What we see is not independent of our beliefs. Photographs provide evidence, but no shortcut to reality. It is often said that seeing is believing. But we do not form our beliefs on the basis of what we see; rather, what we see is often determined by our beliefs. Believing is seeing, not the other way around.

When the *Times* identified The Hooded Man, it provided the solution to a mystery—a who-is-under-it, rather than a whodunnit. But the *Times* piece also allayed our fears and perhaps assuaged our collective guilt about what happened to The Hooded Man. Perhaps there was a collective sigh of relief when we learned that he survived. Perhaps there was a sense that we could put all this behind us. The Hooded Man served a need.

But if The Claw isn't The Hooded Man, the mystery reopens and the guilt and the horror resume. If The Claw isn't The Hooded Man, we have to face again what the American military did to prisoners in their custody. If The Claw isn't The Hooded Man, whose account are we listening to? [6]

Gilligan was interviewed by CID on January 16, 2004, shortly after the investigations into prisoner abuse began. His unsigned statement was translated and later included in the report issued by the Taguba Commission, the military body formed after abuse charges surfaced to investigate detention and internment operations at Abu Ghraib.[7] The report did not include a statement by Detainee #151716 (Qaissi, aka The Claw) nor was I able to find one elsewhere. This is Gilligan's statement as it appears in the report issued by the commission:

TRANSLATION OF STATEMENT PROVIDED BY
Abdou Hussain Saad Falah, Detainee #18470, 1610/16 JAN 04:

On the third day, after five o'clock, Mr. Grainer [*sic*] came and took me to Room #37, which is the shower room, and he started punishing me. Then he brought a box of food and he made me stand on it with no clothing, except a blanket. Then a tall black soldier came and put electrical wires on my fingers and toes and on my penis, and I had a bag over my head. Then he was saying "which switch is on for electricity." And he came with a loudspeaker and he was shouting near my ear and then he brought the camera and he took some pictures of me, which I knew because of the flash of the camera. And he took the hood off and he was describing some poses he wanted me to do, and I was tired and I fell down. And then Mr. Grainer [*sic*] came and made me stand up on the stairs and made me carry a box of food. I was so tired and I dropped it. He started screaming at me in English. He made me lift a white chair high in the air. Then the chair came down and then Mr. Joyner took the hood off my head and took me to my room. And I slept after that for about an hour and then I woke up at the headcount time. I couldn't go to sleep after that because I was very scared.

This statement is an important reminder that there was a *person* under that hood and that something horrible happened to him. The photograph of Faleh should not be viewed as just some image devoid of context to be taken up by any abused prisoner. It is important to remember that Faleh's existence continues outside the frame of the photograph. He is a *real* person.

ILLUSTRATION #60
HOODED MAN 2 (REPEAT OF FIRST)

My staff and I spent a good part of a year trying to find Faleh. He had disappeared without a trace. All that remains is his statement to CID and this photograph of a single, seemingly anonymous hooded figure. The photograph of The Hooded Man has created its own iconography and its own narrative. It has become the iconic image of the Iraq War in the West. But, as Hassan Fattah pointed out to me, "You have to realize that what we in the West think is the iconic image of Abu Ghraib, it's the man on the box. But, actually in the Arab world, in the Muslim world, the iconic image is actually *her* smiling next to the dead body." Hassan Fattah is referring to the photograph of Sabrina Harman smiling and giving the thumbs-up over the body of a dead detainee. It is not surprising that the Muslim world should have a different iconic photograph of the war in Iraq. Nor is it surprising that the image is an even more potent symbol of abuse and victimization.

CHAPTER 3

The Most Curious Thing

"Well! I've often seen a cat without a grin,"
thought Alice; "but a grin without a cat! It's the most
curious thing I ever saw in my life!"

—Lewis Carroll, *Alice's Adventures in Wonderland*

"How can you say she's a good person?" I was sitting in an editing room in Cambridge, Massachusetts, arguing with one of my editors. I replied, "Well, exactly what is it that she did that is so bad?" We were arguing about Sabrina Harman, one of the notorious "seven bad apples" convicted of abuse in the Abu Ghraib scandal. My editor was becoming increasingly irritable. He looked at me as you would a child. "What did she do that is so bad? Are you joking?" And then he brought up his trump card, the photograph with the smile. "How do you get past that? The smile? Just look at it. Come on."

Questions about the smile kept coming up with great regularity as I was trying to finish my film *Standard Operating Procedure*. This photograph is one of the central images in a rogue's gallery of snapshots taken by members of the 372nd MP Brigade at Abu Ghraib in the fall of 2003. It is a photograph taken by Chuck Graner of Sabrina Harman—who is posing for, and looking directly into, the lens of the camera.

If there are lingering questions about whether one or both of the Fenton photographs was posed in my essay "Which Came First," there is no doubt that this photograph was posed. Harman has not been caught unawares; she is looking right at the camera. But here, Sabrina's pose, far from invalidating the image, only serves to heighten its horror.

ILLUSTRATION #62
SABRINA THUMBS-UP

One of the first things I questioned Sabrina about was the thumbs-up:

> **SABRINA HARMAN:** I kind of picked up the thumbs-up from the kids in Al Hilla [a
> camp where her MP brigade was stationed prior to moving to Abu Ghraib],
> and so whenever I would get into a photo, I never know what to do with
> my hands. So any kind of photo, I probably have a thumbs-up because it's
> just—I just picked it up from the kids. It's just something that automatically
> happens. Like when you get into a photo, you want to smile. It's just, I guess,
> something I did.

And, indeed, I have twenty or so photos of Sabrina—from Al Hilla to Abu Ghraib—
where she is smiling with her thumb up. For a long time, the movie contained an
edited sequence with many photographs of Sabrina—different locations, different
circumstances—all with her thumb in the air. I cut the sequence out of the final

version of the movie because I felt that by showing ten or twenty thumbs-up photographs, I wasn't really explaining that *one* photograph. It's fine to say that all ducks quack, but why is *this* duck quacking? I wanted to know why she is smiling with her thumb up in *that* photograph. It's fine for her to claim that it's her standard pose, but a problem remains: it is inappropriate to the point of being incredibly disturbing. Her explanation, "It's just, I guess, something I did," didn't satisfy me.

With Fenton's photographs, we didn't know his intentions, and scholars have spent considerable effort speculating about them. Here, I was speaking directly with one of the Abu Ghraib photographers.

I pressed Sabrina further:

> **ERROL MORRIS:** Why did you take these pictures?
>
> **SABRINA HARMAN:** It was just to say, "Hey look, it's a dead guy. We're with a dead guy." It wasn't anything—I guess we weren't really thinking, "Hey, this guy has family." It was just, "Hey, it's a dead guy, it'd be cool to get a photo next to a dead person." I mean that was it. That was the extent of that one. . . . I know it looks bad. I mean, even when I look at [the photographs], I go, "Oh Jesus, that does look pretty bad." [But] if a soldier sees somebody dead, normally they'll take photos of it. I don't know why, maybe it's a curiosity thing or if they see something odd, they'll take a photo of it. Just to say: "Look where I've been, look what I've seen."
>
> **ERROL MORRIS:** Maybe you couldn't believe it yourself?
>
> **SABRINA HARMAN:** I can't believe they murdered the guy.

Murder?

Just what happened that night? Who killed this man? Could the photograph be used in a reconstruction of the crime?

———

In "Which Came First" I was determined to reconstruct the order of the two war images, but here the consequences are far graver. It is a question of murder, not artistic integrity. Fortunately, the advent of digital photography has made the ordering of the thousands of photographs taken at Abu Ghraib—including those of Sabrina giving the thumbs-up—comparatively simple.

Embedded in every digital photograph is a hidden file, an exchangeable image file format, or Exif, filled with data about the camera make and model, a camera clock, the aperture, the exposure time, and so forth. The Exif standard was created only a few years before the Abu Ghraib digital photographs were taken, but as a result, we know a lot—almost second by second—about the photographs taken not only by

Sabrina Harman but also by several of her fellow soldiers, including Sergeant Ivan "Chip" Frederick and Specialist Charles "Chuck" Graner, on the night of November 4 and the morning of November 5, 2003—the night the thumbs-up photo was taken. We know a lot because the Exifs were used by CID photo expert Brent Pack to create a timeline of the events of that night. Pack identified Harman's camera as a Sony Cybershot, Frederick's camera as a Mercury Peripherals Deluxe Classic Cam, and Graner's camera as a Sony FD Mavica. He then synched the time clocks from the three camera clocks and related them to Baghdad time. Pack's timeline tells us not only the order of the photographs but also the precise moment each was taken.

Just as the presumed (and actual) order of the Fenton photographs encouraged us to ask questions about the intentions of the photographer, the actual order of the Abu Ghraib photographs encourages us to ask questions about Harman's motivation. What was she doing? What was she thinking? What was her complicity? Or even her possible culpability in the man's death? Certainly this was of interest to the military prosecutors who brought Sabrina Harman, Chip Frederick, and Chuck Graner to trial.

Unlike the Fenton photographs, where there was a lack of supporting documentation, the Abu Ghraib photos are accompanied by a wealth of related materials. There are the statements from Harman, Graner, and Frederick to CID and to the Taguba Commission; testimony taken under oath during the various court-martials; and interview material assembled during the making of my film *Standard Operating Procedure.*

This is what we know.

It was a busy night with several new detainees being brought in and processed, including Gilligan and The Claw. There was a bad smell and water leaking under the door of the locked shower room on Tier 1A. Graner and Harman, who worked the night shift, got the key from Sergeant Frederick, the NCOIC (noncommissioned officer in charge), opened the door, turned on the lights, and almost immediately started taking pictures.

The first photograph was taken at 11:32:07 p.m. It was of the black plastic body bag: a nondescript image that doesn't show the body, just the bag on the floor. We really don't know what we're looking at. Six photographs of the corpse follow (first, three more of the bag, then three of the face, including one close-up at 11:34:58 p.m.). These photographs are followed by Sabrina's smiling photograph and by a "companion" photograph of Graner, also smiling with his thumb up. Twin photographs of each other. Graner took the photograph of Sabrina at 11:35:48 p.m.; Sabrina took the photograph of Graner at 11:38:00 p.m., about two minutes later, using Graner's camera, the FD Mavica.

ILLUSTRATION #63
TIMELINE OF AL-JAMADI PHOTOGRAPHS

Photo C-5
Camera Make: SONY
Camera Model: CYBERSHOT
Camera Date/Time: 2002:02:03 12:03:07
Baghdad Date/Time 2003:11:04 23:32:07

Photo C-8
Camera Make: SONY
Camera Model: CYBERSHOT
Camera Date/Time: 2002:02:03 12:05:50
Baghdad Date/Time 2003:11:04 23:34:50

Photo C-10a
Camera Make: SONY
Camera Model: CYBERSHOT
Camera Date/Time: 2002:02:03 12:06:39
Baghdad Date/Time: 2003:11:04 23:35:39

23:32:07

23:34:50

23:35:39

23:30:00 23:35:00 23:40:00 23:45:00

ILLUSTRATION #64
GRANER WITH AL-JAMADI

The Most Curious Thing

The picture of Sabrina is much better known and more appalling because it shows a young, pretty woman with a corpse. There is a sexual element that is hard to ignore in many of the Abu Ghraib photographs.

Did Graner ask Sabrina to pose for the thumbs-up photograph, and then ask Sabrina to take a photograph of him posing in the same way? Or was it the reverse: did Sabrina ask Graner to take a picture of her posing with her thumb up, and then offer to do the same for him? Does it matter? Did they reflexively take turns photographing each other as they had in many other situations? Surely photography must have provided relief from the tedium as well as the horror. The pictures in the shower room were taken over a short amount of time, barely six minutes, between 11:32 p.m. and 11:38 p.m.

Sabrina returned with Ivan Frederick, her commanding officer, almost two hours later. This time, she is in the shower room from 1:18 a.m. to 1:24 a.m. The photographs that she took during this second visit to the shower room are in contrast to the smiling thumbs-up photograph taken during the previous visit. These are detailed forensic photographs—close-ups of the dead man's face and his thumb. And in her last photograph, taken at 1:21:43 a.m., she removed the bandage from the dead man's eye, so she could photograph the large cut underneath. These, unlike the thumbs-up photographs, are relatively unknown—even though they provide unmistakable evidence of the gruesome treatment the man had received: broken teeth, a mangled lip, contusions, bruises, the cartilage of his nose crushed, a gash under his right eye.

The timeline of the photographs suggests a view of Sabrina's motivation. These are *not* photographs taken out of boredom. She is there to photograph evidence.

ILLUSTRATION #65
TIMELINE OF HARMAN EVIDENCE PHOTOS

Photo C-13
Camera Make: SONY
Camera Model: CYBERSHOT
Camera Date/Time: 2002:02:03 13:49:14
Baghdad Date/Time 2003:11:05 01:18:14

Photo C-16
Camera Make: SONY
Camera Model: CYBERSHOT
Camera Date/Time: 2002:02:03 13:49:53
Baghdad Date/Time 2003:11:05 01:18:53

Photo C-19
Camera Make: SONY
Camera Model: CYBERSHOT
Camera Date/Time: 2002:02:03 13:51:42
Baghdad Date/Time 2003:11:05 01:20:42

01:18:14 01:18:53 01:20:42

00:20:00 00:40:00 01:00:00 01:20:00

Here is Sabrina Harman's account of the evening of November 4:

SABRINA HARMAN: When we got to the prison, Captain Brinson [Captain Christopher Brinson and Captain Donald Reese were the two MP officers in charge] had a meeting in the main office with all of us.[1] He said there was a prisoner who had died in the shower, and he died of a heart attack. And he told us that he was on ice, and he was in the shower in Tier 1B. That was pretty much it for that. And then we went upstairs. Sergeant Frederick got the key and we just checked him out and took photos of him. Kind of realized right away that there was no way he died of a heart attack because of all the cuts and blood coming out of his nose.

I asked Sabrina whether it was clear from the beginning that it was a homicide.

SABRINA HARMAN: It took a while. Like, you started undoing the bandages and looking closely. Like, you see his knees were bruised; his thighs were bruised [around] his genitals. He had restraint marks on his wrists. What else? You had to look close. They did a really good job cleaning him up. I mean, he had ice all over his body, so unless you removed things, you couldn't really see the actual physical damage that they had done.

And then:

SABRINA HARMAN: You don't think your commander is going to lie to you about something, first of all. And then you realize, wait, maybe he did lie because there's no way somebody would die of a heart attack and have all these injuries. It just didn't add up.

The Brent Pack timeline resolves ambiguities about the order of the photographs, but it still leaves many questions unanswered. We now have a chronology of what happened between 11:00 p.m. on the night of November 4 and 2:00 a.m. on the morning of November 5, but we still don't know anything about where the body came from. Who is this man? How did he end up in the shower room on Tier 1B at Abu Ghraib? How did he die? Who killed him? And why?

————

The real story behind the photograph starts a little over a week before it was taken, on October 27, 2003.[2] Two Iraqi employees of the International Committee of the

Red Cross (ICRC) were killed in a bomb explosion outside the organization's office in Baghdad. Very early in the morning on November 4, 2003, a group of Navy SEALs (an acronym for SEa, Air, and Land) apprehended Manadel al-Jamadi. He was suspected of having provided explosives for the October 27 bombing.

The SEALs didn't bring al-Jamadi to Abu Ghraib immediately. First, he was brought to Camp Pozzi, a notorious interrogation center adjacent to the Baghdad International Airport. Camp Pozzi was operated by the SEALs, but was also used by the CIA. Several hours later he was moved to Abu Ghraib.[3]

Enter OGA, aka the CIA . . .

Abu Ghraib is in the middle of the Sunni Triangle, essentially a Baghdad suburb that is a battleground for the insurgency. Mortar rounds were lobbed into the prison compound on a daily basis, sometimes many times a day. After two soldiers were killed in September by a mortar attack, most soldiers avoided taking showers in the outdoor facilities. It was just too dangerous. Prisoners in the tent compounds ringed with razor wire were not so fortunate. Sleeping on dirt, deprived of adequate food and water, they had nowhere to go. There were frequent riots and the illegal use of lethal force was not unheard of. Essentially, the U.S. military at the behest of the Defense Department had created a de facto concentration camp outside of Baghdad. That the United States could have created such a prison—more than the abuses depicted in the photographs—represents to me an unforgivable failure of our American democracy.

The prison was also a battleground in a military turf war: MPs (military police) versus MIs (military intelligence), and military personnel versus nonmilitary contractors such as CACI interrogators and Titan interpreters.[4] There were rules for MPs, rules for MIs, rules for CACI and Titan contractors, but most significantly, one principal rule: stay out of other people's way, particularly OGA. OGA was the acronym for Other Government Agencies. It could stand for FBI, CID, or DIA (and sometimes Task Force 121), but it was mostly reserved for the CIA. (Not surprisingly, there was even an acronym for this group of acronyms: TLAs—three-letter agencies.)

OGA could also refer to the detainees or prisoners of the other government agencies. The OGA prisoners were not logged into the system; they had no identification numbers. The fact that they were not even logged into the system made them officially "not there," even though they were as physically present as any other prisoner. Yet another term captures their status of "being there" and "not being there"—they were called ghosts. And to make things more confusing, there were ghost detainees and also ghost interrogators.

Sergeant Hydrue Joyner, the noncommissioned officer in charge on the day shift, sums it up:[5]

> **HYDRUE JOYNER:** When I first got there [to Abu Ghraib] and they first told me about OGA, I'm like, "Wait a minute, you don't add these people to the actual count? Like if I have 50 detainees, but I have these five OGAs, I don't really have 55 detainees, I only have 50?" They say, "Yes." I said, "Well, what about

the five souls that are in those cells?" "They're not there." "Well, yes they are, because I can see them." "Yeah, you can see them, but they're not there." "All right man, hey, whatever works for you, whatever makes you sleep at night, okay." And that's how we ran it because that's what we were told.

When the Navy SEALs brought their OGA—al-Jamadi—to Abu Ghraib, he was placed first in a holding cell on Tier 4B, interrogated, and then taken to the shower room on Tier 1B, adjacent to Tier 1A, the soon-to-be notorious hard site. It was called the "hard site" because it was one of the first permanent buildings constructed at Abu Ghraib. This is the tier where most of the prisoner-abuse photographs were taken. Certain details about what happened early that morning are well known from various investigations and reports. Here are two important facts: (1) al-Jamadi walked into the shower room under his own power, and (2) one hour later al-Jamadi was dead.

What happened to him?

We know what happened initially from the accounts of three MPs: Staff Sergeant Mark Nagy, Specialist Jason Kenner, and Sergeant Walter (Tony) Diaz. Here is the statement of Specialist Jason Kenner, MP, who escorted al-Jamadi to the shower room on Tier 1B:[6]

I was assigned as the runner of tier 1B of the "hardsite" at Abu Ghraib Prison. . . . At approximately 0430–0500 hrs, a person from OGA came to the office located near the intake point of tier 4B and advised me that they had a prisoner. . . . The prisoner did not appear to be in distress. He was walking

fine and his speech was normal. SSG NAGY and SGT DIAZ were in and out of the area when the prisoner was brought in. Within minutes of placing the prisoner in the holding cell, the translator and interrogator began to yell at him. They were yelling at the prisoner to find where some weapons were. The prisoner was responding to the yelled questions in Arabic but I could not understand what he was saying. . . . *I could see the prisoner in the corner of the cell in a seated position like a scared child* [italics mine] with the translator and interrogator leaning over him yelling at him. . . . The OGA personnel then advised SSG NAGY and myself to "take the prisoner to tier one." Upon this request we placed the prisoner in an orange jumpsuit, handcuffed his hands behind his back and shackled his feet. We used steel handcuffs and shackles to secure the prisoner. At this time I did *not* see any injuries on the prisoner.

Al-Jamadi was left alone in the shower room of Tier 1A with a CIA interrogator, Mark Swanner (described by several MPs as "short and fat") and a CIA translator, identified in various reports as Clint C.[7] Al-Jamadi was put in a stress position, a "Palestinian hanging"—a low-budget crucifixion without the nails. His wrists were handcuffed behind him and then the handcuffs were suspended from a window frame.[8] As the prisoner becomes weaker and weaker, greater and greater pressure is put on his arms, potentially pulling them out of the sockets.

Approximately one hour went by.

It was now about 7:00 a.m.

Swanner called for assistance.[9] Al-Jamadi was "playing possum" and Swanner wanted him tied "a little higher." Three MPs on the tier, Sergeant Dennis Stevanus, Sergeant Walter (Tony) Diaz, and Specialist Jeff Frost, were called in to help out.

WALTER (TONY) DIAZ: So we lifted him a little higher, and then he sags again. So I told the OGA guy [Swanner], "You know, there's something wrong here. . . ." So I kind of came close and trying to hear his heart. I didn't hear anything. No pulse, no nothing. . . . So that's when I raised the hood and that's the first time I saw his face. I was surprised because his face was totally messed up. He's got huge black eyes with bruises everywhere. I was like, "Whoa, what happened to this guy?"

We kind of like put him down to the floor. As soon as he got to the floor, all his blood just came out of his mouth, his ears and everything. And that's when I knew, "Okay, this guy is gone. . . ." We just look at each other and we were like—it was kind of like a silence for a while. We were like, what just happened here? And I look at him and I told him, "Hey listen, this is on you guys. I don't know what you guys did to him, but, you know, this guy is dead." And then that's when the OGA guy went and got his phone and started calling his people.

More CIA officers arrived. Sergeant Stevanus, one of the other MPs in the room, recalled: "After we found out he was dead, they were nervous; they didn't know what the hell to do. The short, fat OGA guy said, 'No one's ever died on me before when I interrogated them.'"[10]

The top brass at the prison—Captain Christopher Brinson (MP), Captain Donald Reese (MP), and Lieutenant Colonel Steve Jordan (MI)—arrived and a heated discussion ensued as what to do next.[11] Jordan soon notified Colonel Pappas, the commander of the prison. Pappas made it clear that he wasn't going to take the fall for what amounted to the death of an OGA prisoner.[12] No one wanted to be implicated. Al-Jamadi became the proverbial hot potato, passed quickly from one person to another, until he could finally be disposed of.

Sergeant Hydrue Joyner, the NCOIC on the day shift at Tier 1A, described the scene as a version of the movie *Weekend at Bernie's*, where two sad-sack employees pretend that their murdered boss is still alive so that they can avoid being implicated in his death. Indeed, when al-Jamadi was finally entered into the prison log book on November 5, 2003, he was simply identified as "Bernie."[13]

ILLUSTRATION #67
MP LOGBOOK 2

Soon the body started to smell. By midafternoon, a decision was made to pack him in a body bag, ice him down, and lock him in the shower room overnight while the various MI and OGA officers decided what to do next.[14]

It was an odd and eventful night.[15] Sometime before 11:00 p.m., Gilligan, the Hooded Man, was brought in by a CID officer and turned over to Sergeant Frederick:[16]

IVAN FREDERICK: I, in turn, looked over on 1 Bravo side and I seen Agent Romero [CID] over there. So I asked him, I went over and talked to him and I asked him what was going on with this particular detainee, and he told me

that he had some valuable intelligence about the remains of four American soldiers and who possibly killed them. So I said, "Well, what do you want done to him?" He said, "I really don't give a fuck, just as long as you don't kill him."

The agent's comment becomes even more chilling because it was made on the same day that al-Jamadi was killed. It also should be noted that when the photographs were finally turned in to investigators in January 2004, it was to the CID, the same agency implicated in the prisoner abuse of November 2003.

Sergeant Frederick continues:

IVAN FREDERICK: So, then I went over and I just stood there and looked at him for a while. I seen these wires hanging from the wall inside the shower. I walked by them many times, so I just took one and wrapped it around his finger.

Frederick, Harman, and Graner all took photographs. It was 11:01 p.m.

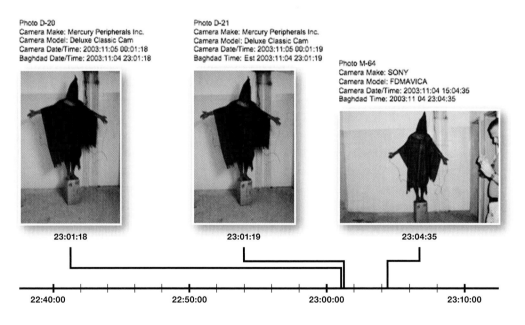

ILLUSTRATION #68
TIMELINE OF HOODED MAN PHOTOS

Photo D-20
Camera Make: Mercury Peripherals Inc.
Camera Model: Deluxe Classic Cam
Camera Date/Time: 2003:11:05 00:01:18
Baghdad Date/Time: 2003:11:04 23:01:18

Photo D-21
Camera Make: Mercury Peripherals Inc.
Camera Model: Deluxe Classic Cam
Camera Date/Time: 2003:11:05 00:01:19
Baghdad Time: Est 2003:11:04 23:01:19

Photo M-64
Camera Make: SONY
Camera Model: FDMAVICA
Camera Date/Time: 2003:11:04 15:04:35
Baghdad Time: 2003:11 04 23:04:35

23:01:18 23:01:19 23:04:35

22:40:00 22:50:00 23:00:00 23:10:00

Harman and Graner got a key to the Tier 1B shower room from Sergeant Frederick and let themselves in. It was now 11:32 p.m. Harman and Graner then took the two thumbs-up photographs with the corpse of al-Jamadi. This is where we entered the story.

ILLUSTRATION #69
THUMBS-UP COMPARISON

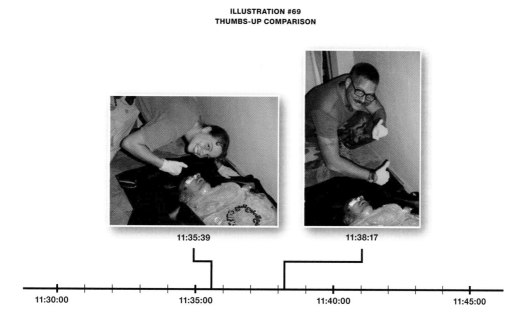

11:35:39 11:38:17

11:30:00 11:35:00 11:40:00 11:45:00

November 5, 2003. The morning following al-Jamadi's death, MI and OGA finally came to some agreement: the corpse was wheeled out on a gurney with an IV in its arm.[17] Ostensibly, the reason for the subterfuge was to prevent a riot—to fool the prisoners into thinking that this was a medical emergency rather than a murder. But clearly, the deception was not just for the prisoners. Soldiers were lied to as well.[18]

An examination of the evidence, photographic and otherwise, supplied by Sabrina Harman and Brent Pack makes the muddy picture of what happened to al-Jamadi far clearer. OGA committed a murder and covered it up.

An autopsy was done several days later, but a full report didn't appear for several months. It was only after the Abu Ghraib photographs were leaked to the army's Criminal Investigation Division that the CID, the CIA, the OIG (Office of Inspector General), and the NCIS (Naval Criminal Investigative Service) started a joint investigation. Eventually the death of al-Jamadi was also taken up by the various military and civil commissions set up to investigate the abuses at Abu Ghraib.

There was not one investigation into the abuses at Abu Ghraib, but multiple investigations blending one into the other—all assigned a little piece of the puzzle. There were investigations by Congress, by the military, and by the Department of Defense. Major General Taguba was asked to examine the MPs but go no further (although,

he did go further and was eventually censured by the military for having done so).[19] Major General Fay and Lieutenant General Jones examined MI operations.[20] Lieutenant General Schmidt and Brigadier General Furlow examined detainment operations at Guantánamo. The Schlesinger Report investigated Department of Defense detainment operations at Abu Ghraib. The Green Report looked into possible wrongdoing by the upper-level command in Baghdad. And so on and so forth. Thirteen government reports in all.[21]

The investigations created a blizzard of paper but failed to answer the fundamental question: "Who is responsible for al-Jamadi's death?"

So many different groups were involved—SEALs, CIA, MPs. Perhaps it was CIA interrogator Mark Swanner and Clint C, his translator. Perhaps the SEALs broke his ribs, and those injuries were exacerbated by, and in turn aggravated, the effects of the Palestinian hanging. Or was it some ill-defined combination of all the injuries? And how do you parcel out the blame? We don't even know whether al-Jamadi was guilty of anything. Could it be that he was just unlucky?

Commander Joe Hodge, the deputy chief medical examiner for the Armed Forces Institute of Pathology (AFIP), concluded in his January 2004 report on al-Jamadi's death that "the manner of death is homicide."[22]

Specifically, Dr. Hodge was asked whether the injuries al-Jamadi sustained—broken ribs, contusion to the lung, etc.—would have eventually resulted in his death, absent undergoing interrogation(s). Hodge's response is quoted in a "Memorandum for the Record," dated June 18, 2004, by Clifford Nivling, Office of Inspector General Special Investigator. Hodge concluded that the position in which al-Jamadi was placed for interrogation at Abu Ghraib prison, together with the hood placed over his head, was "part and parcel of the homicide." He explained that the pulmonary injuries al-Jamadi sustained were "not enough" to cause his death. Dr. Hodge said he recently reviewed the case with his colleagues at AFIP and they agreed that the pulmonary injuries al-Jamadi received most likely did not result from the multiple punches reportedly received while being subdued by U.S. Navy SEAL Team 7 (ST-7) personnel. He said that punching would have resulted in external contusions to the body, which were not evident. Dr. Hodge said al-Jamadi's internal injuries were more consistent with the "slow deliberate application of force," such as would have resulted from someone kneeling on his chest or holding al-Jamadi down by placing the heels of someone's boots on his chest.

According to Dr. Hodge's analysis, the Navy SEALs didn't kill al-Jamadi *or* cause the injuries that resulted in his death, and the Navy SEALs were acquitted of all charges brought against them. If, according to Specialist Jason Kenner, al-Jamadi "did not appear to be in distress" when he brought him to the shower room, then were CIA interrogator Mark Swanner and his translator responsible? To date, no one from the CIA has been charged. I have always wondered why Mark Swanner and Clint C were never prosecuted since there was a wealth of evidence pointing directly at them.

Recently declassified documents show that the Bush administration authorized torture during interrogation and provided legal protection for those involved with

"enhanced interrogation techniques."[23] Could it be that the CIA personnel involved with the death of al-Jamadi were being protected because the White House could not risk an inquiry that would threaten its secret (illegal) interrogation program?

We now know that Abu Ghraib was the center of military intelligence operations in Iraq and that there was constant communication between the White House, the Defense Department, and the officers running the Joint Interrogation and Debriefing Center at Abu Ghraib. Frank Spinner, the defense attorney for the Navy SEALs (and for Sabrina Harman), believed that the CIA personnel involved with the death of al-Jamadi were being protected at the highest levels of government. In effect, those responsible for al-Jamadi's death were "cropped" out of the photograph since their actions happened outside of the frame. They were never prosecuted.

Charges, however, were brought against Sabrina Harman in association with the death of al-Jamadi—for taking photographs of his body.

> **SABRINA HARMAN:** They tried to charge me with the destruction of government property—which I don't understand. And then maltreatment, of taking the photos of a dead guy. But he's dead, so I don't know how that's maltreatment. And then altering evidence for removing the bandage from his eye to take a photo of it, and then I placed it back. In my Article 32 [pretrial hearing], Captain Reese came out and said when he died, they cleaned him all up and then stuck the bandages on. So he was already dead when they stuck the bandages on. So it's not really altering evidence, they had already done that for me, so they had to drop that charge. So in order to make the other charges stick, they would have to bring in the photos, [and] they didn't want to bring up the dead guy at all, the OGA, because obviously they covered up a murder and that would just make them look bad, so they dropped all the charges pertaining to the OGA in the shower.[24]
>
> **ERROL MORRIS:** Didn't they charge you with interfering with evidence?
>
> **SABRINA HARMAN:** Altering evidence, yes. . . . Well, my first lawyer wanted me to plead guilty to all these, and there was no way I was going to plead guilty to any of these charges, especially that one out of all of them, especially that one, so. . . . When he died, they cleaned him all up, got the blood away and made him look all nice. And then they put the bandages in place where they were in the photos, in the first one. And then they tried to charge me with removing the bandage, taking the photo, and putting it back. And they charged me with altering evidence. . . .
>
> **ERROL MORRIS:** You were tampering with the already tampered evidence?
>
> **SABRINA HARMAN:** Guilty.

I asked Sabrina about the officers who were involved.

SABRINA HARMAN: All I know is that Captain Brinson was involved and [Lieutenant] Colonel Jordan was involved. And Captain Reese was there. . . . And then I heard from other people, the guards, how they physically put an IV in his arm and took him out on a stretcher.

ERROL MORRIS: Why would they do that?

SABRINA HARMAN: They were trying to fool the prisoners around him, thinking he was just sick.

ERROL MORRIS: Trying to fool everybody, I guess.

SABRINA HARMAN: Well, we all knew he was dead, but not how he died. That didn't come out until later. . . . They would have done a good job covering it up if the photos weren't there.

Is Sabrina a good person or a bad person? You tell me. She was part of the nightmare of abuse at Abu Ghraib, but her own act of defiance—her act of civil disobedience—was to take these photographs, to provide proof of what others were trying to deny.

But her smile still made me feel uneasy. And I was not alone. The *New York Post* headline characterized her as "The Ghoul Next Door." In the trial of public perception, Sabrina Harman was guilty. Her photographs and the photographs in which she appeared proved it. How are we to interpret her expression?

ILLUSTRATION #70
NEW YORK POST

It was because of my continuing uneasiness with the smile that I contacted Paul Ekman, professor emeritus of psychology at the University of California, San Francisco. I contacted him despite my uneasiness with "smile science." Ekman is an expert on facial expressions and has written many books, including *Emotions Revealed, Unmasking the Face,* and *Telling Lies.*[25] He also had an extremely popular television show, *Lie to Me,* on Fox. I asked him if he could explain Sabrina's smile.

I sent him a CD with over twenty pictures of Sabrina Harman, including the thumbs-up picture of Sabrina with al-Jamadi's corpse. It is labeled picture 2728.

PAUL EKMAN: In picture 2728 she is showing a social smile or a smile for the camera. The signs of an actual enjoyment smile are just not there. She's doing what people always do when they pose for a camera. They put on a big, broad smile, but they're not actually genuinely enjoying themselves. We would see movement in the eye cover fold. That's the area of the skin below the eyebrow before the eyelid. And it moves slightly down only with genuine enjoyment.

ILLUSTRATION #71
SABRINA THUMBS-UP 2

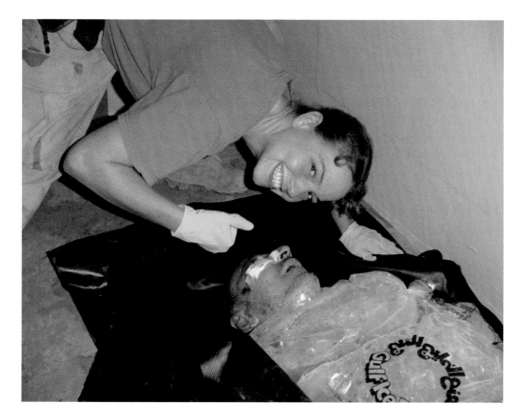

In one of her pictures I get a chance to see her with no emotion on her face. That's picture 4034. So I can see what the eye cover fold looks like when she's not smiling. And it's just the same as with the smile. That's the crucial difference between what I call a Duchenne smile,[26] the true smile of enjoyment, named after the French neurologist who first made this discovery in 1862, and the forced smile, the social smile.

ERROL MORRIS: So picture 4034 is the comparison picture?

PAUL EKMAN: Yes. That's the picture I used for comparison. She's getting something out of a box and has a black beanie on her head. Okay? If you go back to the first picture, 2728, and you look at the eye cover fold on that one, if it was an enjoyment smile, the amount of skin between the upper eyelid and the brow would be considerably reduced. We've got a lot of data on that and some published articles. It's the clue. It's a fairly subtle clue that most people don't attend to. But it's the only reliable clue that the muscle called the *orbicularis oculi pars lateralis* isn't activated. It's an involuntary muscle. It only gets activated in nearly all people when there's genuine enjoyment.

ERROL MORRIS: And you don't see that in Sabrina's smile?

PAUL EKMAN: No. It's just what people put on their face when someone's going to take a photograph of them, a big, broad smile. The crucial thing is, there's no sign that she's really feeling genuine enjoyment while this picture's being taken. Nor is there any sign that she feels any other emotion, no sign of sadness, no fear, no disgust, and no contempt. It's just a say-cheese smile.

ERROL MORRIS: It makes me think the say-cheese smile was invented just for photography.

PAUL EKMAN: Oh, no, no. People do this all the time. This is a very broad smile. It's the *zygomaticus major*. That's the muscle that pulls the lip corners up obliquely. And she's contracted it to its maximum. In the typical polite smile, the smile you give a host for a dinner party, when you're going home and telling them you really enjoyed yourself, but you didn't, you would employ the same *zygomaticus* muscle, but it wouldn't be contracted as much. It would be inappropriate to give this broad a smile for most polite-smile situations. This broad smile only occurs with genuine enjoyment or when you're posing for a camera.

ERROL MORRIS: Just once again so I can be sure I understand. You can distinguish the say-cheese smile from genuine smiling, the smile of enjoyment.

PAUL EKMAN: Absolutely. It's the absence of the *orbicularis oculi pars lateralis*. That muscle orbits the eye completely. It pulls up the cheek and it produces crow's-feet wrinkles. However, when you get a big, broad smile, like she's doing, that pushes the cheeks up anyhow. And it will produce crow's-feet wrinkles just on its own. So the only reliable clue as to whether *orbicularis oculi pars lateralis* has acted is to look above the eye. No muscle can lower that skin other than the *orbicularis oculi*. The smiling muscle, *zygomaticus*, can't affect it. So you can put on as big a smile as you want, and the cover fold skin will not come down.[27]

ERROL MORRIS: I should tell you why I'm asking all of these questions.

PAUL EKMAN: Yes, I'm curious.

ERROL MORRIS: I've just finished this movie on the Abu Ghraib photographs. And I believe that many of the photographs have been misunderstood—for many reasons and in many different ways. The picture of Sabrina Harman smiling with her thumb up above the body of an Iraqi prisoner—we know his name, Manadel al-Jamadi. People saw this picture and were horrified. They took her smile as a smile of enjoyment, a smile of pleasure.

PAUL EKMAN: So what's the explanation of why she has the smile and the thumbs-up?

ERROL MORRIS: Her explanation is that she did it all the time. People took her picture and she would have the same goofy smile and the same thumbs-up, again and again and again and again and again.

PAUL EKMAN: Well, there are a lot of them.

ERROL MORRIS: I often think about Sabrina being a woman, a gay woman in the military, trying to show that she is in command, a master of her

emotions—not cowed by her experiences but in control. Of course, when people see that photograph, they do not see Sabrina. They see the smile.

PAUL EKMAN: Well, here's what I think happens when the typical viewer looks at this picture: one, you're horrified by the sight of this dead person. Most of us haven't seen a dead person. Certainly not in that state. If you've seen a dead person, you've seen them in an open casket where they're made to look like they're alive. Do you know how the word "horror" is defined?

ERROL MORRIS: Tell me.

PAUL EKMAN: Horror, according to the *Oxford English Dictionary*, is the combination of disgust and terror. So I think horror is the right word. It's a horrible sight, and it instills horror. And then you see, right next to that, someone having a good time. Most people will not realize that's a say-cheese smile. They'll think, because of the broadness of the smile and the thumbs-up gesture, they're having a good time. That's what makes this a damning picture to the typical viewer. I'll add one more thing. When we see someone smile, it is almost irresistible that we smile back at them. Advertisers know that. That's why they link products to smiling faces. And when we smile back, we begin to actually experience some enjoyment. So this photograph makes us complicit in enjoying the horrible. And that's revolting to us.

Here is Ekman's explanation: it is not an upsetting photograph just because we see someone smiling in the context of the horrible, but because when we look at her, we have to resist smiling ourselves. We see her smile and start smiling ourselves. But when we see the dead man, we recoil in horror. Our "almost irresistible" need to smile makes us feel complicit in the man's death. And it makes us angry. We "transfer" those feelings to Sabrina.

In a letter written by Sabrina to Kelly, her wife, four days after al-Jamadi's death, she writes about her "fake smile." Many people have read the letter and assumed either the letter is a forgery—that it was written long after the fact, or it was written opportunistically to put herself in a better light. I don't believe either claim. Many of the letters were postmarked from Abu Ghraib. Many of them (including the letter below) were not submitted into evidence at Sabrina's court-martial, and it was only after much negotiation with Sabrina that I was able to see them and publish them. The letters are invaluable because they provide an emotional context for the photographs that is not available from any other source.

November 9, 2003

Kelly,

. . . I'm not sure how to feel. I have a lot of anxiety. I think something is going to happen either with me not making it or you doing something wrong.

I think too much. I hope I'm wrong, but if not, know that I love you and you are and always will be my wife. I hate being so scared. I hate anxiety. I hate the unknown. We might be under investigation. I'm not sure, there's talk about it. Yes, they do beat the prisoners up and I've written this to you before. I just don't think it's right and never have. That's why I take the pictures—to prove the story I tell people. No one would ever believe the shit that goes on. No one. The dead guy didn't bother me, even took a picture with him doing the thumbs-up. But that's when I realized it wasn't funny anymore, that this guy had blood in his nose. I didn't even have to check his ears and I already knew it was not a heart attack they claimed he died of. He bled to death from some cause of trauma to his head. I was told when they took him out they put an IV in him and put him on a stretcher like he was alive to fool the people around—they said the autopsy came back "heart attack." It's a lie. The whole military is nothing but lies. They cover up too much. This guy was never in our prison—that's the story. The fucked up thing was we never touched this guy. As soon as they released him to us, he died only a few minutes later—if I want to keep taking pictures of those events—I even have short films—I have to fake a smile every time. I hope I don't get in trouble for something I haven't done. I hate this. I hate being away from home and I hate half the people I'm surrounded by. They're idiots. I can't be here. I don't want to be a part of the Army, because it makes me one of them. I don't like it here. I don't like what we do.

The letter is clear: "The fucked up thing was we never touched this guy." When the army was looking for a scapegoat for its crimes, it was precisely this smiling image of Sabrina that they used to their advantage. And thus Sabrina Harman's photographs became part of the evidence used against her in military court—and in the court of public opinion.

———

When the Abu Ghraib photographs were first released to *60 Minutes* (April 28, 2004) and to Seymour Hersh at *The New Yorker*, which published them on May 10, 2004, they were presented with little or no context.[28] Eleven photographs taken by (and of) Sabrina Harman, Chip Frederick, Chuck Graner, and Graner's girlfriend, Lynndie England, were shown. One of the photographs was of al-Jamadi's corpse. The implication was clear. These people were responsible for the most horrible of crimes—torture and murder.

Seymour Hersh wrote, "The photographs tell it all." But they do not. We don't learn in the Hersh article that al-Jamadi was not killed by the MPs.[29] The photographs are the start of a trail of evidence, but *not* the end.

From the date the Abu Ghraib photographs were first made public to the present time, very little has been written to clarify the relationship between the photographs and what happened that night.

There are many photographs of al-Jamadi's body, but it is the photograph of Sabrina with his body that stands out among them: the photograph of a pretty American girl who is alive and a battered Iraqi man who is dead. The photograph misdirects us. The public sees the photograph and assumes that Sabrina is the killer and directs their anger at Sabrina, rather than at the *real* killers.

We see al-Jamadi's body, but we don't see the homicidal act that turned him from a human being into a corpse. We don't understand what the photograph *means*, nor what it is about. Instead of asking: "Who is that man?" "Who killed him?" the question becomes: "Why is this woman smiling?" At first I believed that Sabrina was complicit in al-Jamadi's death. I was wrong. I, too, was fooled by the smile.

And so we are left with a simple conundrum. Photographs reveal and they conceal. The photograph of Sabrina smiling over al-Jamadi's body both reveals his death and conceals his killer. We know about al-Jamadi's death because of Sabrina Harman. Without her photographs, his death would likely have been covered up by the CIA and by the military. Sabrina didn't murder al-Jamadi. Nor did she try to conceal his death. She provided evidence of a crime, evidence that this was no heart attack victim. She took photographs to show that, as she put it, "the whole military is nothing but lies," or at the very least, to show that she had been lied to by her commanding officer.

It should be our job to make sure that her photographs are used to prosecute the people truly responsible for al-Jamadi's death. The terrible truth is that the torture techniques that killed al-Jamadi were authorized by the highest levels of government, but none of the myriad investigations into al-Jamadi's death probed this fact. Were there other deadly interrogations? Deaths that we don't know about because the bodies were not photographed? We should demand accountability for the policies that allowed this murder and attempted to cover it up.

We shouldn't allow what happened at Abu Ghraib to disappear except for a smile. And like Alice in Wonderland, we shouldn't be afraid to ask questions.

When Alice first meets the Cheshire Cat, she has a simple question—a question that is perhaps more elusive than one might think at first:

" 'Please would you tell me,' said Alice, a little timidly, for she was not quite sure whether it was good manners for her to speak first, 'why your cat grins like that?' "

She is never given a satisfactory answer. She is told only that it's a Cheshire Cat and all Cheshire Cats grin like that. Later, when Alice parts company with the Cat, she is uncertain about where to go next. "Would you tell me, please, which way I ought to go from here?" The Cat is still smiling, that same enigmatic smile. Left with a smile, we, too, have to figure out where to go next.

ILLUSTRATION #73
THE CHESHIRE CAT

The Most Curious Thing

PHOTOGR
REALITY (C
PROPAGA
FRA

The Case of the
Inappropriate Alarm Clock

Part 1

———

ILLUSTRATION #74
ROOSEVELT TRAIN
(opposite)

*Republican editors throughout the land were soon rubbing their hands over
a dispatch which, on quick reading, seemed to convict the New Deal's
cherished Resettlement Administration of photographic fakery and bad faith.*

—*Time,* September 7, 1936

Summer of 1936. One of the worst droughts in American history spreads across the Dakotas.

On June 7, North Dakota Republican governor Wallace Welford proclaimed a day of prayer. The citizens of North Dakota would kneel en masse to pray for rain. "Only Providence," the governor declared, could avert "another tragedy of tremendous proportions."

On June 21, Governor Welford flew to Washington to ask President Roosevelt for aid. On June 23, Roosevelt ordered Dr. Rexford Tugwell, head of the Resettlement Administration, to make a survey of the needs in the Dakotas and Montana. A million dollars in aid had been requested.

Within a week, a heat wave had also spread across the Great Plains. By July 7, it was a record 119 degrees in parts of North Dakota. Fields were scorched brown and black. The range country seemed to be covered with a tan moss so close to the ground that the hungry cattle could not reach it; so dry was the covering that it was useless for

sheep. It was estimated that 85 percent of the cattle in North Dakota would have to be moved out of state or sent to slaughter. The federal government stepped forward with $5 million to buy a million head of cattle, with the meat to go to the needy. Grasshoppers descended on the region, their vast numbers consuming what little crops remained. By July 9, the heat wave had killed 120 people across the country.

On July 11, the people of Mitchell, South Dakota, turned once more to prayer. Bells in the city's thirteen church towers tolled the signal to the people, eleven thousand in number, to fall to their knees. The temperature stood at 104 degrees. Still the rain did not come.

On July 17, Washington responded to the worsening situation with a vast migration plan. Thousands of families were to be moved by the federal government; about 30 percent of the farm families of North Dakota would be taken off their barren land.

By August, small cactus plants were the only living vegetation over large areas along the Dakota-Montana line. The grasshoppers were gone now, killed by the intense heat or starved to death. They had been replaced by an infestation of rodents driven into homes in search of food. By August 9, supplies of traps in North Dakota were exhausted. Home owners anxiously awaited new shipments to relieve the situation.

The land was turning to desert and dust. It must have felt like the end of the world.

ILLUSTRATION #75
NEW YORK TIMES DROUGHT MONTAGE

On August 25, Franklin Delano Roosevelt boarded a train, the "Dustbowl Special," headed toward the Dakotas. It was an election year and he was campaigning for a second term. Roosevelt, the Eastern Democrat, called for government intervention in the economy, while Alf Landon, the Midwestern Republican, argued for a laissez-faire approach, free of government controls and intervention.

As FDR's train headed west, everything was in place for a series of photo opportunities and news stories that would cast his efforts to fight the drought in the best possible light. But unknown to FDR a controversy was brewing, a controversy involving photography. As *Time* magazine observed on September 7, 1936:

> When Franklin Roosevelt's special train rolled into Bismarck, N. Dakota in the course of its travels through the drought areas it also rolled into a story which brought nationwide attention to a small-town newspaper. Aboard the Presidential Pullmans were placed scores of copies of the Fargo (N. Dakota) Forum, whose front page displayed a strange yarn. Because a corps of the nation's nimblest news hawks were also on the train, Republican editors throughout the land were soon rubbing their hands over a dispatch which, on quick reading, seemed to convict the New Deal's cherished Resettlement Administration of photographic fakery and bad faith.

In 1935, Roosevelt had organized the Resettlement Administration (RA), a federal agency responsible for relocating struggling urban and rural families. By 1937, in response to intense congressional pressure, it was folded into a new agency, the Farm Security Administration (FSA), which aimed to combat rural poverty.[1] Part of the Information Division of the FSA was a small photography program headed by Roy Stryker. That program nurtured many of the important photographers of the 1930s, including Walker Evans, Dorothea Lange, Russell Lee, Ben Shahn, and Arthur Rothstein. It also produced Pare Lorentz's extraordinary documentary films, *The Plow That Broke the Plains* and *The River*.[2]

The FSA faced considerable political opposition. One can imagine the political animosity that would be generated if a modern-day president introduced a national documentary photography program as part of a stimulus package. Fiscal conservatives did not want to see their hard-earned tax dollars spent on relief for the poor, let alone a government photography program, of all things. And in a photograph of a sun-bleached cow skull, Roosevelt's opponents had found their proof of government waste, duplicity, and fraud. A salvo was fired across the front pages of the *Fargo Forum* with the headlines that declared "Drought Counterfeiters Get Our Dander Up" and "It's a Fake: Daily Newspapers Throughout the United States Fell For This Gem Among Phony Pictures."

ILLUSTRATION #76
FARGO FORUM

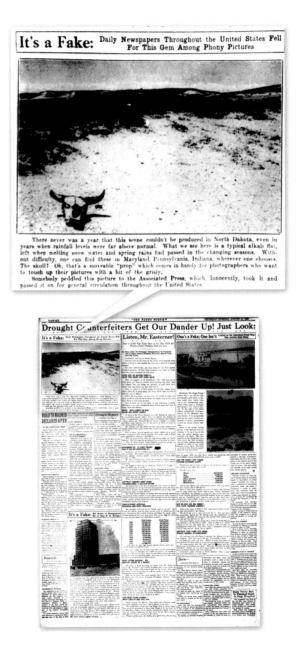

The paper referred to "the man with the wooden-nickel pictures" and claimed it had actually uncovered *three* examples of photo fakery: Arthur Rothstein's cow skull photograph (taken for the FSA and distributed by the government to the

Associated Press); a composite photograph of cattle grazing next to the North Dakota state capitol (printed in the *New York Times*); and a picture supposedly of a section of the Missouri River near Stanton, North Dakota (widely distributed by the Associated Press).

ILLUSTRATION #77
NORTH DAKOTA COWS AT CAPITOL

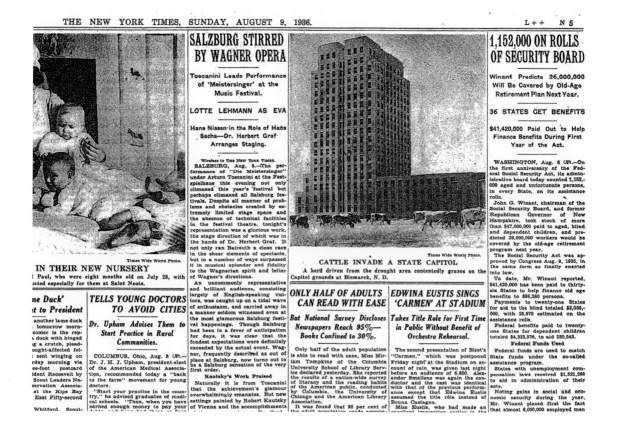

Three different photographs. Three accusations of photo fakery. Of the three, only *one* appeared to be an out-and-out fraud: the picture of the cattle and the capitol. It appeared in the *New York Times* on Sunday, August 9, 1936, with the caption: "Cattle Invade a State Capitol. A herd driven from the drought area contentedly grazes on the Capitol grounds at Bismarck, N. D." As the *Forum* reported:

> If these cows could only read. You'd think they'd been eating loco weed. Where those cows are presumably grazing is a graveled parking lot at the rear of the state capitol, thickly dotted with cars at all hours of the day. The

picture fake, foisted on innocent, unsuspecting newspapers, is the result of a photographic trick—superimposing a herd of cattle on a picture of the North Dakota capitol building.

It would be almost a month before the *New York Times* would publish the story behind this photograph. Meanwhile, the picture of the Missouri River was at best miscaptioned. The *Fargo Forum* later reported:

> Blushingly, *The Fargo Forum* admits that it too fell for this photographic gold brick, a blatant, crude fake, which went out to the unsuspecting Associated Press from a too-smart photographer who wanted nickels [presumably, a somewhat obscure reference to "wooden-nickel pictures"]. To the right is the faked picture, purportedly showing a section of the Missouri river near Stanton, N.D., purportedly showing the water receded sufficiently to permit automobiles to ford the stream without difficulty. Above is the actual, honest picture of the Missouri river at Stanton N.D., as it was at the time the faked picture purportedly was taken. The contraption in the foreground is a ferry which has been in operation 20 years, missing trips only because of the wind or ice, never because of low water. The river is about 16 feet deep at a point about 50 feet from shore.

But it was a photograph of a cow skull taken by a young FSA photographer, Arthur Rothstein, that brought out the real nastiness in the Fargo newspaper:

> There never was a year when a scene like this couldn't be produced in N. Dakota, even in years where rainfall levels were far above normal. What we see here is a typical alkali flat, left when melting snow water and spring rains had passed in the changing seasons. Without difficulty, one can find these in Maryland, Pennsylvania, Indiana, wherever one chooses. The skull? Oh, that's a moveable "prop," which comes in handy for photographers who want to touch up their photographs with a bit of the grisly.

On August 29, 1936, a couple of days after the damning article in the *Fargo Forum,* Ed Locke, an assistant to FSA head Roy Stryker, wrote to Stryker.

> They will probably get in touch with you if the matter goes any further. So if you still have that damn skull, hide it for God's sake.

On that same day, Locke was interviewed by the Associated Press and argued that the photograph was not a fake because the multiple views were all taken within an area of ten feet—ten feet being, evidently, the diameter of documentary probity.

ILLUSTRATION #78
COW SKULL 10 FEET

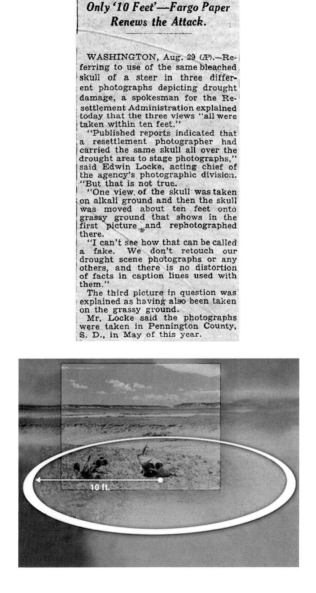

EXPLAINS SKULL USE IN DROUGHT PICTURES

RA Aide Says It Was Moved Only '10 Feet'—Fargo Paper Renews the Attack.

WASHINGTON, Aug. 29 (P).—Referring to use of the same bleached skull of a steer in three different photographs depicting drought damage, a spokesman for the Resettlement Administration explained today that the three views "all were taken within ten feet."

"Published reports indicated that a resettlement photographer had carried the same skull all over the drought area to stage photographs," said Edwin Locke, acting chief of the agency's photographic division. "But that is not true.

"One view of the skull was taken on alkali ground and then the skull was moved about ten feet onto grassy ground that shows in the first picture and rephotographed there.

"I can't see how that can be called a fake. We don't retouch our drought scene photographs or any others, and there is no distortion of facts in caption lines used with them."

The third picture in question was explained as having also been taken on the grassy ground.

Mr. Locke said the photographs were taken in Pennington County, S. D., in May of this year.

10 ft.

The Case of the Inappropriate Alarm Clock

Here is the photograph as it appeared in the *Washington Post* article on July 10, 1936, with the caption "From Pennington, S. Dak., comes this photo of a bleached skull on a sun-baked grassless plain, giving solemn warning that here is a land the desert threatens." The Rothstein photograph appears underneath the heading "Drought Damage Mounting in Western States." The caption is dramatic, and nothing is left to chance. It explicitly provides a meaning for the photograph—it is a picture of drought. But was this caption the handiwork of the *Washington Post* or was it supplied by the FSA? Or by Rothstein?

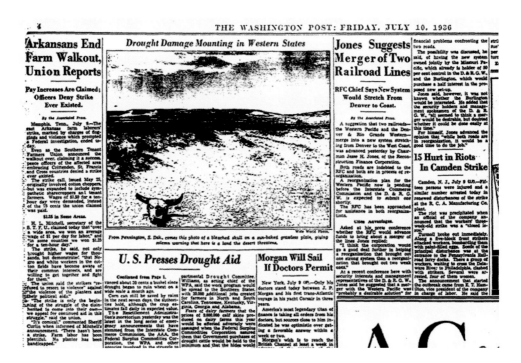

The FSA caption, which is posted in the online database of the Library of Congress, is hardly controversial and much less emphatic: "Overgrazed land, Pennington County, South Dakota; a homestead on submarginal and overgrazed land. Pennington County, South Dakota; Dry and parched earth in the badlands of South Dakota; The bleached skull of a steer on the dry sun-baked earth of the South Dakota badlands." There is a note, however, that states, "title and other information from caption card; annotation on original negative jacket: AR." But are these Rothstein's annotations or the notations of a librarian, putting the collections in order? Where are the "original negative jackets"? We looked for the microfilm of the original FSA office files. In one folder, "F.S.A. (formerly R.A.) Photographer's Original Captions," we found another caption:[3]

ILLUSTRATION #80
DROUGHT VICTIM CAPTION

Part of the problem was the cow skull photograph had been taken months *before* it was published by the *Fargo Forum*.[4] Also at issue was the fact that the Farm Security Administration had provided several versions of the photograph. The *same* cow skull had been photographed in different locations, as if the photographer was looking for the perfect landscape to make his case. The *Fargo Forum* was further incensed by the idea that North Dakota farmers had been badly served by the cow skull. Several articles offered a spirited defense of North Dakota farmers and spoke of the extraordinary agricultural "wealth" produced in the Red River Valley.

Now, the original caption has become not just a "warning" but a "solemn warning" that the land is threatened. Did the *Washington Post* photo editors select this particular Rothstein photograph because of the *caption*?

Within a month, the cow skull photographs had become infamous. By September, accusations of fraud were all over the place. There were dozens of articles about supposed photo fraud and the cow skull. Here is just a sampling:

> August 29, *New York Sun*, "Drought Photo Branded Fake."
>
> August 30, *Washington Star*, "Drought Skull Picture Faking Head Admitted by the New Deal."
>
> August 31, *Fargo Evening Forum*, "Eastern Press Follows Forum's Lead, Unearths History of This Fake Photo."
>
> September 4, *Fargo Evening Forum*, "RA's Perambulating Skull in Poignant Poses."

September 5, *Topeka Kansas Capitol*, "There's Skullduggery Here."
September 6, *Waterbury Republican*, "Lights! Camera!"
September 15, *Burlington Iowa Hawkeye,* "Fakery—Then Bad Faith."
September 16, *Chicago News*, "That Stage-prop Skull."

The conflict produced an almost endless array of accusations, retractions, and counteraccusations—a roundelay of finger-pointing. Meanwhile, the *New York Times* returned to the question of the cows grazing by the North Dakota capitol. Buried on a back page of the September 6 issue, the *Times* published a correction regarding the alleged composite photograph of cattle grazing in front of the state capitol: "a North Dakota newspaper has publicly retracted its charges that a WPA photographer 'faked' a drought picture in Bismarck." The cattle *were* in front of the North Dakota capitol; the photograph had *not* been faked. One picture had *not* been combined with another. The report of the fake had been a fake. And yet, once the faked photograph had been rebaptized as an "honest" photo, the claims against it started all over again. On September 9, the *New York Times* published an article, "[The *Fargo Forum*] Denies Retracting WPA 'Fake' Charge, Paper Again Attacks Drought Picture, Saying Cattle Have Always Grazed at Capitol."

According to the article, the *Fargo Forum* had not retracted the charge that the cattle picture was a drought fake: "It was a drought fake and is a drought fake." The newspaper then relates the history of the picture, which it at first believed to be the result of superimposing one shot on another, then discovered it to be an actual shot of dairy cattle owned by a Bismarck dairyman that frequently meander through the capitol grounds. The capitol is bordered on three sides by open farming and ranch land. Watchmen for years have had the job of chasing wandering cows away from the building. "The Fargo Forum was wrong when it said that the cattle picture was the result of superimposing one picture on another. It was wrong and it said so. That did not alter the status of the picture as a fake one whit."

The *Fargo Forum* had first charged that the picture was created by combining two pictures, and was therefore fake for *that* reason. Then, when it became clear that the photograph was *one* picture—not *two pictures* blended together—the argument changed. The picture was not a picture of drought because cattle had *always* grazed on the land surrounding the state capitol—in good years *and* in drought years. The picture had been taken during a good year. So it became a fake by virtue of its caption rather than the hands-on manipulation of the image. As the *Fargo Forum* charges reveal, if people object to an inference that can be made, properly or improperly, from a photograph—such as the existence of a severe drought—then they will find fault with the photograph itself.

The argument that photographs of typical conditions were recast as evidence of drought was also an issue with Rothstein's skull photographs. An editorial in the September 8 *Chicago Daily Tribune* (reprinted from the *New York Sun*) reported that "one of our readers has done a post-mortem on the skull."

The wrinkled condition at the base of the horns of this bleached skull clearly indicates that the animal was very old. It probably died of old age in some winter blizzard. Its bleached condition shows that it has been out in the weather three years or more. *As an exhibit of the effect of the drought in western North Dakota it is clearly a fake* [italics added].

What makes these accusations of photo fakery utterly perverse is the claim that they unfairly portrayed a drought. The photographs led the viewer to infer that the Dakotas were experiencing a severe drought. But the Dakotas *were* experiencing a severe drought. One of the worst droughts in American history. Was the *real* issue that the cow had died of old age rather than drought? Or that the cow skull had been moved less than ten feet, as the FSA claimed? Or had been moved at all? Or that multiple photographs had been taken? Or was it merely an attempt to shift the nature of the debate from the agricultural problems facing the country to an argument about photography and propaganda?[5]

Now, over seventy years since the 1936 cow skull controversies, the debate continues about photography and propaganda. None of these issues have been laid to rest. Far from it. The advent of digital photography, photo manipulation software, and that instantaneous distribution system known as the Internet have only escalated the claims of posing, false captioning, and photo fakery. While the technology may have changed, the underlying issues remain constant. When does a photograph document reality? When is it propaganda? When is it art? Can a single photograph be all three?

——

In 1991, James Curtis, a professor emeritus at the University of Delaware, published a revisionist history of FSA photography: *Mind's Eye, Mind's Truth: FSA Photography Reconsidered.* Curtis's thesis was simple. "The bitter reality" of the Farm Security Administration photographs was not the result of clinical, photographic fieldwork. Instead, he wrote, "The realism was deliberate, calculated, and highly stylized." According to Curtis, many of the most famous of the FSA photographs—including Walker Evans's interior of the Gudger home in Hale County, Alabama (which appeared in Evans's collaboration with James Agee, *Let Us Now Praise Famous Men*), Arthur Rothstein's "Fleeing a Dust Storm," and the most famous photograph of all, Dorothea Lange's "Migrant Mother"—were all arranged, staged, and manipulated.[6]

JAMES CURTIS: When I published *Mind's Eye*, the dean of the college said to me, "That was a really, really chancy thing for you to do." And I said,

"Why?" "Well, it's so inflammatory and subversive." And I said, "Well, I don't really think so. If historians want to use photographs as *evidence* in the true sense, and put them in the context in which they originally appeared, then you come up with questions about posing. I was just trying to urge my fellow historians to use the same evidentiary practice and technique on photographs that they would use on written documents, that photographs have a point of view. And, despite the fact that the photographers say that they are just snapping what's in front of them, they often go out in the field with a very definite idea of what they want to return with.

ERROL MORRIS: Did you start with the cow skull controversy?

JAMES CURTIS: Yes. The steer skull was my point of entry. But by the time I got around to the book, I decided I wanted to get past the steer skull very quickly, because that issue had already been debated so much. And yes, Arthur Rothstein moved that skull around, and he admitted as much. And Rothstein, if anything, except for "Fleeing a Dust Storm," instead of trying to create his own sense of the world, was a pretty faithful servant of the FSA. He and the other photographers would go out and take a huge number of pictures. You've got a treasure trove in the FSA file for this reason: it is largely unedited. When you go to Ansel Adams, for example, you're going to a collection that has been heavily edited by the photographer himself, so that you're only going to see the particular pictures that the photographer wanted you to see. In the case of the FSA file, they're all there, and even some that have holes punched in them are there. [Negatives were "killed" by having holes punched in them, but the negatives were still retained.]

ILLUSTRATION #81
KILLED PHOTOGRAPHS

ERROL MORRIS: Why do you think Rothstein took so many photographs of the cow skull?

ILLUSTRATION #82
COW SKULL 1

ILLUSTRATION #83
COW SKULL 2

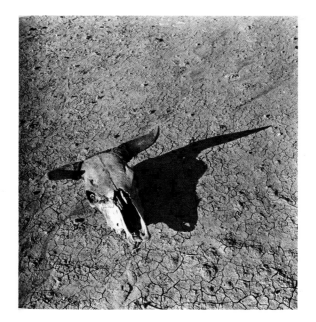

The Case of the Inappropriate Alarm Clock

ILLUSTRATION #84
COW SKULL 3

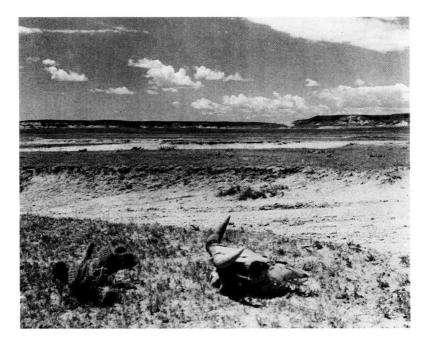

ILLUSTRATION #85
COW SKULL 4

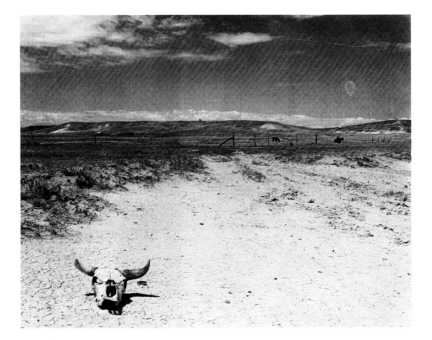

ILLUSTRATION #86
COW SKULL 5

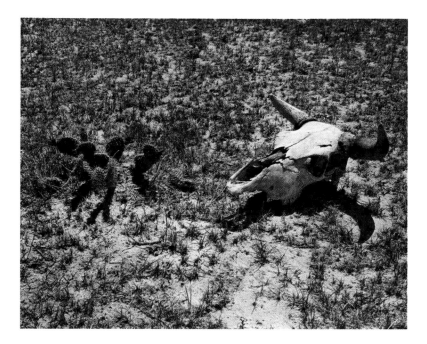

JAMES CURTIS: Rothstein was under pressure from Stryker to come up with some useful images. Some of his original landscapes were not very good. There was no foreground matter to give a sense of scale and proportion. And so Rothstein thought he'd really hit it rich when he found a steer skull and takes a picture of it. And he realizes that this is too good an object to waste in its original location. And he'd like some shadow detail and some other things. And, rather than simply walk around the object, he actually apparently moved it from one spot to another in what was described as a ten-foot-square area. I'm not sure about the actual sequence of the images. Can't tell.

ILLUSTRATION #87
COW SKULL 6

The FSA had a lot of trouble getting its pictures into print. One of the reasons Rothstein shot the whole skull sequence was because they wanted to promote a film that was about to come out, *The Plow That Broke the Plains*. These were probably stills that could be used to help sell the film. The documentary medium was in its heyday in the 1930s. Important documentary films were coming out. The Pare Lorentz films and *The City*, which was associated with the 1939 New York World's Fair. Rothstein saw himself as a film director. And looking back, said, "Well, yeah, you've got to have a script, and you have to take control of your subjects, and you have to basically tell them what to do." None of the other FSA photographers ever went that far, but there was an element of posing, of contrivance, in all of their photographs. There are still people who believe that "Migrant Mother" [Dorothea Lange's iconic photograph of a migrant mother with her children, the most famous of all the FSA photographs] is not a posed photograph. I was interviewed by the BBC a couple of years ago, and I got into a violent debate with the cameraman during our downtime. He was angry. "That's not a posed photograph. You're charging her with deception." I said, "I'm not charging her with anything. You want to see that photograph as the 'Burning Bush.' Fine. What you're doing is taking away all of her talent as a studio photographer who knew how to get a good picture." We never did resolve that issue.

ILLUSTRATION #88
DOROTHEA LANGE ON TOP OF CAR

Curtis's criticisms of Rothstein mirror many of the complaints that were made about the photographer's work in the 1930s. Rothstein, I suppose, was an easier target. But Curtis's inclusion of the "Burning Bush" photographers—Dorothea Lange and Walker Evans—inevitably incited controversy. I asked Curtis about Walker Evans rearranging things for the camera.

ERROL MORRIS: Rothstein was made the fall guy for this whole concept of posing and manipulation, but you suspected that Walker Evans was moving things, as well.

JAMES CURTIS: My favorite example is Walker Evans moving furniture around inside the sharecroppers' cabins in Hale County, Alabama. I was talking to Alan Trachtenberg [a professor of American history at Yale]. And Alan said, "Well, when your article on Evans came out, I was mad as hell." And I said, "Well, what were you mad about?" And he said, "Well, what difference does it make if he moved furniture around inside the sharecroppers' cabins?" And I said, "Because Evans has been regarded as the high apostle of documentary honesty, and he said he never did things like that." And afterwards, Trachtenberg replied, "Oh, hell, we all know he was a liar."

ERROL MORRIS: When did you first suspect that Evans was rearranging the furniture?

JAMES CURTIS: I was teaching at the University of Delaware and using a lot of slides of Walker Evans's photographs. I was just using them as illustrations

of the look of the Depression. And I had a student come up and say, "I've just read *Let Us Now Praise Famous Men*, and there's a room-by-room inventory that Agee makes of all the objects in this one sharecropper's cabin. Why don't we take a look at the relationship between the inventory in his text and what we see in the photograph." And, sure enough, things were different.

I turned to Agee's list in *Let Us Now Praise Famous Men* and compared it with Evans's photograph:

ILLUSTRATION #89
AGEE'S LIST 1

[172]

The mantel

On the mantel above this fireplace:
A small round cardboard box:
(on its front:)

Cashmere Bouquet Face Powder
Light Rachel

(on its back:)

The Aristocrat of Face Powders.
Same quality as 50¢ size.

Inside the box, a small puff. The bottom of the box and the bottom face of the puff carry a light dust of fragrant softly tinted powder.
A jar of menthol salve, smallest size, two thirds gone.
A small spool of number 50 white cotton thread, about half gone and half unwound.
A cracked roseflowered china shaving mug, broken along the edge. A much worn, inchwide varnish brush stands in it. Also in the mug are eleven rusty nails, one blue composition button, one pearl headed pin (imitation), three dirty kitchen matches, a lump of toilet soap.
A pink crescent celluloid comb: twenty-seven teeth, of which three are missing; sixteen imitation diamonds.
A nailfile.
A small bright mirror in a wire stand.
Hung from a nail at the side of the fireplace: a poker bent out of an auto part.
Hung from another nail, by one corner: a square pincushion.

[173]

Stuck into it, several common pins, two large safety-pins, three or four pins with heads of white or colored glass; a small brooch of green glass in gilded tin; a needle trailing eighteen inches of coarse white thread.
Above the mantel, right of center, a calendar: a picture in redbrown shadows, and in red and yellow lights from a comfortable fireplace. A young darkhaired mother in a big chair by the fire: a little girl in a long white nightgown kneels between her knees with her palms together: the mother's look is blended of doting and teaching. The title is Just a Prayer at Twilight.

The closet

On nails on the inside of the door of the shallow closet:
A short homesewn shift of coarse white cotton, square beneath the arms and across the chest and back: a knot in the right shoulderstrap.
A baby's dress, homemade. The top is gray denim; the collar is trimmed in pink; the skirt, in a thinner material, is small yellow-and-white checks.
A long homemade shift of coarse white cotton, same rectilinear design as above. A tincture of perspiration and of sex.
On the closet floor, to the left, a heap of overalls, dresses, shirts, bedding, etc., ready for laundering.
On a shelf above, three or four patchwork quilts of various degrees of elaborateness and inventiveness of pattern, and in various degrees of raggedness, age, discoloration, dirt absorption, and sense-of-vermin, stuffed with cotton and giving off a strong odor.
On nails along the wall, overalls, dresses, children's clothing; the overalls holding the shape of the knee and thigh; an odor of sweated cloth.

Here is a transcript of Agee's list:

The mantel

On the mantel above this fireplace:
A small round cardboard box:
(on its front:)
<div style="text-align:center">

Cashmere Bouquet Face Powder

Light Rachel
</div>

(on its back:)
<div style="text-align:center">

The Aristocrat of Face Powders.

Same quality as 50¢ size.
</div>

Inside the box, a small puff. The bottom of the box and the bottom face of the puff carry a light dust of fragrant softly tinted powder.

A jar of menthol salve, smallest size, two thirds gone.

A small spool of number 50 white cotton thread, about half gone and half unwound.

A cracked roseflowered china shaving mug, broken along the edge. A much worn, inchwide varnish brush stands in it. Also in the mug are eleven rusty nails, one blue composition button, one pearl headed pin (imitation), three dirty kitchen matches, a lump of toilet soap.

A pink crescent celluloid comb: twenty-seven teeth, of which three are missing; sixteen imitation diamonds.

A nailfile.

A small bright mirror in a wire stand.

Hung from a nail at the side of the fireplace: a poker bent out of an auto part.

Hung from another nail, by one corner: a square pinchusion. Stuck into it, several common pins, two large safety-pins, three or four pins with heads of white or colored glass; a small brooch of green glass in gilded tin; a needle trailing eighteen inches of coarse white thread.

Above the mantel, right of center, a calendar: a picture in redbrown shadows, and in red and yellow lights from a comfortable fireplace. A young darkhaired mother in a big chair by the fire: a little girl in a long white nightgown kneels between her knees with her palms together: the mother's look is blended of doting and teaching. The title is Just a Prayer at Twilight.

ILLUSTRATION #90
GUDGER MANTEL ORIGINAL

Where's the clock? It's in the photograph, but not on Agee's list. I asked James Curtis about this.

ILLUSTRATION #91
GUDGER MANTEL INVENTORY

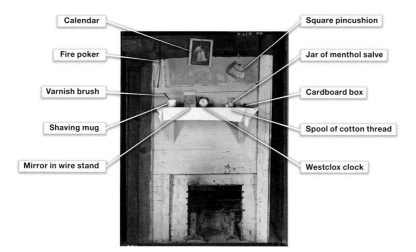

Calendar

Fire poker

Varnish brush

Shaving mug

Mirror in wire stand

Square pincushion

Jar of menthol salve

Cardboard box

Spool of cotton thread

Westclox clock

JAMES CURTIS: My argument with Evans and with Trachtenberg was, if you're going to slam Arthur Rothstein for moving a cow skull around on a ten-foot section of turf, what are you going to do about Walker Evans? There is the redesign of a room. In the bedroom, in one of the sharecroppers' cabins, the mantelpiece is a total rearrangement. He adds a clock to the center of the mantelpiece.

ERROL MORRIS: You believe that Evans altered the room he was documenting by changing the objects on the mantel?

ILLUSTRATION #92
ALARM CLOCK CLOSE-UP

The Case of the Inappropriate Alarm Clock

JAMES CURTIS: Yes, and probably inserts one of his own. The alarm clock. James Agee does not mention the clock and it's in the middle of that mantel. Now, if Agee is going to point out ten paper clips in the bottom of the shaving mug, he's not going to forget about an alarm clock. He has the soap, and he has everything else on the mantel. But there's *no* mention of the clock. And to me, the clock looks very much like the travel alarm that someone like Evans would have carried with him when he was on the road. Unlike Agee, he did not live at the cabins. He went back to a local hotel. Some people were uncharitable enough to say he just didn't like the food, something like that. That's all hearsay. But I'm convinced that there were things that he introduced to the scene and things that he subtracted from the scene.

ERROL MORRIS: These details are important. But why? There's this crazy idea that you can faithfully replicate reality in a photograph.

JAMES CURTIS: Oh, I agree. My graduate students used to pester me all the time and say, "All right, well, what's the truth?" And I'm saying, "Look, you're being trained to be good historians. And to be a good historian is to tell a story faithfully, based upon the evidence that you have at hand."

And what is the evidence at hand? Whose alarm clock was it? Did Walker Evans *bring* it to the Gudger home or did he *find* it there? The reader might ask, "Who cares? Does the addition or subtraction of a clock on a mantel really change our view of the Gudgers?" Perhaps not, but would it change our view of Walker Evans and his photographs as documentary evidence?

I wondered if learning any more about the clock itself might prove helpful. My researcher, Ann Petrone, contacted Gary Biolchini, the author of *Westclox: An Identification and Price Guide,* to ask him about the clock in Evans's photo. Gary wrote back immediately:

> The clock is named Fortune as marked on the dial, with production dates between 1933 and 1937. It was designated as Model #10 and originally sold for $1.45 retail. It was a lower-priced alarm clock in an Art Deco style and is not too rare, although I assume many were thrown away instead of repairing them. Hope this information helps.
>
> Gary

The Fortune No. 10 was the budget alarm clock, but it would still cost about $23.93 in today's dollars,[7] a large sum to the struggling Gudger family. But if the Gudgers were somehow able to afford the alarm clock, why would the Gudgers *need* an alarm

clock? Didn't they get up at sunrise and work until sunset? And why was the alarm clock worn around the edges? Was it a secondhand alarm clock? Or was it, as Curtis suggested, carried about in Evans's luggage? At the heart of the question is how would finding out the truth of the alarm clock change our view of Walker Evans and this photograph?

We are left with many possibilities:

1. The alarm clock could have belonged to Evans. He placed it in the middle of Gudger's mantel because he liked the way it looked. It *improved* his composition.

2. The alarm clock could have *originally* belonged to Evans, but he gave it to Gudger. Proud of the gift, Mr. Gudger placed it in the middle of his mantel.

3. The alarm clock could have originally belonged to Gudger. He removed it from the mantel after Evans took the photograph (and before Agee made his extensive list) for some unknown reason.

The Case of the Inappropriate Alarm Clock

Where do we find more clues to determine who owned the clock and how it came to be on the mantel? Probably not on Agee's lists. Agee could have left things out, wittingly or unwittingly. For example, Agee lists on the mantel "a pink crescent celluloid comb: twenty-seven teeth, of which three are missing." I can't find it in the photograph. Is the comb on the mantel, but I just can't see it in the photograph because it's lying flat or hidden by another object? Does that mean the mantel photograph is an incomplete documentary record? Or does it mean that Evans or one of the Gudgers removed the comb? Agee and Evans were not working together, side by side. In all likelihood, the preparation of Agee's written list and the taking of Evans's photograph occurred on different days. Is it so unlikely that objects on a mantel would change over time?

With the Gudger mantel, we are left endlessly trying to determine the *provenance* of objects and how they relate to one another. We know the provenance of the photograph: it was taken by Walker Evans. But we don't know the provenance of each of the objects on the Gudger mantel.

Our lives are partially defined by ephemera—address books, bus tickets, campaign buttons. A trail of detritus. But do we have the *right* bits and pieces of detritus—the *right* evidence—to answer the question: did Evans put the alarm clock there? A sales receipt with the name of the buyer? A card accompanying a gift? (Perhaps a snapshot of Walker Evans opening a handsomely wrapped present on a snowy Christmas morning, 1934. Guess what it is?) Where does it end? Isn't there always the possibility that something unexpected and definitive could show up? Perhaps. But unlike Fenton's photographs, I don't believe the answer is in the photograph. And try as I might, I have been unable to answer the question of whether the Westclox Fortune No. 10 was owned by Walker Evans or by George Gudger. The photograph can't tell us where the alarm clock came from. All it can do is record its presence in the scene at that moment.

———

Curtis continues with his extensive list of the discrepancies between Evans and Agee.

JAMES CURTIS: There's the scene in the bedroom. Agee says that there is a shotgun above the bed. Agee says that there is a pair of long underwear hanging on a peg right next to the bed [illus. 94]. Well, that *disappears* in the photograph. And furthermore, to take that picture Evans would have had to move the foot of the bed away from the wall. And Agee is very precise in his description. All the objects are lined up evenly against the wall. Well, in the *trial shot* that I've got, you'll see that the head of the bed is out of focus in the foreground of the picture [illus. 95]. That's something Evans couldn't stand.

ILLUSTRATION #94
GUDGER BED

ILLUSTRATION #95
BED/MANTEL, 12:44

The Case of the Inappropriate Alarm Clock

So, what is he doing in the trial shot? Basically, "Okay, I want to take this picture of the mantelpiece. What's it going to look like?" And he immediately sees that, if he bounces his flash off that mirror that's on the mantelpiece, he's going to have big problems. So that's when he takes the mirror, turns it around, puts it on the other side of the mantel, so it is now in a totally nonfunctional location [illus. 96]. All you see is the backside of the mirror, the paper backing of the mirror. You don't see the mirror itself. All of this while Agee is saying, "I'm so guilt-ridden about this that I'm going to put everything back exactly as I found it so they won't know that I touched the things I did."

ERROL MORRIS: I'm not sure that I understand. There is a trial shot that you have of the fireplace and mantel?

JAMES CURTIS: Yes. The photograph of the bed in the bedroom is shot from the foot of the bed toward the head. It is in the same room as the fireplace and the mantel. So when Evans was shooting the picture of the mantelpiece, the head of the bed is pulled out. It is different from the way it was when he took the other picture. And it is out of focus in the foreground. And so that's when he decides to make the changes. In the trial shot, there's a wadded-up newspaper in the fireplace and a pair of shoes alongside the fireplace. They both disappear in the final image.

Curtis is providing an account of what Evans was *thinking*—"that's when he decides to make the changes"—based on a supposition about the chronological order of the photographs. He speaks about the *one* trial photograph taken by Evans, but my researcher found that there are *four* separate shots by Evans: the photograph from *Let Us Now Praise Famous Men* at the Library of Congress (illus. 96) and three additional photographs in the Walker Evans archive at the Metropolitan Museum of Art (illus. 95, 97, and 98). But how can we be sure which are trial photographs? What about the inappropriate alarm clock? It may have failed to tell us how it came to be on Gudger's mantel, but the clock still may hold other clues. Like any functioning alarm clock, it records the time as Evans proceeds with his photo session, and hence provides a way of ordering the photographs: first to last.

This most famous of the photographs is the photograph in the two-volume edition of *Let Us Now Praise Famous Men* at the Library of Congress (right). The time on the alarm clock is 9:58 a.m.

ILLUSTRATION #96
FROM AGEE BOOK, 9:58

The Case of the Inappropriate Alarm Clock

ILLUSTRATION #97
EVANS ARCHIVE MANTEL, 9:40

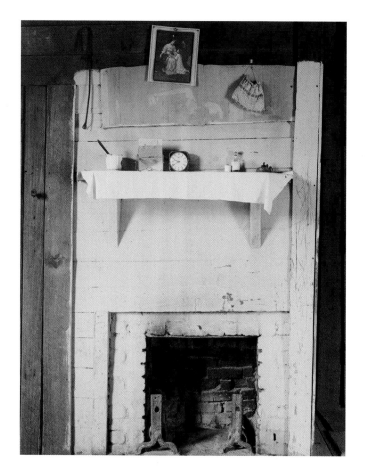

The "other" photograph with the same frame was taken at 9:40 a.m.—eighteen minutes before. Because it was taken *before* the photograph in *Let Us Now Praise Famous Men,* it could be considered a *trial* photograph (to use Curtis's terminology) for the 9:58 a.m. photo. But what about the other two photographs—the photographs with the wrought-iron bed in the foreground? Are they *trial* photographs as well? Look at the alarm clock. The Westclox Fortune No. 10. The times are 12:42 and 12:44. Just as Curtis finds a reason for a certain photographic order by imagining what Evans was thinking, there are other scenarios that may explain an alternative order: Had Evans sat down for lunch and then noticed the sunlight had illuminated the left wall next to the fireplace? Was it at that point that he decided to take a wider shot? (Of course, it could be a different day, or Evans could have manipulated the clock times. But why would he do such a thing? Just to screw up people like me?) In this version, the boots and the crumpled paper are not taken *out* of the shot, but rather placed *in* the shot.

ILLUSTRATION #98
BED/MANTEL, 12:42

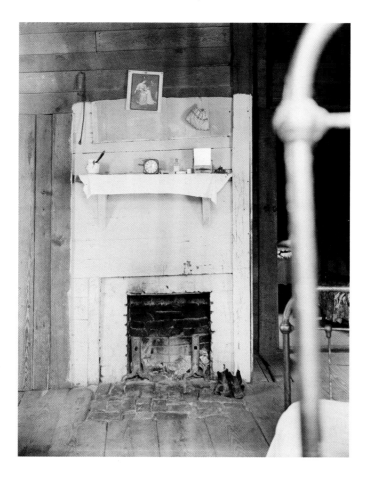

Curtis's analysis of the photographs and of Evans's motivation supposes that the photograph with the wrought-iron bed was taken *before* the photograph in *Let Us Now Praise Famous Men,* but the times on the clock in the *two* photographs *with* the wrought-iron bed are 12:42 and 12:44 p.m. The sun is out, and the left wall next to the fireplace is now illuminated.

Curtis's analysis is incompatible with the clock times. The so-called trial photograph was taken *after* the photograph that appears in *Let Us Now Praise Famous Men.*

ILLUSTRATION #99
DIFFERING CLOCK TIMES

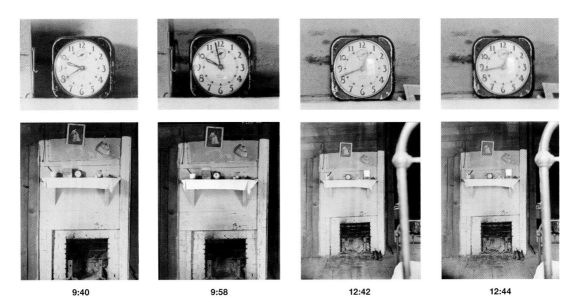

| 9:40 | 9:58 | 12:42 | 12:44 |

The discovery of the additional "trial" photographs and their respective clock times disproved Curtis's claim about the order of the photographs and allowed us to solve the problem of which photograph came first, but not the mystery of where the alarm clock came from or the larger issue of whether Walker Evans arranged these "documentary" photographs. The Case of the Inappropriate Alarm Clock is seemingly unsolvable. It demonstrates an important point: Try as we might, there are limits to what can be recovered from a photograph. I wonder if any further insight can be found in Agee's text. I returned to *Let Us Now Praise Famous Men*.

Agee may be very precise in his descriptions. But is he accurate? Why should we trust Agee and cast suspicion on Evans? Isn't there something perverse about giving the written word primacy over the photographic image? Don't we (habitually) do the exact opposite when considering evidence? Was there anything in Agee's prose, I wondered, that suggested the unreliability of his own exhaustive accounts? I didn't have to look very hard. There is a curious passage in *Let Us Now Praise Famous Men* where Agee wrestles with the idea of capturing reality. The passage is about the Gudgers' home, and specifically, the smokehouse:

> The natural usage of a smokehouse is to smoke and store meat, but meat is not smoked here: this is a storage house. Mainly, there are a couple of dozen tin cans here, of many differing sizes and former uses, now holding sorghum; four hoes; a set of sweeps; a broken plow-frame; pieces

of an ice-cream freezer; a can of rusty nails; a number of mule shoes; the strap of a white slipper; a pair of greenly eaten, crumpled work shoes, the uppers broken away the soles worn broadly through, still carrying the odor of feet; a blue coil of soft iron wire; a few yards of rusted barbed wire; a rotted mule-collar; pieces of wire at random:* all those same broken creatures of the Ricketts' porch, of uselessness and of almost endless saving.

*Invention here: I did not make inventory; there was more than I could remember. I remember for certain only the sorghum cans, the sweeps, the hoes, the work shoes, the nails; with a vaguer remembrance of random pieces of harness and of broken machinery: there may also have been, for instance, a ruined headlight and a boy's soggy worn-out cap. Many of the sorghum cans, by the way, were almost the only bright and new-looking things on the farm. Gudger may have bought them. If so, they are notable, for tenants seldom buy anything new.

The footnote mentions that the "tenants seldom buy anything new," but it also reveals something about Agee. It announces: "Invention here: I did not make inventory; there was more than I could remember. I remember for certain only the sorghum cans, the sweeps . . ." Agee is constantly wrestling with memory and with a dark sense of intrusion. Why should we worry about a damn alarm clock when it is Agee and Evans who are the true interlopers?

He writes:

Here I must say, a little anyhow: what I can hardly hope to bear out in the record: that a house of simple people which stands empty and silent in the vast Southern country morning sunlight, and everything which on this morning in eternal space it by chance contains, *all thus left open and defenseless to a reverent and cold-laboring spy,* shines quietly forth such grandeur, such sorrowful holiness of its exactitudes in existence, as no human consciousness shall ever rightly perceive, far less impart to another: that there can be more beauty and more deep wonder in the standings and spacings of mute furnishings on a bare floor between the squaring bourns of walls than in any music ever made: that this square home, as it stands in unshadowed earth between the winding years of heaven, is, not to me but of itself, one among the serene and final, uncapturable beauties of existence: that this beauty is made between hurt but invincible nature and the plainest cruelties and needs of human existence in this uncured time, and is inextricable among these, and as impossible without them as a saint born in paradise. [emphasis mine]

What makes the prose of *Let Us Now Praise Famous Men* both poignant and peculiar is Agee's anguish about observing, as if Agee wishes to report on the limitations of his craft and at the same time provide an itemized inventory of everything. He continues:

> *But I say these things only because I am reluctant to entirely lie.* I can have nothing more to do with them now. I am hoping here only to tell a little, only so well as I may, about an ordinary* house, in which I lived a little while, and which is the home, for the time being, of the Gudger family, and is the sort of home a tenant family lives in, furnished and decorated as they furnish and decorate. [emphasis mine]
>
> *The whole problem, if I were trying to fully embody the house, would be to tell of it exactly in its ordinary terms.

In Agee's 1937 application for a Guggenheim fellowship, among the possible projects listed was "An Alabama Record" (which eventually became *Let Us Now Praise Famous Men*).

> In the summer of 1936 the photographer Walker Evans and I spent two months in Alabama hunting out and then living with a family of cotton tenants which by general average would most accurately represent all cotton tenancy. This work was in preparation for an article for Fortune. We lived with one and made a detailed study and record of three families, and interviewed and observed landowners, new dealers, county officers, white and negro tenants, etc., etc., in several cities and county seats and villages and throughout 6,000 mile of country.
>
> The record I want to make of this is not journalistic; nor on the other hand is any of it to be invented. It can perhaps most nearly be described as "scientific," but not in a sense acceptable to scientists, only in the sense that it is ultimately skeptical and analytic. It is to be as exhaustive a reproduction and analysis of personal experience, including the phases and problems of memory and recall and revisitation and the problems of writing and of communication, as I am capable of, with constant bearing on two points: to tell everything possible as accurately as possible, and to invent nothing. It involves as total a suspension of "creative" and "artistic" as of "reportorial" attitudes and methods, and it is likely therefore to involve the development of some more or less new forms of writing and of observation. . . .
>
> It should be as definitely a book of photographs as a book of words: in other words, photographs should be used profusely, and never to "illustrate"

the prose. *One part of the work, in many senses the crucial part, would be a strict comparison of the photographs and the prose as relative liars and relative reproducers of the same matters.* [emphasis mine]

The struggle between words and pictures embodied in *Let Us Now Praise Famous Men* made me wonder if Walker Evans had written any captions for his photographs. I asked James Curtis.

JAMES CURTIS: None. That was one of Roy Stryker's problems with Evans. Evans didn't follow directions. First of all, he wouldn't take as many pictures as Stryker wanted and needed to justify the file's existence. And second, Evans didn't caption his photographs. They might have a date, and they might have a location, but there was nothing like Dorothea Lange's "Destitute pea pickers in California; a 32-year-old mother of seven children. February 1936. Seven hungry children, father's out selling tires from the car." [The photograph is commonly known as "Migrant Mother."] Evans never put captions on his images like that. Evans conceived of his images as singular objects. Whereas the other photographers were creating picture stories where one image would relate to the next. They were very much caught up with the idea of film. Evans was much more driven by the art world and taking his rightful place in the long line of photographers who were arguing that photography was a fine art. And Evans loved to speak in tongues by saying such things as, "Documentary photography has nothing whatsoever to do with art. But it is an art for all that."

ERROL MORRIS: The Evans photographs seemed simpler, less self-conscious, less mannered. Agee's prose was often an endless list of objects—as if he was preparing a catalog for a country estate auction. But at other times, highly romanticized and often overwrought. Was Evans interested in simplicity and Agee in something quite different? There's this idea of capturing reality in words—as if his prose was in competition with Evans's camera.

JAMES CURTIS: What is so clear and simple in Evans's photographs is his whole style. Some objects are removed and other objects are rearranged in order to make the scene appear more simple. And, therefore, in his view more *honest*. There is a quote from Mrs. Gudger, the woman in the house, who says, "Oh, I do *hate* this house *so bad*. Seems like they ain't nothing in the whole world I can do to make it *pretty*."

Well, Evans knew what he could do to make it pretty, and that was to remove objects. And the biggest argument there was in the kitchen, in the corner of the kitchen, when he had to move the table out of the way to put his tripod in its place. This is pretty dramatic stuff. And Agee wrote, at the time, that the people were gone that day, and they had access to the house

themselves. And he writes, "I'm going to put things back exactly as I found them so they'll never know we were here." Which is a very interesting and telling criticism or point of view.

The general response to *Let Us Now Praise Famous Men* was that the photographs provided *proof* of Agee's arguments—when in fact it was somewhat the other way around. Evans's photographs were more romantic and aesthetic, whereas Agee was counting thin paper clips in the bottom of a shaving mug. He wanted to rub your nose in all the details of poverty. And Evans wanted to stand back and look at it from an almost dispassionate point of view. It was the view of someone who had very definite ideas about interior design and how a room ought to look. Evans says he couldn't stand a bad object or a bad design in a room. That comment is a good indication of his agendas. They were aesthetic agendas.

————

On close examination, the issue of posing collapses into absurdity. Did Agee count *four* hairpins but we only see *three* in the Evans photograph? Isn't the issue a deeper, far more problematic issue, namely, did the photographer *intend* to deceive the viewer? Was he using photography as sleight of hand? Is it really just a matter of intentions? Had what began as a forensic examination of photographs as evidence devolved into an analysis of the character of the photographer? In the end, was Curtis saying that Evans had moved objects for artistic reasons, while Rothstein was just naive?

Many photo historians did not respond well to Curtis's criticisms. William Stott, the author of *Documentary Expression and Thirties America,* reviewed *Mind's Eye, Mind's Truth* and was not at all complimentary.[8]

> Curtis's chief intention is to prove that the most admired of FSA photographers, Walker Evans, also manipulated photographs. On this question I must declare a personal interest. My *Documentary Expression and Thirties America* quotes Evans saying that documentarians should disturb what they photograph as little as possible. Specifically, they should not add things, as Rothstein added the cow skull. "That's where the word 'documentary' holds," Evans told me in 1971. "You don't touch a thing. You 'manipulate,' if you like, when you frame one foot one way or one foot another. But you're not putting anything in."

One can sympathize with Stott's anger and annoyance, but there is an important principle hidden in Curtis's argument. If there is an element of posing in all pictures, why should we *praise* Evans and *condemn* Rothstein? Evans may not have put the

alarm clock on the mantel, but clearly objects have been changed. The four mantel photographs taken within a couple of hours of one another *are* different. Gudger could have come in and placed the crumpled newspaper *in* the fireplace or the boots *next* to the fireplace, but it is also quite possible that Evans arranged those objects in the scene. The placement of an alarm clock or a pair of boots may seem like a petty issue, but it goes to the heart of what documentary photography is. It goes to the difference between posing and deliberately fakery.

Part 2

ILLUSTRATION #100
PHOTO OF WALKER EVANS

For some reason, perhaps because I was a filmmaker trying to work out my own issues about what "documentary" means, I kept getting deeper and deeper in the controversy over the Walker Evans photographs.

William Stott's *Documentary Expression and Thirties America* is a scholarly attempt to fit Farm Security Administration photography within a broader social context. Stott was a graduate student at Yale in the 1970s, and it was there that he first met Evans. We started our phone conversation with a discussion of James Curtis and Walker Evans.

ERROL MORRIS: In your review of *Mind's Eye*, you write, "Curtis thinks all manipulation is the same." That he wants to *lump* all the FSA photographers into one big pile, and in particular, he wants to *prove* that Walker Evans is guilty of manipulation.

WILLIAM STOTT: Yes. He says that Walker Evans moved things around in the sharecropper cabins. He doesn't say why. That's what's wrong with his whole argument. He compares Walker Evans's photographs with Agee's descriptions. And things have changed a little bit because the two men didn't work together. We know that. I quote Evans talking about that. For me, the telling thing is there is no reason to think that the photographs were better for the way Evans supposedly arranged them. Curtis makes no claim of that. So why would Evans have changed things? And Evans himself, when I brought the original criticism to him, which came from a guy named Eric Larsen, who then published it in 1971, when I brought the criticism to him, he said, "Why would I? They were fine the way they were."

ERROL MORRIS: So Walker Evans, say, would never have moved the cow skull like Rothstein did?

WILLIAM STOTT: When the cow skull incident happened, Rothstein was twenty-one or twenty-two. He was very young. And he was not trained as a photographer and wasn't trained as a journalist. He was trained as an economist. He'd studied with Roy Stryker at Columbia. And when Stryker went to the FSA he was invited to follow him. He didn't know what the strictures were about documenting reality. He was copying from the other people in the FSA. Walker Evans called him, and Evans wasn't usually this bitter, but he called him "a little rubber stamp." You can see him doing knockoffs of photographs by Dorothea Lange and Walker Evans, and maybe some of Russell Lee, too. He was a very young guy. And I, knowing that he was twenty-one and knowing what mistakes I made at twenty-one, I don't hold this at all against him. But he did it clumsily, I have to say that.

ERROL MORRIS: Clumsily?

WILLIAM STOTT: When he had the right picture, he should have burned the other negatives.

ERROL MORRIS: But the fact that he didn't burn the other negatives tells me that he didn't see what he did as *wrong*.

WILLIAM STOTT: Yeah. Well, good for him. A young photographer today would not do that.

ERROL MORRIS: Curtis levels the claim that Evans moved this, he moved that—he moved the alarm clock in the Gudgers' home. Walker Evans says, "No, I did not. I did nothing of the sort."

WILLIAM STOTT: Evans was adamant about this issue. Said that, "That's where the word 'documentary' holds," I remember him saying this. "You use the camera one way or another, if you like, to frame things, but you're not

putting anything in." But often Evans used focal lengths to dramatize things, something that I wasn't technically astute enough at first to pick up on.

ERROL MORRIS: It's all part of a photographer's arsenal. Framing, film emulsion, f-stop, focal length, etc., etc. What people disliked about the cow skull photograph is that the photograph seemingly *implied* something—that the Midwest is dying because of drought. Animals are dying. Crops are dying. It telegraphs an idea. The viewer makes an *inference* that may be unwarranted on the basis of the photograph. And many people clearly disliked the inference. The captions may have contributed to this. There is this *idea* with the cow skull that it *means* something but what it means depends on the focal length of the lens you use: if it is a long lens, then it is abstracted from the landscape; if it is a wide-angle lens, the landscape becomes the *context.* The real complaint with the cow skull is not that it was moved. Who cares? It was that it was photographed, printed, and published in such a way that encouraged the viewer to make *unwarranted* inferences. And they felt manipulated, tricked, deceived. But ultimately, you feel that Rothstein *intended* to deceive the viewer; Evans did not.

WILLIAM STOTT: I remember when Evans visited Texas [where Stott was later a professor of American history], somebody brought up the question of the alarm clock on the mantel. That Evans changed stuff to make it symmetrical or unsymmetrical. And he said, "No, absolutely not." He just said, "God did that. I wouldn't change it."

ERROL MORRIS: "God did that." An amazing quote.

WILLIAM STOTT: At the Evans retrospective at MoMA [the Museum of Modern Art, in 1971] I came upon an [unpublished] photo that just seemed to explode the book. It changed the book [*Let Us Now Praise Famous Men*] for me. And I told Evans that at the opening.

ERROL MORRIS: *One* photo?

WILLIAM STOTT: The Gudgers on Sunday. When I said that to Evans, he became a little bit interested in me. And he accepted my invitation to come to dinner about three or four months after that.

ERROL MORRIS: What was it about just seeing that photograph?

ILLUSTRATION #101
GUDGERS ON SUNDAY

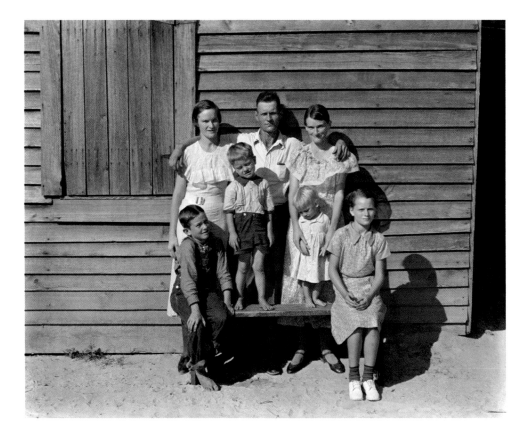

WILLIAM STOTT: It just went against the view that *Let Us Now Praise Famous Men* gives of him [George Gudger]—a beaten-down, not terribly bitter yet but you know he's going to be bitter soon, defeated man. Here you see this photo that's *not* in the book—and George Gudger is just radiating life and virility and joy. And that was what Agee and Evans were supposed to be saying about these people. They were real human beings. And yet they [the publishers] hadn't been willing to give them that measure of humanity. The photo of the Gudgers on Sunday goes too far in suggesting that, "Hey, these are real people. These people are okay. We don't need to worry about them."

ERROL MORRIS: Is this because Evans was supposed to adhere to an aesthetic idea, an American Gothic idea?

ILLUSTRATION #102
GUDGER WITH TENGLE CHILDREN

This photograph, also not in the book, of Gudger with the Tengle children clearly shows their poverty.

WILLIAM STOTT: Yes. It is about the kind of expression people are supposed to wear in documentary photos dealing with social problems.

ERROL MORRIS: This whole idea that Walker Evans conveys to you, that you must not move anything, you must not disturb the "reality of a scene," or the Evans quote, which I like very much—

WILLIAM STOTT: "God made that. I wouldn't change it."

ERROL MORRIS: God made that, yes. Where does that idea come from? Is it part of the era? Or something that goes much further back?

WILLIAM STOTT: Evans was fighting Stieglitz [Alfred Stieglitz, who popularized the idea of photography as a pure art form] and the whole pictorial school of photography. In the period before World War I photographers created very theatrical works where people would get dressed up and pose as though they're an Aztec god or whatever.

ILLUSTRATION #103
AZTEC WARRIOR

Evans would say that his vision came from the modernist writers, surprisingly, Joyce and Hemingway. If you look at his "Brooklyn Bridge," which Evans did because Hart Crane had liked his photography, the photographs are not really typical Evans at all, because they heroicize the bridge.

ILLUSTRATION #104
EVANS'S "BROOKLYN BRIDGE"

But his other work from the late 1920s is just right on—his vision of the untampered beauty of the made world. Not the natural world, but the made world. He always said that he enjoyed living in nature, but nature bored him as a subject. But what man did, what man had fashioned, fascinated him. You also have something that nobody has connected Evans with—the whole purist aesthetic in American art. Ralston Crawford who paints the Whitestone Bridge in the late 1940s. And you have Charles Sheeler. The world is beautiful; you don't manipulate it to find the beauty.

One thing that Evans is famous for saying is what matters in photography isn't the camera, it's your eye. It's seeing what's beautiful. And he himself really didn't have all that much interest in photography at the end of his life. He was collecting things. He just liked collecting junk. And I write about this. You went into his house and you'd have to push the junk aside on his bed for him to lie down and go to sleep at night. He said it was a kind of sickness with him. He much preferred the handmade stuff. But he believed that even machine-made clutter, if you kept it around for a long time, became beautiful, too. And it may simply have been the day I happened to be with him on the beach. He would pick up flotsam and jetsam from the beach. And one of the things that we brought home was a fireman's glove, or some kind of very specialized plastic glove, that would be used for handling dangerous

or hot material. It had washed up on the shore. And it was hideous. He was always in favor of waiting thirty years with photographs. He said after thirty years you will know what you have there. And maybe his feeling was, if you held that for thirty years, you'd have something that was beautiful, too.

ERROL MORRIS: It's a question that reappears endlessly in the history of photography—the relationship between a photograph and reality. And photographers—they have themselves to blame—designed these *rules* to bring a photograph into correspondence with reality. The *rule*: You don't mess with what God has created. You observe; you don't interact. You don't touch anything.

But the minute you take one picture as opposed to another, or the minute you *select* one photograph from a group of photographs, you are doing something very, very similar to manipulating reality. It may not be the same as picking up an object in a home and removing it or taking something out of your pocket and putting it on a table. But you are *selecting* images—as in the case of Walker Evans and the Gudgers. You are selecting certain photographs for *Let Us Now Praise Famous Men*, and you are editing out other photographs that may not support the ideas that you want to present. Why is that so different in kind from taking something out of your pocket or moving something that you see in a bedroom or in a living room from one place to another and then photographing it?

WILLIAM STOTT: You've answered your own question. They're two different things [scene or photo selection versus adding or moving objects within the frame]. I'm reminded of Dorothea Lange's portraiture. She earned her living as a portrait photographer for a while. And she would tell people when they came to be photographed, "Wear old clothes." But she didn't say what kind of clothes. People could choose which old clothes they wanted. She had a feeling that you wanted to present things so that the immediacy of now was not shockingly visible. You wanted to have something that seemed to have a patina of history about it. What was so shocking about that Day-Glo orange glove that Walker picked up was that it just screamed of artificiality. God almighty, why would Walker Evans pick that up? Well, let me tell you another little anecdote. He came down and he stayed with my wife and me for a couple of days. And then we put him in a hotel that was right by campus. I was walking around with him a lot. He was very old by this time, because he'd had half of his stomach taken out, very stiff, had trouble bending down. There was at this time a movie theater that gave out brightly colored paper tickets. There were some of them on the ground. And I could see he was stopping to decide which he would pick up. And I, being in my thirties and spry, went over and picked up one and came to hand it to him. And he had stooped and picked up another. And he said to me, "You don't get the right one, do you?" When I packed up his things for him to go back, he had squashed beer cans that had nicely

eroded. They were not the current, very thick aluminum cans. They had a patina of history on them. It was just an appetite for actuality that he really had. He just thought these things were lovely. He didn't care that anybody else thought they were. He would not have gone into the miner's house in West Virginia and taken out the Santa Claus poster, even though that Santa Claus poster was howlingly wrong. Maybe this is where he used that quote: "I come across something that's a howling error in composition and I leave it there. God made it, you know? That's something God made. I wouldn't change it."

ILLUSTRATION #106
SANTA CLAUS IMAGE

Now Curtis probably can find places where he did change things—Evans would say he was willing to rob a bank to be able to pursue his art. But I don't know. He cropped his photos. And he cropped them specifically because Stieglitz didn't. He wanted to do everything different from Stieglitz. **ERROL MORRIS:** But aren't all photographs cropped? When you take a picture, you're cropping it by nature of picking one frame over another. The whole act of creating a photograph is an act of cropping reality. The "secondary" cropping where you take the negative and you pick some area that you like for the photograph is secondary to the first act, which is the act of tearing an image from the fabric of reality.

WILLIAM STOTT: Absolutely. Evans would absolutely agree with that. And he saw nothing bad about cropping. If you think of the beautiful image of Mrs. Tengle, who dressed all her kids in the same fabric that she bought a lot of—Agee writes about this.

But there's this wonderful thin picture of her, her so thin. It's cropped out. Evans crops a long rectangle top to bottom. She has this look—terribly shy, terribly frightened diffidence. But it is a regal look at the same time. It's an amazing, amazing picture. But there are people behind her, little bits of their bodies that he's cropped out. It would never have occurred to him to white that out, to blur out the rest of the world that he'd cropped away, even though he left these partial pieces of people. Very awkward if you think about it. But that's the world she belonged in. He wouldn't, as a newspaper photographer or portrait taker would do, put white-out over that, as they did in newspapers of the 1930s and 1940s, just to highlight the one thing you wanted.

ILLUSTRATION #107
MRS. TENGLE (TORN AND CROPPED PHOTOS)

ERROL MORRIS: I once tried to come up with a definition of art. Always a risky enterprise. But the best I could come up with was: *create an arbitrary set of rules, and then follow them slavishly.* You set up an idea of what you should and you should not do, and then you strictly adhere to it. You try to develop a worldview or an aesthetic, however you want to describe it. Maybe it's even an idea of rectitude. You are clearly irritated by Curtis's claim that Walker Evans was lacking in a kind of rectitude. It's explicit in your review—that he wanted to sort of lump everyone in the same category. Walker Evans is like Arthur Rothstein who is like Russell Lee who is like everybody else. There are no distinctions to be made. But you see Rothstein differently. Rothstein is the out-and-out manipulator. Is that how you would distinguish between Walker Evans and Rothstein?

WILLIAM STOTT: Well, Rothstein was a media person, as he demonstrated later on, and a successful one. Evans didn't live a happy life. Evans didn't have the kind of success until his last years, and even then, that Rothstein did. For a long period of time, Evans couldn't earn a living as a photographer.

ERROL MORRIS: God knows what one of those pictures sells for today.

WILLIAM STOTT: Evans sold all his photographs that he had to a Chicago dealer—I forget the name of the guy—just before he died for $100,000. It's so strange because history and taste are so strange. And the way we narrow what happened down to a few precious artifacts is so strange.

ERROL MORRIS: These photographs function on so many different levels and mean so many different things to different people. Are they fine works of art? Are they documentary photographs? Can they be both? How much can a photographer interfere with a scene before it's no longer a documentary photograph? When do you cross the line?

You know, someone sent me a book of photographs of an old mental hospital. Many of the photographs were done by Arthur Rothstein in 1939. You look at the photographs and they don't look right. They set up a series of questions: "What am I really looking at here?"

ILLUSTRATION #108
MENTAL HOSPITAL PHOTOGRAPH

And then you read in the back or in a footnote that the photos were done without the real mental patients, but with nurses, doctors, and some actors—

WILLIAM STOTT: Playing mental patients?

ERROL MORRIS: Playing mental patients. And so I thought, this is indeed interesting. It is like the cow skull all over again.

ILLUSTRATION #109
"PRISONER"

Stott has brought us back to Rothstein and the original controversies about posing. Over the years, from 1936 to shortly before his death in 1985, Rothstein provided many different accounts of how his famous photographs were taken. They progress from a story of controlled, posed images to completely uncontrolled, unposed images. Rothstein's changing accounts of how he took his most famous images suggest that he might have *posed* his own stories about posing.

ILLUSTRATION #110
ROTHSTEIN'S DUST STORM

In Rothstein's account of taking "Fleeing a Dust Storm," which appeared in *The Complete Photographer* from April 1944, he sounds like a director posing actors:

The repetition of a scene before a different background with some changes in gesture or direction of movement will sometimes result in a more effective picture. The picture of a farmer and his sons in a dust storm was controlled in this way. The little boy was asked to drop back and hold his hand over his eyes. The farmer was asked to lean forward as he walked. Finally, the whole scene was made to take place in front of the shed. This showed the effect of the dust storm and the poverty of the farmer more clearly than the other buildings.[9]

ILLUSTRATION #111
ARTHUR ROTHSTEIN

In his writings from the 1940s, I can feel Rothstein wrestling with ideas of narrative consistency versus truth and storytelling versus objectivity: "Provided the results are a faithful reproduction of what the photographer *believes* he sees, whatever takes place in the making of the picture is justified."[10] His meaning is overwhelmingly clear. Photographs concern belief, not truth.

Over time his story changed.

In September 1961, in an article Rothstein wrote for *Popular Photography* called "The Picture That Became a Campaign Issue," the dust storm photographs are no longer described in the same way.[11] They are *not* directed. They are pure, undirected documentary photographs.

It was in Cimarron County, in the middle of the Oklahoma Panhandle, that I found one of the few farmers still on his land. A single cow stood forlornly facing away from the wind in a dusty field. The building, barns, and sheds were almost buried by drifts and in some place[s] only the tops of fence posts could be seen. I decided to photograph this scene.

DUST FILLS THE AIR

While making my pictures I could hardly breathe because the dust was everywhere. It was so heavy in the air that the land and the sky seemed to merge until there was no horizon. Strong winds raced along the flat land, picking up the sandy soil and making my hands and face sting.

Just as I was about to finish shooting, I saw the farmer and his two sons walk against the fields. As they pressed into the wind, the smallest child walked a few steps behind, his hands covering his eyes to protect them from the dust. I caught the three of them as they neared a shed. . . .

In contrast, Rothstein goes on in the same article to explain how he purposefully composed the image of the cow skull. He makes it clear that in this instance, he was not recording a scene exactly as he found it.

MAKES HIS SKULL SHOTS

After leaving the Dust Bowl I went north to the Dakotas where I took the picture that was to figure in the election campaign of 1936. It was dry there too, for there had been little snow and even less rain. The Federal Government was buying the Bad Lands for a national park. There was no water for livestock, and the bones and skulls of many animals could be seen around dried-up water holes on the parched pasture lands.

I found a sun-bleached skull and photographed it against the cracked earth in Pennington County, S. Dakota. Experimenting with textures and shadows, I took many pictures and then moved the skull about 10 feet to a grassy spot near some cactus where I could get another effect.

In 1944, Rothstein is busy directing the farmer and his sons; in 1961, he happens to catch them at just the right moment. And there is a clear differentiation between directing people and posing inanimate objects; Rothstein readily admits to moving the cow skull "about 10 feet" to get another effect.

Still, the controversy of the skull photo dogged Rothstein. He attempted to clear up the discrepancies and lay the issue to rest in an article in *The Complete Photographer* that appeared in 1978, in which Rothstein explicitly denies that the "Fleeing a Dust Storm" was posed:[12]

I have always believed in the necessity for truthfulness and honesty in photography and I know that my pictures have been effective because of their

believability. Therefore, it is important to discuss a misunderstanding about one of the most widely reproduced photographs of my career, *Dust Storm Oklahoma*, 1936.

In 1942, I prepared an article for *The Complete Photographer*, a mail-order encyclopedia, on the subject "Direction in the Picture Story." I described the work of several photographers and the methods they used to make their photographs more meaningful. In order to make a point, in my original manuscript, I described a hypothetical situation. "The picture of a farmer and his sons in a dust storm could have been controlled in this way. The little boy might have been asked to drop back and hold his hand over his eyes. The farmer could have been asked to lean forward as he walked."

In fact, I did none of this. The photograph was unposed, not staged, the action was not changed. It is impossible, besides, in a blinding, roaring dust storm to exercise any control over the scene. It was an unfortunate example.

When the article was published, the editor, in order to make the point more effective, had changed my words from a conditional subjunctive mood to an indicative past tense. At that time, I was covering assignments for the Office of War Information and not available to correct the copy.

Rothstein's assertion that his editor had changed his copy "from the conditional subjunctive to the indicative past tense" is at odds with his earlier accounts of how he posed the picture. Were his changing accounts the product of changing ideas about what was "politically correct" in photojournalism? Did he feel it was now essential to claim objectivity, even if the claim made no sense, failed to guarantee objectivity, and contradicted earlier accounts?

Rothstein goes on to "set the record straight":

Since this statement has surfaced several times, recently, let me set the record straight.

My photograph of Arthur Coble and his two sons, Milton and Darrel, was not posed. It is a truthful and accurate representation of the scene. Incidentally, Darrel Coble, now 45 years old, is still living in Boise City, Oklahoma.

The misunderstanding about this picture demonstrates that just as the photograph in its visual sincerity may influence the viewer, so does the printed word carry the power of persuasion. Another of my photographs, for many years, was falsely labeled a fake and a hoax. Without my permission, it was published in a book, *Great Hoaxes of the World*. A senator from Iowa waved it aloft on the Senate floor as an example of fake Government propaganda. This was a picture that I made in Pennington County, South Dakota of a sun-bleached cattle skull on the cracked earth of a dried-up water hole. At the time, I made many exposures, experimenting with textures and shadows.

. . . The picture was honest but the caption written by the A.P. editor was in error. It is interesting that two of my most published photographs, recognized as works of art by many museums around the world, have been the subject of such controversy. Both photographs were accurate and truthful. The words, written or edited by others, in conjunction with the photographs, were wrong and incorrect.

The lesson to be learned is that a photographer must be aware of and concerned about the words that accompany a picture. These words should be considered as carefully as the lighting, exposure and composition of the photograph.

Just as Rothstein's accounts of taking the photographs changed over time, the images themselves changed through the years. In a 1964 interview with Richard Doud, Rothstein offered an analysis of how "Fleeing a Dust Storm"—its very meaning, its purpose—had altered over time.

ARTHUR ROTHSTEIN: Well, when my picture of the dust storm was printed widely, over and over and over again, it made people realize that here was a tragedy that was affecting people—it wasn't just affecting crops, but it was affecting people—the relationships between the dust storms and the migrations of people out of this part of the United States and the way it was affecting them individually. This photograph had a great deal of influence on people in the East, for example, who had no contact and no sense of identity with this poor farmer walking across the dusty soil on his farm in Oklahoma—it gave him a sense of identity. . . . This picture was not controversial; it was informative—the dust storm picture. In the beginning, it was a record; after that it became a news picture, it then became a feature photograph, eventually it became a historical photograph, and now it's considered a work of art in most museums. It's a picture that went through a kind of evolutionary process all by itself. It has a life of its own.

Throughout all these discussions of the aesthetics of FSA photography—posing, fakery, and the like—it is all too easy to forget the lives of the people who were photographed. A conversation I had with a photographer named Bill Ganzel from Lincoln, Nebraska, reminded me of this.

In 1974, Ganzel went on a road trip to track down the people and scenes that the FSA photographers had taken during the 1930s. For seven years, he carried copies of photographs by Arthur Rothstein, Walker Evans, and others across the country searching for the people in the photographs, whom he then interviewed and rephotographed. In 1986, he published his work in *Dust Bowl Descent*.

BILL GANZEL: When I was in college, I saw an exhibit at the Sheldon Memorial Art Gallery—which is on the University of Nebraska campus—of FSA photographs and was just really taken with the way that they brought down to day-to-day living what the big historical event, the Depression, was all about. I was looking at Migrant Mother's face and saw desperation. I started doing some reading about that. My family was going back to Washington, D.C. We got an aunt who lives there, lives in D.C. And somewhere I came across the information that all these photographs were in the Library of Congress. And I thought, well, rather than doing the tourist stuff that I'd done before, I wonder what it would be like to go to the Library of Congress? I did. I was a college student coming in and claiming to be a researcher, and they bought it. They said, "Okay, yeah. Come on in. Sign these forms, and you can look at the photographs." I don't know whether you've ever been to the FSA room. At least what it was like then was that it—just file cabinet after file cabinet. And you can sit there and flip through photographs. There are eighty thousand photographs in the collection. Obviously I never got through the entire collection. But I decided to look at a local area, the Great Plains. And then what was I going to do with those photographs when I came back? I had photocopied some of the photographs just to have them. And somehow thought, "Well, okay, I can go out for a weekend or whatever. And maybe I can find the same place, just to see how it changed."

ILLUSTRATION #112
MAN AND BARN IN DUST STORM

Believing Is Seeing
174

I started with Nebraska, but the project existed in my mind for ten years and ended up taking a lot of time and fifty thousand miles of driving. It started out—just finding the same places. And then, oh, man, what would it be like to find the same people? What happened to them? It just seemed like a logical no-brainer idea. And coincidentally, about the same time that I got really serious about my project the "re-photography" folks, Mark Klett and other guys, were starting their projects. [Mark Klett and his artistic partner, Byron Wolfe, have been involved in a lifelong project to re-photograph many of the famous photographed landscapes of the past—essentially, to document how things change over time.][13]

**ILLUSTRATION #113
TWO TREES**

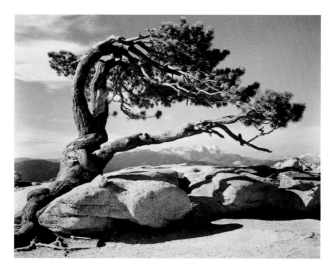

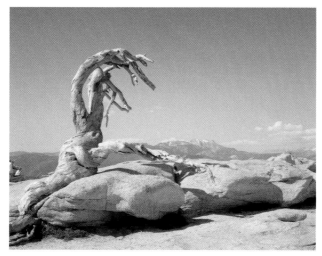

The Case of the Inappropriate Alarm Clock

ERROL MORRIS: But you didn't know about any of that when you first started.

BILL GANZEL: Not when I first started, no. It just seemed logical. It just seemed compelling to me.

ERROL MORRIS: Also the Klett material is really about landscapes, not about people.

BILL GANZEL: Yeah, exactly. And that's one of the differences. Their whole thing was to be very scientific, that if you got in the *same* tripod sticks—in the same time of year, same everything. There was one pair of photographs that showed these standing rock formations. And he said, "Right *behind* our camera position there was a suburban development." And the photograph, because they had to be in the same tripod sticks didn't show that. To me, the suburban development was a story. But their photograph didn't show it. It showed wilderness. You could read it still as wilderness. But the reality was, right behind the wilderness was suburbs.

ERROL MORRIS: Did they take another picture that showed the suburbs?

BILL GANZEL: No. They took the picture, but it wasn't the suburb photograph that I would have shot. And I'm not necessarily criticizing them or anything. I'm just saying it's a difference of approach. Theirs was scientific. Mine was documentary. Mine was humanistic. That's what got me intrigued with the FSA. The FSA focus was humanistic and much more documentary.

ERROL MORRIS: Documentary in the sense of documenting *people*?

BILL GANZEL: And beyond that. If you look at what Stryker was after. He was the guiding light of the collection. He talked about wanting to make an encyclopedic collection of America in the middle of the Great Depression. And so his shooting scripts were always talking about, "Well, this region is . . ." "This is the sociology. This is the economy. These are the people. These are the institutions of this region. These are the photographs you need to get. Oh, and by the way, maybe you need to photograph some of the FSA clients or some of the things that the standard propagandists would do." I wanted to reconnect with the people.

ERROL MORRIS: Yes. I can tell you about my favorite photograph in your book. It's the little boy—now a middle-aged man—underneath a painting of Rothstein's photograph. There is something so strange about this image being reinvented and re-created, and re-created once again in your photograph years later with the painting of the photograph behind him.

ILLUSTRATION #114
BOY IN DUST STORM

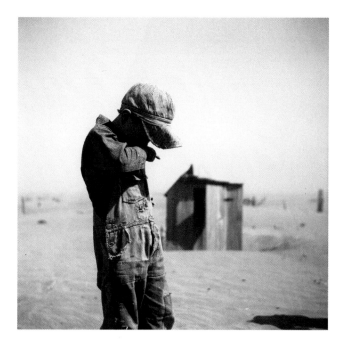

ILLUSTRATION #115
YOUNGER BROTHER IN DUST STORM

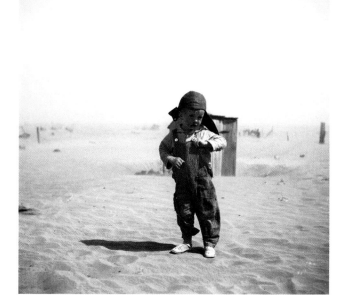

The Case of the Inappropriate Alarm Clock

ILLUSTRATION #116
DARREL COBLE

BILL GANZEL: Yes. That's Darrel Coble. This was pretty early on in the process for me. I wasn't aware that Rothstein had tracked him down already in the 1960s. Arthur had gone back to Darrel. And it happened to be a pretty wet year. In *Look* magazine, they did a then-and-now pairing that Arthur shot.[14] And it has Darrel with a lot of greenery around him, a lot of lush plants around him. Anyway. It didn't have any names with it. And so I thought, "How the hell am I going to find this guy?" And I thought, "Well, a lot of the county agents, they know a lot of what goes on in these counties."

ILLUSTRATION #117
THE DUST BOWL TURNS TO GOLD

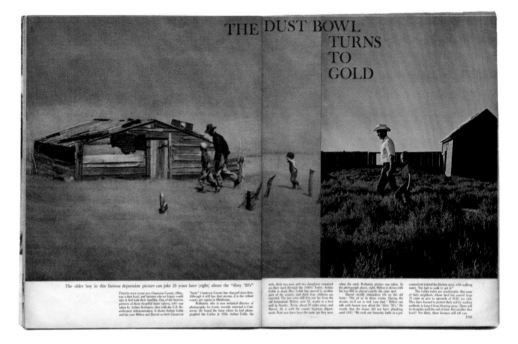

And so I called up the county agent. I got a secretary. The county agent wasn't in. And she says, "Can I help you?" And I said, "Well, yeah, okay. There's this really famous photograph of a kid." Before I even got through with my description, she says, "Oh yeah, that's Darrel Coble. He lives out there. Here's his phone number. He's a nice guy. Call him up." She knew all about it because of the photograph and because it had been published. He had become that minor celebrity in the county because of the photograph. And so I called Darrel up and he was very nice. And the painting there was painted by a local artist. And my memory of that story was—I don't think I've got it on tape—but he said the artist, she just did it on her own and gave it to him.

ERROL MORRIS: It's so interesting.

BILL GANZEL: Yes, and I love his quote: "My dad always used to say, 'If you wear out two pairs of shoes, you'd never leave.'" It's been forty years on. *Look* is now in the Library of Congress. All the collection is in the Library of Congress. And it's finally available, because they've got them catalogued.

ERROL MORRIS: I'm surprised that Rothstein himself wanted to go back.

BILL GANZEL: Yes. And way before Rothstein did that, John Vachon [another FSA photographer] did that as well. The Walker Evans and the John Vachon [photographs] taken a couple of years apart.

The Case of the Inappropriate Alarm Clock

ILLUSTRATION #118
MOVIE POSTERS 1

ILLUSTRATION #119
MOVIE POSTERS 2

ERROL MORRIS: It's a different world. The movie posters have changed. [Ann Shirley in *Chatterbox* and Carole Lombard in *Love Before Breakfast* have been replaced with the Ritz brothers in *Kentucky Moonshine* and Robert Donat in *The Count of Monte Cristo*.] In a photograph, you're trapped in this one timeless instant of time. And when you break through that barrier, however you do it, whether it's by taking a photograph of that same scene, whether it's from the same tripod position or not, but of that same scene in such a way that you can record or you can register—

BILL GANZEL: The change.

ERROL MORRIS: Yes. The change, the impermanence of it, the awareness that it's different, palpably different . . .

BILL GANZEL: You're kicking off a number of different thoughts. I worked for Nebraska Public Television and learned how to be a documentary filmmaker. And so when I got into this project and when I started thinking about this *Look* project there was a decision point of: How do I approach it? Do I really want to do this as a still photography project? Or is this something that should be done on film? Or done on video now, obviously. And for me, the permanence that you were talking about and the pairing of that, of those two moments, it has more power for me. And yet I want to augment that with the oral history interviews that I'm doing on videotape.

ERROL MORRIS: Were you surprised, going in and seeing the painting on the wall?

BILL GANZEL: To be honest, I don't remember exactly. But I was obviously taken by it. Because that's what I chose to photograph him in front of. So I don't specifically remember being surprised by it. I must have been, if that makes sense.

ERROL MORRIS: Yeah. It's my favorite image in your book. It reminds of the power of images, about fathers and sons, about the adversity of the dust bowl, about the distance in time that separates us from events in the past— and all of that hovers around him in your photograph.

BILL GANZEL: Yes, the thing is—I'm thinking about "Migrant Mother" now. It's as if, when I take my photograph up against the iconic depiction of desperation—I don't know—it changes the meaning.

**ILLUSTRATION #120
"MIGRANT MOTHER"**

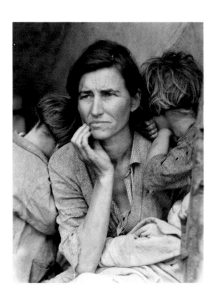

The Case of the Inappropriate Alarm Clock

You know what I'm saying? It negates the desperation. Because here she is in a suburban backyard, which we've got to remember was not her backyard. That's actually [her daughter] Katherine's backyard. And they look fairly well off. And they were definitely much more comfortable than they were in the 1930s. [The photograph is of Florence Thompson, who was identified as the Migrant Mother, shortly after Lange's picture was taken, and her three daughters—the same three children who appear in the original photograph—Norma Rydlewski in front, Katherine McIntosh on the left, and Ruby Sprague.]

ILLUSTRATION #121
MIGRANT MOTHER AND DAUGHTERS

But the other thing to remember—actually the family told me this outside of the interview. At one point, they had bought Florence a suburban house as well. And she hated it. She went back to the trailer. And for me, that's really symbolic because she literally wanted to have wheels under her. This is purely conjecture on my part, but it seems to me the wheels under her are symbolic. "If the hard times come again, I can get up. I can move on. I can survive."

Bill Ganzel interviewed Florence Thompson about her life on the road in the 1930s.

FLORENCE THOMPSON: I left Oklahoma in 1925 and went to California. The Depression hit just about the time them girls' [her daughters'] dad died. I was twenty-eight years old, and I had five kids and one on the way. You couldn't get no work and what you could, it was very hard and cheap. I'd leave home before daylight and come home after dark—grapes, 'taters, peas, whatever I was doing. Barely made enough each day to buy groceries that night. I picked cotton in Firebaugh, when that girl there was about two years old, I picked cotton in Firebaugh for 50 cents a hundred. . . .

BILL GANZEL: How much could you pick in a day, then?

FLORENCE THOMPSON: I generally picked around 450, 500 [pounds of cotton every day]. I didn't even weigh a hundred pounds. I lived down there in Shafter, and I'd leave home before daylight and come in after dark. We just existed. Anyway, we lived. We survived, let's put it that way. I walked from what they called a Hoover campground right there at the bridge [in Bakersfield]. I walked from there to way down on First Street and worked at a penny a dish down there for 50 cents a day and the leftovers. Yeah, they give me what was left over to take home with me. Sometimes, I'd carry home two water buckets full. Well, [in 1936] we started from L.A. to Watsonville. And the timing chain broke on my car. And I had a guy pull it into this pea camp in Nipomo. I started to cook dinner for my kids, and all the little kids around the camp came in. "Can I have a bite? Can I have a bite?" And they was hungry, them people was. And I got my car fixed, and I was just getting ready to pull out when she [Dorothea Lange] come back and snapped my picture.

———

ERROL MORRIS: All of these controversies that have swirled around the Rothstein photograph, did you address that with these people?

BILL GANZEL: The controversy that I'm assuming you're talking about is the skull photograph.

ERROL MORRIS: The skull photograph is one example. But there were similar questions raised about the picture of the dust storm, the picture of the farmer and the two children.

BILL GANZEL: To be honest with you, I'm not aware of that controversy. Who was raising those questions?

ERROL MORRIS: There's a book by James Curtis called *Mind's Eye, Mind's Truth* where he makes the claim that "Fleeing a Dust Storm" was posed or set up. That it was a fake photograph.

BILL GANZEL: Maybe Curtis is making the argument that at that particular time or that particular day, it wasn't as windy or it wasn't as dusty or whatever—

ERROL MORRIS: Yes.

BILL GANZEL: There's no one that can deny that the dust was in the air. Darrel would have stories of what the dust was all about or how the dust affected them. For instance, when his dad got caught out in the dust storm one time and couldn't find his way back because the dust was so thick, he finally came across one of their barbed-wire fences. And he followed it back to the chicken coop and went inside the chicken coop to keep out of the dust. So whether that particular day was exactly as dusty as it looks like in the photograph, I'm not concerned with. It portrays a larger reality. And the thing about the skull, I talked with Rothstein. Okay. He talks about moving it *ten* feet. Yeah, he moved it. Big deal. He chalks it up to a miscaption.

ERROL MORRIS: These controversies persist in photography. And the more famous the photograph becomes, the more likely people are to find fault with it or to question its "authenticity."[15] The Rothstein photograph is a great photograph. It's an iconic photograph. It's a photograph that will be around for a long, long, long time and captures something so powerful that Coble's son had a painted facsimile of the photograph on the wall behind him. Photographs may be *taken*—but we are also taken in *by* them. Rothstein created this great image. Are the critics saying that these weren't real people? That this isn't his chicken coop, that that isn't his land, that he never was in a dust storm on the Plains?

BILL GANZEL: Right. For me to be able to go back and talk to these guys and to actually hear those stories about what they experienced, to flesh out the story, that just became so powerful that I felt like I had to do that. There was a real dichotomy when I talked with Darrel. On one hand, I expected him to tell me it was terrible times. And he did. One quote I discounted. He said, "We didn't know whether or not the world was going to come to an end." And I thought, wow, that's really hyperbole. I don't think I'm going to include that. But then I read *The Worst Hard Time*, and he said, "This was the first time that anybody had experienced that drought or these dust storms. And so people did not know whether the world was going to end." I realized I had other people in interviews who were saying the same thing.[16]

ERROL MORRIS: Would you describe your project as an attempt to get *inside* of a photograph?

BILL GANZEL: I would say it slightly differently. I would say "go *behind* the photograph," or "*extend* the photograph."

ERROL MORRIS: To put it in *history*, to uncover an unseen context?

BILL GANZEL: Absolutely.

The editors of the *Fargo Forum*, scholars James Curtis and William Stott, photographer Bill Ganzel, and even Rothstein himself, all saw Rothstein's photographs in radically different ways. Is one right? Are the others wrong? I don't think so. Their views show the many different ways that a photograph can be seen and the different functions it can serve: as staged propaganda, documentary evidence, and fine art. A photograph can capture a patch of reality, but it can also leave a strange footprint: an impression of an instantly lost past around which memories collect.

For some reason, this controversy makes me think of the myth of Orpheus, and the attempt to bring the dead back into the world of the living. But in Orpheus, there is a warning. To return from the underworld, Orpheus must walk in front of Eurydice and *never* look back. Eternally trapped in the present, we are doomed to perpetually walk "in front" of the past.

A dust storm can be real or imagined. In one sense, it matters whether the storm is real; in another, all that matters is the image, which extends through time, the memory of the storm. In the 1930s, it was a plea for help; now it is a story of triumph over adversity. We see the father and his two sons hunkered down, heading toward the chicken coop. It is an image that defines the boy, his brother, and his father. It becomes part of how the boy, now grown, sees himself and his family. It becomes his connection with a father who is no longer alive. It is not just *that* day that is captured in the photograph; it is how *he* has come to see his childhood. And how we have come to see an entire era. It brings time forward, but also compresses it, collapses it into one moment. It is the idea that the photograph captures that endures.

Postscript

James Agee's manuscript for *Fortune* magazine was recently discovered and published in book form in 2013. A footnote on page 89 resolves the mystery of the alarm clock:

> Though each family has a low-price alarm clock and as a rule keeps it wound and is respectful of it, the clock is almost invariably an hour or two fast or slow, and they are innocent of any time except the sun's.

I would like to thank reader Ash Carter for bringing this to my attention. As he points out:

"This would appear to solve all three mysteries of the clock:

1) Why Agee never mentioned the clock (he did);
2) Why the Gudgers needed an alarm clock at all (they didn't);
3) And why the alarm was set to 8 a.m. (it wasn't, not really)."

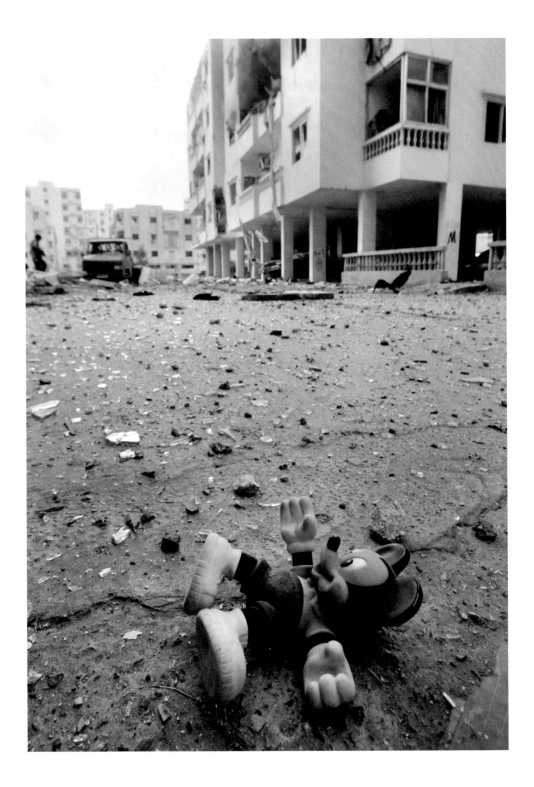

It All Began with a Mouse

*We wanted something appealing, and we thought of a tiny bit of a mouse
that would have something of the wistfulness of Chaplin—a little fellow
trying to do the best he could. When people laugh at Mickey Mouse, it's
because he's so human; and that is the secret of his popularity. I only hope
that we don't lose sight of one thing—that it was all started by a mouse.*

—Walt Disney

ILLUSTRATION #122
MICKEY IN RUBBLE
(opposite)

There he is, lying in the ruins of a bombed-out apartment building. Mickey Mouse,
splayed, limbs akimbo, surrounded not by the denizens of the Magic Castle, but a
bleak war zone landscape of rocks, shards of glass, a dark red truck, a couple of
people in the distance, but otherwise devoid of humanity. The caption to the photo-
graph reads:

> A child's toy lies amidst broken glass from the shattered windows of an
> apartment block near those that were demolished by Israeli air strikes in Tyre,
> southern Lebanon, Monday, Aug. 7, 2006. Israeli bombs slammed into a
> complex of buildings flattening four multistoried apartment blocks, including
> the one apartment that had been the target of Saturday's Israeli commando
> raid, whilst a civil defense ambulance was hit in the rear and slightly dam-
> aged with emergency workers who had gone to the bomb site to search for
> bodies being forced to flee. (AP Photo/Ben Curtis)

The implications of the photo may depend on our politics, but it created a controversy when it was published. Did the photographer have an agenda? Is it anti-Israeli propaganda? Bloggers accused the photographer of deliberately placing the toy in the war zone.

And yet, the Mickey Mouse photograph is not unique. A blog post, *The Passion of the Toys*, collected a number of similar wire service photographs of other toys taken in southern Lebanon. The sheer number of toys photographed seems to suggest that some of the images could have been staged. Among the photographs are a Minnie Mouse and an assortment of non-Disney toys, taken by Reuters photographers (Sharif Karim, Issam Kobeisi, Mohamed Azakir, among others), and one photograph with a Mickey Mouse in Tyre, Lebanon, by an Associated Press photographer (Ben Curtis). Why are there so many similar photographs? How did all these toys come to be photographed? What is the viewer supposed to infer from such a scene? Is it simply that the *idea* of children and their toys ratchets up the drama of a war photograph? The juxtaposition of innocence and destruction in one image? Is it just anti-war? Or is something more sinister involved? Is it disguised propaganda with a definite bias toward one side or another?

I wanted to speak with all the "toy photographers," but found that only Ben Curtis, AP's chief photographer and photo editor for the Middle East, was willing to be interviewed.

(Note: This interview was done in 2007. More recently, I asked the Associated Press about the possibility of interviewing David Guttenfelder, an AP photographer embedded in northern Israel during the same time period—essentially, Ben Curtis's counterpart. I was concerned that I had not provided balance by interviewing a photographer covering the other side of the conflict. Unfortunately, I was told by AP corporate relations that such an interview would not be possible.)

ILLUSTRATION #123
MULTIPLE TOY PHOTOS

Ben Curtis, AP

Sharif Karim, Reuters

Sharif Karim, Reuters

Sharif Karim, Reuters

Issam Kobeisi, Reuters

Mohamed Azakir, Reuters

It All Began with a Mouse

ERROL MORRIS: The first time I noticed your name in a blog was in connection with toys. Can you tell me about the photo you took with Mickey Mouse during the Israel-Lebanon War?

BEN CURTIS: It was after there had been a bunch of strikes on a housing estate in Tyre, that the Israelis had said was housing for Hezbollah operations. Very large strikes. We'd been outside the hospital in Tyre when we heard these huge explosions, and we could see smoke not too far away. We hit the ground. About ten, fifteen minutes later myself and a bunch of other journalists headed up to the scene, where a couple of multistory apartment buildings had been completely flattened. And one of the pictures I took was a toy Mickey Mouse that was in the street. A number of blogs were suggesting that it had either been put there or moved there, or placed in the middle of the street, which of course it hadn't. The buildings that hadn't been flattened but were directly opposite, half the contents of the apartments had been strewn into the street. There were sofas; there were children's toys; there were books — all sorts of the usual things that you have in an apartment were scattered everywhere. Now, interestingly, when I sent that photo, the editors on the AP desk called me up and said, "Ben, we have to ask, was that toy there when you arrived? Was it moved? Was it placed there? Was it altered in any way, either by yourself or by other media?" These are the questions that, as an editor, you sometimes have to ask your photographers. Even if you have great trust in your people in the field, sometimes you have to go through asking those questions to make sure that what we put out is accurate.

ERROL MORRIS: So the call was routine?

BEN CURTIS: As an editor, if you have any suspicions at all about an image, you call up the photographer and say, "Okay, what happened? Where were you?" You interrogate the people in the field. As a photographer, when I write my captions, I'm very meticulous and methodical, and I go through and check them before I send them, and I have to establish to my own satisfaction that everything I've said in the caption is true, and that I can stand by it because I've witnessed it myself with my own eyes, or I've questioned the people in the field and I'm confident that I can stand by that information.

ERROL MORRIS: Do you remember the caption that was put on the Mickey Mouse picture?

BEN CURTIS: I don't, but it was after the Reuters incident.

ERROL MORRIS: The Reuters incident was the photoshopped photograph?

ILLUSTRATION #124
BEIRUT, LEBANON, JULY 26, 2006

BEN CURTIS: The manipulation of the smoke over the Beirut skyline, and then subsequently they also found a photograph where it was an Israeli F-16 flying overhead, and he'd cloned in another F-16, so there were two, whereas there had only been one. But after the smoke incident I instructed our Lebanese photographer to call every single stringer who was working for us in the country to remind them that any technical manipulation or inaccuracy of information or telling us things that they think but are not sure about—that if something inaccurate goes out and it's found out to be inaccurate, they're going to be fired, and they won't work for us again. But technical solutions are never going to be the one and only solution to the problem. At the end of the day, it comes down to the ethics of the people who work for you and the trust that you have in them.

ERROL MORRIS: The good example, of course, is the Mickey Mouse photograph, because it is *not* a photograph that has been manipulated in Photoshop. And yet people find it problematic, regardless.

BEN CURTIS: Photoshop manipulation is one thing; caption manipulation is another thing. But there's also a question of editing in terms of picture selection, and obviously the pictures you select out of all the pictures you've shot, one can argue that that is also one area where the news is shaped. It's what the media decides to report on. And when you're covering a story,

there's quite often a number of different elements of that story, and you may choose certain elements to send pictures of and certain elements not to.

ERROL MORRIS: There is a selection process. And where there's war, there's controversy. I'm sorry to say that it was through your Mickey photograph that I first became familiar with your name.

BEN CURTIS: Here, I just looked up my photo of the Mickey Mouse on the archive and the caption reads: "A child's toy lies amidst broken glass from the shattered windows of an apartment block near those that were demolished by Israeli air strikes in Tyre, Southern Lebanon, Monday, August 7th, 2006." Which I stand by. The toy was there when I arrived. My caption doesn't imply what happened, whose the toy was, whether there were children killed. Keep it neutral, and only say what you know and that you can verify. And I can happily stand by that caption. I can say every element of that caption was true, and I know it to be true.

ERROL MORRIS: One question that immediately comes to mind: Was your photograph the first of the published toy photographs? Did other photographers say, "Ah, he sold that photograph. Let me see if I can produce a similar one?"

BEN CURTIS: I don't know when those other photographs were taken. When you're covering destruction, you're always going to focus in on details, rather than general views of destroyed buildings. If you look at my picture without the toy, you don't know what those buildings are. It could be an office block. It could be anything. So, the inclusion of the Mickey Mouse in the picture adds an element of humanity to it. You get a feel of what was going on, what type of area it is, and that gives you a bit of a context to the fact that there have been recent air strikes in that area.

ERROL MORRIS: There's a famous photograph taken by an FSA photographer, Arthur Rothstein, of a cow's skull. He was accused of moving the cow skull in order to make more effective propaganda for the Roosevelt administration. These issues have been with us probably since the beginning of photography. They weren't invented in the Lebanon war. I thought that you hit on it: even if it was posed, are we saying that no damage was done? Is the crime posing or is the crime using photographs to advance a political view?

BEN CURTIS: Yes. I'm looking at the Mickey Mouse picture again. A reader might infer from the photo that a child had been killed in the attack and that this toy belonged to some child who is dead somewhere. Okay, you're a reader, you can infer that if you want. But we're not saying that. I'm not saying that. I'm saying it's a child's toy lying in the middle of a street after an air strike. That's all I'm saying. If you want to infer from that what you want, that's your prerogative, but you can't then criticize us for that, you know? If I knew who that toy belonged to, if I knew his name and where he was now and what happened to him, that would be great. I'd include it in the caption.

But I'm running around and I've got ten minutes to get in, shoot pictures, and get out of there before maybe they'll launch another air strike.

ERROL MORRIS: You have a limited amount of time.

BEN CURTIS: In an ideal world, you have lots of time to go and do that. We're an up-to-the-minute news agency; you've got to go and file those pictures. Sometimes it'd be nice to go back tomorrow and track this person down and interview them and get their story and provide the context for it. And maybe if I were working for a weekly magazine, I'd have more of an ability to do that. So you make these compromises.

ERROL MORRIS: But in principle, you would like to get more information.

BEN CURTIS: It makes the picture more powerful. You put a picture of a child or an old woman amidst destruction, whatever, okay, visually, it's a powerful image, but you don't know who this person is, you don't know what their story is. If you go up to them and you get their story and you find out what she did and this is her husband, and maybe he's been killed, and she doesn't live here at all, but she came from Beirut and was visiting relatives when this happened or whatever. When you can provide that information on the subjects in your picture, then it makes the visual photograph more powerful. If you see photojournalism as a window on the world, then providing that context and information about the people in the pictures provides a more direct connection with the people in those pictures.

ERROL MORRIS: But the picture of Mickey is powerful because it is vague. Its vagueness allows us to imagine all kinds of diverse scenarios, depending on our political sensibilities. It's one of the things that's fascinating about photography: photographs are both specific and vague.

BEN CURTIS: Someone was arguing the merits of being vague—providing more avenues of inference and this sort of thing. And I read that and I agreed, or at least I understood what he was saying, and that there were merits in his argument. All I can say is, I take the pictures, I write the captions, I put as much information as possible, I send it to my desk in London, they put it out to the world, and everything that happens after is completely outside my control. A lot of newspapers won't put bylines, they won't put credit to either the agency or myself. Other newspapers will put a full byline. Others will put a full credit. Others will print a very full caption. Others won't put a caption in at all. Everything that happens after my pictures hit the wire, it's not within my control.

ERROL MORRIS: The Joe Rosenthal picture of the flag-raising at Iwo Jima is an example of how a picture is often captioned by someone other than the photographer. Rosenthal did not even see his photograph before it was developed and sent off to various newspapers and magazines. Nor did he write the caption.[1]

BEN CURTIS: Going back to that skull photo that you were talking about. I have a basic knowledge of the FSA history, but not in depth in any way. A

photo like that, if you were taking it for artistic purposes, then it's perfectly acceptable to move the skull, to put it in nice light, to move this here, move this there, if your photographs are purely for artistic consumption. The reason why you're taking the photos affects everything. If you're doing fine art photography, you can do what you want. But if your photos are intended to represent the truth, then it's a completely different situation.

ERROL MORRIS: Truth in photography is an elusive notion. There may not be any such thing.

BEN CURTIS: You can have one event, say, an explosion takes place somewhere in Iraq. Now, there is one single reality to that situation. Now, in our imperfect world, there are five different points of view to that situation. Insurgents are going to see it one way. American military will see it another way. The public will see it another way. And more and more, it seems impossible to bridge those realities.

ERROL MORRIS: And there are those who turn to conspiracies when they don't want to bother with more complex explanations. They come up with all sorts of ideas that are usually the product of not wanting to think about why things happened. For example, your photograph with Mickey Mouse: I'd be interested in how you happened to take that photo. Would you be interested in looking through the photographs that you took that day?

BEN CURTIS: The Mickey Mouse day?

ERROL MORRIS: Yes, if you were willing to do this, we would go through the photographs and we would talk about the whole day.

After a brief negotiation with Ben Curtis and Santiago Lyon, the director of photography for the AP, Curtis and I agreed to talk at length about the Mickey Mouse photograph and that entire day in Tyre, Lebanon, when the Mickey Mouse photograph was taken. It was my attempt to put the photograph in context, or, if you prefer, to write an elaborate caption for it.

Much as I had prepared myself for the trip to the Crimea by finding Fenton's location on a series of antique French, British, and Russian maps, I wanted to orient myself to the *exact* location of Curtis's Mickey Mouse photo, and so I attempted to pinpoint the location using a series of UN reconnaissance maps and aerial photographs.[2]

ILLUSTRATION #125
TWO SATELLITE IMAGES AND A MAP OF LEBANON

ILLUSTRATION #126
DETAIL OF SATELLITE IMAGE

ILLUSTRATION #127
MAP OF LEBANON

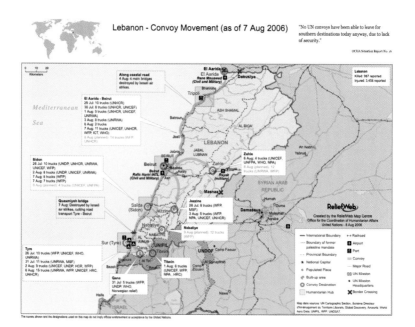

I sent them to Ben Curtis and asked him to identify where the Mickey Mouse was found. He sent back an e-mail:

> Re: the map and the insert "Destruction of 8 large residential building . . ."
>
> This does appear to be the same as the location of the Mickey Mouse incident. I couldn't say 100%, but it's in pretty much the correct area and the layout, particularly the green area to the left of the buildings makes sense. That green area is I think seen on far left of the "truck" photo.
>
> The hospital (from which I took the photo of the smoke from the buildings) is a small way down a side street on the right of the road that leads from Tyre center to the buildings site, but I couldn't pinpoint it exactly. . . . We didn't have any maps then, I'd only recognize it from ground level.

The maps provide a "picture"—two of them are photographs—of a vast area of destruction, but little explanation of why the destroyed areas were targeted. Were they of strategic value? Without additional information we are left with a cornucopia of possibilities. We can see from the detail of the satellite reconnaissance map that a number of buildings around the Mickey Mouse were destroyed. Were there families living there? Had the buildings been occupied by Hezbollah? If wire service photographs are often too specific, these satellite images are too general.

———

The photographs arrived by e-mail, and Ben Curtis and I got back on the phone.

ILLUSTRATION #128
BABY RAAD IN HOSPITAL

It All Began with a Mouse

BEN CURTIS: The file names should be 101 to 119. So there should be nineteen pictures. [Files] 101 through 109 are in sequence of when I filed them, not necessarily when they were taken. Basically, I spent the whole day out and then came back and then sat down and sent pictures. If you look at the pictures of the very small baby, 110 to 115, that was what I did first in the day. That's unrelated to the bombing incident with the Mickey Mouse.

ERROL MORRIS: Where are those taken?

BEN CURTIS: In the morning, we went to Najm Hospital. There are two hospitals in Tyre that received casualties and wounded from throughout southern Lebanon. Najm Hospital is on the outside of town. It was a bit more dangerous to get to because there was some bombing around there. And then there was the main hospital in town, which is called Jebel Amer, which was where we went later. So, we went to Najm Hospital speculatively in the morning to see if they'd received any casualties or wounded. And when we were there, we heard that they had this two-week-old baby who'd been transported across southern Lebanon in an ambulance during the night and had arrived at the hospital that morning.

It was unclear what had happened to his parents or his mother, but he had been born in the middle of the bombing zone and an ambulance had transported him across southern Lebanon for about nine hours to get to the hospital in Tyre, because that was the only medical facility. Some days there'd be bombing in Tyre itself, other days there wouldn't be so much bombing in Tyre, but you could hear it and see it in surrounding areas. But they weren't safe to go to, so quite often we'd go and check on the hospitals twice a day or something to see if they'd brought anybody in, whether they might be Lebanese soldiers or civilians.

ERROL MORRIS: So, were you with a reporter this day?

BEN CURTIS: AP had a reporter in Tyre at the time. I would generally move around with other photographers, because in that situation often the reporter's interests are different from the photographer's. [An AP wire service story on baby Raad was filed by Kathy Gannon.[3]]

ERROL MORRIS: How so?

BEN CURTIS: Well, you might have a reporter who's writing a story about something specific or they might be doing a roundup of all the events that have happened in southern Lebanon. Most of those places you can't get to. They might do a lot of that stuff on the telephone. They might spend a lot of time speaking to people, for example, hospital workers or maybe local government people or officials. They're seeking information that's useful to them. But as a photographer, it's not really what you're looking for.

ERROL MORRIS: Right.

BEN CURTIS: If a reporter thinks they're going to be interviewing someone in particular who they're going to use as a major part of their story, then you'll go and photograph with them. A lot of it depends on the situation.

We generally try and coordinate what we do, but it doesn't mean we would spend the majority of the day working together.

ERROL MORRIS: Yes. So you wouldn't remember the names of any of the people who might have been there with you that day?

BEN CURTIS: The first bit with the baby, I think we had the only pictures. There might have been one other photographer. If you look at 116, you'll see a casualty, an injured person, arriving at the Jebel Amer Hospital. And we were waiting outside the hospital. During the day ambulances would sometimes come back from having gone out into the field and sometimes they'd bring injured people or elderly or people who were ill rather than injured, and bring them to the hospital and people, reporters and photographers, would try and speak to them and see what information they had, what their experiences were, that sort of thing. So we were outside this hospital waiting around when these explosions occurred.

ILLUSTRATION #129
AMBULANCE AND STRETCHER (BEN'S #116)

ERROL MORRIS: You could hear them there?

BEN CURTIS: Yes. Those pictures, 102 and 103, were taken from outside the hospital. If you see where the photographers are in 116, it's right outside the emergency entrance to the hospital. And that 102 and 103 pictures are taken from that position. It was deafening. It was incredibly loud.

ILLUSTRATION #130
SMOKE ABOVE BUILDING AND STREET (BEN'S #101)

ERROL MORRIS: And it's the aftermath of this explosion that we're looking at right now?

BEN CURTIS: Yes. There was a succession of explosions, at least a quarter an hour apart.

ERROL MORRIS: And this is in a residential area?

BEN CURTIS: Yes. You can get a feel of it in 101, 104, 118. It's a residential area of tower blocks and five-story-high apartment buildings.

ERROL MORRIS: Right.

BEN CURTIS: Now, most of the people in those buildings had left by this point. They had fled. And then, I don't know exactly whether there were still civilians still living there. The pictures, 105, 106, 107, of the mother and her daughter—they were residents of an apartment block opposite the ones that got bombed. But they were obviously still living in the area. And there were also Hezbollah people living in that area, as well.

ILLUSTRATION #131
LITTLE GIRL (BEN'S #105)

ERROL MORRIS: The mother and daughter, tell me something about them?

BEN CURTIS: The only information I have is that they live in an apartment block opposite. They could have nothing to do with Hezbollah. They could be the wife and daughter of a Hezbollah soldier. I don't know.

ERROL MORRIS: And 104, the picture that's taken inside an apartment, presumably?

BEN CURTIS: That was taken in one of the apartment blocks that was still standing, looking through the window at one of the apartment blocks that had been flattened completely.

ERROL MORRIS: Weren't you nervous that there would be another air strike?

BEN CURTIS: Absolutely. Absolutely. When we saw these explosions from the hospital, we waited a while, because these days journalists are more aware than they used to be about the dangers of going into places where there's been a recent bombing. Where there's one, there's often more. So we waited around outside the hospital. One of the ambulances went off

to the scene to try and find injured or wounded or dead, which was when the second explosion took place, and the ambulance then came screaming back to the hospital. Before that happened, we were standing around, debating whether it was safe to go there. When the second explosion happened, it made things a bit clearer. And so, we waited a bit longer. And then we made a decision to go up there and see what we could find.

ILLUSTRATION #132
LITTLE GIRL AND HER MOTHER (BEN'S #106)

ERROL MORRIS: So, this would be a group of photographers?

BEN CURTIS: Yes. Nobody likes working in a group. As a photographer, I would prefer to have the scene all to myself, not to have other media walking around in it. But you have to weigh that up with general safety. I'm not sure whether it's an unjustified psychological feeling of safety or whether it's real, but at least there's a feeling that if something happens, there might be someone there to help you or to get you out of a situation. So, when things are looking fairly hairy, photographers and other media quite often travel around in groups.

ERROL MORRIS: Maybe it's magical thinking. You think if there's a lot of you there, the chances—

BEN CURTIS: We knew that the Israelis were watching what was going on because of the drones. There's the feeling that if one or two photographers go up on their own, they could be mistaken for somebody carrying a gun or a rocket launcher or mistaken for someone in that area and attacked. There's a feeling that if a bunch of journalists turn up in five vehicles that are marked "TV" and the drones can clearly see that, well, there's a hope at least, that there's less of a chance of being attacked.

ERROL MORRIS: Do you mean the drones have cameras?

BEN CURTIS: I'm no expert. From what I understand, the drones are remote-controlled aircraft that would fly around pretty much all day long, probably all night as well, and they have video cameras that relay a live link back to whoever is controlling them. I don't know what the range of that signal is, but whoever is controlling them gets a bird's-eye view of whatever the drone is seeing. There was always a feeling that you're being watched.

ERROL MORRIS: It seems very spooky to me.

BEN CURTIS: Yes, it was. It was. It was very strange. That's one of the reasons why journalists would often drive in convoys, because there was a certain feeling on our side that one car driving on a road is more suspicious than a big group of cars who clearly aren't trying to hide.

ERROL MORRIS: Probably more magical thinking. So what was the exact date of this?

BEN CURTIS: These are all on August 7.

ERROL MORRIS: I was wondering if that was a transmission date or the date—

BEN CURTIS: It was both. They were filed the same day.

ERROL MORRIS: So you arrive at the scene of this bombing, the apartment building. Tell me about this.

BEN CURTIS: We arrived at the scene and we cautiously made our way toward the buildings that had been flattened. We parked in an open area nearby and then walked in on foot. There was still a lot of smoke in the air and huge piles of rubble from where there had been five- or six-story apartment block complexes that had literally been flattened into a huge pile of rubble. So we were walking around, trying to see what we could find, to see if there was anybody there. There were not many people on the scene. We came across one guy at the actual scene of the bombing, but that was it. Some of the apartments were still on fire. And there's always a danger of them collapsing from structural weakness. So you have to be pretty careful.

ERROL MORRIS: Yes, I would think so. So how did you stumble on Mickey Mouse?

BEN CURTIS: There were hardly any people at the scene. You can send pictures of the rubble—it tells you something, maybe—but you're looking for

something that shows some humanity or shows some indication of what the place was like, who was living there.

ERROL MORRIS: Yes.

BEN CURTIS: It was very strange. I remember there was an apartment on fire. It was on the second or third floor, but we heard a door banging. We thought it might be someone in the building, so we went up there. The whole thing was ablaze, and we realized the door was banging because of the heat coming out of the room. But those sorts of memories, you think, "This is a strange place to be."

ERROL MORRIS: So there were very, very few people in the streets?

BEN CURTIS: There were very few. The woman and the child that I photographed. It's possible there were more people living there that didn't come out of the apartments for whatever reason. My guess is that after the first explosion, anybody who'd been there would have left.

ERROL MORRIS: Now, 109 is a picture in that same area?

BEN CURTIS: Yes. That's a picture of a photographer standing on top of one of the buildings that had been flattened by the strikes, and he's taking pictures of the damage done. I'm photographing him from another building.

ILLUSTRATION #133
PHOTOGRAPHER ON TOP OF RUBBLE (BEN'S #109)

ILLUSTRATION #134
RUBBLE THROUGH THE WINDOW (BEN'S #104)

ERROL MORRIS: And this is, again, the same area as the Mickey Mouse?

BEN CURTIS: Yes. I couldn't say it's the same street, but it's the same area. We'd been in a building where we had come across some weapons and, what do you call them, those green khaki pouches that you'd wear around your waist that soldiers would wear? We'd come across some of those piled up next to a door with nobody around. And we took a couple of pictures of them, but it wasn't particularly exciting visually. We were going street to street around this whole area in between the apartment blocks and the flattened apartment buildings, looking to see what we could find. We left this one building, and then we walked down a street in between two apartment blocks, and I came across this Mickey Mouse lying on the ground. I spent a minute, only about a minute or forty-five seconds photographing it. I did about, I don't know, ten or so exposures of it and then carried on, touring

the area. It's strange, to be honest, talking about this one image so much, because at the time it was really one image among a huge number, and it wasn't something that I spent a lot of time photographing. Your adrenaline is pumping so much, and what you're trying to do is investigate the whole area and see what's happened, what you can find visually and photographically, and then get out, because you don't want to hang around. If there's been a couple of strikes, it's entirely possible that there's going to be another. It was very focused: shooting pictures, shooting, shooting, shooting. And, to a certain extent, when you're shooting pictures in that situation, you're not editing in camera, you're not selecting what pictures you're going to use. You're going around photographing pretty much anything that you come across that looks vaguely visually interesting, and then, when you sit down later, on your laptop, that's when you edit. And with digital cameras, it's very easy. I can shoot four hundred or five hundred frames and it doesn't cost me anything. I don't have to develop film by hand anymore, so you can afford to shoot a lot of pictures.

ERROL MORRIS: With what camera was that picture taken?

BEN CURTIS: A Canon EOS 1D Mark II. I carry two of them.

ERROL MORRIS: And the lens is a wide-angle?

BEN CURTIS: Probably around a 20mm.

The 20mm is a wide-angle lens. We discussed the nature of various lenses used with digital cameras, conversion factors to compare the lens with standard 35mm lenses, and then turned to the issue of posing.

BEN CURTIS: There's no single definition of posing. When the president is photographed at the White House, is that posing? He's posing for the cameras. The photographers know that he's posing for the cameras. And I find there's a bit of a difference, at least among the photographic community in Europe and America on this. Okay, you have the British prime minister outside No. 10 Downing Street, and he's doing a photo call, shaking hands with some visiting diplomat. They're both looking at the camera and not each other when they're shaking hands. The photographers know they're posing. Is that illegitimate? That's a question.

ERROL MORRIS: The answer is, of course not. Portraits, for example, are all posed.

BEN CURTIS: My feeling is: you have to credit the reader with a certain amount of intelligence. And the reader knows what these situations are like. They know that outside No. 10 Downing Street, the photographer wasn't passing through on his way to the shop and happened to come across a candid picture. But in a war zone, different standards apply.

ERROL MORRIS: I would describe it somewhat differently. We know that certain conventions apply. We know that the photograph of the prime minister is posed in a way that satisfies certain conventions, certain expectations. The Mickey photograph is different. When we ask whether the Mickey was posed, aren't we asking questions about how it got there and what its presence in the scene means. Was a child killed? Was the Israeli bombardment justified? And if so, under what circumstances? We want context. We want additional information. So, here's a question. Would you be willing to share with me all of your Mouse pictures from that day?

BEN CURTIS: I'm not totally comfortable doing that, to be honest, as a general matter of policy about images that have not been transmitted, simply because once I select and file my images for the day, it's pretty much case closed, you know? I'm willing to look through them and discuss them with you. To be honest, they're all pretty much the same.

ERROL MORRIS: I thought it would be interesting to see all the photos in view of what the bloggers are suggesting—that you put the Mickey Mouse in the rubble.

BEN CURTIS: That's what the allegation is, yes. Either I put it there or I moved it from somewhere else in order to get a visual effect. I don't think it's that great a picture, so I can't imagine moving it from somewhere else to this particular position, in this position where it is, it's not really visually that great a position. You have a lot of empty space in the middle between the Mickey Mouse and the building, which, if you're looking for a single image that says something, you don't necessarily want a lot of empty space.

ERROL MORRIS: I like this as a new genre: talking to photographers about why their images are no good.

BEN CURTIS: I'm looking through the [other Mickey Mouse] pictures. I arrived. I took a straight shot, looking straight down on it from above, with no background at all. That doesn't work to me, because it could be in LA, it could be in a garbage dump—there's no context to it. The first two images are the one that you've got there. And then, after that, I put the camera lower to the ground to get the Mickey Mouse close visually to the burned-out building. So that I can get a tighter crop without the empty space in the middle. But looking at my pictures, it wasn't sharp. I was trying to crouch down on the ground. It was lateish afternoon at this point, and I'm shooting at a thirtieth of a second, and I was trying to shoot a very small aperture to get everything in focus. And bear in mind, I'm carrying two cameras, a belt full of lenses, a bulletproof vest, and a helmet. It's hard to crouch down and maintain a very stable position for the camera. So all of those pictures didn't come out, which is why I didn't use them.

ERROL MORRIS: Did you put the camera on the ground and take a picture? That's what I would do.

BEN CURTIS: Well, the problem with that was the Mickey Mouse doesn't look

like a Mickey Mouse, because you don't see his face. You only see the side of him. And it's not—

ERROL MORRIS: That makes complete sense, yes.

BEN CURTIS: I didn't get them sharp. There was movement blur in them, so it was unusable for that reason alone. It looks like I did put the camera on the ground, but visually it didn't really work because you couldn't see Mickey's face. Now if I was, as the blogs accuse, manipulating or moving the object on the scene, it would have been best visually to move him on his side, so that he was facing me, and put the camera on the ground, and got him without all the empty space but still facing the camera. But, of course, I didn't do that, and so I couldn't get that picture. Which is why the one that I sent has all this empty space, because it was the only way I could get him in the picture and the burning building. If I'd had a wider lens, it would have been useful because I could have been closer to the Mickey Mouse and still got the building.

ERROL MORRIS: You needed a 14 [an extremely wide-angle lens that I am very fond of: modern lens design has even produced a 14mm lens without substantial distortion].

BEN CURTIS: I know, I know. But you know what? It's a compromise. I have a 14mm [lens], but I never carry it, because, firstly, that means you're going to be changing your lens in that scene which (a) slows you down, (b) means you're going to get dust in your camera, which, in that situation, you might be in that place for like a month or two without being able to get out. We can't even get our cameras cleaned in Egypt, so it could be months. So, I try and minimize changing lenses. But also it slows you down in terms of the weight you have to carry. You really try and go as light as you possibly can, because you're already wearing a bulletproof vest that's like ten kilos or something, plus a helmet, plus two digital SLR bodies, 16–35, 70–200. I usually carry a 100–400 with me. It's a lot of equipment. Generally, I don't take the 14. But on that occasion, it would have been useful.

ERROL MORRIS: Well, when you said that you took a picture of the Mickey looking straight down, you do have a photograph like that, which is—

BEN CURTIS: I have a photograph of literally 90 degrees perpendicular above him, looking down at the ground, and it's him with the ground and a bit of broken glass. But I didn't send that picture because, to me, it didn't say anything. There was no context for it. You needed to have the burned-out buildings.

ERROL MORRIS: Absolutely. For example, 117 is a picture looking straight down, a picture frame, a blue picture frame with a child's face.

BEN CURTIS: Ah, that's true. I can't remember the exact circumstances of that. I can have a look. I'm guessing it wasn't possible to get rubble or damaged buildings in the background.

ILLUSTRATION #135
PHOTO ALBUM AMID RUBBLE (BEN'S #117)

ERROL MORRIS: If you went much lower, the image in the frame would vanish.

BEN CURTIS: Exactly. That was the situation. It's on an 80–200 [zoom], probably the equivalent of a 100mm lens looking straight down on it from above. But I imagine if you took that at any angle, you're not going to see the face. Plus there's dust on the plastic, so you're probably going to get some reflection from the sunlight.

ERROL MORRIS: Yes. And the idea is to see the frame within the frame or the frame within the frame within the frame.

BEN CURTIS: I've got pictures of the burning interior of this apartment, which is the apartment in the background of the Mickey Mouse picture. That's the one I went into. This is why I didn't send it, because it's literally a burning door frame. It looks interesting because there's flames and charred wood, but there's absolutely nothing to contextualize it. You can't see outside. You can't see the apartment. All you can see is flames and burnt wood.

ERROL MORRIS: But you are contextualizing it with the story that you're telling me.

BEN CURTIS: Yes, but when I send pictures to the wire, I don't have the opportunity to. I can see that that picture as part of a feature with a long narrative by the photographer might work. But as a wire agency image, there's no context. It could be a house fire in Dundee, Scotland. There's nothing intrinsic in the image that conveys anything to the reader. And that's what, as a photojournalist, you're looking to do. And especially as a wire agency

photojournalist, you're looking to do that from a single image. You're looking to find an image that, hopefully, conveys to the reader what has happened at this scene. And a burning door frame, to me, it doesn't do anything.

ERROL MORRIS: It's narrative compression.

BEN CURTIS: It's very compressed. You're really trying to compress a huge amount of things. An air strike. Destruction. Some humanity. You're trying to convey all of that in a single image. And, frankly, it's pretty hard, especially when there's not many people around.

ERROL MORRIS: Yes. Your stories are endlessly interesting, because you're telling us about the way in which stories are told by newspapers, by photographic convention, and influence how photographs are made, how they're distributed, how they're printed and published and disseminated, etc., etc. I'm not telling you anything you don't know, but it's interesting to take a step back and to talk to a photographer, particularly when we're dealing with a controversial photograph, a supposedly posed photograph, and attempt to contextualize it thoroughly for the first time.

BEN CURTIS: The explanation is often very mundane.

ERROL MORRIS: That's good.

BEN CURTIS: And when you understand how people who work for the media work and the difficulties they have there is a lot of mundane reasons why things happen—light, dust, cameras, trying to compress everything into one image. If the public understood more about the process, then perhaps there'd be less suspicion of it, although I suspect that's probably not the case.

ERROL MORRIS: I suspect they would still be suspicious. But you can act in such a way as to explain something which might be unexplained, and then people can think about it. At least they have that choice as opposed to not thinking about it at all. You have these two photographs—the one of the Mickey and the apartment building in the background, taken with a relatively wide-angle lens, and you have a picture of a picture frame taken with a longer lens—and it's absolutely essential for the nature of what you're photographing to be at a certain angle to the object, or otherwise the picture doesn't work as a picture.

BEN CURTIS: In an ideal world, if the Mickey Mouse had been lying on its side, that would have provided the optimum image. You would have been able to capture him very large in comparison and next to the building. But that wasn't the case. I'm looking at the one of the photo album here. Basically, I shot two frames of it, that was it. It was when we were about to leave, so I suspect that I was in an I-don't-want-to-hang-around-here-much-longer mood. So I shot two virtually identical frames and then carried on. There was one other thing. There was a photo album with a lot of pictures that one of the reporters had started leafing through. And he picked it up and put it onto a piece of rubble so that he could be in a better position to look at the pictures and take notes at the same time.

ERROL MORRIS: Right, he picked it up to look at it.

BEN CURTIS: Exactly. I shot some pictures of him looking at the photo album, taking notes, but I didn't use those pictures because it had been moved. It hadn't been moved for any ulterior reason, it had been moved by a reporter who wanted to look through it and take notes. But as a photographer, okay, it hadn't been moved by me, but it had been moved by the media, so I felt that it wasn't justified to use that picture.

ERROL MORRIS: People look at the Mickey Mouse picture and they say, "He's trying to say that Jews are baby killers." But wait a second. To take a step backward: Are the bloggers saying that there were no children killed or injured in these bombing attacks? Is that the claim? Or is it only that I don't like this image because it telegraphs political ideas that I disagree with or that I find offensive?

BEN CURTIS: I see your point entirely. I'm not trying to imply something. I'm showing a scene. I'm showing what I consider the reality of the scene. It's a window into the scene. And for me, the caption is very important. Somebody else who took the picture could have written a caption that was misleading, and put in pieces of information that they didn't know for sure to be true, but maybe they suspected and put that information in the caption. The caption is key. "This is what is here. This is what we know happened."

ERROL MORRIS: The other picture that I wanted to ask about, 118, which is of a demolished truck, and then 119, which is of an apartment building.

<div align="center">

ILLUSTRATION #136
TRUCK IN RUBBLE (BEN'S #118)

</div>

<div align="center">

It All Began with a Mouse

</div>

BEN CURTIS: Yes. The truck. If you see the pile of rubble, it's hard to see, but above the truck, that used to be an apartment building like the one in the very top right-hand corner. I don't know what the truck was, but all that rubble behind it used to be an apartment building like the other ones you see at the top of the picture. These pictures are taken on Monday, August 7. There was an Israeli commando raid on Saturday near this area. None of us got to the scene then, because it was in the middle of the night and we were in the hotel—or I was staying in somebody's house opposite the hotel that we'd rented—and we were woken up, like four o'clock in the morning with heavy gunfire. It shocked all of us because the conflict was all aerial. Hezbollah firing missiles at Israel and Israel air-striking Lebanon. And in the areas where the media were able to go, there wasn't really hand-to-hand small-arms fighting. So when we heard small-arms fire, plus heavy-caliber fire, it was very surprising. I remember at the time we thought it was some invasion, possibly from the sea. I remember getting up, waking up my driver, and packing everything we had in case we had to leave. And then venturing out. There was a hotel opposite where a lot of the media was staying, and so I went over there to see what I could find out. People were saying it was some attack on Tyre and the Lebanese army were firing back. Now, that was quite unusual. Pretty much throughout the whole conflict, the Lebanese army wasn't involved. It was a fight between Hezbollah and the Israeli forces, and the Lebanese army tried to distance themselves. So this is unusual. But there was a lot of gunfire and heavy-arms fire and explosions in the middle of the night. Now, at four o'clock in the morning we didn't go out, because (a) moving around at night is very dangerous, and it's also somewhat suspicious to any combatant who might be in the zone; (b) as a photographer, there's really not much point. All hell could be breaking loose, but for sure you're not going to open up a flash gun at four o'clock in the morning, and it's way too dark to shoot without flash. So, visually and photographically, if you weigh up danger versus what you think you're likely to achieve photographically, it's pretty much unarguable that it's not worth it.

ERROL MORRIS: Were any children killed in this particular raid, or was this more like a raid on an apartment building?

BEN CURTIS: I don't know whether children were killed or not. What I would say is, on the day, or at least when I filed the pictures, I didn't have any hard information one way or another. Now, I know the ambulance people went up there, and I seem to remember some of them saying that people had been killed or people had been injured, or whatever. I didn't see any bodies personally when I was up there, which doesn't necessarily say anything one way or the other.

ERROL MORRIS: And the last photograph, 119?

BEN CURTIS: Ah, yes. I almost didn't send this picture. I thought it was

incredible, this bed with the pink sheets standing in this part of an apartment block where the outside wall had been blown off. You can see there's like a teensy bit of rubble on the right, in the bottom right. That's the top of one of these large mounds of rubble that used to be an apartment block. If I'd had more time, I would have gone up into an apartment block opposite this bed and shot down, so that you could see the bed and a bit more of the surroundings, a bit more of the area. But at this point, there wasn't time for that.

ILLUSTRATION #137
BOMBED BUILDING (BEN'S #119)

ERROL MORRIS: This is telling you that this is a residential area?

BEN CURTIS: You might see people who you thought were Hezbollah, but do you know they're Hezbollah? If you go up and ask them, they'll probably say no. Now, I may be pretty sure that they are Hezbollah—perhaps the way they're dressed, perhaps the location or the way they're moving or the way they're behaving. But do I know that well enough to write that in a caption? Not really. And that was one of the frustrating things—the lack of direct coverage of Hezbollah activities compared to what everybody was receiving from the Israeli side. You had many photographers embedded with the Israeli forces, providing a daily stream of images of right up close military activity, firing missiles, traveling around in tanks—the whole lot. Obviously, a lot of their secret operations they didn't allow the media access to, but there was a daily stream of many, many, many images from very up close

to what the Israeli military was doing. Now, on the Hezbollah side, there was virtually none of that. Now, why is that? Because it was impossible. Hezbollah wouldn't allow the media to be in areas where Hezbollah military activities were taking place. At least they wouldn't allow them to be close enough to photograph them or video them. So there was a certain frustration. At one point, I remember, we called them up, and said, "Look, we want to cover your activities," and it was always, "Absolutely not."

ERROL MORRIS: Hmm, that's interesting.

BEN CURTIS: There were some times where I felt that somebody was probably from Hezbollah, but I didn't feel confident enough to say that in a caption. I did a picture, a separate incident of somebody on a motorcycle who was hit by one of these very small rockets. I don't know if it was fired by a helicopter or a drone or something like that, but a very small rocket that killed the person, two people, who were riding on a scooter. And I was maybe thirty, forty meters around the corner when it happened, and I was very quickly on the scene. And there was a guy at the scene with a pistol tucked into his jeans, telling onlookers to move away from the scene. So he was instructing people to keep back a bit. Now, who is this guy? I'm pretty sure he was Hezbollah, but can I say that in a caption?

Ben Curtis is deeply concerned about maintaining a standard of veracity and objectivity in photojournalism. He is not alone in this; complaints about photo fraud are rampant on the Internet. There are Web sites entirely devoted to accusations of the manipulation of photographs, in particular, Reuters photographs from the war in Lebanon. For example, Zombietime.com[4] has a section titled "The Reuters Photo Scandal," which tells us, "It's important to understand that there is not a single fraudulent Reuters photograph, nor even only one fraudulent photograph. There are in fact dozens of photographs whose authenticity has been questioned, and they fall into four distinct categories." The four categories (as discussed) are: (1) digitally altering photographs after the photograph has been taken; (2) photographing staged events as if they were real events; (3) staging scenes or moving objects and then photographing them; and (4) providing false or misleading captions.

The photograph of Mickey Mouse in the rubble of a Tyre apartment building doesn't fit into any of these categories. It was *not* posed or manipulated in any way. Nonetheless, it is a photograph that telegraphs a message. Like Rothstein's cow skull photographs seventy years before, does it advance an idea that many people do not want to hear? What are we *really* objecting to? Are we objecting to how a photograph was produced or the inferences that can be made from it? Or both?

ILLUSTRATION #138
"HAMAS KINDERGARTEN"

Unlike the Cox & Forkum political cartoon "Hamas Kindergarten,"[5] Ben Curtis's Mickey Mouse photograph serves both political camps with equanimity. When I first saw the Ben Curtis photograph I assumed that it would be interpreted as anti-Israeli propaganda. I was wrong. It can also be interpreted as anti-Hezbollah propaganda. On August 8, 2006, John O'Sullivan published an editorial in the *Chicago Sun-Times*. It was illustrated with Ben Curtis's Mickey Mouse photograph.

ILLUSTRATION #139
JOHN O'SULLIVAN *CHICAGO SUN-TIMES* EDITORIAL

In its three major wars since 1967—the Six-Day War, the Yom Kippur war, and the 1982 Lebanese incursion—Israel has enjoyed little international support but it has triumphed easily in military terms. Those victories did not always produce good political outcomes for Israel. But they gave the country a strong bargaining position—and its adversaries a weak one—in later diplomatic negotiations at Camp David and elsewhere. This war has been different. . . .

And would Hezbollah agree to be disarmed even as part of a general disarmament agreement in Lebanese politics? Such an agreement would mean that Lebanon was becoming a stable country—prosperous, at peace with its neighbors, and linked with the West—in which democratic politics had replaced civil war.

That is not exactly utopian; Lebanon used to be exactly that. But it is not what Hezbollah, Hamas, Syria and Iran want. They launched the anti-Israel offensive—and devised the tactic of using Lebanese civilians as "human shields"—to unite the Islamic and Arab worlds in a global anti-Western jihad on their terms. It has worked well for them. They are unlikely to sign onto a UN peace plan that reverses this success.

There is a line in the editorial that might serve as a caption for the photograph: "They . . . devised the tactic of using Lebanese civilians as 'human shields.'" Here, the civilian deaths are blamed on Hezbollah. The photograph becomes part of a protracted argument on barbaric behavior. But whose barbaric behavior?

Photographs can give us a glimpse of the specific, of the particulars, in a cauldron of seething politics. And yet, the meaning of the image remains unclear. The Mickey Mouse photograph can function as pro-Arab or as pro-Israeli propaganda, depending on the text it accompanies. Not just the text: our mind-set, our mental captions, also inform how we see it. Mickey Mouse, after all, is "so human, that's the secret of his popularity." Images are plastic, malleable, and lend themselves to any and every argument. They can exacerbate as well as mollify. It seems that Walt Disney was right: "It was all started by a mouse."

Postscript

Nearly a year after the publication of *Believing Is Seeing* I received a curious e-mail from Rita Leistner, a photographer who just happened to be taking photographs *the same day* in the ruins of *the same* apartment complex as Ben Curtis. She included commentary and a number of photographs—photographs of the mouse, photographs of Ben Curtis taking pictures of the mouse, photographs of other toys and other photographs in the general vicinity.

Here is Ben Curtis on his knees photographing the mouse. It looks dirty, battered, used. Leistner tells us Ben Curtis didn't move the mouse, but did someone else? We know something happened. The mouse was thrown from the apartment building, or it wasn't. Which? We know there is an answer even though we might not know what the answer is. And there is a further problem illustrated handsomely by this surprising e-mail. We may not have the evidence we need, but we can never know what *additional* evidence might be out there. Another Rita Leistner who can put a story that we think we know into a new perspective.

CIVIL
(PHOTOGR
MEM

WAR
APHY AND
ORY)

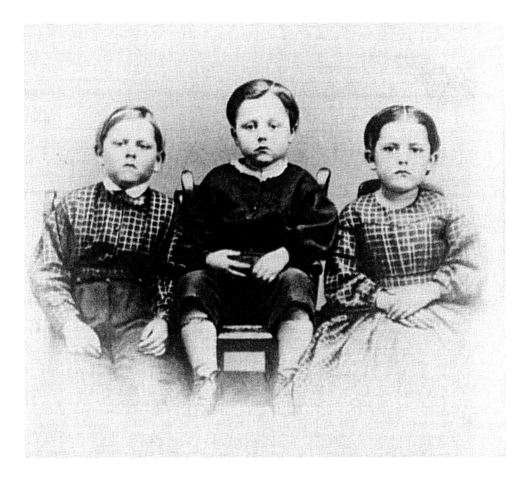

Whose Father Was He?

Part 1

No name—but a soldier brave, he fell. We shall find her, without a name; This picture, sometime, will tell whence he came.

—Emily Latimer, "The Unknown"[1]

ILLUSTRATION #140
AMBROTYPE OF THREE CHILDREN
(opposite)

The soldier's body was found near the center of Gettysburg with no identification— no regimental numbers on his cap, no corps badge on his jacket, no letters, no diary. Nothing save for an ambrotype (an early type of photograph popular in the late 1850s through 1860s) of three small children clutched in his hand. Within a few days the ambrotype came into the possession of Benjamin Schriver, a tavern keeper in the small town of Graefenburg, about thirteen miles west of Gettysburg. The details of how Schriver came into possession of the ambrotype have been lost to history. But the rest of the story survives, a story in which this photograph of three small children was used for both good and wicked purposes.

First, the good. Four men on their way to Gettysburg were forced to stop at Schriver's Tavern when their wagon broke down. They heard the tale of the fallen soldier and saw the photograph of the children. One of them, Dr. J. Francis Bourns, a Philadelphia physician on his way to tend to the wounded from the battlefield, was intrigued. He convinced Schriver to give him the photograph so that he might attempt to locate the dead man's family. Perhaps he was touched by the poignancy

of the photograph—three children, all under the age of ten, now without a father. As a lifelong bachelor he might have yearned for a wife or family of his own. Or perhaps he saw it as an opportunity for financial gain.

Dr. Bourns returned to Philadelphia with the ambrotype. He had it copied by several photographers, producing hundreds of inexpensive duplicates in the carte de visite format. The carte de visite photograph, roughly the size of an index card, could be printed in multiple copies, allowing for quick mass production of a single photographic image. Because there was no way of printing photographs in a newspaper, Bourns knew that he might need dozens, if not hundreds, of cartes de visite to put the image of the three children before the eyes of someone who knew them.

But the story had to be circulated as well, so the photographs were supplemented by a series of newspaper articles, the most prominent of which appeared in the *Philadelphia Inquirer* on October 19, 1863, a little over three months after the discovery of the ambrotype. It appeared under the heading, "Whose Father Was He?"

After the battle of Gettysburg, a Union soldier was found in a secluded spot on the field, where, wounded, he had laid himself down to die. In his hands, tightly clasped, was an ambrotype containing the portraits of three small children, and upon this picture his eyes, set in death, rested. The last object upon which the dying father looked was the image of his children, and as he silently gazed upon them his soul passed away. How touching! How solemn! What pen can describe the emotions of this patriot-father as he gazed upon these children, so soon to be made orphans! Wounded and alone, the din of battle still sounding in his ears, he lies down to die. His last thoughts and prayers are for his family. He has finished his work on earth; his last battle has been fought; he has freely given his life to his country; and now, while his life's blood is ebbing, he clasps in his hands the image of his children, and, commending them to the God of the fatherless, rests his last lingering look upon them.

When, after the battle, the dead were being buried, this soldier was thus found. The ambrotype was taken from his embrace, and since been sent to this city for recognition. Nothing else was found upon his person by which he might be identified. His grave has been marked, however, so that if by any means this ambrotype will lead to his recognition he can be disinterred. This picture is now in the possession of Dr. Bourns, No. 1104 Spring Garden [Street], of this city, who can be called upon or addressed in reference to it. The children, two boys and a girl, are, apparently, nine, seven and five years of age, the boys being respectively the oldest and youngest of the three. The youngest boy is sitting in a high chair, and on each side of him are his brother and sister. The eldest boy's jacket is made from the same material as his sister's dress. These are the most prominent features of the group. It is earnestly desired that all the papers in the country will draw

attention to the discovery of this picture and its attendant circumstances, so that, if possible, the family of the dead hero may come into possession of it. Of what inestimable value it will be to these children, proving, as it does, that the last thoughts of their dying father was for them, and them only.

For those of us used to seeing stories illustrated with photographs, the photoless *Philadelphia Inquirer* article is fascinating. The absent ambrotype is described but not shown. The description asks us to think about the details, to imagine them, to pick from among many other details the relevant ones, the ones that can be used to unravel the mystery. The use of "the same material" implies a mother's hand, or at the very least, a bolt of cloth that was purchased and then used to make clothing for both children. It is evidence—a clue. We are looking for the unseen wife—"we shall find *her* without a name"—the woman who made the garments out of whole cloth.

ILLUSTRATION #141
CLOSE-UP OF CLOTH IN AMBROTYPE

In the traditional detective story, someone asks around: Do you know the identity (or the name) of the people in this photograph? Here, the identification is not made on the basis of recognizing the people from a photograph, but by first "translating" the photograph into words and sentences. The ages of the children were estimated—as it turns out not far from the truth—but the really telling details were their respective positions in the photograph, the fact that there were three of them, and the fact that the shirt and dress worn by the brother and sister flanking the brother in the middle were similar.

At the time, family portraiture was not commonplace. A family had to go to a photography studio or be visited by an itinerant photographer. The family of the fallen soldier was asked to identify the *one* picture that was taken. The widow would have enough information to make an identification. Today, we are able to seamlessly integrate words and pictures—captions and photographs—but the *Philadelphia Inquirer*

article allows us to see how this was done before there were means to easily put the two together in a newspaper or broadsheet.

In early November, a woman in Portville, New York, was shown a story about the photograph that appeared in the *American Presbyterian*. She feared the worst, not having heard from her husband since the battle of Gettysburg. She asked the town postmaster to write to Dr. Bourns on her behalf and request a copy of the ambrotype. When she opened the letter from Philadelphia in late November of 1863, Philinda Humiston knew that her husband, Amos Humiston, the father of her three children—Franklin, Alice, and Frederick—was dead.

The story of Amos Humiston has been chronicled in a book by Mark H. Dunkelman, *Gettysburg's Unknown Soldier*,[2] an attempt to recover the "identity" of Amos Humiston from the depredations of history. There were two separate searches, more than a century apart, an initial search to identify the fallen soldier and then a subsequent search to discover something about the man. These investigations sought to answer a series of questions. The first question was: "What is his name?" The second question: "Who is he?" Tell us something about Amos Humiston. And now, there is a third question: "Who is he to us? What does he mean to us?"

———

I contacted Mark Dunkelman, who lives in Providence, Rhode Island. Here was someone who clearly shared my obsession with these questions. Also, I wanted the story of how he had researched the book, of how he had come to write it. He told me about some of the discoveries he had made about Amos Humiston.

MARK DUNKELMAN: In all the previous tellings of this story, Amos Humiston appears as a corpse on the battlefield with this photograph in his hand. I wanted to *resurrect* the man somehow. And I was able to finally do that by making a connection with a guy in Belmont, Massachusetts, Allan Lawrence Cox. His branch of the family is the one that had preserved Amos's letters home to his wife. And that was the key because Amos spoke *again* through the letters. It was a tremendous find. It was exciting because I had long known that there was a book there. But without his voice, it was an empty shell. And bingo, I made the connection.

ERROL MORRIS: Let me back up a moment. Can you tell me how you first became aware of Amos Humiston?

MARK DUNKELMAN: As a child I heard stories of my great-grandfather, a fellow named John Langhans, who served in the Civil War with the 154th New York Volunteer Infantry. My dad had grown up on a farm with his grandfather and his parents in Ellicottville, Cattaraugus County, New York. And my dad had imbibed these stories that his grandfather told, of marching with

Sherman to the sea. And he in turn imparted them to me during my youth in suburban Buffalo, New York, in the 1950s and 1960s. And the stories grabbed me. They just fascinated me. And together with the stories were relics that the family had preserved, including six letters John had sent home to a younger brother during the war, some cotton bolls he reportedly had picked during Sherman's march to the sea, ribbons he had worn at regimental reunions, the buttons from his Grand Army of the Republic coat, the Silver Star Corps badge, 20th Corps badge, that he had worn during the war. And those tangible reminders excited me as well. I was a kid. My interest soon went beyond his personal involvement to that of his regiment as a whole. And I started to do research. As a teenager I made my first visit, on a family trip to Washington, to the National Archives. And they set three immense boxes full of records in front of me.

ERROL MORRIS: So you knew that you were going to research the Civil War? Or was it something more specific?

MARK DUNKELMAN: I was even more interested in becoming an artist. I had been the class artist since third grade. So that's what took me to RISD [Rhode Island School of Design] rather than to a liberal arts college to study history. But I said to myself that I wanted to research and publish a regimental history of the 154th New York by the time I reached the age of fifty. I figured that gave me plenty of time. And I started to collect material. And in the thirty-plus years since then, I've had the good fortune to connect with more than a thousand descendants of members of the regiment who shared with me more than sixteen hundred wartime letters written by members of the 154th, twenty-five diaries, portraits of more than two hundred members of the regiment, and basically a roomful of other material. And if it isn't the largest, it's one of the largest collections of primary-source material on any single particular Civil War regiment.

ERROL MORRIS: My God.

MARK DUNKELMAN: During my high school years, I became good friends with a neighbor, Christopher L. Ford, who had Confederate ancestors. We both shared this interest in the Civil War, so we would discuss the Civil War often. As a matter of fact, we used to hold sort of trivia contests to see who could stump each other on our Civil War knowledge. And at one point, Chris gave me a book that he had had for a while. It's called *Gettysburg: What They Did Here,* by L. W. Minnigh.[3]

ILLUSTRATION #142
BOOK COVER

In the back is a collection of human-interest stories relating to the battle of Gettysburg. The very first one is about John Burns, the elderly Gettysburg resident who took his War of 1812 musket and joined the battle when the armies arrived at his hometown. And the very second story is about the Humiston children. And it included a postwar photo of the three kids, a very brief description of the story, and a copy of James Clark's poem-song, "The Children of the Battlefield." That was my first exposure to the Humiston story. When Mike Winey and I published our history of the 154th, *The Hardtack Regiment,* we included an account that was brief since at the time—it was all I knew about Amos—and, of course, a copy of the famous ambrotype of the three kids. And then it occurred to me that I'd never sent for Amos's pension records. So I did. And they provided some more material. And I said, "Jeepers, I wish I would have done this before the book was published."

ERROL MORRIS: What was in the pension records?

MARK DUNKELMAN: More material on the later life of his wife and children. There was nothing about him or his service record. It was more about all the procedures that Philinda went through to obtain a pension, because her husband had been killed in battle, and a little more about her postwar life. So I wrote an article and submitted it to *Civil War Times Illustrated*, which is the largest circulating of the popular slick Civil War mags. And they published it. It was called "The Hunt for Sergeant Humiston." And there the matter lay for a number of years. I would collect anything that I saw about the case. And I kept thinking, "Boy, there's a book here. There's a book here." But without Amos's voice, I couldn't pull it off. It really seemed like a pipe dream. It seemed virtually impossible that I'd be able to find what I needed. According to the National Union Catalog of Manuscript Collections, there was nothing. And it didn't appear that I was going to be able to find anything in repositories of Amos's own writing. And so years passed.

ERROL MORRIS: What did you find so compelling about the original story, the Amos Humiston story?

MARK DUNKELMAN: Well, it got his name into books about Gettysburg. He was the most well-known of the 1,065 men who served in this regiment that I was busy trying to chronicle as deeply as I could. And the story itself just has this intrinsic drama and interest to it—jeepers, it's a great story.

ERROL MORRIS: There's the irony that the Gettysburg soldier who was the Unknown Soldier becomes the best-known soldier of Gettysburg.

MARK DUNKELMAN: He is. I think there's sort of a triumvirate of human interest stories to emerge from Gettysburg that virtually every Civil War aficionado knows about. John Burns; Jennie Wade, the civilian who was killed in her house when a bullet struck her while she was baking bread; and the Humiston story. It's a big story. And then I realized there's this influence of the media in the story. It was integral to the story—the fact that he had a photograph, that the photograph was the means of identification, that it was the newspapers that spread the story. And of course they didn't reproduce the photograph. They couldn't do that then. They gave a very minute description of the children—how they were posed, what they were wearing, their approximate ages. And that's what led to the identification. If Dr. J. Francis Bourns didn't have the photograph in his hand, none of it would have happened. If he hadn't taken it back with him to Philadelphia and instigated this wave of publicity, Amos and his family would have never been identified.

ERROL MORRIS: Chance.

MARK DUNKELMAN: Yes, and there was another element of chance. Dr. Bourns did not travel directly from Philadelphia to Gettysburg. Instead, he first went to Chambersburg, a designated rendezvous for civilian physicians heading to the battlefield. Had he gone direct from Philadelphia to Gettysburg, he would not have passed through Graefenburg, as he did by

approaching Gettysburg from the west. And he would not have stopped at Schriver's Tavern and would not have seen the ambrotype.

ERROL MORRIS: It's amazing that you were able to uncover these odd details.

MARK DUNKELMAN: Yes. I was rolling along, but I needed primary source material. So in Portville, New York, Amos Humiston's hometown, I managed to make good connections. And somebody in Portville managed to track down a Humiston descendant. And I got in touch with this fellow. His name is David Humiston Kelley. He is a professor emeritus at the University of Calgary in Alberta, Canada. And David is a very interesting guy. I eventually met him several times. He is an archaeologist whose first book was helping to break the Mayan code, to learn how to read all those Mayan hieroglyphics. And I've got a copy of his most recent book here. It's called *Exploring Ancient Skies: An Encyclopedic Survey of Archaeoastronomy.*[4] I open this book to any page at random, and it's virtually unintelligible to me. But I'm sure that it's the definitive word on the subject. So I got in touch with David, and we started a correspondence. And eventually I went out to Calgary and spent a week with him going through all the Humiston material he had. I was really kind of surprised at what little mention there was of Amos. The family was thrust into the spotlight against their will. They became celebrities. And they didn't like being celebrities, particularly celebrity born out of tragedy. They tried to avoid the story pretty much. I learned an awful lot about what happened to Philinda and her three children in the years after the war, but it still left a great big gap regarding Amos and his wartime service. And so I was out of luck there. Now, David, in addition to his archaeoastronomy work, is a very avid genealogist. He's traced branches of his family back to King David in the Bible.

ERROL MORRIS: King David?

MARK DUNKELMAN: But he's been unable, to this day, to link Amos's branch of the Humistons to this first Henry Humiston, the first Humiston to arrive in America back in the 1600s in Connecticut. There's a missing link, and David's been unable to fill it in.

ERROL MORRIS: So after you got this additional information from David Humiston Kelley, what happened next?

MARK DUNKELMAN: I'm not really sure about the sequencing of all this, but at one point, some good friends of my wife and mine, the Reverend Dan Warren and his wife, Meg, invited us to a little dinner party. One of the reasons was, they wanted to introduce me to another Episcopalian minister, a fellow named Gardiner H. Shattuck, also known as Tuck. Tuck had written a very well regarded Civil War book called *A Shield and Hiding Place,* a study of religion in the Union and Confederate armies. So we got together at the Warrens here in Providence. And Tuck and I proceed to be very rude, and basically ignore everybody and jabber to each other all night about the Civil War. Toward the end of the evening, Tuck says, "Well, what are you working on now?" And I said, "The Humiston story." And he said, "Eleanor

Cox, Amos's granddaughter, was the church secretary when I was at a parish in Belmont, Massachusetts." And that was a branch of the family that David Kelley had lost track of. The next day, I called information. This is all in the pre-Google era, right? I got a number for a Mrs. John Cox in Belmont, Massachusetts. And a male voice answers the phone. I introduce myself, explain what I'm doing, and Allan Lawrence Cox says to me, "You're lucky you caught me. My mom's in a nursing home, and I only come by the house about once a month to check on things. And you just happened to catch me while I'm here." And he said, "I've got Amos's wartime letters at home. Why don't you come up and take a look at them?"

ERROL MORRIS: He had Amos's letters? That's amazing.

MARK DUNKELMAN: It was meant to be. It was meant to be. It was just astonishing. Needless to say, I got up there pretty soon. I took a look at these letters, and I saw the one line acknowledging the receipt of the photograph: "I've received the likeness of the children." And there was Amos's poem.

ILLUSTRATION #143
AMOS'S LETTER "TO MY WIFE" 1

ILLUSTRATION #144
AMOS'S LETTER "TO MY WIFE" 2

Here is the transcription of Humiston's Letter:

You have put the little ones to bed dear wife
And coverd them ore with care
My Frankey Alley and Fred
And they have said their evening prair

Perhaps thy breathed the name of one
Who is far in southern land
And wished he to were thare
To join their little band

I am very sad to night dear wife
My thoughts are dwelling on home and thee
As I keep the lone night watch
Beneath the holley tree

The winds are sighing through the trees
And as they onward roam
They whisper hopes of happyness
Within our cottage home

And as they onward passed
Ore hill and vale and bubbling stream
They wake up thoughts within my soul
Like music in a dream

Oh when will this rebellion cease
This cursed war be ore
And we our dear ones meat
To part from then no more?

March 25th 1863 AH

ERROL MORRIS: Was this the first time that these letters had been seen?

MARK DUNKELMAN: Other than by the Humiston family and the descendants. Allan Cox just had this stuff stored in an old shoebox or something. He didn't really pay much attention to it.

ERROL MORRIS: Why was it even saved?

MARK DUNKELMAN: Soldiers' families saved their letters. They were writing letters all the time back then, but these were letters chronicling the most momentous events in their lives. Often they didn't save the letters that the wife sent the husband. They saved the letters that were sent from the husband or son describing these great adventures.

ERROL MORRIS: I take it the other letters are just simply lost—the letters that Philinda sent to Amos.

MARK DUNKELMAN: Unfortunately, they are.

ERROL MORRIS: And the last letter that Amos sent?

MARK DUNKELMAN: It was sent on May 24, about five weeks before Amos died. The most powerful letter is the one sent two weeks before, the letter of May 9:

ILLUSTRATION #145
AMOS'S MAY 9 LETTER 1

May 9 1863
Camp near Stafford
Dear wife
it is with pleasure
that I address a few lines
to you to let you know
that I am in the land
of the living after
the battle
The last letter that I
wrote to you I was in
the hospital but when
Captain Warner come
back I was with company
and was in the last
battle at Chancellorburgh
and got away with a hole
head but I got a wipe
in the side with a spent
ball that made me think
of home it struck on the
short ribs just over the

ILLUSTRATION #146
AMOS'S MAY 9 LETTER 2

hurt but glanced off
if it had not I should
not be writing to you
now
The 154 has gained a name
but at what a loss our
company has lost 19 in
killed wounded and miss
ing Senour Sikes is
killed he was hit with a piece
of shell in the head
Burt Champlin is
missing that is all
that is missing from
our place
the regement lost 227
men we had a hard
fight
I am tired and worn out
with hard marching and
hard fare

I looked for a letter
from you when I got
back but did not I
am in hopes to get one
to night I got the
likeness of the children
and it pleased me
more then every thing
that you could have
sent me how I want
to se them and their
mother is more then
I can tell I hope that
we may all live to
see each other again if
this war does not last
to long the first
time that I see you
I tel you more then
can think of now
be a good girl so good by
A He.

May 9 1863
Camp near Stafford

Dear Wife,

It is with [pleasure] that I address a few lines to you to let you know that I am in the land of the living after the battle.

The last letter that I wrote to you I was in the hospital but when Captain Warner came back I was with company and was in the last battle at [Chancellorsville] and got away with a [whole] head but I got [hit] in the side with a spent ball that made me think of home. It struck on the short ribs just over the [heart] but glanced off. If it had not I should not be writing to you.

The 154 has gained a name but at what a loss. Our company has lost 17 in killed wounded and missing. Seymour Sikes is [killed] he was hit with a piece of shell in the head. Mart Champlain is missing, [but] that is all that is missing from our place. The regiment lost 227 men. We had a hard fight.

I am tired and worn out with hard marching and hard fare.

I looked for a letter from you when I got back but did not. I am in hopes to get one to night. I got the likeness of the children and it pleased me more than eney thing that you could have sent me. How I want to see them and their mother is more than I can tell. I hope that we may all live to see each other again if this war does not last [too] long. The first time that I see you I [will] tell you more than [I] can think of now. Be a good girl, so good by.

AH

ERROL MORRIS: But I interrupted. You were talking about the two Humiston descendants.

MARK DUNKELMAN: Allan is the total opposite of David Kelley. He is not really interested in the past. But he and I hit it off, just as David and I hit it off. And several times, David came back east for conferences at Harvard. And the three of us would get together. Allan's got a lot of health problems, including a bad back. We were getting together. And Allan had a favorite seafood restaurant. I showed up once, and David was already at Allan's apartment. David likes to go around without shoes on. So he's barefoot. Allan doesn't have his shirt on because he's got some back brace he wants to put on himself. And I look at the two of them, I say, "We're going out for lunch and here's no shoes and no shirt. And you expect service?" It was just highly amusing to me, these two guys, who were so unlike, but nonetheless, they're family. I served as a link between the two because they both really supported my efforts to tell their ancestor's story. And then another crazy thing happened. One of the newspaper articles published after Amos was identified stated that he had made a Pacific Ocean whaling voyage. I have

a neighbor here in Providence, who was the librarian at the New Bedford Whaling Museum. I said to her, "How can I find out if a guy named Amos Humiston made a whaling voyage out of New Bedford back in the heyday of the American whaling industry?"

ILLUSTRATION #147
WHALING LOG

She said, "I'll get back to you." She called me a couple days later. She said, "Amos Humiston sailed out of New Bedford on the ship *Harrison* in 1850. And the logbook of the voyage is at the Providence Public Library." And so there it was, right in my backyard—the story of Amos's three-plus years aboard a whaling ship. I just kept digging, because I knew that there was a book there.

ILLUSTRATION #148
WHALING MAP 1

ILLUSTRATION #149
WHALING MAP 2

Believing Is Seeing

ILLUSTRATION #150
WHALING MAP 3

VOYAGE OF THE HARRISON, 1853–4

Shantar, Sakahalin, Kuril,
Onekotan, Paramusir Islands
Cape Alevina
Oct. 1–May 1

Oct. 9

Hilo, Hawaii
March 7–30
Maui, Oahu, Kauai
April 1–9

Returned to New Bedford
April 20, 1854

April 19

April 1

Lahaina, Maui
Oct. 27–Nov. 13

March 25

EQUATOR

On the Line
Jan. 1–Feb. 1853

Brake Passage,
Diago Ramirez Islands
Cape Horn
Jan. 25

March 1

Jan. 1, 1854

Feb. 1

Jan. 15

ERROL MORRIS: From the moment you saw these letters in the box?

MARK DUNKELMAN: Yes. Allan had them in a shoebox. They were bundled up somehow. And he hadn't looked at them, for God knows how long.

ERROL MORRIS: As you read the letters for the first time, did you feel that Amos was coming back to life?

MARK DUNKELMAN: Yes. My whole idea of him was changing because I knew nothing of his personality or his personal experiences during the war. He was sick on occasion during the war. He mentions his comrades caring for him like a brother. And he referred to his hands. He said they looked like bird's claws. That was great stuff. That was the key to me. That was the key. He could speak again. He could be a living person again instead of a corpse in rigor mortis on the battlefield.

———

There is something magical and sad about chronicling the history of a man who went more than halfway around the world on a whaling ship and then died (presumably

alone) in a small town, a couple of hundred miles from his home. It is possible to chart Humiston's movements from the moment he joined the 154th in Jamestown, New York, to Gettysburg, Pennsylvania—a winding, circuitous, antlike path that might have meaning—but then again, might not. And even if we could chart it completely, does it bring us closer to Amos Humiston? Does it capture the *essence* of the man? Even if we knew where he was every minute of his waking life, would that tell us who he is?

There is also a stereogram of the place where he died.[5] Does it make his death more *real*? Does it reconnect us with the *event* by showing us where it happened? By looking at a photograph of the fence on Stratton Street where Humiston was found—does it allow us to imaginatively reenact Humiston's death? There was a full moon that night.[6] But it was raining on and off through the three days of battle, and the sky was intermittently overcast. Can we imagine Humiston looking up through shifting clouds at the moon? And then at the ambrotype?

There is an endless fascination with last words, but what about last images? There is the legend of a last image being permanently imprinted on the retinas of those about to die. Here, the ambrotype reveals that last image. By looking at the faces of the Humiston children, we can see what Humiston was *seeing* as he died.[7]

And what about us? Does linking his experiences with ours allow us to better *know* him or only to *imagine* ourselves *as* him? Is he important as an individual or as an unknown everyman? Maybe we don't learn anything at all. But I couldn't help but try to find out more.

ILLUSTRATION #151
STEREOVIEW

ILLUSTRATION #152
MAP OF THE DATES OF LETTERS SENT FROM HUMISTON

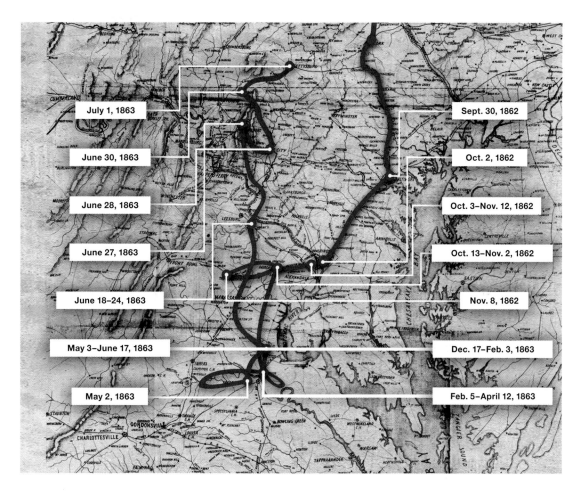

Humiston's story reminds us that most historical mysteries remain unsolved, and in all likelihood can never be solved. That Mark Dunkelman was able to recover so much of Humiston's lost history is the exception, not the rule. On the whole, we know little or nothing of the thousands of soldiers who lost their lives at Gettysburg.

Dunkelman writes:

> Even when an item obviously belonged to a dead soldier, it didn't always serve to identify him. Scattered near a dead Confederate on the first day's field were letters and a photograph of his South Carolina fiancée, torn to pieces. The burial party who found him surmised the man had ripped apart the items before he died to prevent them from becoming souvenirs. . . . On

Whose Father Was He?
239

some lucky occasions, an artifact served to identify a corpse. Two cases involved privates found on the southern portion of the battlefield. A Pennsylvanian was identified by a silver medal found clutched in his hand. Another soldier was found missing his hat, shoes, and socks, but inside one of his pockets the burial squad found a gold locket with a photograph of his wife or sweetheart, along with her name and address. And so some of the Gettysburg dead were identified in a fortuitous manner by a letter, a photograph, an inscribed testament or diary, a stencil plate, or an identification disc found on their bodies. But their stories remained unknown to the general public, merely noted in passing by the members of the burial squads who found them.[8]

A gold locket, a diary, even the images of bloated corpses that dot Alexander Gardner's photographs of the battlefield. It is all ephemera. Odds and ends. Flotsam and jetsam.

ILLUSTRATION #153
BATTLEFIELD STEREOGRAPH

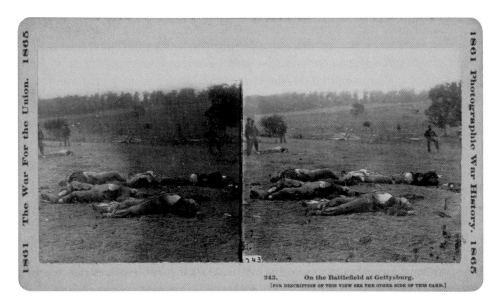

ERROL MORRIS: And then there's the photograph of Amos Humiston himself, taken before the war. David Humiston Kelley has the original ambrotype. But I've seen two versions: Amos with and without a beard.

ILLUSTRATION #154
AMOS WITHOUT AND WITH A BEARD

MARK DUNKELMAN: Bourns wanted to issue photographs of him. But rather than just reproduce the photograph of him as a civilian, Bourns, or in all likelihood one of the photographers employed by him, had the brilliant idea to make a soldier out of him and slap the beard and the uniform on him, retouched.

ERROL MORRIS: Why would someone in a photography studio want to slap a beard on Amos Humiston? Doesn't it seem to be the handiwork of someone who was marketing this image to the public? Isn't it about how Amos Humiston *should* look as opposed to how he *did* look?

MARK DUNKELMAN: Maybe. Philinda knew he had grown a beard, probably before he left home. Because I don't think he mentioned it in his letters. And the uniform was just a no-brainer. But it's obvious that it was retouched from the original. If you look at the hair, etc., the eyes, it's the same image. The one that I've got says, "Sergeant Amos Humiston of the 154th New York Volunteers" on the front. And on the back, it gives the blurb written by J. Francis Bourns: "Sergeant Humiston fell in the first day's struggle at Gettysburg. When found, he could not be recognized, and was buried among the unknown dead. But the Picture his brave hand grasped in death—the portrait of his three little children—months afterward led to his identification. After the discovery of his family, who reside at Portville, N. Y., the original of this photograph was obtained; and the copies are sold in aid of the Orphan's Homestead. J. Francis Bourns, Sec'y. Philadelphia, Pa."

ILLUSTRATION #155
AMOS PORTRAIT CARTE DE VISITE

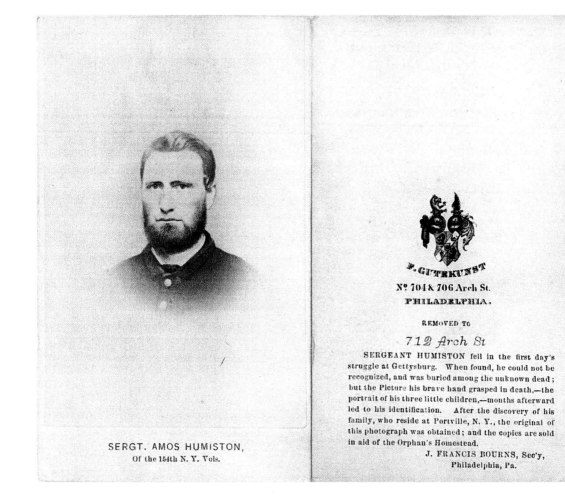

SERGT. AMOS HUMISTON,
Of the 154th N. Y. Vols.

F. GUTEKUNST
N.º 704 & 706 Arch St.
PHILADELPHIA.

REMOVED TO

712 Arch St

SERGEANT HUMISTON fell in the first day's struggle at Gettysburg. When found, he could not be recognized, and was buried among the unknown dead; but the Picture his brave hand grasped in death,—the portrait of his three little children,—months afterward led to his identification. After the discovery of his family, who reside at Portville, N. Y., the original of this photograph was obtained; and the copies are sold in aid of the Orphan's Homestead.

J. FRANCIS BOURNS, Sec'y,
Philadelphia, Pa.

ILLUSTRATION #156
CHILDREN CARTE DE VISITE

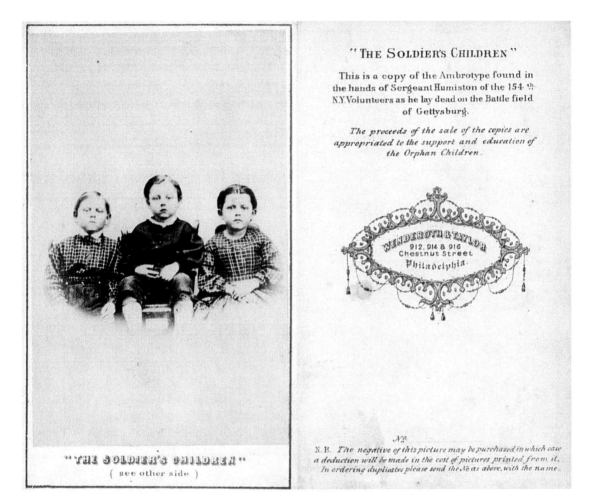

"THE SOLDIER'S CHILDREN"
(see other side)

"THE SOLDIER'S CHILDREN"

This is a copy of the Ambrotype found in the hands of Sergeant Humiston of the 154 th N.Y. Volunteers as he lay dead on the Battle field of Gettysburg.

The proceeds of the sale of the copies are appropriated to the support and education of the Orphan Children.

WENDEROTH & TAYLOR
912, 914 & 916
Chestnut Street
Philadelphia

N°
N. B. *The negative of this picture may be purchased in which case a deduction will be made in the cost of pictures printed from it. In ordering duplicates please send the N° as above, with the name.*

Bourns established the Homestead Association in 1866, three years after Amos's death. Its purpose was to establish an orphanage for the children of deceased soldiers. A house adjacent to the cemetery was acquired, a board appointed (which included James Garfield, future president of the United States), and a superintendent hired. Dr. Bourns was the general secretary. Philinda, Amos's widow, accepted a position as a housekeeper, and Frank, Alice, and Fred, the three Humiston children, came to Gettysburg to live at the Homestead, less than a mile from where their father had died. The orphanage opened with an elaborate ceremony that included the children singing "America." It was celebrated in newspapers around the country.

It was an attempt to give meaning to the terrible battle losses that had occurred at Gettysburg—to heal a wound that affected the entire nation.

As an article in the *American Presbyterian* intoned: "The fidelity and affection of the dying sergeant for his own little household has set in motion a stream of benevolent intentions and efforts designed to embrace many bereaved families in widely different sections of the country. . . . Parental love has secured for the humble soldier his personal share in the gratitude of his countryman and made his name immortal."

Dr. Bourns provided a drawing of what the Homestead Orphanage would look like. It depicts a palatial domicile, complete with gables, arches, columns, and a mansard-roofed tower. The actual Homestead Orphanage, photographed on June 21, 1867, on the occasion of the first visit to Gettysburg by Ulysses S. Grant, was somewhat less impressive. The caption on the card-mounted photograph says, "It is used until a more commodious and suitable structure can be erected to shelter its present fatherless inmates." The use of the word "inmates" may simply be an anachronism or a forbidding harbinger of what was to happen next.

ILLUSTRATION #157
HOMESTEAD ORPHANAGE DRAWING

ILLUSTRATION #158
HOMESTEAD PHOTOGRAPH WITH GRANT IN IT

Gen. Ulysses S. Grant

Sales of the cartes de visite—the retouched pictures of both the children and Amos Humiston—continued to provide income to the orphanage, and it is clear from various newspaper accounts that Dr. Bourns was constantly monitoring the production of cartes de visite. In one letter to the editor, he expresses concern about "a recent counterfeit copy of the photograph."

ILLUSTRATION #159
GERMAN REFORMED MESSENGER

For the German Reformed Messenger.

THE CASE OF SERGEANT HUMISTON.

To the Editor of the Ger. Ref. Messenger:

Sir—The history of Sergeant Humiston, and of the effort in progress to provide for the dependent family of the honored soldier, is now known to the country. It is known that the sales of the photograph of the children, have been the simple means relied upon to secure the family's present and prospective support. These sales have been most seriously damaged by a recent counterfeit copy of the photograph, which is being extensively circulated and sold to benefit parties concerned in its issue. The spurious picture comes, or purports to come from New York. This grievous wrong to the widow and orphan children of the fallen soldier ought to be held up to the indignation of the public.

The humane and patriotic, desiring to assist in paying the debt the country owes to this stricken family, will be glad to learn that the genuine copies of the orphans' photograph are now executed only in Philadelphia, and have upon them a printed statement of the object of their sale, with the im-

print of the several Philadelphia artists who furnish them.

The amount thus far realized for the family is not quite fourteen hundred dollars. It is not intended to enrich this soldier's family, to the neglect of families of other soldiers who have perished in defence of the Union; but after suitably providing for the Humiston orphans, any profits arising from continued sales of their picture, and of the music just published, shall be appropriated to the relief of other orphaned families, having an equal claim to the country's grateful sympathy and protection.

I am, sir, respectfully yours,

J. FRANCIS BOURNS.

Philadelphia, May 28th, 1864.

☞ Genuine copies of the photograph referred to in the foregoing note from Dr. Bourns, may be had at the Bookstore of Mr. S. S. Shryock, Chambersburg. Price 25 cents for small size, and 75 cts for large.

By 1869, Philinda had accepted an offer of marriage from a man twenty-four years her senior. She left the Homestead with her new husband and then sent for the children. Various superintendents came and left. And this is when the story takes a turn for the wicked.

Part 2

In 1870, Dr. Bourns hired Rosa J. Carmichael, whom he later described: "As a teacher and disciplinarian, Mrs. Carmichael has few equals, and she is a most assiduous and faithful worker, laboring often beyond her strength in school and out." Indeed. She was the Cruella de Vil of the Homestead. Except she was no comic book villain, she was the real thing. Rumors began that all was not well with the children. Locals noticed that they were no longer allowed to participate in Memorial Day activities like putting on a pageant and decorating graves. The orphans were instead forced to watch while "happy children" brought flowers to the various cemeteries around town. Edward Woodward, a local veteran, wrote, "They are kept like galley slaves, while strangers decorate their fathers' graves."[9]

Woodward's poem is preserved in the Gettysburg College Library, with a letter from the donor introducing the poem and its author:

REV. STANLEY BILLHEIMER, D.D.
226 East Oak Street
PALMYRA, PENNSYLVANIA

November 28, 1945.

Librarian, Gettysburg College.

Possibly the enclosed might find a place among Gettysburgiana. If not, they may be discarded. Woodward, author of the poems, was an eccentric veteran of the Civil War, living on "Woodward" avenue. He was an umbrella mender, well known to the students of the 80's and 90's. He often spoke in rhyme, in ordinary conversation. He was an expert in opening dud shells found on the field.

Respectfully, Stanley Billheimer, '91

The letter and poem are courtesy of Gettysburg College, Musselman Library, Special Collections. As a service to the reader, the Woodward poem is presented here in its entirety:

Is this the thirtieth day of May,
On which a Nation its floral tributes pay?
Nature hath lavished her gorgeous powers,
In the form of the choicest flowers,
To decorate the soldiers' graves,
Who fought like freemen—not likes slaves.
Where are the children of the slain,
Are they enjoying freedom or in pain?
No! they are kept like galley slaves,
While strangers decorate their fathers' graves.
In Gettysburg at the Orphans' Home,
A modern Borgia does rage and foam,
On the consecrated Memorial Day
When a Nation its grateful tributes pay
To the memory of the noble dead
Who fought and oftener bled.
During the first, second and third of July
The fathers of the orphans fight and die;
At night no one to lift them from the cold sod,
No one to hear them cry but their God;
All for love of country. Then tell me why
The Soldier's Orphans should mourn and cry.
To you, their father's living comrades:
You saw them use their muskets and trusty blades.
In those days of carnage and bloody strife,
That gave the Nation new hope of life.
Remember the mess, the bivouac fires,
When you conversed with our now dead sires.
You promised to be kind one to another.
Then defend the children of a dead brother.
Grand Army of the Republic if you are strong,
Think of those who are feeble and young;
Our fathers fought, starved, bled and died,
And left us helpless, their hope and pride,
Ere secession's cruel war's alarms
Caused patriot soldiers to fly to arms.
Have the orphans no privileges to claim?—
We are told their dead are handed down to fame.
Are we to be ruined in body and soul—
Are there no laws a wretch to control
Who clothes two females in men's attire,
While the sun burns like scorching fire?
Afterward abused and driven to bed,

Causing us to wish we were dead.
Spirits of our fathers speak from your graves,
If your comrades act like thoughtless slaves!
Then let us orphans, not strangers, decorate the graves
Of our loved and honored country's fallen braves.
Far better shut the bastile [*sic*] — set us free
Than cripple us in our infancy.

More stories began to circulate about strange goings-on at the Homestead. Little Lizzie Hutchinson and Bella Hunter were forced to wear boy's clothes for more than two months as punishment for tearing their dresses. Mrs. Carmichael even conscripted one of the older children to serve as informant and stooge. John M. Vanderslice, a Philadelphia investigator, the assistant adjutant general of the Department of Pennsylvania, Grand Army of the Republic, reported, "The boy beats and kicks in the most cruel manner little children of tender age and does it with the apparent delight of the matron and with her certain approval." Vanderslice also made his strong opinions about Dr. Bourns evident. He called the Homestead "a summer resort of Dr. Bourns, where he is waited upon by the little inmates, whose fathers sleep in the adjoining cemetery."

May 30, 1876, marked the beginning of the end. The nightmare conditions at the orphanage were finally exposed in a series of newspaper articles in the *Philadelphia Times* and the *Gettysburg Star and Sentinel*. The orphans had been denied food, clothing, and schooling. Not only had they been beaten, but leg irons and hobbling chains were also used.

ILLUSTRATION #160
HOBBLES

In 1877, Dr. Bourns was charged with embezzling. The suit against Mrs. Carmichael and him also included "mismanagement, waste of property and violation of trust." They were removed, a receiver was appointed, and the sale of the Homestead ordered. An injunction to delay the sale was granted until homes could be found for the nine remaining orphans, lest they be "turned upon the street as objects of charity." Three were sent to the Home of the Friendless in Philadelphia; another was adopted by the superintendent of the cemetery. When the last of the orphans was finally placed, the sheriff seized the property and its contents were auctioned.

Shortly after my interview, I sent an e-mail to Mark Dunkelman asking him about Dr. Bourns:

> Bourns continues to fascinate me. What kind of man preys on widows and children?

Mark Dunkelman responded:

> I get the impression that there were Jekyll and Hyde aspects to Bourns's personality. At first he used the ambrotype to instigate the wave of publicity that eventually led to Amos's identification. Most likely he paid for the initial, pre-identification cartes de visite out of his own pocket. And he stipulated that proceeds from the sales of the cartes and the Hayward and Clark sheet music were to benefit the "orphan children"—meaning the Humistons. All of those seem to be acts of true and heartfelt altruism. And Bourns must be given credit for seeing his dream of an orphanage for soldiers' children become a reality. But at some point after the founding of the Homestead, Bourns went wrong. Was he suffering financial difficulties, or was it simply greed? We don't know. In addition to the Sunday school monies he embezzled, there's the question of the sales of the photographs. By then the cartes of the children were being produced in mass quantities. What sort of financial arrangements Bourns had with the manufacturers—and how much of the proceeds went into the doctor's pocket—I have no idea.[10]

And then Mark Dunkelman sent me another e-mail, this time going much further into the character of Dr. Bourns and adding recent information that was not available for his book:

> During my recent New York research trip, I came across an article, "The Gettysburg Orphan Asylum," in the Aug. 29, 1868, issue of *The Soldier's*

Friend, a newspaper aimed at veterans. It published a letter from a member of a Grand Army of the Republic post inquiring about placing orphans in the Gettysburg asylum, and a reply from Dr. Bourns stipulating the requirements: "Orphans are received only on the nomination of shareholding Sabbath-schools. A Post of the G.A.R. might constitute some Sabbath-school a shareholder by contributing the amount of one share ($25) or more, for the purpose, and the school could then nominate the orphan desired to be placed in the institution, only agreeing annually to contribute something toward the maintenance of its orphan ward, the amount of this yearly donation being left entirely to the option of the Sabbath-school. The Homestead being dependent absolutely upon public charity for its existence, the arrangement made with the Sabbath-schools represented by the orphans in the institution secures a handsome yearly revenue to the treasury." So in addition to paying $25 to place an orphan in the Homestead, a Sunday school had to make an annual donation toward the support of said orphan. In the end, Bourns was not only cheating the orphans themselves, but all the little Sunday schoolers who supported them.

The grown Humiston children eventually weighed in on Dr. Bourns's character. Alice Humiston, in particular, was concerned about recovering the ambrotype from Dr. Bourns. In the *Gettysburg Star and Sentinel*, October 31, 1914, she was quoted: "He refused to return it, saying that we would receive it at his death. Even then we did not recover it and although my brothers have made a number of efforts since that to find the picture, they were unsuccessful in the work." And then there is a handwritten notation by Alice on an empty envelope now in the possession of David Humiston Kelley. It contained a carte de visite copy of the original ambrotype:

ILLUSTRATION #161
THE EMPTY ENVELOPE

Copy of original tin type which Amos Humiston was looking at when he died. The original was never handed over to the rightful owners, who were cheated out of all the profits from the sale of the picture by Dr. Francis Bourns who never did a stroke of work after the pictures began to be sold but lived in comfort all his days. He had absolutely nothing until then. So my mother was told by a Lady who knew him well. My mother was young or this would not have happened.

Various attempts by Humiston heirs to find the ambrotype have been unsuccessful. Mark Dunkelman hoped that his book would draw attention to the story and secure its return, but the ambrotype has yet to be found. Perhaps it is displayed on a mantle or in an antiquarian's shop or in an eccentric, personal collection of Gettysburgi-ana (like Edward Woodward's poem). Where is the ambrotype? The promise of its return still remains unfulfilled.

Dr. Bourns will forever be an enigma. Who was this bachelor who intervened in the lives of the Humiston family? Was he a Good Samaritan, a villain, or both? Mark Dunkelman found a diary that Dr. Bourns had kept as a young man. He had read his first book at age eight or nine, John Bunyan's *The Pilgrim's Progress*, the story of how Bunyan's pilgrim makes his way from the Valley of Humiliation and the Slough of Despond to the Gates of the Celestial City. Did Dr. Bourns imagine himself as a pilgrim on a similar journey?

Among the many clippings collected by David Humiston Kelley is a poem written by Dr. Bourns in 1888 and published in the *Episcopal Recorder*, about ten years after the demise of the Homestead Orphanage and about ten years before Dr. Bourns's death on December 20, 1899. It is reprinted in Mark Dunkelman's book:

> Thou Light above! the powers of darkness come, Environing where thou hast ever shone; Hope and perception grope in baffling gloom; Despair's chill terror in my soul I own, And hope-abandoned, now I am alone.

But what does the poem mean? Does it humanize Dr. Bourns, or is it merely a villain's maudlin journey into self-pity? At the very least, the poem tells us that history is always open to reexamination, if only because something new can show up or something forgotten can resurface.

Mark Dunkelman urged me to talk to Amos Humiston's two great-grandchildren, David Humiston Kelley, an expert on archaeoastronomy, and Allan Lawrence Cox, a retired salesman. David Humiston Kelley's curriculum vitae is quite impressive. He is in part responsible for deciphering the Mayan hieroglyphs, has written the definitive textbook on the astronomical techniques of ancient civilizations, and has pioneered research on routes of communication between ancient Egypt and the civilizations of Mesoamerica.[11] David Humiston Kelley was clearly impressed by Mark Dunkelman's achievement, but he mentioned a piece of evidence that had slipped away—the log of the whaling ship that Amos Humiston had taken halfway around the world.

DAVID HUMISTON KELLEY: The log was actually on sale shortly after Mark became interested. But he didn't know it was on sale at that time. It got sold, and we've never been able to find out who bought it. This was the captain's personal log, as opposed to the official ship's log. And it would have had details.

ERROL MORRIS: Mark also told me that you have prepared elaborate genealogies of many families, including your own.

DAVID HUMISTON KELLEY: By my standards, not nearly elaborate enough, but still, yes.

ERROL MORRIS: Some that go back to King David?

DAVID HUMISTON KELLEY: The material on King David isn't yet published. I have been working on the King David materials, and I'm collaborating with Bennett Greenspan, who does DNA testing.[12]

ERROL MORRIS: Really?

DAVID HUMISTON KELLEY: Of course, social descent does not always coincide with biological descent. Particularly, you get adoptions of close relatives. A man may adopt his sister's son or his brother's son. If he adopts his brother's son, the male line DNA is going to be the same. But if he adopts his sister's son, it might be, but more likely it isn't. And it's remarkable that you have a few examples of cases where there hasn't been a shift, that it is a valid male line descent the whole way.

ERROL MORRIS: What would be an example of that?

DAVID HUMISTON KELLEY: Well, the two families that I'm particularly interested in with American and English ancestry go back to the eighth century AD before they have any common ancestry. But the DNA evidence gives a rough estimate of mid-eighth century, which is almost perfectly correct. And that means that both lines have common male line ancestry all the way from the eighth century to the present, biologically.

ERROL MORRIS: Now, you became interested in this research in connection with your own genealogy? Or independent of that?

DAVID HUMISTON KELLEY: Independent, essentially. I became interested in genealogy when I was in high school. And there were all kinds of fake royal genealogies, including some that had descents from the House of David. And I found about one in twenty royal genealogies were valid. And, at that time, my critical sense was probably as good as it is now. But it was much more sporadically applied, so that I looked at some things and said, "Oh, that can't be." Other things I just said, "Oh, this says such and such . . ." and let it go at that.

ERROL MORRIS: I would be interested in your connection to the Amos Humiston story, what you knew about it prior to—

DAVID HUMISTON KELLEY: Oh, I knew all about it. I was brought up with it. My mother came from Jaffrey, New Hampshire. And that's where my grandfather, Franklin Humiston, was the local M.D. And he was Amos's son. I saw Fred occasionally, but I very rarely saw Alice. Her niece, Alice Mildred Humiston, was the librarian at UCLA. She was a cataloger.[13] She started there the year before they actually had the campus open. And she became chief cataloger before she retired, and wrote a history of the catalog department. And she was actually the one who gave me Ann Axtell Morris's *Digging in Yucatan*, which led me into my professional work and my archaeology.[14]

ILLUSTRATION #162
DIGGING IN YUCATAN **COVER**

DIGGING
IN YUCATAN

BY ANN AXTELL MORRIS

DECORATIONS BY JEAN CHARLOT

Illustrated with Photographs

ILLUSTRATION #163
DIGGING IN YUCATAN **PHOTOS**

Courtesy of Carnegie Institution

A MAYA YOUTH BEFORE THE SHRINE OF HIS ANCESTORS
*In sunset reverie, dreaming, it seemed to me, of what might have been
had he lived in the noonday of his race.*

Courtesy of Carnegie Institution

DIGGING OUT THE GREAT TEMPLE OF THE WARRIORS
*Bit by bit, the entire weight of the massive upper building was trans-
ferred from its old foundations to its new artificial braces.*

I had a genealogy that my great-aunt had prepared. It showed our descent from Roger Williams. It turned out to be incorrect, because there were two men named Hiram Williams in the same town. And one of them had two brothers, and the other one didn't. And the one who didn't lived next to the two brothers, and the other one lived well away from town. And she, of course, thought that the three brothers were living together, which made normal sense—but wasn't right.

ERROL MORRIS: How were you able to uncover this error?

DAVID HUMISTON KELLEY: Well, puttering away. You know, you check one thing, and then you check another thing, and then you check a third thing. And eventually, you find something.

ILLUSTRATION #164
HUMISTON FAMILY TREE

ERROL MORRIS: But you knew about the Amos Humiston story from your childhood?

DAVID HUMISTON KELLEY: Yes. I certainly did. I don't remember when I first heard about it. It probably was one of the times when Great-Aunt Alice or Fred was coming to visit. I was probably five or four or six, somewhere in there. From a very early age, I knew about Philinda Betsy Ensworth Smith Humiston Barnes. That, of course, was Amos's wife. She was married first to Justin Smith, who was in western New York and a cousin of the famous prophet [Mormon founder Joseph Smith]. They got married very young, and he died right away from some disease. I don't know what. And then she

married Amos. And they went out to Flint, Michigan, and they saw relatives there. I've never been able to find out whom they saw. The Humistons didn't keep much contact with each other.

ERROL MORRIS: You have the original ambrotype of Amos, if I'm not mistaken.

DAVID HUMISTON KELLEY: Yes.

ERROL MORRIS: But the ambrotype of the children has been lost.

DAVID HUMISTON KELLEY: Right.

ERROL MORRIS: The whole story of Dr. Bourns is odd. There's a paucity of evidence, but clearly he saw an opportunity to make a dollar.

DAVID HUMISTON KELLEY: Well now, what's bothering you particularly?

ERROL MORRIS: There's something interesting about making money from a photograph. Bourns grasped the possibility of turning the ambrotype into a cause célèbre and conceived the idea of marketing it.

DAVID HUMISTON KELLEY: Yes. That *is* Dr. Bourns's doing, very largely. Who, incidentally, was alleged to be a relative of that famous Robert Burns. He changed the spelling. He was supposed to be a descendant. And given the thirteen children, it's quite possible.

ERROL MORRIS: Adding the *o* to "Burns" is very peculiar. At least, it strikes *me* as peculiar. What is Dr. Bourns's reputation in the family?

DAVID HUMISTON KELLEY: Bad. It seems quite clear to me that he collected money and did not pass it all on, that he profited a bit more than he should have from this tragedy. He profited in ways that were not quite scrupulous.

ERROL MORRIS: What would those ways be?

DAVID HUMISTON KELLEY: Well, allegedly he had connections with that remarkably nasty woman who was running the place, the matron in charge. And she was actually taking money intended for food for the orphans and skimming it, and giving them less expensive food, less food—sometimes *no* food. I don't remember how much of this Mark talked about, because, of course, there are some things that, even today, can put you in trouble if you talk too much about them.

ERROL MORRIS: How so?

DAVID HUMISTON KELLEY: People can claim ancestral connections and say that it ultimately damages their reputation. I'm not saying that this argument has ever met much support from the courts, but it *has* happened on occasion.

ERROL MORRIS: That you've gratuitously defamed the memory of Dr. Bourns?

DAVID HUMISTON KELLEY: Yeah. And of the lady in charge of the orphanage.

ERROL MORRIS: But this goes back to the 1870s.

DAVID HUMISTON KELLEY: Particularly if you haven't got awfully good proof. And there isn't awfully good proof. There are a number of strong indications and the belief in the family.

ERROL MORRIS: I went to the astronomy library and got a copy of your book, *Exploring Ancient Skies*. Your own interest in doing archaeoastronomy or piecing together . . .

DAVID HUMISTON KELLEY: Well, my interest in archaeoastronomy is very, very secondary, even though it ended up with that book. I started by being interested in the Maya. And then I became interested in the chronology of the Mayas, and in the things that they did in their books. And particularly in the Dresden Codex.[15] I'm very interested in connections between cultures around the world. I'm very interested in *continuities*, both geographic and temporal. And so, I have worked on these, both genealogically and archaeologically, and ultimately calendrically and astronomically.

ERROL MORRIS: When you say you were interested in *continuities,* it is as if you are trying to find patterns in a morass of historical materials.

DAVID HUMISTON KELLEY: Yes. In the new world, what ideas are there? Where do they come from? Are they separate inventions? Or are they things that they learned from other places and then modified somewhat? All of that sort of thing. I've found out, recently, that there were Egyptians in Mesoamerica. I had thought there were connections, but I had thought they were second-hand through an intermediate, perhaps through Phoenicians or Greeks or somebody. But I didn't think they were directly Egyptian. But I now have *massive* evidence that they were.

ERROL MORRIS: And when you say massive evidence, for example?

DAVID HUMISTON KELLEY: Three different calendric types of continuity. That's one sort. Then I've got over thirty deities and mythical place names, starting with Egypt itself. The Aztecs say that they came from Tlapallan, which is the ancient red land. And the Egyptians called their land Red Land Black Land. The Aztecs actually called it Tlillan-Tlapallan, which is "black land–red land." And they were under the leadership of the inventor of the calendar, who was called Cipactonal. And *cipactli* means "crocodile," and *tona* is "day" and is related to the word *tonatiuh,* which is "sun god." And *tona* relates to Aton in Egypt. And *cipactli* relates to Sebek or Sobek in Egypt. So you've got linguistic evidence for a very complex name.

ERROL MORRIS: I was interested in what Mark Dunkelman was doing, because of the nature of this kind of historical exercise—trying to put together a picture of the past from odds and ends of material, bric-a-brac. I'm not sure whether it's more difficult to reconstruct the story of a nineteenth-century individual or an ancient civilization.

DAVID HUMISTON KELLEY: I wouldn't say there's much difference. That may sound funny, but there is, of course, a great deal more bric-a-brac to deal with. But in terms of the way you go about it, I don't think it's that much different.

ERROL MORRIS: How so?

DAVID HUMISTON KELLEY: Well, you're trying to fit together pieces. And some pieces come together relatively easily and others only with great difficulty. You can find certain similarities and explain them, and then you find that they seem to contradict other similarities, which suggests a different interpretation. It's much the same sort of thing.

ERROL MORRIS: But you *do* believe, in principle, it is possible to recover the past?

DAVID HUMISTON KELLEY: Yes. But only in part. I don't think we're ever going to know how many times Egyptians sailed to the New World. I don't think we're going to know who the captains of any of the ships were or anything about the crews. We can say a lot about it, but we can never say the sorts of things that we can say about the *Titanic*. And there's a lot we can't say about *that*.

ERROL MORRIS: You use the word "similarities." What makes one thing *similar* to another?

DAVID HUMISTON KELLEY: One, rarity of occurrence, and two, specificity of unusual *arbitrary* characteristics. Arbitrary characteristics, particularly ones that are unusual, are good evidence. Things like a lion's head with pink and white whiskers on a snake's body. I've got the lion's head in Egypt, and I've got jaguar heads in Mesoamerica, with the pink and white whiskers. I have jaguars with snake bodies, but they aren't specifically identified with the jaguar with the whiskers. But still, when you put the two together, it makes a reasonable similarity with this Egyptian one. And it's a very *arbitrary* similarity.

ERROL MORRIS: Arbitrary? In what sense?

DAVID HUMISTON KELLEY: Lions don't have snakes' bodies.

ERROL MORRIS: Ah.

DAVID HUMISTON KELLEY: They are very rarely thought of as having snakes' bodies. Felines, of any sort, do not have snakes' bodies. And neither do they have red and white whiskers.

ERROL MORRIS: Yes, it's not something that would just happen accidentally, this kind of pattern.

DAVID HUMISTON KELLEY: That's correct. It isn't due to the common workings of the human mind. There are no other cultures anywhere in the world that I know of that have either a feline with a snake's body or red and white whiskers.

ERROL MORRIS: Where can I read about this? Have you written this up?

DAVID HUMISTON KELLEY: There's some of it in *Exploring Ancient Skies*. It's in the last chapter, fairly near the beginning.

Shortly after my conversation with David Humiston Kelley, I turned to my copy of *Exploring Ancient Skies*. In the last chapter, chapter 15, "The Descent of the Gods and the Purposes of Ancient Astronomy," Kelley writes:

We draw attention to notable similarities and differences among cultures around the world and offer some interpretations of the patterns we recognize. The major difficulties of interpretation lie in deciding which material is relevant.

This is indeed a central question. Which material *is* relevant? How do we *see* the pattern in the morass of data? But the problem is, of course, much worse. There is at the same time a morass and a paucity of data. You would think that it is easy to lose an ambrotype or a document or even the entire story of one man, but how about the story of an entire civilization? That seems unlikely, and yet the decipherment of the Mayan hieroglyphs in which David Humiston Kelley, Amos Humiston's great-grandson, played a significant role was hampered because virtually all of the original historical material created by the Mayas was destroyed by the Spanish invaders. As Michael Coe writes in *Breaking the Maya Code*, "What we are left with are four [books] in various stages of completeness or dilapidation . . . and monumental inscriptions, many weathered beyond recognition."[16] Diego de Landa (1524–1579), bishop of the Yucatan, who played a crucial role in the destruction of the Mayan bark books, wrote, "We found a large number of books in these characters and, as they contained nothing in which were not to be seen as superstition and lies of the devil, we burned them all, which they [the Maya] regretted to an amazing degree, and which caused them much affliction."[17]

Last but not least, I felt that I had been remiss in not asking David Humiston Kelley about the often repeated claim that the Mayan calendar fixes the end of the world as December 21, 2012, the winter solstice—just a few years away. And so, I called him back, and we talked about the Mayans, their concept of time, and the apocalypse.

DAVID HUMISTON KELLEY: The Mayans could talk about dates that happened roughly five times the present supposed age of the universe. They were fascinated with time. We can't say much more than that.

ERROL MORRIS: Did the Mayans really predict that the world would end on December 21, 2012?

DAVID HUMISTON KELLEY: No. It's based on a false assumption.

ERROL MORRIS: You mean the world isn't going to end on that date? [I was disappointed.] Please explain.

DAVID HUMISTON KELLEY: They are 208 years too early. [The correct date is December 21, 2220.] I wrote a long article on various ways of solving this problem. I included in a footnote that you could almost get things to match up correctly if you used correlation 660205, the Julian day number of the base state of the Mayan calendar. Which is also the interval between the translation of the number in the Mayan baktun, katun date, if you add that number to that date you get what we would consider to be the equivalent date. Ha! A bit complicated but I think you can follow. The colonial Mayas, most of them didn't have any clue about this. The ones who *did* were the calendar specialists and they made sure to keep their mouths pretty tightly shut because the Spaniards were burning people at the stake for maintaining pagan ideas, of which the calendar was a major part. The calendar

determined all the ceremonies and rituals, when people were sacrificed, all the nasty things and all the good things.

At Mark Dunkelman's urging I contacted Allan Cox, the other great-grandson who had found the Humiston letters.

ALLAN COX: My mother was in the nursing home, and I was at the house to feed the cat. And the phone rang. It was him. He said, "Is this Allan?" And I said, "Yeah." But we just talked, and he told me what he was doing and everything. And we got together one day and had lunch. And then we ended up at the dedication down in Gettysburg for the monument. So that's basically how it all came together.

ERROL MORRIS: Just so I understand the genealogy . . . you are related to whom?

ALLAN COX: Eleanor Humiston Cox is my mother. And her grandfather was Amos Humiston.

ERROL MORRIS: And which of the three children was her father?

ALLAN COX: Not the doctor. Not Franklin. Fred. He's the one who was the salesman.

ERROL MORRIS: Did you know that your mother had these letters?

ALLAN COX: Mark copied them all. I was going to give him the originals and he said, "No." And then I got thinking about it, and I told him again that I was going to give him all the letters just so he could have them and put them in the library in—

ERROL MORRIS: Portville? [The town where Amos Humiston lived before joining the 154th New York and going off to war.]

ALLAN COX: Yeah. He was going to donate them to them. I haven't followed up. They're in a box someplace, and I haven't gone through all the boxes. So I haven't found the letters to give him. I looked through the boxes and stuff like that. My back is screwed up, and to bend over and go through all that stuff, I haven't got the energy to do it. But I did go through quite a few of the boxes that I have, and I couldn't find the letters.

ERROL MORRIS: Is there any way that I could help?

ALLAN COX: Not really, it's just two boxes. What I'll do is some day I'll get a couple of friends of mine or something, and I'll go through the boxes again. Because I got the boxes right here.

ERROL MORRIS: I was thinking I could send someone over, or I could get someone to help you do it. It's not the letters; it's getting scans of them and of the poem.

ALLAN COX: What I'll do is go through what I've got, the boxes here, and I'll see if I can find them.

ERROL MORRIS: And if you need my help or anything like that, I'm happy to either send someone over from this office or come myself.

ALLAN COX: I'll get somebody. It's about ten boxes, I don't know. They're here. I don't know why the hell I couldn't find them when I went looking for them for him, because I wanted to just give them to him. Originally, I had wanted to give them to him anyway to start with, but he said no. So he just made the copies.[18] I'll look through what I've got in the boxes. See, I moved since then. I was living in Watertown. Originally I was living in Belmont, and then I bought a condo in Watertown. Then I sold that. The house that I'm in now was my mother and father's house, which was my grandmother's to begin with. It's a matter of just going through the boxes that I've got here. Okay, this was like a couple of years ago, and I couldn't find them. And maybe I missed one of them and whatever. But it's probably four closets with boxes is what it amounts to. I remember just what they look like. It is tied around with a rope, and they were all together. Maybe they got lost when I moved. Maybe somehow or another they disappeared when I moved. I just don't know.

Four closets with boxes. The letters (at least, Amos Humiston's side of the correspondence) were saved by Philinda, passed down to Fred, to Fred's daughter, and eventually to Allan Cox, who may have misplaced them or even lost them. Could it be that the act of rediscovering them—Allan Cox finding them in his mother's house that he just happened to be visiting—caused them to be permanently lost? Can we predict who our heirs will be or whether they will be interested in our artifacts from their past? David Humiston Kelley is obsessed with genealogy, but it is Allan Cox who inherited the letters. Luck of the draw.

The letters themselves may have vanished, but their *content* has been preserved in the Xerox copies made by Allan Cox and given to Mark Dunkelman, who transcribed them, preserving the inaccuracies in spelling and grammar. As Amos Humiston made his way from Jamestown, New York, to Gettysburg, Pennsylvania, he left a trail of dates but also of letters, letters that tell an endlessly sad story of a shattered family, an uncertain future, and vain hope. There is the longing for his wife and children; his illness ("the dirty hurty" or "the Virginia quickstep"); his close brush with death at Chancellorsville, two months before Gettysburg; followed by his acknowledged receipt of the ambrotype. And sadly, we know where he is heading.

ILLUSTRATION #165
MAP WITH DATES OF HUMISTON'S LETTERS

September 5, 1862: "Dear wife, . . . tel the babies that I want to see them very mutch."

October 11, 1862: ". . . the prospects is that we shal have a fight before long . . ."

November 22, 1862: ". . . if thare is a place on god's earth that I hate, that place is virginia . . ."

December 2, 1862: ". . . I am nothing but an old frame. My fingers looks like birds claws but I feal quite well . . . thare is some thing in the wind that we can not tell. But we are going to leave this camping ground, that is shure . . ."

December 8, 1862: ". . . you would be surprised to see me coming home about the first of May with an honerable discharge. That may or may not be. We can not tel."

December 22, 1862: ". . . you will hardley know the old soldier when he gets back. You will be so grand in your new house and other fixings."

January 2, 1863: "If I ever live to get home you will not complain of being lonesome again or of sleeping cold for I will lay as close to you as the bark to a tree."

January 11, 1863: ". . . our tent is full this morning talking about home and the close of the war . . . I think that we shal have to serve our time out here . . . If you were here I would not care but thare is no use talking. That cannot be."

January 29, 1863: ". . . how I should like to call in this morning and se how you are getting along and then I should not like to leave you again. Remember me to the children and be a good girl."

March 9, 1863: "It has ben very loneley here without you but thar is no use in talking about it. Let us hope for the best."

March 25, 1863: ". . . my health is poor but I am some better than it was . . . The Captain and the regamentle sergeon have ben trying to get me a sick furlow for 30 days but they cannot do it. . . ."

April 3, 1863: "Captain Warner is going to start for home . . . I want you to see him and make him promise to give me a furlow if it is onely for ten days. But don't let him know that I wrote to that afect."

May 9, 1863: "I got a wipe in the side with a spent ball that made me think of home. It struck on the short ribs just over the hart but glanced off . . . I got the likeness of the children and it pleased me more than eney thing that you could have sent me. . . ."

May 24, 1863: "I want you to write to [me] as often as you can and not wait for me and be a good girl and keep your courage up. So good by. Yours truly, A Humiston."

ILLUSTRATION #166
"AN INCIDENT OF GETTYSBURG"

AN INCIDENT OF GETTYSBURG—THE LAST THOUGHT OF A DYING FATHER.

Whose Father Was He?

In the years since the terrible battle there have been hundreds, maybe thousands of accounts of Gettysburg. Civil War historians have crisscrossed the battlefield, providing detailed tactical diagrams and maps; the matching of contemporary photographs with the photographs of Brady, O'Sullivan, and Gardner; lists of the casualties, diaries, letters, and personal accounts. Enthusiasts have reenacted the major events, complete with artillery, guns, uniforms and hardtack in their knapsacks.

Here are the essentials of Day One of the battle. There was a broad movement of the Confederate forces from the west and north that drove Union forces through Gettysburg to positions on Cemetery Hill and adjacent hills and ridges, where heavy fighting (including Pickett's Charge) occurred on the following days, July 2 and 3, 1863. The accounts range from the overwhelmingly general to the insanely specific, from the poetic to the pedantic. Of the 43,000 casualties at Gettysburg, there are 43,000 stories, most unknown. Amos Humiston's is one of them. It has now become known as Coster's Last Stand, named for Colonel Charles Coster's brigade.[19] The brigade marched north into town from Cemetery Hill. They followed Stratton Street, crossed Stevens Run, and finally filed through a narrow carriage gateway into Kuhn's brickyard—brick kilns and a house, fenced off from the surrounding area. There was one way in and no other way out. They continued across the brickyard, moving in lines along a downward slope, taking position along a fence. To the left, the 27th Pennsylvania held the highest ground, adjacent to the 154th New York in the center, and the 134th New York made up the right flank. They knew they had to hold their fire until the Confederates were within range, but they had no idea that they were outnumbered three to one.

ILLUSTRATION #167
GETTYSBURG MAP

Confederate infantry units
Federal infantry units
Confederate artillery
Federal artillery
Worm fence
Post and rail fence

0 300 600 yards

1. *General Schurz posts three regiments of Coster's brigade in Kuhn's brickyard to cover the retreat of the Eleventh Corps's right. Heckman's battery's four guns are on the brigade's left, west of the Harrisburg Road. Remnants of the corps rally briefly on the swell of ground west of the Harrisburg Road.*
2. *Early halts Gordon's advance. He orders Hays's and Avery's brigades to attack Heckman and Coster.*
3. *Hays attacks down the Harrisburg Road, routs the Eleventh Corps line, captures two of Heckman's guns, and drives off the left of Coster's line.*
4. *Avery's brigade crosses Rock Creek and envelopes the right of Coster's line, capturing many men.*

When they crested the hill, the Confederates sent a curtain of shot and shell into the line of federal troops. Coster's brigade was engulfed. One great fear in nineteenth-century infantry combat was the enfilade attack—fire from the flanks across the line. And that is exactly what happened—the Confederates, wrapping around the 134th New York to the right and the 27th Pennsylvania to the left.

Lieutenant Colonel Allen of the 154th New York ordered his men to retreat. Racing across the brickyard, he reached the top of the rise and found a steadfast wall of Confederate troops. It was a surprise. He thought the position had been held by the 27th Pennsylvania, but the 27th Pennsylvania was no more. Unaware of Lieutenant Colonel Allen's predicament, Lieutenant John Mitchell, the commander of the 154th New York, Company C (Amos Humiston's company), rallied his men to hold what he thought was an advantageous position. "Boys, let's stay right here," he called to them. But shortly, Mitchell came to what must have been a sickening realization: he was mistaken. They could not hold the Confederates off. He shouted again, "Boys, we must get out of here."

What role did Amos Humiston play in the battle? What effect did Colonel Coster's brigade—the brigade in which Amos Humiston served—have on the battle as a whole? Does the question make any sense? The Union was routed on Day One of Gettysburg, but the actions of Coster's brigade allowed Union forces to consolidate their positions south of the town, and ultimately facilitated the Union victory on Day Three. Is it possible that Coster's brigade, by protecting the flank and allowing a retreat, ultimately saved the day? Is it possible, is it *meaningful* to ask the question: how did Amos Humiston's actions on Day One of Gettysburg—the day he died—contribute to the Union war effort? There is a tendency when writing about one man to make him the center of the universe, the hub of some vast wheel around which everything else revolves. What meaning does Amos Humiston's life and death have?

ILLUSTRATION #168
154TH REGIMENT BATTLES AND CASUALTIES

154th NYVI Regiment Battles and Casualties, Civil War

| PLACE. | Date. | Killed. | | Wounded. | | | | Missing. | | Aggregate. |
| | | | | Died. | | Recov'd. | | | | |
		Officers.	Enlisted men.	Officers.	Enlisted men.	Officers.	Enlisted men.	Officers.	Enlisted men.	
	1863.									
Chancellorsville, Va.	May 1–3	1	31	10	3	68	4	111	228
Gettysburg, Pa.	July 1–3	6	6	1	14	9	164	200
Wauhatchie, Tenn.	Oct. 28–29						1			1
Chattanooga and Rossville Campaign, Tenn.	Nov. 23–27									
Missionary Ridge	25						6			6
	1864.									
Atlanta Campaign, Ga.	May 3– Sept. 2									
Rocky Faced Ridge	May 8–10	8	5	2	35	50
Resaca	14–15	1	3	4
Dallas	May 25– June 4	1	2	9	6	18
Kenesaw Mountain	June 9– July 2	1					
Pine Mountain	June 14–15	2	4	1	24	36
Golgotha	16–17	2	1	1					
Culp's Farm	22					
The Assault	27					
Peach Tree Creek	July 20	1	2	1	2	1	7
Atlanta	July 21– Aug. 26					
Gen. Sherman's Savannah Campaign, Ga.	Nov. 15– Dec. 21									
March to the Sea	Nov. 15– Dec. 10	..	1				3	3	7
Savannah	Dec. 10–21									
Monteith Swamp	9									
	1865.									
Campaign of the Carolinas	Jan. 26– Mar. 20							10	10
North and South Edisto River, S. C.	Feb. 12–13									
Snow Hill, S. C.	March 27	1		4	5
Bennett House, N. C.	April 26					
By guerillas		1	1
Total loss	1	54	1	30	10	169	13	295	573

Who can say? We know about battles in aggregate but not through their constituent parts. We can know something about Colonel Coster and his men—less about the individuals, including Amos Humiston, who were part of the brigade under his command. (We can know about the links between Egyptian and Mesoamerican civilizations but *not* the names of the men who made the voyages from the Old World to the New.) We may know that the casualty rate among the 154th New York regiment that afternoon was 78 percent, that four out of five men were casualties.[20] But it is the photograph of Humiston's children, the knowledge that he had a family, and what that family looked like, that not only gives him a face but also provides the face of battle. It satisfies a deep craving to make the war about us, to allow us to see ourselves in the midst of it. It offers us the recovery of a *unique* individual from the myriad complexities of history.

ILLUSTRATION #169
ARMY OF THE POTOMAC CHART

ARMY OF THE POTOMAC.

July 1st 1863

First Army Corps.
Maj. Gen. Abner Doubleday.
Maj. Gen. John Newton.

Eleventh Army Corps.
Maj. Gen. Oliver O. Howard.

Cavalry Corps.
Maj. Gen. Alfred Pleasonton.

Second Army Corps.
Maj. Gen. Winfield Scott.

Third Army Corps.
Maj. Gen. Daniel Sickles.

First Division.
Brig. Gen. Francis C. Barlow. Brig. Gen. Adolph von Steinweher.
Brig. Gen. Adelbert Ames.

Second Division.
Brig. Gen. Adolph von Steinweher.

Third Division.
Maj. Gen. Carl Schurz.

Artillery Brigade.
Maj. Gen. Thomas W. Osborn.

First Brigade.
Col. Charles R. Coster.

Second Brigade.
Col. Orland Smith.

134th New York.
Lieut. Col. Allan H. Jackson.

154th New York.
Lieut. Col. D.B. Allen.

27th Pennsylvannia.
Lieut. Col. Lorenz Cantador.

73rd Pennsylvannia.
Capt. D.F. Kelley.

A Company B Company C Company D Company E Company F Company G Company H Company I Company

Sgt. Amos Humiston

ILLUSTRATION #170
SYNOPTICAL CHART OF THE CIVIL WAR

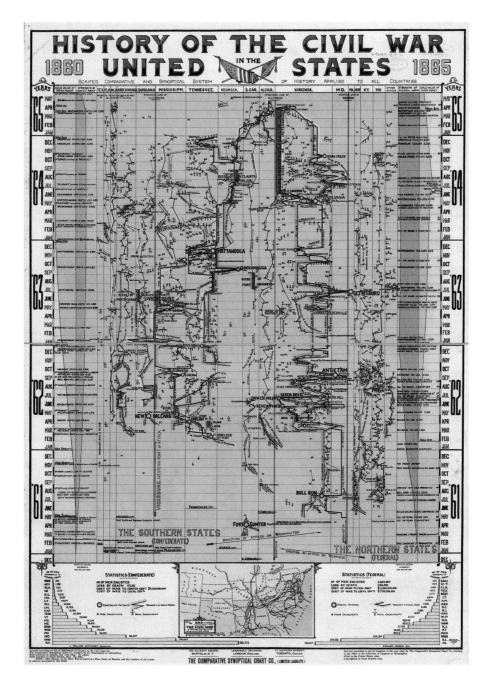

"History of the Civil War in the United States, 1860–1865,"
J. Kellick Bathurst, compiler; Edward Perrin, del.; Courier Litho. Co.[21]

Whose Father Was He?

Mark Dunkelman, in one memorable passage, excerpted below, describes the remains of the battlefield:

> Gettysburg in the aftermath of the great battle was an appalling place. . . . Wrecked caissons and wagons littered twenty-five square miles of battlefield. Shells, cannonballs, and musket balls were everywhere, embedded in trees, fences, and houses, and dotting the surface of the ground. Unexploded shells would maim or kill the curious who handled them in days and months to come. At least three thousand mangled, swollen, and fetid dead horses rotted on the battlefield, clumps of them marking positions where batteries had been decimated. Offal and bones of butchered cattle, sheep, and hogs were scattered widespread, evidence of a heavy loss of local livestock, and loose animals strayed over the battlefield. Swarms of flies covered decaying flesh in crawling, buzzing black masses. Notable by their absence were scavenging birds. Crows and vultures had been scared away by the tremendous noise of the battle and the acrid stench of burned gunpowder. . . . And everywhere were the grotesque, decomposing corpses and body parts of men, transforming Gettysburg into a vast city of the dead.[22]

A vast city of the dead. But also a city of the *nameless* dead.[23] Today in Gettysburg, there is a monument to Amos Humiston—a granite boulder with a bronze plaque with a likeness of Amos Humiston and his children affixed to it.[24] It is, as Mark Dunkelman told me, "The only monument to an individual enlisted man on the Gettysburg battlefield."

At the heart of this story is the dream, perhaps the delusion, of defeating time and thereby achieving immortality. There are those who refuse to give up the pursuit. Mark Dunkelman and David Humiston Kelley were inspired by their grandfathers' stories and spent a considerable fraction of their adult lives sifting through evidence and compiling genealogies. They are placing themselves in the arc of first being inspired by the past and then creating their future place in it. But not everyone is like this. Ironies abound. What about the other Humiston descendants? David Humiston Kelley was obsessed with history, but Allan Cox, who inherited the letters, was much less interested in the past. Mark Dunkelman found the letters, but how many Mark Dunkelmans are there in *our* futures? How many future historians will lovingly research and re-create *our* past?

Perhaps more than any other artifact, the photograph has engaged our thoughts about time and eternity. I say "perhaps," because the history of photography spans less than two hundred years. How many of us have been "immortalized" in a newspaper, a book, or a painting versus the number of us who have appeared in a photograph?[25] The Mayas linked their culture to the movements of celestial objects: the ebb and flow of kingdoms and civilizations in the periodicities of the moon, the

sun, and the planets. In the glyphs that adorn their temples they recorded coronations, births, deaths. Likewise, the photograph records part of our history.

The photograph of Amos Humiston's three children—of Frank, Alice, and Fred—allows us to imagine that we have grasped something both unique and universal. It suggests that the experience of this vast, unthinkable war can be reduced to the life and death of one man. The photo offered the hope that by identifying Gettysburg's "Unknown Soldier" a family could be reunited, and that perhaps we too can be saved from oblivion by an image that reaches beyond our lives, that communicates something undying and transcendent about each one of us.

EPILOGUE

Perhaps every culture leaves markers for the future, a means of connecting the dots, of linking the past to what is yet to come. The "frozen moment" of photography provides a possible answer to the problem of Heraclitus, that one cannot step into the same river twice. Perhaps one *can* look at the same photograph twice. Even though our thoughts and our memories change, we change, the perspective through which we look at the world changes, there is the thought that a photograph partially takes us outside of ourselves. That it gives us a glimpse—even though it may be only a two-dimensional representation—of something real. My past, the more of it that there is, and the less of a future, is spectral, insubstantial. I have never liked to take photographs. There are very few of them after the period of my childhood. I'm not sure why. But there is one photograph that is left over, saved from oblivion, *one* photograph from my wedding, between two prostitution cases in Brooklyn criminal court. It was taken by Tom Waits. He lost it and then found it on the floor of his garage years later.

ILLUSTRATION #171
ERROL WEDDING PHOTO

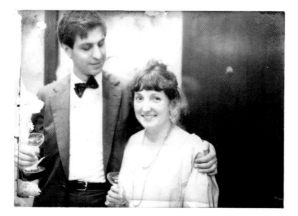

ACKNOWLEDGMENTS

I would like to thank my principal researcher and editor, Ann Petrone. We have worked closely together for over a decade. My wife, Julia Sheehan, who has argued with me tirelessly about this book and most other things. Without her none of this would have been possible. I met her close to forty years ago at the University of Wisconsin. On our first date, I took her out in a rowboat on Lake Mendota and asked her if she had ever seen *A Place in the Sun*. She looked at me and said, "What is wrong with you?" Thankfully, she stuck around trying to find an answer to that question. Our son Hamilton, himself now a writer and filmmaker. Charles Silver, whom I met in graduate school and remains a close friend and a central part of my intellectual life. There is nothing in this book that does not owe a debt of gratitude to him. My friend Ron Rosenbaum, who has inspired me with his writing and intelligence over the years. My editors at Penguin, Ann Godoff and Laura Stickney. Scott Moyers, who began as my literary agent at Wiley and is now my publisher at Penguin. The three Branson Gill sisters, Amanda, Rosie, and Sophie, who have contributed so much to this book in both research and editing, but also in encouragement and support. I would like to especially thank Sophie, who worked tirelessly on the clearances and revisions of the book as it was prepared for publication. Julie Fischer, who worked as a researcher and fact-checker and who contributed so many helpful ideas. My newest researcher, Max Larkin. My colleagues at Pentagram who designed the book, in particular Michael Bierut and Yve Ludwig. They achieved the seemingly impossible by making both the writer and the publisher happy. Daniel Mooney created many of the graphics. It is a long collaboration that includes the editing and design of my movies. I have benefited enormously from my association with Homi Bhabha and the Mahindra Humanities Center at Harvard. It's indeed fortunate to have access to one of the great research libraries. Many, many other archives and libraries were consulted. In particular, I would like to thank the staff at the Library of Congress in Washington, D.C., the Harry Ransom Humanities Research Center at the University of Texas at Austin, and the Walker Evans Archive at the Metropolitan Museum of Art in New York. Most of these essays were read in early drafts by good friends and colleagues: Alfred Guzzetti, Maggie Causey, Nancy Rappaport, Dennis Jakob, Willie Russe, Alice Kelikian, Paul Jankowski, Rosamond Purcell, Maria Tatar, Barbara Norfleet, Dan Polsby, and Lawrence Weschler. The many assistants who have worked in my office, including Sam Bjork, Hannah Mintz, Leon Neyfakh, Morgan Peissel, John Purcell, Jared Washburn, Joshua Woltermann, and Zach Arnold. My film editors, who have contributed so much to my work: Steven Hathaway, Daniel Mooney, and Karen Schmeer, who died tragically in 2010. My photographers Bob Chappell and Eric Zimmerman, who came with me to Crimea, the start of this whole crazy adventure. Philip Gourevitch, with whom I collaborated on my previous book, *Standard Operating Procedure*. George Kalogerakis and David Shipley at *The New York Times*, who gave me my first real writing job. Without them, none of this would be possible. Thank you, all.

This book would also not have been possible without the many people who graciously allowed me to interview them.

Chapter 1: Which Came First, the Chicken or the Egg?

The many curators and photo experts who lent their time and expertise to this endeavor: Gordon Baldwin, Ralph Bouwmeester, Malcolm Daniel, Roy Flukinger, Mark Haworth-Booth, Ulrich Keller, Richard Pare, and Chris Russ. In particular, Dennis Purcell, who provided a surprising solution to the puzzle. Yes, it was possible to order the photographs without appealing to the intentions, real or imagined, of the photographer. Although I disagree with many of her conclusions, I would be remiss not to mention Susan Sontag and her book *On Regarding the Pain of Others*. Her essays on photography have framed the nature of this discussion. Lydia Davis, a friend from the Putney School, kindly told me about Billy Klüver's *A Day with Picasso*. I felt, reading Klüver's book, that I was in the presence of a kindred spirit. Klüver was someone clearly obsessed with using empirical methods to determine details about photographs, particularly their sequence.

Chapter 2: Will the Real Hooded Man Please Stand Up?

Hassan Fattah, Sabrina Harman, and Brent Pack. All three of them helped enormously with this essay. Brent Pack was the forensic investigator for the Criminal Investigation Division of the Army. His timeline and analysis contributed much to our understanding of the Abu Ghraib photographs. And in essence represents a new way of looking at photographs. Even though this story was a dark moment in his journalistic career, Hassan Fattah was unfailingly helpful and supportive. I thank him for his courage and honesty.

Chapter 3: Most Curious Thing

Walter (Tony) Diaz, Paul Ekman, Ivan Frederick, Sabrina Harman, and Hydrue Joyner. And all of the soldiers at Abu Ghraib who I have interviewed over the years. I am particularly indebted to Sabrina Harman for allowing me to use her letters from Abu Ghraib.

Chapter 4: The Case of the Inappropriate Alarm Clock

James Curtis, Bill Ganzel, and William Stott. It's hard to imagine three more diverse perspectives on some of the most famous photographs in American history. I was lucky to have their cooperation.

Chapter 5: It All Began with a Mouse

Many war photographers are unwilling to talk about their experiences. This essay would have been impossible without the cooperation of Ben Curtis. Santiago Lyon at the Associated Press allowed me to talk to Curtis and to use the photographs that appear as part of this essay.

Chapter 6: Whose Father Was He?

I first read about the Humiston story in Drew Gilpin Faust's *This Republic of Suffering*, an extraordinary work in its own right. Mark Dunkelman's *Gettysburg's Unknown Soldier* is the source of much information in this essay. And it was Mark Dunkelman who put me on the trail of the two Humiston heirs, David Humiston Kelley and Allan Cox. Sadly, David Humiston Kelley died as the book was going to press. Mark Dunkelman's book has never been issued as a trade paperback, and it is my hope that a publisher will make it available to a much wider readership. To learn more about his work, visit his Web site at hardtackregiment.com.

ILLUSTRATION CREDITS

1. Morris family photo. Courtesy of the author. **2.** Skull drawing. Courtesy of the author. **3.** Detail of skull drawing. Courtesy of the author. Graphic by Steven Hathaway. **4.** *Winky-Dink and You.* Six-year-old girl using her Winky-Dink drawing kit on her home TV screen as she watches the children's program by that name. Photograph by Walter Sanders/Time & Life Pictures/Getty Images. **5.** Valley of the Shadow of Death "OFF." Roger Fenton, "Valley of the Shadow of Death." Photography Collection, Harry Ransom Humanities Research Center, The University of Texas at Austin. **6.** Valley of the Shadow of Death "ON." Roger Fenton, "Valley of the Shadow of Death." Photography Collection, Harry Ransom Humanities Research Center, The University of Texas at Austin. **7.** Sparling, Fenton's assistant. Roger Fenton, "The Artist's Van." John Sparling, Fenton's assistant, gets his picture taken before heading to the Valley of the Shadow of Death. Fenton had written, "The picture was due to the precaution of the driver on that day, who suggested as there were a possibility of a stop being put in that valley to the further travels of both vehicle and driver, it would be showing a proper consideration for both to take a likeness of them before starting." Library of Congress, Prints & Photographs Division, LC-USZC4-9240. **8.** *Illustrated London News. The Illustrated London News*, June 30, 1855, p. 668. **9.** Siege of Sebastopol, 1854–55. "Seige of Sebastopol 1854-5," map from *A School Atlas of English History—A Companion Atlas to "The Student's History of England,"* Samuel Rawson Gardiner, M.A., LL.D., Longmans, Green, and Co., 1892. **10.** Detail of Siege of Sebastopol. Detail from the above map, showing the Valley of the Shadow of Death and the location of Fenton's camera. The Woronzoff Ravine is to the east. Graphics added by John Purcell. **11.** Detail showing Valley of the Shadow of Death. Detail from above map. The Valley of the Shadow of Death was in the line of fire from three batteries. The radius of the circle is approximately one mile. There are slight discrepancies among the various French, English, and Russian maps of the period. Graphics added by John Purcell. **12.** Olga's shoes. Photograph by Eric S. Zimmerman. **13.** The same frame 1. Frame enlargement from 16mm film shot by Bob Chappell. Two images of the same location in the Valley of the Shadow of Death. In the first photograph, the lens is partially covered by Fenton's 1855 photograph (OFF). In the second photograph (below), OFF has been taken away, revealing the "identical" landscape behind it. Not quite identical because the photographs were taken 150 years apart. **14.** The same frame 2. Frame enlargement from 16mm film shot by Bob Chappell. **15.** Compass. Photograph by Eric S. Zimmerman. **16.** Interior of the Panorama Museum. Photograph by Eric S. Zimmerman. **17.** Cannonball and hand. Crimean War–era cannonball. Photograph by Eric S. Zimmerman. **18.** Cannonball. Crimean War–era cannonball. Photograph by Eric S. Zimmerman. **19.** Balaclava submarine base. Tunnel in Soviet submarine base at Balaclava. Photograph by Eric S. Zimmerman. **20.** Panorama. An assembled reconstruction (LC cat. no. PR 13 CN 2004:112) by Richard Pare of Roger Fenton's panorama of Sebastopol based on a set of unmounted originals in the collection of the Library of Congress. The online catalog of the Crimean Photographs by Fenton at the Library of Congress can be found here: http://www.loc.gov/pictures/search/?st=grid&co=ftncnw. **21.** Close-up of shadow. "Sebastopol from the front of Cathcart's Hill" by Roger Fenton, Library of Congress, Prints & Photographs Division, LC-USZC4-9261. Graphic by Daniel Mooney. **22.** No. 24 *A Day with Picasso*. Text by Billy Klüver, *A Day with Picasso* (Cambridge, Massachusetts: MIT Press, 1997). © Billy Klüver. Courtesy Klüver/Martin Archives. Jean Cocteau, photograph of Modigliani, Jacob, Oritz, and Salmon © 2010 Artists Rights Society (ARS), New York/ADAGP, Paris. **23.** No. 8 Picasso and mistress. From Billy Klüver, *A Day with Picasso* (Cambridge, MA: MIT Press, 1997). Text by Billy Klüver, *A Day with Picasso*. Cambridge, Massachusetts: MIT Press, 1997. © Billy Klüver. Courtesy Klüver/Martin Archives. Jean Cocteau, photograph of Picasso and Pâquerette © 2010 Artists Rights Society (ARS), New York/ADAGP, Paris. **24.** The intersection of Raspail and Montparnasse. Maps and text by Billy Klüver, from Billy Klüver, *A Day with Picasso* (Cambridge, Massachusetts: MIT Press, 1997). © Billy Klüver. Courtesy Klüver/Martin Archives. Jean Cocteau, photographs of Max Jacob and Picasso with Pâquerette © 2010 Artists Rights Society (ARS), New York/ADAGP, Paris. Graphic by Daniel Mooney. **25.** No. 7 Position C. From Billy Klüver, *A Day with Picasso* (Cambridge, MA: MIT Press, 1997). Courtesy Klüver/Martin Archives. Jean Cocteau, photograph of Max Jacob © 2010 Artists Rights Society (ARS), New York/ADAGP, Paris. **26.** The administration building. Graphic by Daniel Mooney. Maps and text by Billy Klüver, from Billy Klüver, *A Day with Picasso* (Cambridge, MA: MIT Press, 1997). Courtesy Klüver/Martin Archives. Jean Cocteau, photograph of Modigliani, Jacob, Oritz, and Salmon © 2010 Artists Rights Society (ARS), New York/ADAGP, Paris. **27.** Sebastopol sun map. © 1995–2011 Wide Screen Software LLC, www.sunPATHonline.com. **28.** Detail of shadows and sun. Graphic by Daniel Mooney. **29.** Detail of "OFF." Roger Fenton, "Valley of the Shadow of Death." Photography Collection, Harry Ransom Humanities Research Center, The University of Texas at Austin. **30.** Detail of "ON." Roger Fenton, "Valley of the Shadow of Death." Harry Ransom Humanities Research Center, The University of Texas at Austin. **31.** Two cannonballs. Graphic by Daniel Mooney. Details of Roger Fenton, "Valley of the Shadow of Death." Photography Collection, Harry Ransom Humanities Research Center, The University of Texas at Austin. **32.** Fenton dedication page. Title page for *Photographs of the Seat of War in the Crimea*, Thomas Agnew and Sons, 1856. **33.** Helmut Gernsheim, 1946. Felix Man, "Portrait of Helmut Gernsheim, 1946." Gelatin silver print. Photography Collection, Harry Ransom Humanities Research Center, The University of Texas at Austin. **34.** Diagram of rock movement. Diagram depicting the movement of specific rocks in Fenton's photographs by Dennis Purcell. **35.** Fred, Oswald,

George, Marmaduke, and Lionel blue "ON." "Fred," "Oswald," "George," "Marmaduke," and "Lionel" highlighted in blue in "OFF." Graphics by Dennis Purcell. **36.** Fred, Oswald, George, Marmaduke, and Lionel orange "OFF." "Fred," "Oswald," "George," "Marmaduke," and "Lionel" highlighted in orange in "ON." Graphics by Dennis Purcell. **37.** Olga. Photograph by Errol Morris. **38.** Errol's shadow. Shadow of Errol Morris in the Valley of the Shadow of Death. Like Fenton, Morris is facing north with the sun behind him. Photograph by Errol Morris. **39.** Color photo of valley. Photograph by Eric S. Zimmerman. **40.** Excluded elephant. This, of course, is not the Valley of the Shadow of Death. It is a Fenton photograph taken after his return from the Crimea. The idea of excluding the elephant from the frame should be clear. Roger Fenton, "The Long Walk at Windsor Castle," 1860. The Royal Collection © 2011, Her Majesty Queen Elizabeth II, RCIN 2100070. Graphics by Daniel Mooney. **41.** Fenton camel photo. Roger Fenton, "Dromedary," 1855. Library of Congress, Prints & Photographs Division, LC-USZC4-9364. **42.** Blue cannonballs. "OFF" with cannonballs identified in blue. Graphics by Dennis Purcell. **43.** Red cannonballs. "ON" with cannonballs identified in red. Graphics by Dennis Purcell. **44.** Tolstoy vs. Fenton. Photograph of Tolstoy, Library of Congress, Prints & Photographs Division, LC-USZ62-68307. Photograph of Fenton [Self-portrait], Roger Fenton, 1852, © The Metropolitan Museum of Art/Art Resource, NY. Graphics by Daniel Mooney. **45.** Hooded Man. Photograph by Sgt. Ivan Frederick, Abu Ghraib Prison, November 5, 2003. **46.** *New York Times* front page. From *The New York Times*, March 11, 2006. © 2006 *The New York Times*. All rights reserved. Used by permission and protected by the Copyright Laws of the United States. The printing, copying, redistribution, or retransmission of this Content without express written permission is prohibited. **47.** Ali Shalal Qaissi *New York Times* detail. Front page of *The New York Times*, March 11, 2006. © 2006 *The New York Times*. All rights reserved. Used by permission and protected by the Copyright Laws of the United States. The printing, copying, redistribution, or retransmission of this Content without express written permission is prohibited. **48.** Hooded Man business card. Association of Victims of American Occupation Prisons. **49.** Rabbit/duck profile. Illustration from Joseph Jastrow, "The Mind's Eye," *Appleton's Popular Science Monthly*, January 1899, vol. 54, p. 312, fig. 20. **50.** Ali Shalal Qaissi photo. © 2006 *The New York Times*. All rights reserved. Used by permission and protected by the Copyright Laws of the United States. The printing, copying, redistribution, or retransmission of this Content without express written permission is prohibited. **51.** "The Claw" back of jumpsuit. Photograph by U.S. military personnel, Abu Ghraib Prison, Iraq, 2003. **52.** "The Claw" left hand. Photograph by U.S. military personnel, Abu Ghraib Prison, Iraq, 2003. **53.** "The Claw" back of jumpsuit, full body. Photograph by U.S. military personnel, Abu Ghraib Prison, Iraq, 2003. **54.** Exif file photo D-20. Detail of timeline of Abu Ghraib photographs created by Brent Pack, Special Agent, U.S. Army, Criminal Investigation Division. **55.** Photo D-20. Photograph by U.S. military personnel, Abu Ghraib Prison, Iraq, 2003. **56.** Exif file photo D-21. Detail of timeline of Abu Ghraib photographs created by Brent Pack, Special Agent, U.S. Army, Criminal Investigation Division. **57.** Photo D-21. Photograph by U.S. military personnel, Abu Ghraib Prison, Iraq, 2003. **58.** Wide-angle by Harman. Photograph by U.S. military personnel, Abu Ghraib Prison, Iraq, 2003. **59.** Hooded Man through doorway. Photograph by U.S. military personnel, Abu Ghraib Prison, Iraq, 2003. **60.** Hooded Man 2 (repeat of first). Photograph by U.S. military personnel, Abu Ghraib Prison, Iraq, 2003. **61.** Alice and the Cheshire Cat. Illustration by John Tenniel from Lewis Carroll, *Alice's Adventures in Wonderland* (London, 1865). **62.** Sabrina thumbs-up. Photograph by U.S. military personnel, Abu Ghraib Prison, Iraq, 2003. **63.** Timeline of al-Jamadi photographs. Detail of timeline of Abu Ghraib photographs created by Brent Pack, Special Agent, U.S. Army, Criminal Investigation Division. **64.** Graner with al-Jamadi. Photograph by U.S. military personnel, Abu Ghraib Prison, Iraq, 2003. **65.** Timeline of Harman evidence photos. Portion of timeline of Abu Ghraib photographs created by Brent Pack, Special Agent, U.S. Army, Criminal Investigation Division. **66.** MP logbook 1. Excerpt from MP logbook at Abu Ghraib Prison, Iraq, 2003. Graphics by Daniel Mooney. **67.** MP logbook 2. Excerpt from MP logbook at Abu Ghraib Prison, Iraq, 2003. Graphics by Daniel Mooney. **68.** Timeline of Hooded Man photos. Portion of timeline of Abu Ghraib photographs created by Brent Pack, Special Agent, U.S. Army, Criminal Investigation Division. **69.** Thumbs-up comparison. Timeline of Abu Ghraib photographs by Daniel Mooney, based on timeline by Brent Pack. **70.** *New York Post*. "The Ghoul Next Door Was Jail Abuse Fotog." Sabrina Harman in the *New York Post*, May 9, 2004, p. 4. © 2004 NYP Holdings, Inc. **71.** Sabrina thumbs-up 2. Photograph by U.S. military personnel, Abu Ghraib Prison, Iraq, 2003. **72.** Sabrina in black hat. Photograph by U.S. military personnel, Abu Ghraib Prison, Iraq, 2003. **73.** The Cheshire Cat. Illustration by John Tenniel from Lewis Carroll, *Alice's Adventures in Wonderland* (London, 1865). **74.** Roosevelt train. President Roosevelt speaking from train, Bismarck, North Dakota, 1936. Photograph by Arthur Rothstein. Library of Congress, Prints & Photographs Division, FSA/OWI Collection, LC-USF34-005302-E. **75.** *New York Times* drought montage. Montage of newspaper articles published about the drought in the summer of 1936. Graphic by Daniel Mooney and Yve Ludwig. **76.** *Fargo Forum*. "Drought Counterfeiters Get Our Dander Up!," *The Fargo Forum*, August 27, 1936. **77.** North Dakota Cows at capitol. "Cattle Invade a State Capitol." From *The New York Times*, Sunday, August 9, 1936, p. N5. © 1936 *The New York Times*. All rights reserved. Used by permission and protected by the Copyright Laws of the United States. The printing, copying, redistribution, or retransmission of this Content without express written permission is prohibited. **78.** Cow skull 10 feet. Graphic by Daniel Mooney based on Arthur Rothstein, "Overgrazed Land." Pennington County, South Dakota, May 1936. Library of Congress, Prints & Photographs Division, FSA/OWI Collection, LC-USF34-004389-D. **79.** *Washington Post*, July 10, 1936, page 4. "Drought Damage Mounting in Western States," From *The Washington Post*, July 10, 1936, p. 4. © 1936, *The Washington Post*. All rights reserved. Used by permission and protected by the Copyright Laws of the United States. The printing, copying, redistribution, or retransmission of the Material without express written permission is prohibited. **80.** Drought victim caption. FSA-OWI written records, Library of Congress. **81.** Killed photographs. "Photographer Arthur Rothstein on L Street in Washington, D.C." Photographs by Russell

Lee, 1938. Image by Daniel Mooney. Library of Congress, Prints & Photographs Division, FSA/OWI Collection, LC-USF33-011408-M1 and LC-USF33-011408-M2. **82.** Cow skull 1. "Dry and parched earth in the badlands of South Dakota" by Arthur Rothstein, 1936. Library of Congress, Prints & Photographs Division, FSA/OWI Collection, LC-USF34-004380-D. **83.** Cow skull 2. "The bleached skull of a steer on the dry sun-baked earth of the South Dakota Badlands" by Arthur Rothstein, 1936. Library of Congress, Prints & Photographs Division, FSA/OWI Collection, LC-DIG-fsa-8b27761. **84.** Cow skull 3. "Overgrazed land. Pennington County, South Dakota" by Arthur Rothstein, 1936. Library of Congress, Prints & Photographs Division, FSA/OWI Collection, LC-USF34-004389-D. **85.** Cow skull 4. "A homestead on submarginal and overgrazed land. Pennington County, South Dakota" by Arthur Rothstein, 1936. Library of Congress, Prints & Photographs Division, FSA/OWI Collection, LC-USF34-004378-D. **86.** Cow skull 5. "Overgrazed land. Pennington County, South Dakota" by Arthur Rothstein, 1936. Library of Congress, Prints & Photographs Division, FSA/OWI Collection, LC-USF34-004376-D. **87.** Cow skull 6. "Overgrazed land. Pennington County, South Dakota" by Arthur Rothstein, 1936. Library of Congress, Prints & Photographs Division, FSA/OWI Collection, LC-USF34-004389-D. **88.** Dorothea Lange on top of car. "Dorothea Lange, Resettlement Administration photographer, in California," 1936. Library of Congress, Prints & Photographs Division, FSA/OWI Collection, LC-USF34-002392-E. **89.** Agee's list 1. From James Agee and Walker Evans, *Let Us Now Praise Famous Men* (Boston: Houghton Mifflin Company, 1941). **90.** Gudger mantel original. "Fireplace in bedroom of Floyd Burroughs's cabin. Hale County, Alabama" by Walker Evans. Library of Congress, Prints & Photographs Division, FSA/OWI Collection, LC-USF342-008136-A. **91.** Gudger mantel inventory. "Fireplace in bedroom of Floyd Burroughs's cabin. Hale County, Alabama" by Walker Evans. Library of Congress, Prints & Photographs Division, FSA/OWI Collection, LC-USF342-008136-A. Graphics by Daniel Mooney. **92.** Alarm clock close-up. Detail of the alarm clock from "Fireplace in bedroom of Floyd Burroughs's cabin. Hale County, Alabama" by Walker Evans. Library of Congress, Prints & Photographs Division, FSA/OWI Collection, LC-USF342-008136-A. **93.** Westclox ad. *Westclox: A Century of Progress*, promotional catalog for the 1933 World's Fair. Courtesy of Gary Biolchini. **94.** Gudger Bed. "Part of the bedroom of Floyd Burroughs's cabin. Hale County, Alabama" by Walker Evans, 1936. Library of Congress, Prints & Photographs Division, FSA/OWI Collection, LC-USF342-008134-A. **95.** Bed/mantel 12:44. "Bedroom fireplace" by Walker Evans, 1935 or 1936. Library of Congress, Prints & Photographs Division, LC-USZC4-9514. **96.** From Agee book, 9:58. "Fireplace with Arrangement of Objects on Mantel in Floyd Burroughs's Home, Hale County, Alabama" by Walker Evans, 1936. © The Metropolitan Museum of Art/Art Resource, NY. **97.** Evans Archive mantel, 9:40. "Fireplace (with Bedpost in Foreground) in Floyd Burroughs's Bedroom, Hale County, Alabama" by Walker Evans, 1936. © The Metropolitan Museum of Art/Art Resource, NY. **98.** Bed/mantel, 12:42. "Fireplace (with Bedpost in Foreground) in Floyd Burroughs's Bedroom, Hale County, Alabama" by Walker Evans, 1936. © The Metropolitan Museum of Art/Art Resource, NY. **99.** Differing clock times. Graphic by Daniel Mooney. **100.** Photo of Walker Evans. "Walker Evans with View Camera" by Peter Sekaer. c. 1936. © The Metropolitan Museum of Art/Art Resource, NY. **101.** Gudgers on Sunday. "The Burroughs Family, Hale County, Alabama" by Walker Evans, 1936. © The Metropolitan Museum of Art/Art Resource, NY. **102.** Gudger with Tengle children. "Floyd Burroughs and Tengle children, Hale County, Alabama" by Walker Evans, 1936. Library of Congress, Prints & Photographs Division, FSA/OWI Collection, LC-USF33-031306-M5. **103.** Aztec warrior. "Menelek" by Fred Holland Day, 1897. © The Metropolitan Museum of Art/Art Resource, NY. **104.** Evans's "Brooklyn Bridge." "Brooklyn Bridge, New York" by Walker Evans, 1929, printed ca. 1970. © The Metropolitan Museum of Art/Art Resource, NY. **105.** Whitestone Bridge. "Whitestone Bridge" by Ralston Crawford, 1939–1940. Memorial Art Gallery of the University of Rochester, Marion Stratton Gould Fund. **106.** Santa Claus image. "West Virginia Living Room" by Walker Evans, 1935. The Metropolitan Museum of Art. Walker Evans Archive, l994 (1994.258.155). © Walker Evans Archive, The Metropolitan Museum of Art. **107.** Mrs. Tengle (torn and cropped photos). "Mrs. Frank Tengle, wife of a cotton sharecropper. Hale County, Alabama" by Walker Evans, 1935 or 1936. Library of Congress, Prints & Photographs Division, FSA/OWI Collection, LC-USF342-008178. **108.** Mental hospital photograph. The Kentucky Historical Society, Lexington Narcotics Farm Collection. **109.** "Prisoner." The Kentucky Historical Society, Lexington Narcotics Farm Collection. **110.** Rothstein's dust storm. "Farmer and sons walking in the face of a dust storm" by Arthur Rothstein, 1936. Library of Congress, Prints & Photographs Division, FSA/OWI Collection, LC-DIG-ppmsc-00241. **111.** Arthur Rothstein. "Arthur Rothstein, FSA (Farm Security Administration) photographer," 1938. Library of Congress, Prints & Photographs Division, FSA/OWI Collection, LC-DIG-ppmsc-00192. **112.** Man and barn in dust storm. [Untitled]. Library of Congress, Prints & Photographs Division, FSA/OWI Collection, LC-DIG-fsa-8b38285. **113.** Two trees. Top: "Jeffrey Pine, Sentinel Dome, Yosemite National Park, California," c. 1945. Photograph by Ansel Adams, © 2011 The Ansel Adams Publishing Rights Trust. Bottom: © 2002 Mark Klett and Byron Wolfe. **114.** Boy in dust storm. "Dust is too much for this farmer's son in Cimarron County, Oklahoma" by Arthur Rothstein, 1936. Library of Congress, Prints & Photographs Division, FSA/OWI Collection, LC-DIG-fsa-8b38283. **115.** Younger brother in dust storm. "Son of farmer in dust bowl area. Cimarron County, Oklahoma" by Arthur Rothstein, 1936. Library of Congress, Prints & Photographs Division, FSA/OWI Collection, LC-USF34-004046-E. **116.** Darrel Coble. Darrel Coble in his home, Cimarron County, Oklahoma, September, 1977. From Bill Ganzel, *Dust Bowl Descent* (Lincoln: University of Nebraska Press, 1984). **117.** The Dust Bowl Turns to Gold. "The Dust Bowl Turns to Gold," *Look*, vol. 25, no. 22 (Oct. 24, 1961), p. 41. Library of Congress, Prints & Photographs Division, Look Magazine Photograph Collection, LOOK—Job 61-9380 <P&P> [P&P] . **118.** Movie posters 1. "Houses. Atlanta, Georgia," by Walker Evans, 1936. Library of Congress, Prints & Photographs Division, FSA/OWI Collection, LC-DIG-ppmsc-00236. **119.** Movie posters 2. "Houses. Atlanta, Georgia," by John Vachon, 1938. Library of Congress, Prints & Photographs Division: LC-USF34- 008447-D . **120.** "Migrant

Mother." "Migrant Mother" or "Destitute pea pickers in California. Mother of seven children. Age thirty-two. Nipomo, California," by Dorothea Lange, 1936. Library of Congress, Prints & Photographs Division, FSA/OWI Collection, LC-DIG-fsa-8b29516. **121.** Migrant mother and daughters. Florence Thompson and her daughters Norma Rydlewski (in front), Katherine McIntosh, and Ruby Sprague, at Norma's house. Modesto, California, June 1979. From Bill Ganzel, *Dust Bowl Descent* (Lincoln: University of Nebraska Press, 1984). **122.** Mickey in rubble. Associated Press/Ben Curtis. **123.** Multiple toy photos. Associated Press/Ben Curtis (top left), Reuters/Sharif Karim (top right, middle left, and middle right), Reuters/Issam Kobeisi (bottom left), Reuters/Mohamad Azakir (bottom right). **124.** Beirut, Lebanon, July 26, 2006. Unlike the Reuters photograph by Adnan Hajj, this photograph by Ben Curtis is not digitally manipulated. Associated Press/Ben Curtis. For more info on the Reuters photo controversy, see http://en.wikipedia.org/wiki/Adnan_Hajj_photographs_controversy. **125.** Two satellite images and a map of Lebanon. UNITAR/UNOSAT. **126.** Detail of satellite image. UNITAR/UNOSAT. **127.** Map of Lebanon. "Lebanon–Convoy Movement (as of 7 Aug 2006)." Map provided courtesy of the ReliefWeb Map Centre, UN Office for the Coordination of Humanitarian Affairs. **128.** Baby Raad in hospital. Associated Press/Ben Curtis. **129.** Ambulance and stretcher (Ben's #116). Associated Press/Ben Curtis. **130.** Smoke above building and street (Ben's #101). Associated Press/Ben Curtis. **131.** Little girl (Ben's #105). Associated Press/Ben Curtis. **132.** Little girl and her mother (Ben's #106). Associated Press/Ben Curtis. **133.** Photographer on top of Rubble (Ben's #109). Associated Press/Ben Curtis. **134.** Rubble through the window (Ben's #104). Associated Press/Ben Curtis. **135.** Photo album amid rubble (Ben's #117). Associated Press/Ben Curtis. **136.** Truck in rubble (Ben's #118). Associated Press/Ben Curtis. **137.** Bombed building (Ben's #119). Associated Press/Ben Curtis. **138.** "Hamas Kindergarten." Courtesy of John Cox. **139.** John O'Sullivan *Chicago Sun-Times* editorial. Courtesy of *Chicago Sun-Times*. **140.** Ambrotype of three children. Mark H. Dunkelman Collection. **141.** Close-up of cloth in ambrotype. Detail of above. **142.** Book cover. L. W. Minnigh, *Gettysburg: What They Did Here* (Tipton & Blocher, 1924). **143.** Amos's letter "To My Wife" 1. Mark H. Dunkelman Collection. **144.** Amos's letter "To My Wife" 2. Mark H. Dunkelman Collection. **145.** Amos's May 9 letter 1. Mark H. Dunkelman Collection. **146.** Amos's May 9 letter 2. Mark H. Dunkelman Collection. **147.** Whaling log. Nicholson Whaling Collection, courtesy of the Providence Public Library. **148.** Whaling map 1. Voyage of *The Harrison*, 1851. Adapted from maps by Mark H. Dunkelman, *Gettysburg's Unknown Soldier*. **149.** Whaling map 2. Voyage of *The Harrison*, 1852. Adapted from maps by Mark H. Dunkelman, *Gettysburg's Unknown Soldier*. **150.** Whaling map 3. Voyage of *The Harrison*, 1853–4. Adapted from maps by Mark H. Dunkelman, *Gettysburg's Unknown Soldier*. **151.** Stereoview. "Stereogram: Gettysburg street view." John J. Richter Collection. **152.** Map of the dates of letters sent from Humiston. Graphic by Daniel Mooney adapted from the new war map of Virginia, Maryland & Pennsylvania, Boston: B.B. Russell, [186–] (Boston: Mayer & Co.'s Lith.). Library of Congress, Geography & Map Division, G3790 186– .R8. **153.** Battlefield stereograph. "On the battlefield at Gettysburg" by James F. Gibson. Library of Congress, Prints & Photographs Division, LC-DIG-ppmsca-18947. **154.** Amos without and with a beard. Mark H. Dunkelman Collection. **155.** Amos portrait carte de visite. Mark H. Dunkelman Collection. **156.** Children carte de visite. Mark H. Dunkelman Collection. **157.** Homestead orphanage drawing. "Proposed design for the National Homestead of Gettysburg for soldiers' orphans," Library of Congress, Rare Book & Special Collections Division, Alfred Withal Stern Collection of Lincolniana. **158.** Homestead photograph with Grant in it. Gettysburg National Military Park. **159.** *German Reformed Messenger*. *German Reformed Messenger*, June 8, 1864, p. 2. **160.** Hobbles. Courtesy of Larry Runk. **161.** The empty envelope. Mark H. Dunkelman Collection. **162.** *Digging in Yucatan* cover. Ann Axtell Morris, *Digging in Yucatan*, courtesy of Elizabeth Ann Morris. Artwork by Jean Charlot © The Jean Charlot Estate LLC. With permission. **163.** *Digging in Yucatan* photos. Ann Axtell Morris, *Digging in Yucatan*, courtesy of Elizabeth Ann Morris. Artwork by Jean Charlot © The Jean Charlot Estate LLC. With permission. **164.** Humiston family tree. Graphic by Daniel Mooney. **165.** Map with dates of Humiston's letters. Graphic by Daniel Mooney, adapted from *Seat of War* (New York: Horace Thayer, c. 1861). Library of Congress, Geography & Map Division, G3709.31.S5 1861 .T4 CW 17.6. **166.** "An Incident of Gettysburg." "An incident of Gettysburg—the last thought of a dying father," 1864. Library of Congress, Prints & Photographs Division, LC-USZ62-80266. **167.** Gettysburg map. From Harry W. Pfanz, *Gettysburg—The First Day*. Copyright © 2001 by the University of North Carolina Press. Used by permission of the publisher. www.uncpress.unc.edu. **168.** 154th Regiment battles and casualties. Frederick Phisterer, *New York in the War of the Rebellion*, 3rd ed. (Albany: J. B. Lyon Company, 1912). **169.** Army of the Potomac chart. Graphic by Daniel Mooney. **170.** Synoptical chart of the Civil War. "The History of the Civil War in the United States, 1860–1865," (Buffalo, N.Y.; London, England; Toronto, Canada: The Comparative Synoptical Chart Company, c.1897). Library of Congress, Geography & Map Division, G3701.S5 1897 .C6 CW 62.4. **171.** Errol wedding photo. Courtesy of the author. **172.** Ekman A, B. Paul Ekman, Ph.D./Paul Ekman Group, LLC. **173.** Ekman C, D. Paul Ekman, Ph.D./Paul Ekman Group, LLC. **174.** Ekman E, F. Paul Ekman, Ph.D./Paul Ekman Group, LLC. **175.** Rosenthal, flag raising. U.S. Marines of the 28th Regiment, Fifth Division, cheer and hold up their rifles after raising the American flag atop Mount Suribachi on Iwo Jima, a volcanic Japanese island, on February 23, 1945, during World War II. Associated Press/Joe Rosenthal. **176.** Rosenthal taking picture of flag raising. Joe Rosenthal photographing the Iwo Jima flag raising, February 23, 1945. Photograph by Marine photographer Private Robert R. Campbell. National Archives. **177.** Bird's-eye view of Philadelphia with notes. "Bird's Eye View of Philadelphia." Library of Congress, Prints & Photographs Division, LC-USZ62-23778. Graphics by Daniel Mooney. **178.** Chestnut Street between 5th and 6th Streets. Chestnut Street between 5th and 6th, 1865. Print and Picture Collection, Free Library of Philadelphia. **179.** Wenderoth Taylor, & Brown. The Library Company of Philadelphia.

NOTES

Preface

1. I have always considered my brother, who died over twenty years ago, to be the genius in the family. He worked for many years for Project MAC at MIT, and I have read in diverse places on the Internet that he is in part credited with the invention of e-mail.

2. I played the cello; my mother played the piano. I realized how difficult the cello parts were, but I didn't realize how difficult many of the piano parts were— Beethoven's Opus 69 or the Rachmaninoff sonata for cello and piano.

Chapter 1: Which Came First, the Chicken or the Egg?

1. Sontag's unwillingness to include photographs in her book becomes a troublesome conceit. The presence of photographs in her manuscript would force us to ask questions about the photographs themselves. Without photographs Sontag's theoretical concerns predominate, and we end up thinking about her remarks in a photographic vacuum.

2. Fenton's entire correspondence from the Crimea, twenty-five letters, is available online at http://rogerfenton.dmu.ac.uk/index.php.

3. The books are located at the Harry Ransom Humanities Research Center in Austin, Texas, and at the National Media Museum, Bradford, West Yorkshire, UK.

4. I might add that my interpretation of Baldwin's and Daniel's motivations is also a psychological theory.

5. Readers may recall the poem but not the events that inspired it. On October 25, 1854, Lord Cardigan led his men into a cul-de-sac where they were surrounded on three sides by Russian artillery. The end result was entirely predictable—carnage.

6. Fenton himself, in his April 4–5 letter, writes about the "valley of death," although he is clearly referring to the Valley of the Shadow of Death.

7. Early on in my investigations of the photographs, I collected French, English, and Russian maps of the Crimean battlefields. It is endlessly interesting to compare these maps, which provide important clues as to what was significant to each army. I spent my childhood completely obsessed with maps. I owned hundreds of them. One wall of my bedroom was papered with the USGS maps of Long Island, New York.

8. I had tried to convince Julia, my wife, to come with me to the Crimea. My first argument was that it would give her an opportunity not only to read but to see the Twenty-third Psalm. Then I suggested that it was an opportunity to experience the Twenty-third Psalm. And while I didn't have a chance to make the argument before I went there, it turns out that there are parts of the Valley of the Shadow of Death that are for sale, and there is an opportunity not just to see and experience the Twenty-third Psalm, but to own it. Who could resist? I started to think about the possibility of Valley of the Shadow of Death time-shares. What a fantastic place for a nursing home!

9. My trip to the Crimea also dispelled one other concern—the possibility that the photographs had been flopped, left-right. Since the landscape corresponds so closely to the photographs, I feel that's not very likely.

10. Is it possible that two hundred thousand people "were killed over who should have the right to put a star up over the manger"?

11. From *Eyewitness in the Crimea: The Crimean War Letters of Lieutenant Colonel George Frederick Dallas*, edited by Michael Hargreave Mawson (London, UK: Greenhill Books, 2001).

12. Cecil Woodham-Smith, *The Reason Why: The Story of the Fatal Charge of the Light Brigade* (New York: Penguin, 1958), p. 229.

13. Although, to paraphrase Shakespeare, "the fault, dear Brutus, lies not in our photographs but in ourselves."

14. I was first shown the book by Lydia Davis, a friend of mine from the Putney School. I felt that I was in the presence of a kindred spirit. Klüver was someone clearly obsessed with using empirical methods to determine details about photographs, particularly their sequence.

15. I had previously contacted Alastair Massie, the director of the National Army Museum in London and the author of several books on the Crimean War. He sent several helpful e-mails. One clarified the size of the cannonballs: "At Sevastopol the guns in use for siege operations were 68, 32, and 24 pounders. This is the weight of shot fired. These heavy guns were mostly ones taken off ships; both sides did this." A second e-mail discussed the range of the guns: "The heaviest ordnance could fire at a range of up to two miles: this is why the British had to site their camp further than that away from Sevastopol (but by supercharging their guns the Russians could still reach the camp). We have a Crimean War 68 pounder gun sitting outside the Museum and its bore is just over 10 inches, so the diameter of the largest cannonball you can see in the picture will be 10 inches." The cannonball I borrowed from the Panorama Museum was a 24-pounder. I suppose if I had been utterly scrupulous, I would have tried to lug a 32- and a 68-pounder up to the Valley of the Shadow of Death as well. I have an excuse, however. The 24-pounder was the only cannonball they lent me.

Chapter 2: Will the Real Hooded Man Please Stand Up?

1. I later had the opportunity to ask Susan Burke about the blanket. She confirmed that she had the blanket. But when I asked the inevitable question, "How do you know it's the same blanket?" she said she didn't know if it was the exact same blanket, but Haj Ali had a blanket just like the one in the photo and she had no doubt it was given to him by Americans during his detention at Abu Ghraib. At the risk of boring the reader, there were several additional questions that needed to be answered. How many blankets similar to the one worn by The Hooded Man were at Abu Ghraib? How do you know it was that one? How did you prove Qaissi's claim that it was the same one?

2. See http://www.roangelo.net/logwitt/gestalt-shift.html.

3. The embedded Exif files record the data for digital photographs, including the time stamp from the camera, the make and model of the camera, the use of a flash, the f-stop, etc.

4. Lieutenant Colonel Steve L. Jordan, Military Intelligence, was the director of the Joint Interrogation and Debriefing Center at Abu Ghraib. He was the only officer tried in the Abu Ghraib abuse scandal.

5. Cognitive dissonance at its finest. The theory holds that when we embrace one theory, we will firmly reject beliefs that are incompatible with it. It is also known as the Duhem-Quine thesis. Faced with evidence that is incompatible with a theory, we will throw away the evidence, rather than the theory.

6. The interest in the identity of The Hooded Man is not unlike the interest in the identity of the flag-raisers on Mount Suribachi. Two flags were raised, two groups

of soldiers were involved, but public interest was focused on the second flag raising because an iconic photograph was taken of it.

7. Major General Antonio Taguba was appointed on January 31, 2004, to conduct an investigation into the 800th MP Brigade's detention and internment operation. It was the first major investigation into the Abu Ghraib scandal, but there were imposed limitations as to the scope of the investigation. It was assumed that the problem was within the 800th MP Brigade and with its leaders, particularly Brigadier General Janis Karpinski (since demoted to colonel), and so the investigation was limited to the MPs. The investigation was restricted from looking at the Defense Department and the White House where these policies of abuse originated.

Chapter 3: The Most Curious Thing

1. According to Sabrina Harman, most of the nightshift was present: Harman, Wisdom, Jones, Graner, Frederick, Javal Davis, Cathcart, Hubbard, Megan Ambuhl, Stephens, Goodman, and Escalante. I interviewed Sabrina twice on film and numerous times on the telephone.

2. "Bomb Explodes at ICRC Headquarters in Baghdad," story posted on ICRC Web site, https://web.archive.org/web/20081202190112/http://www.redcross.org/article/0,1072,0_332_1829,00.html.

3. In some cases, OGA sent prisoners for further interrogation to "client-states," like Jordan. According to Lieutenant Colonel Steve Jordan, "All they were doing was using the Abu Ghraib facility as a holding area. And sometimes they would bring them out there because they would use the linguistic support of the 205th MI Brigade there at the JIDC. And then, if they decided: 'Hey, we're not going to keep this person; we're going to render them out.' I was aware of at least three or four folks that they rendered out through Amman, Jordan. Now, where they went to, I don't know, sir . . . I asked somebody, and they said, 'We've got a flight that goes to Amman, Jordan.' And that flight was the OGA flight, the CIA flight. And that's how their people came in and out of country that I was aware of, was through facilities over in Amman."

4. CACI, formerly Consolidated Analysis Center, Incorporated, is a civilian defense contractor that supplied interrogators for Abu Ghraib. Titan is a civilian defense contractor that supplied interpreters.

5. Errol Morris interview with Sergeant Hydrue Joyner, May 20, 2006.

6. SPC Jason Kenner, Sworn Statement, March 18, 2004, CID, file 0237-03-CID259-61219. The statement is part of the Navy SEALs investigation into al-Jamadi's death.

Kenner had no reason to lie. He was in no way linked to the death of al-Jamadi, but his statement was important to the defense attorneys for the Navy SEALs because it clears the SEALs of direct involvement in al-Jamadi's death.

7. Jane Mayer reported in her 2005 article in *The New Yorker*, "A Deadly Interrogation": "For most of the time that Jamadi was being interrogated at Abu Ghraib, there were only two people in the room with him. One was an Arabic-speaking translator for the C.I.A. working on a private contract, who has been identified in military-court papers only as 'Clint C.' He was given immunity against criminal prosecution in exchange for his cooperation. The other person was Mark Swanner." There were, however, two interrogations. One was on Tier 4B; the subsequent one was in the Tier 1B shower room. Tier 1B is where he died.

8. SPC Jason Kenner, Sworn Statement, March 18, 2004, CID, file 0237-03-CID259-61219: "The interrogator told us that he did not want the prisoner to sit down and wanted him shackled to the wall. I got some leg irons and shackled the prisoner to the wall by attaching one end of the leg irons to the bars on the window and the other end to the prisoner's handcuffs."

9. Mr. Mark Swanner, CID Agent's Investigation Report, ROI 0237-03-CID259-61219, Interview with Mr. Mark Swanner, Mr. Clint C, and "Steve": "About 1510, 05 Nov 03, SA J. D. Stewart interviewed Mr. Mark Swanner who stated that he, Mr. Clint C and Steve were part of a team along with SEAL Team 7 on a mission to apprehend Mr. Al-Jamadi at his residence. . . . At approximately 0530, Mr. Swanner, and Mr. Clint C resumed the interrogation of Mr. Al-Jamadi. Some time around 0700, while answering a question, Mr. Al-Jamadi's head slumped over to the side. Mr. Swanner stated Mr. Al-Jamadi's chest was not moving, so he removed his hood to further observe his condition. At this point Mr. Clint C summoned the Military Police to seek medical assistance for Mr. Al-Jamadi. At this point, both men left the interrogation cell."

10. Dennis E. Stevanus, Sworn Statement, March 24, 2004, CID, file 0024-04-CID389-80640:

> **Q:** Describe the demeanor of the OGA personnel before and after the interrogation?
> **A:** Before, they were normal as like every other day. They took their gear off and grab[bed] a cup of coffee. Then they just went into the room. Afterwards, before we found out he was dead; they were just normal like every other day when they are finished with interviews. After we found out he was dead, they were nervous; they didn't know what the hell to do. The short fat OGA guy said, "No one's ever died on me before when I interrogated them."
> **Q:** Did the OGA personnel make any statement about what happened?
> **A:** They said the guy just quit talking and slouched down. When I told them

I was calling my NCOIC, the short OGA guy got on the phone and started calling somebody.

11. Errol Morris interview with Walter (Tony) Diaz, April 22, 2006:

> **WALTER (TONY) DIAZ:** So that's what I told him, "Listen, sir, I don't know what happened. You guys [are] in charge of this. I don't know what happened, I don't know what's going to happen." So that's when he took his cell phone, went out and started calling his people, I guess. And then as soon as that happened, I went and called my NCOIC, called him up on the radio. "Hey, sir, you need to respond here quick. We got this situation going on here." And then he was like, "Oh, what is it?" Because, you know, it was early in the morning, nothing went on. I said, "You need to get here now." He said, "What is it? Tell me." I said, "Well, I think we have a dead guy here." And that's when they all started running and trying to find what was going on. And then in no time, you had medics, you had the entire chain of command right there trying to figure out what was going on.
>
> **ERROL MORRIS:** By the entire chain of command, whom do you mean? Who was there? Who showed up?
>
> **WALTER (TONY) DIAZ:** Well, we had a colonel that showed up.
>
> **ERROL MORRIS:** Jordan?
>
> **WALTER (TONY) DIAZ:** Colonel Jordan, yeah, he was in charge of the MIs. He came in; the medics came in. Later, Captain Reese came in, Captain Brinson, First Sergeant. You had everybody showed up. Platoon sergeant, Sergeant Snider, everybody showed up.

See also Article 32 Transcript *U.S. v. Harman*, June 24, 2004:

> **DONALD REESE:** I did see him after he died. His body was on the top tier as you walk into the cellblock to the left. It was on the top left side of the tier. I was called by CPT Brison, Officer in Charge (OIC) of the wing, and he told me that we had a situation and that I should come up to see what was going on. . . . The body was clothed and laying on the floor. COL Pappas, LTC Jordan and some OGA guys were present looking at the body.

See also Captain Christopher R. Brinson, Interview Report, April 5, 2004, OIG, Case 2003-7423-IG, Death of Iraqi Detainee: "Brinson advised that he did not assume control of the situation surrounding al-Jamadi's death. He stated he was in charge of the MPs and considered al-Jamadi an OGA and Military Intelligence (MI) matter."

12. Errol Morris interview with Lt. Colonel Steve Jordan, August 5, 2007:

STEVE JORDAN: Colonel Pappas looked at me and said, "You know, I'm not going down alone for this." I said, "Sir, going down for what? The guy's an insurgent and he died." I said, "We didn't even know he was here. They brought him out. They failed to let anybody know, and they took him right in and started processing him. And started interrogating." And he said, "All right, when the team leader gets here, bring him. We need to handle this." "Roger that, sir."

13. Errol Morris interview with Sergeant Hydrue Joyner, May 20, 2006:

HYDRUE JOYNER: Yeah, I called him Bernie. You ever see that movie, *Weekend at Bernie's*? I don't want to spoil it for you. Go rent that and you'll understand what I'm talking about. But for you folks out there that knew what I'm talking about, when Bernie surfaced, if you will, again that happened on my day off. I come in the next day—

ERROL MORRIS: Hey, wait a second. All this happens on your day off?

HYDRUE JOYNER: I'm telling you, everything happened on my day off. Everything that happened on my day off. You know, I don't know if that's a good thing or a bad thing, but it happened on my day off. So I come in after being off that day, and I'm going there and relieve—I think it was Sabrina that briefed me on it. And at four in the morning, your brain hasn't really started to function yet. It still hasn't decided if it wants to be awake or not. So she's telling me, yeah, this, that, and the other happened and I'm like, "What is that smell?" You know, we been in Iraq for a while and you can pretty much filter out certain senses. But I'm like, "Something just don't smell right, what is that smell?" And just as sure as I'm sitting right here, she says, "Oh, that's the dead guy in the cell." "Oh, okay." And she goes on about five minutes past it. "Wait a minute, did you just— What did I hear you say?" "There's a dead guy in there." I had to wipe the—clean out my eyes and out my ears. "Did you say there's a dead guy in the shower?" She said, "Yes." I said, "Are you playing with me? Am I getting punked?" "No." So I goes over to the shower and it was locked. The shower room is never locked, there's a padlock on the lock. Like, "What the hell is that, and why is there water coming out of there?" "He's on ice." "What the hell do you mean, he's on ice? What is he doing dead, and why is he still here?" And apparently the guy was in some kind of interrogation and during the interrogation, the man just died and that was it. That's the story I got, and I was like, "Wait, whoa, somebody—you don't just die, you know, in the middle of talking to somebody." It just doesn't seem—it doesn't happen every day. So she was like, "No, he was in the middle of interrogating and just expired. Ceased to exist." And I'm like, "And they left him here?" And, "Yeah, they left him there and put him on ice because we don't have a morgue. Where you going to take him?" You know, I guess, I guess that was the thinking. And I'm like,

"Oh my goodness, this is not good. This can't be—no, this ain't good." So lo and behold, I get the story and yeah, he died in interrogation and they put him on ice, and a decision, I guess, was being made of how they were going to move him out without everybody thinking the man had just died. I'm like, "Oh Lord, have mercy." And I'm thinking to myself in the back of my head, "Oh, thank God I was off yesterday." The only thing—yeah, I mean, the man's dead, that's wrong, you know, I don't know him but I feel sorry for his passing. But it didn't happen while I was working, so you got to take your victories where you can get them. So I was like, "Whew." But yeah, Bernie expired on my day off.

14. Captain Christopher R. Brinson, Interview Report, April 5, 2004, OIG, Case 2003-7423-IG, Death of Iraqi Detainee: "Brinson stated that sometime after he arrived at the scene, a senior OGA person, whose name was Steve, arrived. He knew Steve from previous dealings at the prison with OGA detainees that were housed in the wing and tier reserved for sensitive prisoners of interest to OGA and MI. Brinson related that the officer in charge of MI, Lieutenant Colonel Jordan, also came to the scene that morning and discussed with Steve what to do with al-Jamadi's body. As a result of those discussions, Steve advised Brinson that OGA would be removing the body from the prison. However, Steve subsequently informed Brinson that he could not move the body on that day and inquired whether Brinson could obtain ice to ice the body to delay composition [*sic*]."

15. The first photographs of al-Jamadi are taken less than half an hour after the two pictures of the Hooded Man.

16. This statement is part of Ivan Frederick's Record of Trial, 20 October 2004, p. 285.

17. Captain Christopher R. Brinson, Interview Report, April 5, 2004, OIG, Case 2003-7423-IG, Death of Iraqi Detainee: "Brinson advised that OGA and MI developed a plan intended to remove Al-Jamadi's body from the prison without alarming or upsetting other prisoners. The plan was to place a bandage over Al-Jamadi's bloody eye and inserting an intravenous line in one arm, placing Al-Jamadi on a gurney, without the body bag, and moving him out to an ambulance that would take him out of the prison. This plan was to be carried out the day after Al-Jamadi died."

18. Errol Morris filmed interview with Walter (Tony) Diaz, April 22, 2006:

WALTER (TONY) DIAZ: Well, what they didn't want to find out, other people, that there were other prisoners, they didn't really want to make them think that yeah, we're killing people here. And we didn't want to start no riots or nothing like that. So what they did, within the compound, they['re] trying to cover it up. They actually called an ambulance, medics came in, and actually put in

an IV, a fake IV, on this guy, and took him on the stretcher. Make him seem like he was actually sick when they were transporting him. So they did a couple things just to—but that was for the site, though, that was to make it seem like nothing's happened here, everything's okay. This guy, he's still alive, he's just sick, we going to take him to the hospital.

And as far as trying to cover up for Army-wise, I don't know if that really happens. I don't know if they intended to do that, I never figured out what happened after that.

ERROL MORRIS: To do what? Intended to do—I'm sorry?

WALTER (TONY) DIAZ: To cover up. I don't know what the OGAs did to try and cover it up. I don't know the story about that. Once he left the site, we had no idea what was going on.

19. The report can be seen at http://www.npr.org/iraq/2004/prison_abuse_report.pdf.

20. The report can be seen at news.findlaw.com/hdocs/docs/dod/fay82504rpt.pdf.

21. Through 2005, the Department of Defense cites twelve government reports; see http://www.defenselink.mil/news/newsarticle.aspx?id=16017: " 'Formica's investigation was one of 12 major investigations and reports DoD has done,' the defense official said. 'The 12 investigations have yielded 492 recommendations, almost all of which have been implemented,' he said."

As of June 2006, the Minnesota Human Rights Library cites seventeen major investigations, of which thirteen were conducted by the military. The remaining investigations were conducted by the FBI, the UN, the Red Cross, and the Intelligence Science Board; see http://www1.umn.edu/humanrts/OathBetrayed/general-investigations.html.

22. The "Final Autopsy Report," signed by Dr. Hodge and dated January 9, 2004, states: "According to investigating agents, interviews taken from individuals present at the prison during the interrogation indicate that a hood made of synthetic material was placed over the head and neck of the detainee. This likely resulted in further compromise of effective respiration. Mr. Al-jamadi was not under the influence of drugs of abuse or ethanol at the time of death. The cause of death is blunt force injuries of the torso complicated by compromised respiration. The manner of death is homicide."

23. The release of documents detailing and authorizing torture techniques were widely reported. See: *Washington Post,* September 25, 2008, "Top Officials Knew in 2002 of Harsh Interrogations"; *Washington Post,* April 23, 2009, "Harsh Methods Approved as Early as Summer 2002"; *Boston Globe,* April 17, 2009, "Newly Released Bush Documents Detail Torture Tactics."

24. Among the many charges listed in Sabrina's charge sheet dated March 20, 2004: "Charge VI, Violation of the UCMG, Article 134, Indecent Acts, Specification #1: In that Specialist Sabrina D. Harman, U.S. Army, did, at or near Baghdad Central Correctional Facility, Abu Ghraib Iraq, between on or about 1 August and on or about 31 October 2003, desecrate a human corpse by entering the Baghdad Central Correctional Facility Morgue, and unzipping a body bag in which a corpse was contained, and posing for photographs with the said corpse. . . . Specification #3: In that Specialist Sabrina D. Harman, U.S. Army, did, at or near Baghdad Central Correctional Facility, Abu Ghraib Iraq, between on or about November 2003 desecrate a human corpse by entering a shower-room where the corpse was covered by ice, opening the body bag in which the corpse was contained and taking pictures of the said corpse." These charges were eventually dropped.

25. Oliver Sacks has written, "No one in the world has studied facial expressions as deeply as Paul Ekman. In *Emotions Revealed* he presents—clearly, vividly, and in the most accessible way—his fascinating observations about the covert expressions of emotions we all encounter hundreds of times daily, but so often misunderstand or fail to see. There has not been a book of such range and insight since Darwin's famous *Expression of the Emotions* more than a century ago." His work is also prominently featured in Malcolm Gladwell's *Blink*.

26. In *Emotions Revealed* Ekman quotes Duchenne: "The emotion of frank joy is expressed on the face by the combined contraction of the zygomaticus major muscle and the orbicularis oculi. The first obeys the will but the second is only put in play by the sweet emotions of the soul. . . . The muscle around the eye does not obey the will; it is only brought into play by a true feeling, an agreeable emotion. Its inertia in smiling unmasks a false friend."

27. Ekman provides a graphic photo illustration of the difference between the Duchenne smile (the real smile) and the social smile.

ILLUSTRATION #172
EKMAN A, B

A B

"At first glance it might seem that the only difference between these photos is that the eyes are narrower in photo B, but if you compare A and B carefully you will see a number of differences. In B, which shows real enjoyment with a Duchenne smile, the cheeks are higher, the contour of the cheeks has changed, and the eyebrows have moved down slightly. These are all due to the action of the outer part of the muscle that orbits the eye."

ILLUSTRATION #173
EKMAN C, D

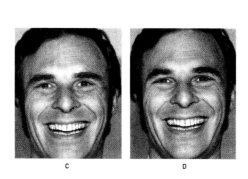

C D

"When the smile is much broader, there is only one clue that distinguishes between enjoyment and non-enjoyment smiles. A broad smile, such as in photo C, pushes up the cheeks, gathers the skin under the eye, narrows the eye aperture, and even produces crow's-feet wrinkles. All of this without any involvement of the muscle that orbits the eye."

"In comparison photo D shows the eyebrow and eye cover-fold (the skin between the eyelid and the eyebrow) have been pulled down by the muscle orbiting the eye. Photo D is a broad enjoyment smile, while C is a very broad non-enjoyment smile. Photo C, incidentally, is a composite photograph made by pasting D from the lower eyelids down on to the neutral photograph."

ILLUSTRATION #174
EKMAN E, F

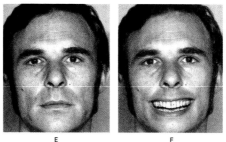

E F
(NEUTRAL)

"Photo F is another composite photograph, in which the smiling lips from picture D have been pasted on to the neutral photograph E. Human beings can not produce the expression shown in photo F. It should look strange to you, and the reason it looks so strange is because when the smile is this broad it produces all the changes in the cheeks and eyes that you see in D." I made this composite illustration to underline the fact that very broad smiles change not only the lips but also the cheeks and the skin below the eyes. Paul Ekman, *Emotions Revealed: Recognizing Faces and Feelings to Improve Communication and Emotional Life,* New York: Owl Books, 2003, pp. 207–8.

28. See http://www.newyorker.com/archive/2004/05/03/slideshow_040503?viewall =true#.

29. It would be another year and half before Jane Mayer's article "A Deadly Interrogation," detailing the death of al-Jamadi, appeared in the November 14, 2005, issue of *The New Yorker.* It is one of the finest pieces of investigative journalism to come out of the Iraq War.

Chapter 4: The Case of the Inappropriate Alarm Clock

1. In 1935, when the Resettlement Administration was established, there were almost 7 million farms in the United States. These were small family farms. Less than 10 percent had electricity. Programs such as the Rural Electrification Administration and Resettlement Administration had a dramatic impact on the quality of rural life. Focused initially on emergency relief, the Resettlement Administration experimented with a range of programs to aid farmers in dire situations. The RA made small loans to carry farmers through difficult times, built migrant worker camps, constructed rural water projects, purchased conservation land, and resettled displaced farmers on new land. There were those who opposed these government interventions and questioned their cost and efficacy. After the 1936 election, the agency, perhaps in response to critics, was renamed the Farm Security Administration. According to Beverly Brannan, curator of photography at the Library of Congress, in her book *FSA: The American Vision*: "Over the project's eight years its administrators and photographers were not only documenting but contributing to a paradigm shift. Between 1935 and 1943 the American economy completed a transition in its economic base—from traditional agriculture to mass culture, mechanization, and corporate structure—and in its focus—from individual subsistence to mass mobilization for international warfare."

2. *The Plow That Broke the Plains* and *The River* are available with the re-recorded original music on a Naxos DVD.

3. Despite the file folder label "Photographer's Original Captions for Photographs," there are questions. In 1942, Roy Stryker hired Paul Vanderbilt to improve access to the FSA/Office of War Information files. Under Vanderbilt's direction, a massive reorganization was undertaken between 1942 and 1946 in which records were consolidated and order was brought to the whole. The result is that caption sheets now on file at the Library of Congress, according to library's Web site, "range from those written by the photographers themselves on hotel stationery, to rough handwritten drafts (often marked up with corrections), to captions in final form written by office staff." While the caption sheet for the May 1936 skull photographs by Rothstein is labeled "Photographer's Original Captions," it would appear that they were prepared by the office staff in the 1940s, based on the photographer's captions. The cover sheet is labeled RA/FSA, dating it to after 1936 and the introduction of the FSA. The caption for "Drought Victim" is significantly longer than the others, supplying a sort of script for the photograph. It is possible that the caption was either drawn from an assignment sent to Rothstein by Stryker or expanded by Stryker's staff into a final caption. The caption sheet also lists killed negatives. The decision to kill a negative usually rested with the staff in Washington, not the photographer out on assignment. I had hoped to trace the evolution of Rothstein's caption from the original submission by the photographer to final publication in newspapers and magazines, but this does not appear to be possible with the surviving records.

4. Notes from Rothstein's itinerary suggest that the photographs were taken on May 24, the day Rothstein was photographing in Pennington County. His expense report shows that he traveled 120 miles round trip from Rapid City that day. Even though the photograph was not taken at the height of the drought, the drought was clearly anticipated by the government. On April 29, Henry A. Wallace, secretary of agriculture, reported the federal government was preparing itself for action in the event of another great drought year like 1934. On May 24 (the same day that Rothstein photographed the skull) the *New York Times* reported that "general rains are needed over a large part of the spring wheat areas. Special attention is being given to the territory between the Red River on the eastern boundary of Minnesota and the Dakotas and the Missouri River. Reviewing the moisture situation, Nat C. Murray, statistician for Clement Curtis & Co., says the percentage of rainfall for the first three weeks of May has been approximately 36% in South Dakota."

5. Photography seems to bring out the amateur epistemologist in us all. Isn't it odd *and* ironic that many of the recent debates concerning faked photographs have concerned inferences made from photographs that turn out to be true? The faked photograph of the launching of the Iranian missiles telegraphed the idea that Iran was launching missiles that could threaten Israel and the West. One of the missiles and several clouds of smoke had been "cloned" into the photograph with Photoshop. The photograph was a fake. But without the additional missile, the photograph would have made a similar point. It is that element of manipulation that has become

the source of controversy, particularly when the viewer is "manipulated" into believing something he or she already believes. These issues are discussed in a *New York Times* online essay, "Photography as a Weapon." http://opinionator.blogs.nytimes .com/2008/08/11/photography-as-a-weapon.

6. The sharecropper family names were all pseudonyms in *Let Us Now Praise Famous Men*. However, since the republication of the book in 1960 and in subsequent years, their real names have become part of the public record. George Gudger is the pseudonym for Floyd Burroughs. And strictly speaking, the photographs for *Let Us Now Praise Famous Men* were not produced for the FSA but under a separate contract with *Fortune* magazine. Walker Evans was on loan from the federal government.

7. See inflation calculator at http://www.bls.gov/data/inflation_calculator.htm.

8. William Stott, "Review of James Curtis's *Mind's Eye, Mind's Truth: FSA Photography Reconsidered*," *The Journal of American History*, vol. 77, no. 3 (December 1990), pp. 1076–77.

9. Arthur Rothstein, "Direction in the Picture Story," *The Complete Photographer*, vol. 21 (April 10, 1944), pp. 1356–63; and "Setting the Record Straight," *Camera*, vol. 35 (April 1978), pp. 50–51.

10. These ideas have been part of my own work in documentary.

11. *Popular Photography*, vol. 61 (September 1961), pp. 42–45 and 78–79.

12. Rothstein, "Direction."

13. Mark Klett, *Third Views, Second Sights: A Rephotographic Survey of the American West* (Santa Fe: Museum of New Mexico Press, 2004).
 I sent Mark Klett and Byron Wolfe a copy of this essay to obtain permission to reprint their photographs. In response, Byron Wolfe sent me the following note:

> The main purpose for this note, however, is to encourage you to take another look at the work Mark and I have done together over the years. On the surface, it may appear to be a use of photography to scientifically study change in the landscape, but I'd suggest that it's something entirely different—something much more subversive. I've long held the idea that our work poses as one thing in order to address something else. In fact, I think that if you'll examine the whole of our collaboration, you'll find that it has much more in common with your interests in how both photographers and photographs function and (intentionally and unintentionally) create meaning for a viewer. We have consistently worked to provide a context for the

relationship that is created with our rephotographs. I think it would be more accurate to say that our work, when taken in whole and as we normally intend for it to be seen with collateral material (titles, written notes, site photographs, interviews, animations, collected artifacts, and more), is more of a study of representation, perception, and decision making, as well as a consideration of changes in aesthetics, culture, history, and technology. In short, it's more about what's happening with the world outside the frame of an original view and inside the mind of the photographers—ourselves included. Our rephotographs aren't any more about a scientific study of landscape change than your analysis of Roger Fenton's Crimean war photograph was a study of cannon balls or revegetation of roadside burms after a war. The picture pair ("Jeffries Pine, Sentinel Dome") you used to illustrate [illustrate our work] was essentially stripped from its original context that described how the Jeffries Pine had become a powerful symbol of wilderness and nature and once acted as a magnet to draw people from across the globe to make pilgrimage visits to the site. That's a complicated idea woven into two seemingly straightforward . . . pictures of a tree, one alive, one dead.

14. "The Dust Bowl Turns to Gold," *Look*, vol. 25, no. 22 (October 24, 1961), p. 41: "The older boy in this famous Depression picture can joke 25 years later (right) about the 'dirty '30's.' Twenty-five years ago, Cimarron County, Oklahoma, was a dust bowl, and farmers who no longer could take it fled with their families. One of the historic pictures of those dreadful times (above, left) was taken by Arthur Rothstein, then with the U.S. Resettlement Administration. It shows Arthur Coble and his sons Milton and Darrel on their Cimarron 'farm.' Cimarron County has changed since then. Although it still has dust storms, it is the richest county per capita in Oklahoma. Rothstein, who is now technical director of photography for *Look,* recently returned to Cimarron. He found the farm where he had photographed the Cobles in 1936. Arthur Coble, his wife, their two sons and daughters remained on their land through the 1930's. Today, Arthur Coble is dead. Mrs. Coble has moved to another part of the county, and their four children are married. The two sons still live not far from the old homestead. Milton, now 31, works in a feed mill in Hartley, Texas, about 50 miles away, and Darrel, 26, is with the county highway department. Both now have boys the same age they were when the early Rothstein picture was taken. In the photograph above, right, Milton is shown with his son Bill in almost exactly the same spot. Darrel vividly remembers life on the old farm: 'Six of us in three rooms. During the storms, we'd eat in bed. Less dust.' Milton can talk with humor now about the 'dirty '30's.' He recalls that the house did not have plumbing until 1947. 'We took our Saturday baths in a galvanized tub behind the kitchen stove, with walking water. You had to walk to get it.' The Cobles today are comfortable. But some of their neighbors, whose land has soared from 75 cents an acre to upwards of $150, are rich. They have learned to protect their soil by modern methods, to keep it from blowing away. There will be droughts until the end of time. But another dust bowl? Not likely, these farmers will tell you."

15. You see it with the Robert Capa photograph "Fallen Soldier." You see it with the Fenton photographs "Valley of the Shadow of Death," and the Rosenthal photograph "The Raising of the Flag on Mt. Suribachi." All of the photographers have been accused of posing these photographs.

16. Timothy Egan, *The Worst Hard Time* (Boston: Mariner Books, 2006): "It seemed on many days like a curtain was being drawn across a vast stage at world's end. The land convulsed in a way that had never been seen before." The frontispiece of Egan's Pulitzer Prize–winning account of the dust bowl of the 1930s includes Rothstein's photograph "Fleeing a Dust Storm."

Chapter 5: It All Began with a Mouse

1. Later, when asked whether his photograph was posed, Rosenthal said that it was. But he was referring to a *different* photograph—his photograph of the soldiers posing for his camera just *after* the flag was raised. Indeed, there is even a photograph of Rosenthal taking the posed photograph of the soldiers. Private Robert R. Campbell, a Marine photographer, was standing behind Rosenthal and captured the scene. Joe Rosenthal himself was seemingly unaware his picture was being taken by Campbell. And the soldiers were posing for Rosenthal's camera—not for Campbell. So is Campbell's photograph candid or posed?

ILLUSTRATION #175
ROSENTHAL, FLAG RAISING

ILLUSTRATION #176
ROSENTHAL TAKING PICTURE OF FLAG RAISING

2. Illustration #125 shows the damage in the region of Tyre, Lebanon, as of August 14, 2006. It was produced by UNOSAT, the UN Institute for Training and Research (UNITAR) Operational Satellite Applications Programme, implemented in cooperation with the European Organization for Nuclear Research (CERN); see http://www.unitar.org/unosat/node/44/767. Illustration #127 provides an overview of the war zone in Lebanon through the movement of UN relief convoys as of August 7, 2006. This map was produced by the United Nations Office for the Coordination of Humanitarian Affairs, http://www.reliefweb.int/rw/RWB.NSF/db900SID/JOPA-6SH8XB?OpenDocument.

3. An AP wire story was filed by Kathy Gannon, as follows:

> The Associated Press
> August 7, 2006 Monday 6:01 PM GMT
> Premature baby winning fight for life after being left in a hospital
> BYLINE: By KATHY GANNON, Associated Press Writer
> SECTION: INTERNATIONAL NEWS
> LENGTH: 544 words
> DATELINE: TYRE Lebanon
>
> Only two hours old, Raad fought for his life in an ambulance that screamed along a treacherous, bombed-out stretch of road out of the heart of southern Lebanon's war zone.
> His shock of black hair was still matted with blood from his birth and his frail body was swaddled in a blanket when ambulance drivers brought the

barely 3-pound infant from the village of Tibnin to the Najem hospital in the port city of Tyre.

He was born two months early, delivered by Caesarean section at a smaller hospital in Tibnin after his mother fled her home village. Tibnin, some 12 miles from Tyre, has been thronged by thousands of refugees from nearby villages, escaping heavy Israeli bombardment in the area.

Tyre also has been repeatedly hit by Israeli strikes. But the hospital has far better facilities to care for a premature newborn.

For now two weeks after his birth Raad is effectively abandoned. He was rushed out of Tibnin, but his mother stayed, either too weak or too frightened to come along, hospital worker Ali Jawad Najem said Monday.

She called the Tyre hospital once to ask about her son, but hung up when a nurse asked when she would come for him. Later, a man who said he was Raad's uncle came to the hospital to check on him, but refused to take the infant.

"I don't know why she doesn't want her baby or if she will come after the war to take him. We haven't heard anything since that one telephone call," nurse Nada Daeg said.

The mother identified as Reema Jawad Hameer on a form filled out by the Lebanese Red Cross might be afraid to risk traveling or may believe the baby is safer and better cared for in Tyre, the hospital staff said.

Without a relative to claim him, Raad now has "five mothers and six fathers," Daeg said of the nurses and doctors. "We love him very much. He is our family now."

Raad's face was so small it seemed lost in the palm of Daeg's hand as she held him. His tiny feet were blue. His fingers clutched tight to Daeg's fleshy finger, and he frowned as the people around him talked about his short life.

He was born July 23, 11 days after the start of fighting between Israel and Hezbollah guerrillas, and his life was a struggle from the beginning. His lungs were weak and his breathing labored when ambulance drivers scooped him up and brought him to Tyre, said Najem.

Then he developed jaundice, common among premature babies, and his tiny body took on a yellow tinge, the nurse said.`

But Raad is gaining strength, Daeg said.

"It's slow and he looks very small and weak but he is eating fine and everything is OK," the nurse said.

Many of the hospital workers have lived at the hospital since the outbreak of fighting, unable to return to neighboring villages because the roads are cut.

With no mother to name him, one of the hospital doctors, Nidal Mahboob, picked a name, one that indicates the depth of support for the Hezbollah guerrillas here in southern Lebanon.

Notes
297

In Arabic, Raad means "thunder" and Mahboob said the name represents the sound of Hezbollah rockets being fired into Israel. Raad is also the name of one type of rocket the guerrillas have launched.

Held gently in Daeg's arms, Raad was silent, his eyes wide, as she said, "We want him to be like the Hezbollah rockets when he grows into a young man, a fighter against Israel."

4. "The Reuters Photo Scandal: A Taxonomy of Fraud, A Comprehensive Overview of the Four Types of Photo Fraud Committed by Reuters," August 2006; http://www.zombietime.com/reuters_photo_fraud/.

5. Syndicated in May 2007.

Chapter 6: Whose Father Was He?

1. "The Unknown," written by Emily Latimer for the Orphans Homestead (Philadelphia: Bryson & Son, 1867).

2. Mark Dunkelman, *Gettysburg's Unknown Soldier: The Life, Death, and Celebrity of Amos Humiston* (Westport, CT: Praeger, 1999).

3. The Minnigh guidebook is a book that a young boy could page through endlessly. The front cover with pictures of the two commanders, Lee and Meade, the bucolic scene of Pickett's Charge, and the words of Lincoln's Gettysburg Address: "The world will little note nor long remember what we say here but it can never forget what they did here." Oddly, the events of Gettysburg may sink into oblivion, but it is less likely that Lincoln's words will be forgotten. There are lists of soldiers, pictures of monuments, and a foldout map of the entire battlefield. The best part, however, is Minnigh's introduction to the battlefield: "The contest at Gettysburg marks the flood-tide of the rebellion. The Southern cause received its deathblow on that field. The decisive victory infused new hope into Northern hearts and nerved their arms for the brilliant victories which culminated in the formal surrender of Lee at Appomattox. The Gettysburg of today no longer reeks of blood. The dead are buried, the widespread devastation of those few days has been repaired by the merciful hand of Time, and yet, every spot is hallowed with memories that can never die."

4. David Humiston Kelley and Eugene F. Milone, *Exploring Ancient Skies: An Encyclopedic Survey of Archaeoastronomy* (New York: Springer, 2005).

5. From the collection of John Richter, director, Center for Civil War Photography. A stereogram is a pair of images taken from a slightly different perspective, mirroring the slight difference in perspective between one eye and the other in

binocular vision. It is intended to be viewed through a stereoscope, a device invented by Charles Wheatstone circa 1838. An illusion of depth is created from flat, two-dimensional images, in some ways paralleling how the eye perceives depth through the use of parallax.

6. Consult the NASA site, Moon Phases: 1801 to 1900. http://eclipse.gsfc.nasa.gov/phase/phases1801.html.

7. There is an extensive literature on images on the retinas of the dead. It has been claimed that the retinas of a murder victim record the perpetrator of the crime. For an overview see Bill Jay, "In the Eyes of the Dead." http://www.billjayonphotography.com/Images%20in%20the%20Eyes%20of%20the%20Dead.pdf.

8. Mark Dunkelman, *Gettysburg's Unknown Soldier*, p. 129.

9. Ibid., p. 203.

10. Dunkelman continued:

> I also can't imagine why he used several photographers rather than giving one exclusive rights. From the frequency with which they turn up, the cartes produced by Wenderoth & Taylor (later Wenderoth, Taylor & Brown) seem to have been the most numerous. On the other hand, the only cartes of Amos as a soldier that I've ever seen were by Frederick Gutekunst. At the risk of boring you, here's a list of some of the Humiston cartes in my collection: Sgt. Amos Humiston, Co. C, carte de visite by F. Gutekunst, Philadelphia, PA. The Humiston Children, carte de visite by H. C. Phillips & Brother, Philadelphia, PA (pre-identification horizontal version). The Humiston Children, carte de visite by H. C. Phillips & Brother, Philadelphia, PA (pre-identification vertical version, inscribed in pencil, "January 11th 1864"). The Humiston Children, carte de visite by F. Gutekunst, Philadelphia, PA (pre-identification horizontal version). The Humiston Children, carte de visite by Wenderoth & Taylor, Philadelphia, PA (pre-identification horizontal version, oval print). The Humiston Children, carte de visite by J. E. McClees, Philadelphia, PA ("The Children of the Battle-Field," vertical version, with red lines on mount). The Humiston Children, carte de visite by J. E. McClees, Philadelphia, PA ("The Children of the Battle-Field," vertical version, with unlined mount). . . .

The list goes on and on. But what does the list mean? I kept wondering: is there some pattern in the data that I am missing? The names of the photography studios? Their location? The pre-identification cartes versus the ones issued post-identification? The horizontal version versus the vertical format? What can we

learn from this information? There is an inherent problem in historical research. You can never know in advance where evidence will lead you. It could be to somewhere or to nowhere—or to nothing terribly useful. Three of the four Philadelphia studios involved in the duplication of Dr. Bourns's cartes de visite are located on the same block of Chestnut Street. But so what?

ILLUSTRATION #177
BIRD'S-EYE VIEW OF PHILADELPHIA WITH NOTES

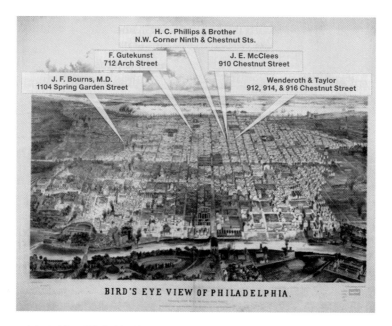

Adapted from "Bird's-Eye View of Philadelphia," J. Bachman, Library of Congress.

I kept looking for more information. I tried to project myself into Dr. Bourns's world. I tried to imagine him scurrying from one studio to another and wondered: is it possible that all of the photography studios operating in Philadelphia were enlisted in his crusade? I looked for photographs of the studios themselves and couldn't find any. But I found one photograph (from the Free Library of Philadelphia) taken on Chestnut Street in 1865 during the celebrations that marked the end of the Civil War. The view is from the 500 block looking west toward the 900 block of Chestnut. Could you imagine that one of the men in the photograph is Dr. Bourns in transit to Wenderoth & Taylor or J. E. McClees? And if so, what would it tell us about his underlying motivation? It may just be that not every collection of data yields something of interest. Or I have yet to uncover a pattern in this data that reveals something exciting and interesting about the past.

ILLUSTRATION #178
CHESTNUT STREET BETWEEN 5TH AND 6TH STREETS

Addendum to footnote 10: I received a later e-mail from Mark Dunkelman, taking me to task for being somewhat dismissive about the list of cartes de visite in his collection. Here is an excerpt from the e-mail and the photograph of the interior of Wenderoth, Taylor & Brown:

> As for my collection of cartes, it identifies the various photographers used in the fund-raising drive (with two non-Philadelphians of interest); it reveals a larger proportion of pre-identification cartes than might be expected, with all the sad implications; it charts the evolution of the charitable effort through the inscriptions; and it offers occasional glimpses into notions of the story held by contemporaries, such as this handwritten note found on one example: "Found at Gettysburgh in a Bible of a Union Soldier killed after the battle July 1864." Taken together, I think the collection has more to offer than strictly antiquarian interest. And of course there is the pleasure of handling these tangible links to the past.

I've got a photograph of the interior of Wenderoth, Taylor & Brown's studio circa 1869, from the Library Company of Philadelphia. It's one of many illustrations that were omitted from the book because of lack of space. Attached is the resized photograph.

ILLUSTRATION #179
WENDEROTH, TAYLOR & BROWN

11. Mark Stengel, in an article in *The Atlantic* on the controversy between the "diffusionists" and the "independent inventionists" suggests it comes down to an argument about what constitutes significant historical evidence. "The influential archaeologist David Kelley, of the University of Calgary . . . is a Harvard-trained scholar of catholic interests, which range from ancient calendrics and archaeoastronomy to the prehistory of the Celts to the decipherment of Mayan glyphs. In conversation he seems to guide by indirection, answering questions with questions or with references to the writings of his peers. His wispy eyebrows sit above eyes undimmed by more than forty years of serious scholarship; a tight-lipped smile suggests that there are many things he will not say about himself or his accomplishments. Indeed, he is almost painfully reticent about what most scholars now consider to be a monumental achievement in the field: his having broken a century-old logjam in Mayan epigraphy. Prevailing amid a hail of academic and personal attacks, Kelley made a persuasive argument for a phonetic, as opposed to an ideographic, method of interpretation. Drawing on the work of the Russian linguist Yuri Knorosov, Kelley's work offered a way to unlock the sounds and meanings of glyphs that had stood mute for centuries—inaugurating a new age of decipherment that is transforming Mayan studies." See Mark Stengel, "The Case of Barry Fell," *The Atlantic,* January 2000; http://www.theatlantic.com/issues/2000/01/001stengel2.htm.

12. Bennett Greenspan is a well-known researcher and entrepreneur in DNA and genealogy.

13. David Humiston Kelley reminded me that the story of the Humistons didn't end with the three children from the ambrotype; instead they are branches on a continuously growing Humiston family tree. Frankie grew up to become a doctor and had a large family and well-respected practice in Jaffrey, New Hampshire. Freddie became a successful traveling salesman, based out of Boston near his mother and his sister Alice. In fact, there were two Alice Humistons. The Alice from the ambrotype moved several times as an adult, living in numerous towns in New England, finding employment as an office worker, a caretaker, even a chicken farmer. She never married. As an elderly woman, she headed west to Los Angeles where her niece Alice worked in the UCLA library. According to Mark Dunkelman, one morning (December 16, 1933) the elderly Alice was tidying her rooms when her skirt came too close to the flame of a heater. Within seconds she was engulfed, and though her neighbors quickly came to her aid to douse the fire and dress the burns, she died in the hospital two days later, attended at her deathbed by her namesake. That Alice, Alice Mildred Humiston, played a crucial role in David Humiston Kelley's own life. She was the one who gave him his copy of *Digging in Yucatan*. David Humiston Kelley also noted that there was another namesake in the family, a contemporary Amos Humiston, who was in the military and worked for the CIA.

14. It is fun to page through Ann Axtell Morris's *Digging in Yucatan*. Could David Humiston Kelley's experience of reading the book parallel Dunkelman's experience of reading Minnigh's *Gettysburg: What They Did Here*—the excitement of being introduced to an unknown world? We could be in a Nancy Drew mystery. Ann Axtell Morris writes, "Those old diaries and letters make thrilling reading today. The tales of battles and plots, of gold and precious stones, of American kings and Spanish conquerors, fascinate as much by what they leave untold as by what they actually say." Ann Axtell Morris, *Digging in Yucatan* (Garden City, NY: Country Life Press, 1931), p. 29.

15. The Dresden Codex is one of the few books of Mayan writing to survive.

16. Michael Coe, *Breaking the Maya Code* (New York: Thames and Hudson, 1992), pp. 264–65.

17. Inga Clendinnen, *Ambivalent Conquests: Maya and Spaniard in Yucatan, 1517–1570* (New York: Cambridge University Press, 2007), p. 67.

18. My brand of craziness is different from Mark Dunkelman's. For Dunkelman it is the text of the letters. The odd turn of phrase, "fingers like bird claws" or "music in a dream." To me, it's the written words on a page. I need to feel the documents. And if I can't hold them, I need to able to see them. The Xerox of the poem, complete with misspellings, has emotional weight. And yet there is still something missing. It is that connection with the original document, that scrap of history that has been passed down through 150 years.

19. This account has been assembled from many sources. Several books detail the events of Day One, among them: Harry Pfanz, *Gettysburg: The First Day* (Chapel Hill: University of North Carolina Press, 2001), pp. 258ff; David G. Martin, *Gettysburg: July One* (Cambridge, MA: Da Capo Press, 1995), pp. 306ff.

20. Frederick Phisterer, *New York in the War of the Rebellion*, 3rd ed. (Albany: J. B. Lyon Company, 1912); www.dmna.state.ny.us/historic/reghist/civil/infantry/154thInf/154thInfTable.htm.

21. The chart has been described as a "history of the Civil War drawn to a time scale of months, and the location of all events is entirely governed by this scale." According to the *American Monthly Review of Reviews*, 1898, "A very satisfactory series of historical charts has been prepared under the supervision of Mr. A. H. Scaife. The distinctive feature of these charts is the application of an exact time-scale in the presentation of any given historical period. The idea of distance between events is thus conveyed accurately and impressively. Many ingenious devices are employed in representing historic movements to the eye. Mr. Scaife's chart of the Cuban question covers the past fifty years of Cuba's history more graphically. It more than fills the place of a printed volume on the subject. The same is true of the chart devoted to Mr. Gladstone's life and times. Mr. Scaife also publishes wall charts of United States, English, and Canadian history, a special chart of the American Civil War, a genealogical tree of British sovereigns from 494 to 1897, The Genealogy of the Sovereigns of Great Britain, showing the descent from Earliest Times, of her Majesty, Queen Victoria, and The History of the First Century of the Christian Era, including the Principal Events in the Life of Christ." See History of the Civil War in the United States, ca. 1897, Comparative Synoptical Chart Co., Ltd., http://hdl.loc.gov/loc.gmd/g3701s.cw0062400.

22. From Mark Dunkelman, *Gettysburg's Unknown Soldier*, pp. 127–28.

23. Drew Gilpin Faust in *This Republic of Suffering* writes a perfect epitaph for the Civil War in general, but she could be writing about Gettysburg in particular: "These men had given their lives that the nation might live; their bodies, repositories of their 'selfhood' and 'surviving identity,' as Harper's had put it, deserved the nation's recognition and care. . . . Yet these soldiers' selfhood and their identity were also inseparable from their names. The project of decently burying the Civil War dead required more than simply interment. The work of locating the missing and naming the tens of thousands of men designated as 'unknown' would prove one of the war's most difficult tasks." Drew Gilpin Faust, *This Republic of Suffering: Death and the American Civil War* (New York: Alfred A. Knopf, 2008), p. 101.

24. See http://gettysburg.stonesentinels.com/Individuals/Humiston.php.

25. I had an opportunity to visit the fossil collections at the Museum of the Rockies in Bozeman, Montana. It was part of a dinosaur fossil-hunting trip with Jack Horner, the premier hunter of *T. rex* skeletons. Downstairs in the lab, there was a triceratops skull sitting on a table. I picked it up and inserted my finger into the brain cavity. (I had read all these stories about how small the triceratops brain had to have been and I wanted to see for myself.) I said to Jack Horner, "To think that someday somebody will do that with my skull." And he said, "You should be so lucky. It's only the privileged few of us who get to be fossils."

INDEX

Index